Tara Moss is a novelist, journalist, blogger and TV presenter. Born in Victoria, BC, Canada, Tara is the author of nine bestselling novels and has been published in eighteen countries and twelve languages. She has researched criminal investigation extensively, earned her private investigator credentials from the Australian Security Academy, and is currently undertaking a Doctorate of Social Sciences at the University of Sydney. Moss is an outspoken advocate for the rights of women and children. She is a UNICEF Goodwill Ambassador and UNICEF Patron for Breastfeeding for the Baby Friendly Heath Initiative, advocating for better support for breastfeeding mothers in hospital, the workforce and general community. As of 2013, she has taken on a larger role as UNICEF's National Ambassador for Child Survival. For more about the author, visit taramoss.com.

The Fictional Woman
Tara Moss

HarperCollins*Publishers*

HarperCollins*Publishers*

First published in Australia in 2014
by HarperCollins*Publishers* Australia Pty Limited
ABN 36 009 913 517
harpercollins.com.au

HarperCollins*Publishers*

Level 13, 201 Elizabeth Street, Sydney NSW 2000, Australia
Unit D1, 63 Apollo Drive, Rosedale, Auckland 0632, New Zealand
A 53, Sector 57, Noida, UP, India
77–85 Fulham Palace Road, London W6 8JB, United Kingdom
2 Bloor Street East, 20th floor, Toronto, Ontario M4W 1A8, Canada
195 Broadway, New York NY 10007, USA

National Library of Australia Cataloguing-in-Publication data:

Moss, Tara, author.
 Fictional woman / Tara Moss.
 978 0 7322 9789 3 (paperback)
 978 1 4607 0058 7 (ebook)
 Moss, Tara.
 Women – Social conditions.
 Sexism.
 Sex discrimination against women.
305.42

Cover design by Matt Stanton, HarperCollins Design Studio
Cover photography by Steve Baccon @ Reload Agency
Hair & make up by Rachel Montgomery @ Reload Agency
Face art by Becca Gilmartin
Typesetting in 12/16.5pt Bembo Std by Kirby Jones
Printed and bound in Australia by Griffin Press
The papers used by HarperCollins in the manufacture of this book are a natural, recyclable
product made from wood grown in sustainable plantation forests. The fibre source and
manufacturing processes meet recognised international environmental standards, and carry
certification.

for my daughter, Sapphira

Contents

Introduction

The year is 2002, I am twenty-eight years old, and I am sitting in a small, unfamiliar hotel room hooked up to a lie-detector machine.

Pneumo tubes are wrapped firmly around my chest to measure my respiration, a tight armband sphygmomanometer measures my blood pressure and a clip pinching the end of my index finger measures tiny changes in my perspiration. Standing over me is a journalist from the *Australian* newspaper. Across the table is a professional polygraph examiner – a former Victorian police officer who normally tests suspected paedophiles, rapists and killers. He is testing me to see whether or not I actually write my own books.

I worked as a photographic and catwalk model in North America, Europe and Australia before quitting at age twenty-five and publishing my debut crime novel. Two and a half years later, as my second novel hits the shelves, the book itself has seemingly been overshadowed by a more compelling mystery: how a 'model-turned-author' (as I'm frequently dubbed in the press) could possibly write a book.

The rumours abound: that my novels are heavily edited; that my boyfriends wrote them for me; that I employed a ghost writer; that they are plagiarised. But the truth is, I have written every day since I was a child, and I have spent hours every day for years now plotting, researching, writing, editing and labouring over my novels. The rumours are false, but without a strong public voice (social media is yet to exist) I have very little means to defend myself. So when a call came from a journalist asking if I would take a polygraph test to prove that I write my own novels, I replied without hesitation: 'Bring it on.'

More than a decade later, the lie-detector test that became a defining moment in my early publishing career feels like the experience of some other woman. At forty, the struggles of my twenty-something self to be given credit for writing my own words has been largely forgotten. I am now the author of nine novels, a blogger and freelance journalist, a doctoral candidate, happily married and the mother of a young girl. The thirty-page document confirming that I am indeed the author of my own work collects dust in a corner cupboard.

Over the years I have become a big believer in statistics and empirical research. This, I suspect, is the lesson I have learned from my polygraph test: that sometimes cold, hard facts are the only way to break through unfounded assumptions – my own assumptions as well as those of others. They help us to see beyond the biases formed by our own experiences to larger patterns in the world.

Here are a few statistics that grab me at the moment:

- Women comprise 50.2 per cent of Australia's population, but as of 2014 they make up less than one-third of all

parliamentarians and occupy roughly 5 per cent of all Cabinet positions.[1]

- About 70 per cent of front-page by-lines in Australian newspapers belong to male journalists, despite the fact that an equal number of men and women are employed as journalists.[2]
- During six months of US election coverage in national print, TV broadcast and radio outlets, 81 per cent of statements about abortion were made by men.[3]
- As of 2010, the National Gallery in the UK had 2300 works in its collection, of which ten were by women.[4]
- In the top-grossing 250 films of 2012, 91 per cent of directors were men, as well as 85 per cent of writers, 83 per cent of executive producers and 98 per cent of cinematographers. In 2013 the top ten male actors combined made over 2.5 times more than the top ten female actors combined.[5]
- Women working full time in Australia earn, on average 17.5 per cent less than their male counterparts.[6]

Perhaps my interest in these statistics stems simply from the lived experience of being a woman, or from the fact that I now have a daughter and I want her to have opportunities and a voice. Perhaps my interest in women's representation and the lack of celebrated female writers, journalists, directors, cinematographers and artists stems from my personal experience of *fictions* about certain types of women (models, blondes) and the stark disconnect I once experienced between the real and the fictional me – and by extension, I imagine, the disconnect between the representations of other women and the reality of who they are. Perhaps my interest in women's representation in parliament (and non-white representation,

and non-heterosexual representation) stems from an interest in seeing a more equitable representation of the community in the parliamentary processes of our democratic country. Whatever the reason, I have taken notice of these facts.

I have also noticed something else: a large number of people are dismissive or even aggressive when confronted with statistics like those above. Women are accused of 'playing the gender card'. Time and time again we are told that advancement in our society depends solely on merit and hard work, that everything is equal now, that 'gender doesn't matter'. But as long as one gender continues to be paid less, represented less, and continues to be consistently less involved in parliamentary decision making and public debate (even when it is about their own bodies), we have to conclude that, unfortunately, gender does still matter.

There are many important discussions to be had about our society and the world at large: discussions about the issues facing our children, our seniors, our environment, and the circumstances of those from different cultures and countries. (Some of which I also write on.) But this book is focused unapologetically on the experience of women and girls, within the culture I know best. Despite its title, *The Fictional Woman* is a work of non-fiction. Many of my arguments are based on statistical and media analysis – empirically supported facts and figures – and much of the book draws on personal experiences I have never written about before, some unpleasant for me to recall and some a joy. Some of the dates are guesses. All of the stories are true.

And I wrote them myself. The results of the lie-detector proved unequivocally that (shock!) I am a writer.

1

THE MODEL

How ironic this all is. I'm hired for my looks, and yet it takes
them three hours to make me pretty enough to photograph.
Isn't that weird?
Supermodel Monika Schnarre, at age 15[1]

It was the first day of summer, and I was sitting in the front
passenger seat of the family car sipping a Dairy Queen
milkshake. The cold of the milkshake froze the metal braces
on my teeth, so I had to remember not to drink it too fast. My
mother, Janni, was in the driver's seat. We were parked at the
scenic lookout at the top of Mount Tolmie, my hometown of
Victoria, British Columbia, spread out below us.

My mother put down her own milkshake and took my
hand. 'Tara, is this what you want?' she asked, looking me in
the eye. She was not referring to the milkshake, but to the
sudden, rather staggering suggestion that I become an
international fashion model.

In many ways, I was the most unlikely candidate for a model
you could imagine. Throughout my childhood I was what

many people refer to as a 'tomboy'. I loved climbing trees and playing with toy cars. It wasn't that I hated 'feminine' things; I just liked cars and horses and spaceships – things that could go fast and take you to exciting places and planets – more than I liked toys that needed to have their hair brushed. I preferred toy monsters to toy kitchen sets. My parents never emphasised that I was different or needed to change my preferences; these choices of mine were not conscious, at least not yet. And I didn't have a problem with girls' clothes per se; I just hated wearing dresses because they got in the way when I was going places, like up trees.

When I was six years old, my father took me and my sister to his work picnic. Thanks in large part to my height and the long legs that came with it, I could run faster than most kids my age, and that day I won a running race. I think it was the first time I had ever won anything. One of the organisers led me to a table marked 'Girls Age 6–8' to collect my prize. The table was covered in wrapped gifts, and fearing I'd be stuck with a toy I would not like, I asked if I could please take a gift from the boys' table instead. The woman bent over and told me quite pointedly, 'No, darling, those are for boys. These are the ones for *girls*.'

Reluctantly, I took a gift from the girls' table and opened it to find my worst fears realised. It was a Barbie doll.

I held the 'useless' doll I'd won, my first prize ('It doesn't *do* anything!') and watched through eyes swimming with tears as the winning boys collected their Hot Wheels cars and train sets and action figures. Thankfully, my mum understood. She wiped the tears from my face and explained that we could make my prize into anything I wanted it to be, anything at all. So when we got home she helped me to dye Barbie's blonde hair black and add stitches to the doll's sculpted plastic cheek

to transform her into a kind of Vampirella/Bride of Frankenstein monster. I loved her. (To this day I wish I knew what happened to that doll.)

In my preteen years, I became interested in makeup. I was perhaps twelve and I was experimenting with my appearance. Mostly I wanted to be David Bowie, who, truth be told, I resembled a bit at the time, physically speaking. I had grown up but not yet 'out'. I was the Thin White Duke. In fact, I was so skinny my dad used to joke that if I turned sideways and stuck my tongue out I'd look like a zipper.

By fourteen I was painfully skinny and unusually tall. Complete strangers had taken to commenting that I 'should be a model'. Then my parents watched a TV program about an Ontario girl named Monika Schnarre. Having been 'discovered' at age thirteen, she was now sixteen years old and six foot one, and had already launched a successful modelling career in Europe; apparently modelling agencies favoured young girls who were tall and slim. The airing of the program coincided with the semi-annual marking of our heights with pencil on the frame of the kitchen doorway. I had surpassed my older sister's impressive stature and cracked five foot eleven. I was growing fast and I wasn't finished yet. In fact, I'd grown so fast there were faint stretch marks on the backs of my knees.

I was tall and young, but still quite shy and introverted. My parents had noticed that I had started collecting American *Vogue*, and after watching the TV program it occurred to them that appearing in a fashion show at the local mall might help to boost my confidence. So one afternoon my mother took me to a local model agency, Charles Stuart. The reaction of the agent, Corey Paisley, was not at all what we'd expected. He said I had something called 'It'. He said I was just what they were looking for in Europe, and as soon as European casting

agents saw me they would want me to fly to Milan and Paris to work. He urged us to sign a contract, and urged me to book in for a modelling 'test shoot' immediately, so they could see how I looked on camera in makeup. It would cost us a lot of money to have the test shoot done, though, he warned.

Instead of agreeing right away, my mother played it safe. Surprised and a bit wary, she thanked the agent for his time and left without making any commitments. Thirty minutes later we were at the top of Mount Tolmie looking over the town I know so well. This was where I had grown up. I could name the streets below, I could see the houses of my friends, my high school, even the hospital where I was born. I'd never been on an aeroplane, let alone to another continent. The only work I'd done was a newspaper route with my friend Debbie, and delivering the local Penny Saver coupon flyer with my mom.

My mother hadn't been on a plane either. She had come to Canada by boat from Holland after World War II. Her father, my Opa, had been forced by the Nazis to work in a munitions factory in Berlin during the occupation, along with a lot of other young, able-bodied Dutch men. A baker by trade, he baked bread in the munitions oven to bribe the foreman, got a pass to leave the factory, then stole a horse and cart and galloped past the guards at the checkpoint. He freed the horse in a field and continued on foot, walking nearly 700 kilometres, mostly under cover of darkness, back to his hometown of Numansdorp, a small town south of Rotterdam. There he hid, emerging from the family home only at night, worrying every day that the Nazis would come after him for escaping the work camp. By the time the war was over, their village had been flooded twice and their house was shelled.

My Oma and Opa had four children when they departed for Canada. Boats left frequently for Australia and Canada,

Opa told me, and they took the one to Canada because it left one day earlier. My mum was too young to remember the journey.

'Is this what you want? To go to Europe?' my mother asked me. 'You want to be a model?' She seemed slightly rattled. A career as a fashion model was a far cry from a kid doing a show at the local mall.

But I was excited by the idea. I was thinking of those pictures in *Vogue* – how everyone in them looked so healthy and glamorous and happy. (It was the late eighties, after all, a few years before the sad 'heroin chic' look hit.)

I took another sip of my milkshake, trying to act casual though my stomach was in knots. 'Yes,' I said.

More than a quarter of a century later, now that I am roughly the age my mother was then and the mother of a girl myself, I still remember the look on my mother's face. I wonder sometimes about the fear and uncertainty she must have been wrestling with that day.

'Okay. If this is what you want, we'll support you,' she told me. 'And if they really want you, we shouldn't have to pay them to take your picture – they'll call us.'

We finished our milkshakes and she drove us down the mountain. When we got home the answering machine was flashing. There were several messages on it, all from the model agency. They said they wanted to shoot me straight away and they would drop the fee.

When I sat for the test shoot a few days later, it seemed my brief brush with an exciting career would be over before it began.

The photo studio was in the back of the agency. It was a small room with a paper backdrop and a mirror in one corner for doing hair and makeup. I dutifully sat in the stool and let

them go to work. I expected to look like I was in *Vogue*. Instead I looked like I was in Barnum & Bailey. 'Contouring' was in. The makeup artist believed that my cheekbones (what I had of them at that age) absolutely required prominent, rectangular strips of dark brown blush. The eye shadow was likewise heavy and contoured around my eyes in weird strips. The lipstick was nearly black. I didn't get it. I looked like a clown. But when I asked the makeup artist about it, she just said, 'We're shooting in black and white.'

Looking now at the contact sheet (a series of small photo images from which one chose an image to enlarge), I can see that my braces look ready to burst through my tightly pursed lips. And for all the makeup artist's insistence that the makeup was necessary for shooting in black and white, you can see every edge of contour. One frame in the middle of the roll shows me with my mouth wide open, eyes closed and metal braces flashing, caught in a silent scream.

My clown-like appearance did not stop me from getting a casting call for the Mayfair Mall fashion show. I practised the catwalk gait they'd taught me at the agency, walking back and forth along the carpeted hallway of the family home, lacing my feet and pushing my hips forward and shoulders back. When it came time to do the casting, however, I started blushing like a beet. I was so awkward, I was sure I'd blown it. But they hired me. I still had that full set of metal braces, though, and my hair was cut in a classic eighties mullet, with 'feathering' at the sides. The show organisers fixed this by putting me in a fashionable hood and instructing me to keep my mouth closed. In the images from the show, I don't look like a fourteen-year-old kid. I look like a woman.

Soon after, I had my first 'real' photo shoot. It was on the mainland in Vancouver, and it was exciting at the time just to

be leaving Vancouver Island. It was starting to feel real. In the shoot, I wore a tight pencil skirt and suspenders over a T-shirt, with slicked-back wet hair and geisha-white makeup. I looked twenty-four. And slightly dangerous.

Not long after that, the European casting agents came to town, saw the pictures and declared that they wanted me in Europe the next summer, when I would be fifteen and my braces would be off.

Though the discussion around models and fashion magazines these days tends to focus almost entirely on the weight of models and the Photoshopping of their images, what strikes me the most, looking back on my early career, is the *age* of the models. It was routine to use underage girls – of which I was one – to sell products aimed at adult women, including gowns, lingerie and age-defying skin creams.

So it was that around the time of my fifteenth birthday, I was modelling an ivory silk camisole and matching French knickers for the Woodward's department store catalogue in Canada. It was a relatively demure, family-friendly image, of course, Woodward's being a family store. I was sitting on an old-fashioned wooden chair, looking off wistfully, perhaps dreaming of more glamorous times to come. It was my first-ever appearance as a 'published model' and my parents were proud of me. (One day my father took our family car, the Dodge Lancer, to a mechanic and saw that Woodward's advertisement cut out and stuck on the wall in the garage. When he told them my age, and that I was his daughter, they had a rather large freak-out. He found it amusing and told us about it over dinner.)

The innocence of that image haunts me. Everything in my world was about to change. I just didn't know it yet. In the

1980s, Victoria was a small town with something of a deficit in big dreams. On the southern tip of Vancouver Island, an hour and a half by ferry from the mainland of Canada, Victoria had (and still has) a population of under 80,000. It is a safe and friendly place to live, and made for an idyllic childhood, but back then few people spoke of having an 'international career' or making a 'groundbreaking discovery'. In fact, it was cruelly joked that Victoria was for 'newlyweds and nearly-deads' – a stunning place for visitors and perfect for those settling down, but not for teenagers trying to find themselves and expand their horizons.

I went to public school, as most kids did, and at my high school the kids with intellectual gifts were known to everyone. They were on the Honor Roll, posted on wooden plaques in the school hallways, and most were given scholarships for higher education when they graduated. The troubled kids were also well known. Some of them were expelled or tragically ended their lives before graduation; some became single mothers as teenagers and lived in trailer parks, unable to hold down a job with a child to care for and no graduation certificate. Then there was the vast expanse of grey in between. The not-troubled, not-gifted kids worked at the local video shop or McDonald's, or tried to break out by way of the school track team. Some joined the military. Some went on to university. The majority did not.

My sister, Jacquelyn, who is three years older, distinguished herself early. When she was very young she went on a TV show to talk about computers, which were new at the time. It was a big deal. She was spoken about as a prodigy. She helped tutor kids in primary school, earned straight A grades and made the high school Honor Roll. She was bullied for her gift, however, and even beaten up once in class, and soon

learned to wear Billy Idol-style leather jackets, sit at the back and not to raise her hand. She was gorgeous – fairer than me, and less gangly. Even though she hardly studied (by her own admission), she graduated with honours and a scholarship.

I did not earn straight As. I needed to study hard to pass higher level maths. As gifted as my sister was with numbers, I abhorred them. I wrote horror stories in algebra, hung with the Dungeons & Dragons crowd and, being the tallest student in my grade for much of school, took on an unofficial role of Protector of the Nerds, breaking up fights when the jocks inevitably picked on the kids in wheelchairs or with glasses. I looked pretty normal and dressed okay but I was not remotely cool. I preferred the oddballs and the tomboys over the popular kids and jocks, but the truth was I didn't really fit in with either group.

Mr Bendall, my high school English teacher, saw something in me, and allowed me and my friend Dan Wood to write a novel in class instead of doing the assignments. This was perhaps the first inkling that I had a writing career ahead of me, though I did not yet know it. Mostly, I just knew that I liked to write stories and I liked that more than I liked hanging out with kids my age. I now recognise that I was a classic introvert.

Because my sister was so academically gifted, and I did nothing much to distinguish myself – while I got As in art and English, for algebra I was lucky to earn a C+ – I was not considered smart. Many years later, a family member confided that everyone thought my sister 'was the smart one' and 'you were the pretty one'. (And never the twain shall meet, I suppose.) It is perhaps unsurprising, then, that modelling seemed to be my destiny. After all, strangers don't walk up to young girls and tell them they should be writers.

And so, in the summer of 1989, my parents used up most of their savings to take me to Milan and Hamburg to start my career. But despite having been told that I had 'It', and that I was the 'next Monika Schnarre', things did not go as planned. The agents who, less than a year earlier, had insisted that I come to Europe, were dismayed to discover that my 'look' had changed. The problem was that I was no longer quite so androgynous as I'd been when I was fourteen. I was becoming a woman. Looking back, I was very tall and thin, and I was just *fifteen*, for heaven's sakes, but I had started to get a hint of breasts and some hips – which I would be encouraged to diet off.

The professional disaster that was the 1989 Europe trip was sealed one night in Hamburg when my parents left the window of their room open a crack to let in some fresh air. I was down the hall, fast asleep on a futon in front of a mirrored wall. In the morning I felt a strange, hot tightness in my face. When I sat up and saw my reflection, I let out a horrified scream that lasted a full two bloodcurdling minutes. I was covered in mosquito bites as big and round as watch faces. There were bites inside my ears, my nose, across my eyelids, on the end of my nose. The swelling became so severe I looked something like the famous 'Elephant Man', Joseph Merrick. To say it put a damper on my work opportunities that summer – whatever scant opportunities there were at the time – would be an understatement. I have been allergic to those little flying beasts ever since. (My parents somehow escaped unscathed.)

Once I'd recovered from the bizarre mosquito incident, I did a test shoot in Milan with a makeup artist whose mascara caused some kind of allergic reaction. It came on suddenly while I was in the makeup chair, the whites of my eyeballs swelling until they protruded beyond my eyelids. I was briefly

hospitalised and the agency decided that I was unsuited to the work because I couldn't wear makeup. (To this day I bring my own mascara to photo shoots to be safe. I recommend all models and performers do this.)

True, I barely worked a day that summer yet it was one of the most important times in my life. The three of us – Mom, Dad and I – travelled together through Italy, Germany, France and the Netherlands. For a kid straight off Vancouver Island, the old cities of Europe were an utter revelation. We saw Michelangelo's *David*. We saw the Duomo in Milan. We floated in the sea in Nice. I met Dutch relatives and, most importantly, my mother returned to Numansdorp, to her birthplace, for the first time since she'd left nearly four decades before. She got to see her parents' names scratched into the bell tower of the chapel they were married in. She got to see the house in which she was born, and the spot where the shells came through the roof during the war. She would never have seen those things if that charade of a modelling trip hadn't forced us all onto a plane.

It was the last time she would see her birthplace. Less than a year later, she would be dead.

Not long before we had that fateful meeting at the model agency in Victoria, my mother had an adenocarcinoma removed from her adrenal gland. I knew she'd had surgery, but I was too young to understand what it was all about. As far as I was concerned, she'd had a tumour and the doctors had cut it out. End of story. She was my mother. She was invincible in my eyes. Invincible. Later I would find out from my father that the doctor at the Royal Jubilee Hospital's cancer clinic had shown her an X-ray of the tumour. It was as big as an orange.

In 1990, less than two years after having the cancer removed from her side, my mother was diagnosed with multiple myeloma – an uncommon cancer of the bone marrow. There were no available drug treatments. The only known treatment was a bone-marrow transplant from a compatible donor, in this case her brother Otto. The doctors warned that there was at least a 25 per cent chance the treatment itself would kill her, and the likelihood of a cure was unknown. Multiple myeloma is more common in older men, and they diagnosed her late, despite her earlier brush with cancer. So this was what she faced at forty-three – she could endure a gruelling operation that might well kill her, or die in terrible pain as her bones disintegrated and her organs failed, a grim death that might take months or years. In her position, knowing what I do now, I don't honestly know what I'd choose, but my mother, when faced with this terrifying choice, was brave and determined to be there 'for her girls' and for her husband of twenty-five years. She opted for what was, at the time, an experimental treatment.

My mother was one of the first 100 patients in the world to be treated for multiple myeloma with a bone-marrow transplant. She was in hospital for two long months and I tried to keep up with school during that time, but with my parents on the mainland at the hospital I was distracted, to say the least. With my frequent trips across to Vancouver General Hospital, my school attendance dropped dramatically and eventually the school decided to pass me through my eleventh grade exams based on my good previous marks and attendance record. Several times a week I travelled between Vancouver Island and the mainland on the ferry. My sister and I had to put on sterile gowns and scrub ourselves with disinfectant before being allowed in to visit our mother. The ward was

full of young kids fighting leukaemia, and I remember feeling *so fucking guilty* to be so healthy.

That bone-marrow transplant was a brutal way for my mother to die. She was hooked up to tubes and a respirator, unable to leave the hospital room, largely unable to walk. My loyal father, who has always had back trouble, slept on a cot beside his wife every single night for two months. He would not leave her side. When she slipped into unconsciousness, ravaged by the treatment and complications, no longer able to breathe on her own, we all held hands around her swollen body in ICU, listening to the machine that made her lungs work, keeping her alive. I'll always remember the feel of her hand as I held it. It was hot and puffy like a balloon. The smell was so strange, like she was filled with chemicals. She'd lost her hair and eyebrows, and her swollen features were indistinct. The sound of a respirator can still reduce me to shakes. We left the room, eventually, and my dad stayed with her to hold her when they turned the machines off.

Right until the end I thought it had to be a terrible mistake. There was no way she could die. She just couldn't. It was impossible to consider life without her.

At the memorial, I wore her favourite floral Laura Ashley dress, which has hung in my wardrobe ever since, never to be worn again. It is bright and cheerful; she wouldn't have wanted me in black. Her parents, my Oma and Opa, stayed in a separate viewing room throughout the service, unable to face the crowd of mourners.

My sister, then nineteen, retreated into her own grief, but for the first few months after my mother's death I shadowed my father, unable to let him out of my sight. I dragged him to the beach with me. To the pool. To the shopping mall. The

two of us took a trip up island to Tofino, where we'd always spent summers as a family. Sometimes in the night I would hear my father weeping. The sound was soft, creeping like damp through the walls of the family house – a house that suddenly seemed so empty it was as if it were a different place entirely, no longer a home at all. The grief was stifling.

Months later, using my modest savings and some money borrowed from my father, I booked a flight to London. I'd been told I should be a model and, even though that first trip hadn't worked out, I was going to throw myself in headfirst. That Woodwards ad of me had been taped to the wall next to my mother's hospital bed, among the family photos and get well cards – a symbol that even as she was dying, she was proud of me for pursuing my dreams. I needed to make my mother proud, and my father too. I had to show everyone that I was okay. I had to make something of myself, and there was no time. It had to be now. My mother's death lit a fire under me that would not go out for decades. I had to run and keep running. I had to make it.

As usual, things did not go according to plan. A locally born photographer who lived in London had offered to set me up with an agency there, but when I arrived, what he mostly did was try to get me into bed. I started knocking on agency doors by myself, with a slender portfolio of questionable photos from my few professional Canadian shoots. I didn't know anyone and it was amazing that any agency took me on, but they did. I lived in a youth hostel, going to castings and being rejected time and again. I remember how cold London was, and how I'd sit in the galleries staring at the oil paintings, wondering what life was like beyond the canvas. At one point I lived in the freezing granny flat of a mansion in Hereford Square, where I babysat the owner's children. I bought a tiny blow heater and

used to fall asleep with it next to me on the bed, it was that cold. Looking back, I'm surprised I didn't set the bed alight.

It was a rocky start but modelling was my ticket out of small-town life after all. I am grateful for that. I also have to be honest about the downsides of my career choice, however. It was a hard, lonely, frequently unsatisfying and sometimes downright dangerous life. And I didn't manage to save much. Not because I spent my (frankly infrequent) pay cheques on clothes or booze or anything like that; I was not a party girl. I didn't touch drugs and I didn't drink alcohol or even coffee until I was twenty-five years old. But while a high-paying hair commercial – say $5,000 at the time – was usually enough to live on for a while, it wasn't enough to build a nest egg. I catwalked for the top designers, appeared in some ads and on the covers of more than a hundred magazines, but I wasn't a household name. Like actors and musicians, most models go from pay cheque to pay cheque, hoping to break through. That was me. Sometimes you'd luck out and there'd be a small windfall, but then you had to live on that money until the next big job. A lot of the best designers and magazines paid next to nothing, because they knew you wanted to work with them. It was a rort. There was zero job security, no union, and you could easily go weeks or even months without earning a cent. You just had to keep chipping away, hoping for something better, hoping that you'd get your big break and that all you'd done to get that far wasn't for naught.

My first breakthrough came in the form of a series of posters and billboards splashed across London for *Cosmopolitan* magazine and Braun hairdryers, where I appeared to be reading a *Cosmopolitan* magazine with a cover bearing an image of me reading the magazine with a cover of me reading the magazine,

and so on. Naturally I was doing all this reading while drying my hair with a Braun. The only problem was that the storyboard showed my hair fanning out dramatically, pushed by the wind of the hairdryer, and in real life, the hairdryer lifted only about half an inch of my thick hair, the ends barely stirring. Before the day was through, the crew had concocted an intricate mane of chicken wire and threaded my hair through it to make it look like it was flying back. The image was displayed in every bus stop on Kings Road and I had a stranger take a picture of me standing next to it to send home. Prior to that shoot, I had spent over two months unemployed and knocking on doors.

I posed for editorials, which paid terribly, and I did a lot of covers, which paid worse. Once I agreed to a weekend shoot for a 'photo library'. The shoot itself was, in fact, one of my fondest memories from that time, traipsing around the French countryside in summertime with a couple of other models in generic summer clothes, smiling and laughing. The photographer and his wife were normal folks and treated us like human beings. They even cooked for us. We were each paid about $150 a day for two days and the deal was that our rights would be signed away to the photo library, so the images of us could be used for anything, forever. (Incidentally, this is *not* something I'd recommend anyone agree to, under any circumstances.) About ten years later, my father walked past a camera store in our hometown and saw that the entire window display was made up of photo frames, each with the same image of me as a sixteen-year-old from that shoot in France. Who knows what random things I advertised with those pictures.

Modelling was excellent work if you considered the hourly wage, and that would have been fine if I was in demand every day, but I wasn't. Few of us were. Commercials were what

kept me going. One or two a year was enough to live on, though my first commercial was a near disaster – in the literal life-and-death sense.

I was sixteen when I attended a German casting, and the agent asked if I could drive a car. I replied, quite honestly, that I didn't have my licence yet but I was pretty sure I could work an automatic if I had to. I got the job. In the ad, I was dressed as a motorcyclist in masculine leathers and a full-face helmet with a tinted visor. I would walk away from a parked motorbike and then step up to a shiny convertible BMW, at which point I would peel off the jacket and helmet, throw them in the back seat, and toss my hair in the sunlight to reveal that, hey, I was *a lady*! I would then get behind the wheel, start up the car and drive past the camera – the strong, glamorous, independent (never mind underage) woman. Well, that was the storyboard plan, anyway. I turned up on the day to find that they had a manual car, not an automatic. I'd never even *seen* a manual before. We were shooting the commercial on an empty airport runway, on a beautiful clear blue day, with a massive budget and crew, and each time they reset the camera and started shooting again, and I pulled off that helmet and shook my hair, I would get behind the wheel, start the convertible and the thing would conk out. I simply *could not* get it to drive. At one point a crew member actually crawled in and lay at my feet to work the pedals, but even he couldn't get it to go.

The director began screaming at me in German – rather unhelpfully, though perhaps understandably – and the only word I could make out was 'Gas! Gas!', so after another couple of failed takes with the car bunny-hopping two feet before conking out, I slammed on the gas, pedal to the metal, and peeled out at *high speed* directly towards the director and crew, who leapt out of the way, screaming. I missed the camera by

inches. I never did see the finished commercial, but if it made it to air it must have looked, well … dramatic.

I would wait over a decade and a half to get my licence after that, and true to my never-do-anything-by-halves philosophy, earned my motorcycle licence, car licence and race car driver's licence at the same time.

I was the face (or face and hair, as it were) of Nivea hair care for a stretch. I remember shooting one of the commercials in London in a cold, cavernous warehouse, wearing only a strapless bikini, pretending to shampoo my hair in front of a tiled facade – a faux bathroom – while a member of the crew straddled a massive plastic water tank above me, suspended from the ceiling by chains, pouring water on me from a garden hose. The water was unheated, of course, and it was a freezing London winter. They kept having to stop the shoot because my skin was – for some mysterious reason – turning blue and covered in goosebumps. They shampooed and dried my hair several times for the standard silky-hair close-up shots after that, and to my knowledge never used the actual product. (I understand the advertising industry has rules about that sort of thing now. Mostly.)

When I was seventeen we shot a Nivea commercial in Istanbul, and I had to learn the Turkish lines by rote on a Walkman. Unfortunately, after practising for a day, I came down with food poisoning after lunch with the local producers and crew. I vomited all night before the shoot, and when they took me to the doctor in the morning to have me sign paperwork to say that I was okay (I kept insisting that I was fine, as I was terrified of losing the job and being sued for the massive production costs) I actually passed out in the doctor's doorway. When I was revived, I still insisted I was okay. The

film assistant walked me out, and when we were in the elevator I passed out *again*. I remember slowly oozing down the wall of the elevator, everything turning to stars and then blackness, while the poor young man, a devout Muslim, tried to keep me up by my collar because he couldn't touch me. I woke in a Turkish hospital bed, half blind and hooked up to an IV. I'd been so dehydrated that I had to stay overnight under special care.

In the end we shot the commercial in reverse order, doing the wider crowd scenes first. In one scene, where I was hailing a cab, all shining hair and conspicuously blonde in a sea of Turkish locals, I still looked rather green beneath all the makeup. At the end of the week the film crew bought me a silver ring to thank me for being so determined. It was a highlight, and the money I earned for the shoot (perhaps $15,000 – a lot for me at the time) helped me to pay back the money I'd borrowed from my dad for my trip to Europe. I'll always remember the kids in Istanbul following me around and giving me flowers.

My early modelling years were marked by uncertainty and long stretches of unemployment. At times I was penniless because clients or agencies failed to pay me. (It took over a year to get paid for that British Braun/*Cosmo* ad, for instance, because the agency held the money.) But nothing could deter me. I was not going to go home to Canada with my tail between my legs, and I certainly wasn't going to burden my bereaved father with my insignificant problems. Every letter I sent home to him was filled with only the good news. When I was broke I just ate less and moved to a cheaper hostel.

The thing was, I had to keep going. I had to make something of myself. And so I kept on.

What do I have left to lose? I thought.

2

THE BODY

When a model who was getting good work in Australia starved herself down two sizes in order to be cast in the overseas shows ... the *Vogue* fashion office would say she'd become 'Paris thin'.

Kirstie Clements, *The Vogue Factor*[1]

In 2013 I interviewed former *Vogue* editor Kirstie Clements about her memoir, *The Vogue Factor*, on stage for the Sydney Writers' Festival. As I read the book and went over my interview notes to prepare, I did my best to untangle my personal experiences with modelling from the observations made by Clements. Likewise, I tried to reconcile the disappointment I felt when she, as the *Vogue* editor, chose a baby-faced underage girl in a ball gown for a cover (a choice that led to a significant public backlash) with the fact that she had since denounced the pressures within the industry to use models who are too young or thin: 'I felt foolish even trying to justify it ... I immediately instigated a policy that we would not employ models under the age of sixteen,' she wrote of the incident.[2] Meanwhile, kids dressed to look like adults were

24

still being used by the trendsetters in Europe, as I had once been.

In her memoir, Clements describes a shoot where the model ate nothing and had to be photographed lying down next to a fountain because she could no longer stand. Then there is the model with scabs and scars on her knees. ('Because I'm always so hungry I faint a lot.') And the models on hospital drips, and eating tissues to stave off hunger, as the tissues would swell in the stomach. It sounded a little too familiar – part of a world I'd walked away from at twenty-five.

I don't remember *seeing* anyone eat tissues, but I certainly recall many a conversation at castings in New York, Milan or Paris, where the other girls talked about how they were faint because they 'forgot to eat today'. (I say girls, because many were fourteen or fifteen, not yet women.) Mostly, though, as I was not privy to other people's actual eating habits, when I was modelling it just seemed that everyone was under twenty and smoked far too much. Not all of the models, of course, but the models who did a lot of runway work and couture editorials smoked a great deal indeed. It seemed peculiar to me, coming from Canada, to see all the constant smoking; it was common for me to be the only one at castings *without* a cigarette in hand. I also noticed after five years or so that the same models who spoke of starving themselves tended to visibly age quite fast and fall out of the industry early, looking hollowed and tired. Sometimes I would see the same person two years after meeting at a casting and find myself disturbed by how unwell they looked at just eighteen or nineteen. In my experience, besides a general lack of wellbeing (and, to be honest, many of us lacked wellbeing at that stage in our lives), heavy smoking and sun exposure are the things that will rob a person of their physical blessings faster than anything else. Add

to that a borderline (or not so borderline) eating disorder and you have a fast track to a short modelling career – and quite possibly a shortened life. Some rare people had the ability to maintain an unlikely beauty while slowly killing their bodies, but most could not manage it. I saw that. It didn't appeal – which is not to say that I don't sympathise with the instinct to starve for work, or for affection, or a sense of control, or for the other many things that drive people to disordered eating. In fact, I understand the feeling well.

I know people who have suffered terribly with eating disorders for decades. I am fortunate that my flirtation with 'skinny' was short-lived, but it did get me for a while there. When I first started modelling, agencies weighed and measured their models on a regular basis, often on Fridays. On each dreaded Friday you came in and if you didn't weigh the right amount you were cast out. That was the reality and we were all quite aware of it. Feelings were not considered. Eating disorders were not mentioned. If you were too big you were told to lose weight immediately or go home. The grace period in which to lose the required weight was very small.

I recall the awful experience of being weighed and measured in Europe for the umpteenth time (the measuring tape was always so cold against my skin, I still remember the feeling) and being told, *again*, that I was 'too big' to get work. I had by that stage done the Braun/*Cosmo* thing, the BMW ad where I nearly killed the crew, and a couple of beauty editorials, but not much else. ('Beauty' work usually involves only the face, and is mostly done by teenagers to show how lovely and young the skin cream in question will make you look.) I was seventeen and had no money. I knew I could go home to Canada and my kind father would pay the fare, but that would be an admission of defeat, so I did as I was told and

aimed for weight loss, fast. I didn't want to end up too unhealthy, though, so I adopted a regime I thought was sensible: in the morning I ate a small bowl of cereal with skim milk; lunch was one rice cracker and a single apple; for dinner I had a can of soup.

I did not deviate from this routine for weeks. The soup was full of vegetables and had some meat in it so I figured that, along with the apple and cereal, I was covering all the food groups. I felt hungry and uncomfortable, but I lost weight rapidly, and when I returned to the agency having dropped a dress size or two I was accepted again. Soon after, I was photographed in a designer bandage dress looking quite 'high fashion', and proudly sent a copy of the shot home with my weekly letter. When my dad received it he contacted me immediately. My ribs were clearly visible. My cheeks were hollow. My hips were angular and my breasts had completely disappeared. The budding woman's body of only a year before had turned skeletal. He was extremely concerned.

Meanwhile, I was showing up at castings, sometimes the last casting of the day, with chain-smoking models who talked openly about having forgotten to eat all day. I didn't get it. How was that even possible? I wondered. To *forget*? *All day?* I felt hungry much of the time, my ribs were sticking out and I was *still* too big for many designers. I was Amazonian in size and that was just the way of it. How did people actually eat nothing?

Thankfully, I soon gave up on being 'Paris thin' and went back to finding modelling agencies who were happy to get me 'beauty work', hair commercials or swimwear shoots. (Swimwear and visible ribs don't go well together, so I was popular once I returned to a normal weight.) Though I had catwalked for some of the most prominent designers in the

world during those few skinny months, they could take a hike, as far as I was concerned. Commercial work paid a lot better and I didn't need to kill myself for it. My father was relieved.

When I see the photograph from those skinny days now, it makes my stomach twist. I see a deep sadness in my eyes beneath that fashionable makeup. It is as if someone has actually cut my body parts away. I feel a sense of loss just looking at myself. Thank goodness my dad felt he could say that he was concerned, because back then, no one else was telling me the truth about my health. Years after I quit modelling, I was in a supermarket when I spotted a can of the same soup I'd eaten for 'dinner' each night for months. There was no way I could forget that label. I picked it up and looked at the nutritional contents. The entire can provided only 75 calories. *Seventy-five!* That was my big meal of the day. I worked out I had probably been on no more than 500 calories a day, as a six-foot-tall seventeen-year-old, less than a third of the recommended daily intake for teenage girls.

The reasons for eating disorders are complex and varied. You don't need to be in an industry that worships thinness – like fashion or dance – to develop an eating disorder, but there is undoubtedly a reason why so many professional models do. Eating the wrong thing can cost you your pay cheque. Once they had been told to lose weight, for some girls it was hard to stop. They associated the weight loss with success and achievement. They felt that it was one thing they had control over in a world that was often uncertain. And any loss of control for those young women was detrimental to their self-esteem.

Once I left the catwalks of Europe, I found myself doing a lot of beauty and hair ads, swimwear, lingerie (some of it quite

matronly, but hey, it paid double time) and, finally, bridal gowns. Such work was considered a career killer by many, but if you weren't thin enough for couture it could be your bread and butter (which, unlike the catwalk models, I could eat). One day, I was in Milan on a bridal shoot and I noticed that the other teenage model, an extremely thin American brunette, had long downy fur all over her face and arms. I found it so peculiar that I couldn't help staring at her. After lunch she emerged from the toilets with bloodshot eyes and smudged makeup and the makeup artist got cross with her. I tried to defend her, thinking something had happened during the shoot to make her cry (I'd seen that before), but when I got close I was struck by a strange, acrid smell. The girl was embarrassed and I didn't know how to approach her. Then the makeup artist announced to the entire studio in a loud voice that the model had thrown up her lunch, *again*, and the makeup would have to be redone. It was so insensitive, looking back, and I didn't know what to do. I'd never heard of people throwing up on purpose.

That photo shoot was my education about bulimia. Until I was confronted with it in this overt way I hadn't known bulimia existed, and while the commonplace starvation I saw around me seemed unhealthy and at times downright baffling, this seemed like a more concrete disorder, perhaps because it was treated as such, due to the inconvenience it caused the crew.

Unless you witness the red eyes and smell, or notice the downy fur (a common symptom of malnutrition called 'lanugo') that is the hallmark of so many anorexia and bulimia sufferers, you can't be sure if someone is naturally thin – as some people genuinely are – or whether they are suffering from an eating disorder. One need only travel to see that there

are many very skinny people in the world in places which are not so affected by sedentary living and fast-food culture as we are in the US, Canada, UK and Australia. Thinness can be natural, but in the modelling industry, self-imposed starvation can be a common response to the need to fit into a sample size and get work. It's a form of survival that can ultimately kill you if you don't get help.

Ironically, perhaps, it was only towards the end of my modelling career that I developed an identifiable eating disorder.

Looking at it now, I don't honestly think that, in my case, it was the modelling industry that did it. I'd spent most of my career doing work that required a healthy look, bright eyes and clear skin, and did not require me to starve. (In fact, being thought of as curvy often worked for me. I was even a 'plus-size' model for Maggie T at one stage, at only size Aus 12.) But on a personal level, I was suffering, and for me that suffering took the form of emotional eating, which eventually led to feelings of shame and a loss of control and, ultimately, bulimia, just like that girl in Milan so many years before.

I was in my early twenties, and the disorder lasted a relatively short time, perhaps a year or less. Though it seems distant now, it was a truly awful and frightening period in my life. Since I did not drink, do drugs or party, food became my escape, somehow. At the peak of the disorder the episodes occurred every few days, the actions always compulsive and fast. I was doing fine, I'd conquered it for a few days, and then I would race home and devour ice cream or chips in some private, exhilarated flurry, pushing my pain down. Briefly, I would feel high on the sugars of the food and, I think, on a deep-seated sense of rebellion against what I 'should' have been doing – that is, being 'professional' and watching my

weight as a model – and my heart would pound so hard it was all I could hear. And then, when the adrenaline subsided, that awful moment would arrive when I would debate what to do. Often I felt too full for comfort. Many times I told myself, as I was shovelling food in, that I could always just throw it up, but then when the crucial moment arrived I couldn't go through with it. That was a good thing. But other times, I forced myself. My throat hurt from my fingers, my teeth ached from the stomach acids and my guts hurt.

For a while I had nightmares about losing my teeth altogether (bulimia sufferers can indeed lose their teeth from the bile, tooth-enamel loss and calcium deficiency) and I thought of that American girl in Milan and how sad I had felt for her, and how peculiar she had seemed at the time. I was on a roller-coaster of shame and secrecy until I went to see a psychologist about it, something I could just afford to do. After some productive discussions in the safety of that professional space, I managed to untangle some of the emotions that were causing me to binge and, as a bonus, I learned a bit about myself in the process.

I had literally been pushing my grief down.

Binge eating was for me a kind of clumsy, ineffective self-medication. After the loss of my mother, and after some of the more troubling things I'd experienced up to that point, I needed to heal. I thought I was coping, but bulimia was the big neon sign that told me I was not. Unfortunately my boyfriend at the time, who was quite beautiful, somewhat vain and a fair bit older than me, was not the one to help that healing happen. He'd suffered anorexia himself and frequently criticised my weight in the most explicit terms.

I would not be able to heal until I stopped running. And in order to stop running, I needed to feel safe again.

3

THE SURVIVOR

So this male friend of mine ... entered into the following
dialogue: 'I mean,' I said, 'men are bigger, most of the time,
they can run faster, strangle better, and they have on the
average a lot more money and power.'

'They're afraid women will laugh at them,' he said.
'Undercut their world view.'

Then I asked some women students in a quickie poetry
seminar I was giving, 'Why do women feel threatened by
men?'

'They're afraid of being killed,' they said.

Margaret Atwood[1]

In 2012 I found myself sitting alone in a hotel room with a
chain across the door. I had ordered room service, but when
I heard a knock on the door I felt a surge of adrenaline and my
heart began to race. Until then I had thought I was doing fine,
but my reaction said otherwise. I'd let him get to me.

I had a stalker, you see; one who had announced himself as
such and intimidated the staff where I was about to make a
book-related appearance. He had a police record. My instinct,

after speaking with the police, was to retreat to my room and lock the door. It had been a while since I'd felt that kind of fear of violence – maybe ten years – but there it was again.

As I sat there, separated from my husband and young child, jumpy and fielding calls from the police and my publishers, it struck me that it simply shouldn't be this way. By now I was on social media. I was a public speaker. I hosted TV documentaries. In today's increasingly open world, there was something peculiar about not being able to speak up. Sometimes there are good reasons for this – in this case because of personal security – but it is interesting how the threat of violence still isolates its target. The silence it requires so often carries with it a peculiar sense of shame, particularly because, at the time, I was required to lie in order to avert the threat. If the individual knew the police were there because of him, or that we'd had to cancel an event because of him, he would feel he had won: he had affected me, had made me take notice. It would have meant we had a connection. It was decided that the best thing to do was announce that I was unwell and unable to attend the event, without letting on that it had anything to do with him and his threats. And yet the silence meant he had, in a sense, already won. I couldn't tell my fans the real reason why I had to cancel the event at the last minute. I wanted to be the girl who came out fighting with her sword whenever she was threatened, but I had to accept that sometimes this was not the best course of action. I had a child, a family. It was not worth the risk. So I'd flown all the way to another city and now there was nothing for me to do but hide in my hotel room, alone. It cut me up inside.

Most women have a story about physical and sexual threats or violence. It is shockingly common. We don't hear about the

extent of the problem because of this very code of silence. Sometimes it is safer for the women to remain silent until court proceedings are underway, until they can prove their case, until the danger has passed. Sometimes they are incorrectly advised to remain silent for fear of further threats. Sometimes they are told it is in their heads, they are lying, or it is their fault.

These kinds of stories are more common than we know, because like so many traumas experienced by women – sexual harassment, rape, domestic violence, miscarriage, birth trauma, abortion – we don't talk about it. We keep it to ourselves, or share it only with trusted women friends and women-only forums. We primarily hear about sexual violence against women through annual public campaigns like V-Day or White Ribbon Day, campaigns which are sometimes attacked for supposedly demonising men – this for providing statistics showing that over 90 per cent of rapes are perpetrated by one sex,[2] (in Australia roughly 98 per cent of sex offenders apprehended by police are male) and despite the fact that campaigns like White Ribbon were started by men who were sick of what was happening to their daughters, sisters, wives and mothers. Too often in the public narrative, sexual assault is something that 'really' happens to women in India, Africa or Afghanistan, or to white women travelling in those countries. It's not a 'real problem' in our own culture. When it hits our headlines it's framed as a freak occurrence, or something that could have been avoided if the victim had just heeded advice to not drink or walk alone or wear that dress. We look elsewhere rather than acknowledging that this is something that happens to our children, our elderly, to men, to the mentally ill, and most often in family homes by someone the victim knows and trusts. We look elsewhere rather than acknowledging that

sometimes people are raped just because there are violent people in the world. And that it happens right here in Australia.

I think it is not a stretch to say that I do understand the nature of violence better than some. I've seen autopsies and crime scenes, spent hundreds of hours talking to cops, investigators, survivors of crime (I do hate the term 'victim' though I understand it is sometimes appropriate) and some perpetrators of crime. I have also personally survived violence, though nothing so extreme as the violence experienced by Mak Vanderwall, the main protagonist in my crime fiction. (If it can be said that novels are life with the boring bits taken out, then crime novels are life with the happy and safe bits taken out.) What all of this has given me is an insight into the terrifying reality that some people do horrible things to others, and that people suffer and die in ways that are not fair or deserved. Though the first of these realities is understood by many adults – reading newspaper headlines tends to make that perfectly clear – the second reality is trickier, because acknowledging that bad things happen to good people, people like *you*, is often too unsettling and disturbing to contemplate.

Victoria Police Chief Commissioner Ken Lay wrote:

> We are constantly misapprehending the nature of violence.
>
> We do this because we want to feel safer – so we apportion complicity to those who die violently.
>
> In our heads, we make them somehow responsible for the wickedness that befell them.
>
> When we do this, we feel better.
>
> We feel safer.
>
> And it's also much, much easier to do this when the crimes are domestic – when they're behind closed doors.

When it happens we might think, 'Well, why did she marry him?' just as we might think of a rape victim, 'Well, why was she wearing a short skirt?'

When we imagine this sort of complicity for the victim – when we essentially blame them – we are congratulating ourselves for our superior judgement, a judgement that will ensure it never happens to us.

But when we do this we are injuring our imaginations, which is the lifeblood of our sympathy.

When we do this, we come up with the wrong answers about why violence happens.[3]

This hits home for me. I've seen this many times in reactions to violence, even in my own reaction to violence and tragedy. When a child dies in an accident I have an urge to assure myself that it simply couldn't happen to *my* child. Which, of course, is not true. We do this to assure ourselves that everything will be okay, and the sad reality is that this human tendency also impacts the survivors of violence and their families. It is called 'victim-blaming' and is particularly common when it comes to women and girls who suffer violence and sexual assault.

When twenty-nine-year-old Irishwoman Jill Meagher went missing in Melbourne in 2012, there were instances of victim-blaming. As writer Clementine Ford noted in *Daily Life*:

Yesterday, Andrew Rule spent approximately a thousand words in the *Herald Sun* painting a picture of a beautiful, naive young woman who simply should have known better than to walk down dark, foreboding Hope Street when another route would have served her better and proved safer.

'We all have our favourite routes, from habit rather than logic,' Rule wrote. 'But for a stranger looking around in daylight, there seems no obvious reason why a young woman would choose to walk this way home late at night … There are better spots for a young woman to be walking alone after a night out drinking with workmates …'[4]

Ford also noted the many trolls on a 'Help Find Jill Meagher' community Facebook page.

She was obviously at a bar/club, left there in the early hours of the morning, obviously partially pissed/drunk, and she 'lead someone on' [sic] and the consequences followed her. If she is going to flirt with someone, make sure that you go through with it because someone is obviously pissed off with her … in my opinion, it's now old news, she met with foul play as a result of her actions inside the pub/bar OR as I mentioned before … ask the husband.

While there are always going to be trolls on the internet, one can't help but be concerned by how closely they reflect the words of people in the public eye who should know better. Many noted that Meagher had enjoyed a drink or two on the night of the incident, and was wearing a skirt. When men go missing, few people – I'd venture to say no one – asks if what they were wearing was 'appropriate'. Even those who are entrusted with our safety will sometimes blame the victim. Police Constable Michael Sanguinetti was giving a talk on health and safety to a group of law students in Toronto when he reportedly said, 'You know, I think we're beating around the bush here. I've been told I'm not supposed to say this – however, women should avoid dressing like sluts in order not

to be victimised.' His comments were the impetus behind the spontaneous 'Slut Walk' movement around the world, mass public protests involving a call for law-enforcement agencies and members of the public to stop blaming victims for sexual assaults.[5]

Sadly, Ms Meagher was later found to have been raped and murdered. Her story captured the country's attention and some 30,000 people walked down Sydney Road, Brunswick, in her memory and to protest against sexual violence. Make no mistake: the terrible crime that took her life was solely the fault and responsibility of the perpetrator – the man who stalked her, assaulted her and killed her; a man who is in jail at the time of this writing, awaiting trial, and was on bail and parole for another rape when he killed Meagher. This crime was the failure of a man and a system, not a woman's choice of route or her skirt.

Too often commentators claim that girls wearing tight clothes are *asking* for trouble. It's the rock videos. It's Miley Cyrus. (Or a Kardashian. Or Paris Hilton. Or Beyoncé. Or Madonna. Take your pick of the sexy – female, always female – scapegoat of the day.) It's the fault of those slutty pop stars that our young women dress inappropriately and will be disrespected and abused. We must re-educate these young women and tell them where they are going wrong. Re-educating those who *commit the abuse* somehow does not occur to these commentators. Yet women were abused long before pop stars existed, and indeed long before the sexual revolution enabled many women to express and pursue their own sexual desires with the openness long considered acceptable in men. Women are abused in countries where traditional dress covers their faces, not to mention their ankles or thighs. Children are abused. Men are abused. The elderly are abused. The problem

is not women (or men) in revealing clothes. The problem is the entitlement some people feel over other human beings and their bodies.

Children and women are the most common victims of sexual violence, and according to S. Laurel Weldon, co-author of the largest study ever published on the problem of violence against women, a study conducted in seventy countries over forty years:

> Violence against women is a global problem. Research from North America, Europe, Africa, Latin America, the Middle East, and Asia has found astonishingly high rates of sexual assault, stalking, trafficking, violence in intimate relationships, and other violations of women's bodies and psyches. In Europe it is a bigger danger to women than cancer, with 45 per cent of European women experiencing some form of physical or sexual violence. Rates are similar in North America, Australia and New Zealand and studies in Asia, Latin America and Africa show that violence towards women there is ubiquitous.[6]

Not only did the study find that violence against women and girls was a global problem, it determined that 'feminist movements' were the number-one key to change, as 'strong, autonomous feminist movements were the first to articulate the issue of violence against women and the key catalysts for government action, with other organisations sidelining issues perceived as being only important to women'.[7]

One reason Jill Meagher's shocking murder resonated with so many people was that Jill was a beautiful, young, 'normal' woman. Many of us could relate to her. If it could happen to her, it could happen to anyone. Another reason it resonated

was that so many women have had 'near misses'. Times when they narrowly escaped.

I am one of those women.

I was seventeen when I arrived at Munich airport well after dark. I collected my luggage from the carousel and walked outside to find a cab, clutching a folded piece of paper in one hand. Using the few words of German I had been practising, I asked the driver to take me to the address written on that already fading fax; it was the address of an affordable room for rent that my model agency had found for me in something we commonly called a 'models' apartment'. While I would eventually have a working grasp of German, Italian, Spanish and French, I was still new to Europe at this stage, and I couldn't understand what the driver was telling me. I kept pointing at the address on the fax, and when at last he nodded I said, '*Danke*,' in my Canadian accent, feeling far from my Vancouver Island home.

Half an hour passed. The drive was taking a while, I remember thinking, but then I'd never been to Munich before. The trip from the airport was going to be expensive, I could see, and I worried a little about what groceries I'd be able to buy, or not buy, as the meter ticked higher. But I was in a cab for a reason; it was safer than using public transport at night, particularly in a new and unfamiliar city. I'd already dealt with stalkers on London's tubes. It seemed that this was a problem with travelling alone, and travelling alone was what models were required to do. It was an occupational hazard. I wasn't put off by the photographer in London who'd promised to help me and instead tried to help himself *to* me, and I was not going to be put off now. I had been invited to Munich by a large and reputable model agency, thanks in part to my billboard ad for *Cosmopolitan* and Braun hair driers. They

seemed to think there was some money to be made and I hoped they were right, as I was broke.

Eventually the car pulled up in a cobblestone alley by the entrance to a dark, early-twentieth-century apartment block. I asked the cab driver to wait while I buzzed the name on the door that matched the name on my fax, and a few minutes later a man stepped out and welcomed me in German. He grabbed my bag and the taxi disappeared into the night. I followed the stranger up a narrow winding stairway to an apartment on the second floor. He ushered me into a sitting room, to a couch. *Strange*, I thought. Though I'd only glimpsed the entryway and a short hallway, the apartment seemed much smaller than I'd imagined. This *was* a models' apartment, wasn't it?

The man sat on a chair across from me, smiling, then asked a question that included the word *wasser*. That meant water, I knew. I nodded. '*Danke.*'

He got up and I stayed seated with my hands in my lap and my suitcase at my feet. The window to my right overlooked the alley, I noticed. There was an old television in one corner, and a tall lamp in another. Near the corner closest to me was a glass display case. I was about to get up to look at it when the man returned.

He was perhaps forty, with a slim build, dark blond hair and blue eyes, and he was tall, though not taller than me. *Very German*, I thought. He had what I thought of as classically Germanic features, though there was something else too. His chest was a bit concave and his hands were small. He was pale in a way that seemed unusual. There was something damp about him.

'*Danke schoen*,' I said as I accepted the glass he offered.

I sipped the water, my stomach tightening. I felt uneasy there in the sitting room with that man, but I wasn't sure why.

I knew I had the right address and that this was the place the model agency had organised. But there was something wrong and I felt it in my bones. There were no other models. No women. That was unusual for a models' apartment. Usually there were other teenagers like myself, visiting from other countries, trying to get some photographic work or coming for the shows. And what about the apartment? I was supposed to stay here for a month, but it seemed so small, even by European standards. Might it have extra rooms somewhere? Or perhaps the man would leave soon; it was possible that the weekly rent I had agreed to pay, via the model agency, was for the whole apartment. But I wasn't sure, so I waited politely, sipping water, wishing I spoke a little German, or that he spoke a little English.

It was past midnight when I finally decided I would have to ask to see my room. Over an hour had passed, with the man speaking from time to time in German, and me replying in English that I was sorry but I couldn't speak German. My dread that something wasn't right could no longer be ignored. Nor could my exhaustion. I stood up. 'Well,' I said. 'It's getting late.' When he didn't respond I held my hands beside my face in the kind of inclined prayer position that is the international symbol for 'sleep'.

Enthusiastic now, he jumped up and led me down the short hallway and I saw, finally, that there were three other doorways. One opened on to a small kitchen, and through another I glimpsed a toilet and bath. The last door led to the bedroom.

There was only one bedroom. His bedroom. With one bed.

One.

He had it made up with a folded towel at the foot, so I'd know which side was mine.

He expected us to sleep together.

I quickly retreated to the sitting room, panicking. It was Oktoberfest, and every hotel room in the city was booked. It was also approaching one in the morning. I was exhausted, I had no telephone (this was long before mobile phones), and I knew no one in the entire city. What should I do? Drag my suitcase out into that alley and back into the dark street? Where would I go?

To the police, I thought. That's where. To the police.

But a voice in my head immediately started arguing: *Don't be rash, Tara. Don't make a scene. Surely the agency wouldn't have sent you here unless they knew it was safe …*

Then he was back in the sitting room, and I still hadn't decided what to do. And, incredibly, he had a ring. He dropped to one knee and offered it to me, grasping my hand and trying to put it on my wedding finger.

'No! *Nein, nein, nein!*' I said. I clenched my hands into fists, refusing the ring, almost overwhelmed by panic.

He grabbed me by the upper arm. 'I want to show you … my last wife,' he said in broken English. He knew some English after all. *'My last wife.'*

He pulled me to the glass cabinet while I eyed the door, wondering how fast I could move carrying the suitcase. Or maybe I would have to leave it? What about my wallet and passport?

In the cabinet was a wallet-sized photograph of a girl of perhaps fifteen or sixteen, with pale blonde hair and blue eyes. She was beautiful. The photo has haunted me ever since.

'My last wife,' he said again, though that seemed impossible. Surely she was his daughter. Or … she looked Russian. She could have been a model, I realised.

He tried again to put the ring on my finger and I refused. 'No,' I said, pushing him towards the door of the sitting room. 'I want to be alone.'

As soon as he'd left the room I flipped a chair over and wedged it under the door handle, then moved to the window to watch the alley for any sign of life, anyone who could help me.

Nothing.

I heard movement on the other side of the door. The door handle turned once. Twice. And then there was silence.

I sat on the sofa with my arms around my suitcase, drifting in and out of sleep for what remained of the night. At daybreak, I tiptoed to the door and listened. All was quiet. I picked up my suitcase, slipped out the front door, and ran down the stairs and out into the street. After walking for a few blocks I managed to hail a cab and got to the model agency before it opened. When a woman arrived I told her what had happened. She actually smiled. 'You are so pretty,' she said. 'This must happen to you all the time.'

If this conversation took place now, I would explain that people don't do that to someone because they are pretty. They do it because they themselves are dangerous, because they need psychiatric help. But at the time, I just stared slack-jawed at that woman's face and wondered why she didn't think what I'd been through was even remotely alarming.

Inadequate though it was, at least I was able to ensure that the man was removed from the models' apartment listings – at *that* agency.

Sometimes I think of the girl in that picture, his 'last wife'. Who was she? Where did he find her? What happened to her?

These are questions I will never have answers for.

*

Another 'near miss' took place in Milan in 1991. It was already dark as I walked home from the gym. I tried to avoid walking alone at night, but the days were getting shorter and I had to live, after all. Besides, the gym was only three blocks away from the models' apartment where I was staying along with a younger girl from Russia and another from America. Italy was/is notorious for male attention, including unwanted male attention, and as a consequence I chose to wear a long and shapeless dark grey hooded coat, which both hid my figure and covered my blonde hair. I also wore a fake gold wedding band on my finger, though I was single. I wore jeans and motorcycle boots with the aforementioned coat and I fancied that I was walking with a slightly masculine gait. I was feeling pretty pleased with my efforts, until a car pulled up next to me and I heard a wolf-whistle – then, in an American accent, 'Hey, baby.'

I picked up my pace and kept my head down to avoid eye contact, but the car cruised alongside me. In my peripheral vision I saw there were four men inside. I calculated the distance to the apartment; only one and a half blocks to go.

Then I heard the car door open.

A quick sideways glance told me that a man had jumped out behind me while the car was still moving. The back door was being held open by another man, so I could be thrown inside.

I ran.

When I reached the intersection the lights were not in my favour but I sprinted across anyway, my pursuer close behind, the car gliding straight through the red light like it was nothing. *One block, just one block, half a block …*

The men were starting to argue. 'Hurry up!' one of them called.

The man running after me was fast and fit but I managed to stay just ahead of him, running for my life, lungs heaving but I was almost there. *Almost. Here comes the doorway. I can see the keypad. The security code – what's the security code? One four five six? No, one four five four,* and then I was punching in the numbers and pushing the door open and scrambling inside. I tried to shut it but my pursuer was there, grasping the edge of the door. I slammed it on his fingers. Once. Twice. He withdrew his hand, and with no further obstacle I shut the door and it clicked, locking

I slid down the inside of the doorway with tears running down my face, weeping and shaking, my muscles burning from the sprint.

What would those men have done to me? Would they have dumped me on the side of the road when they were through? I often look back and think that was the closest I've come to death. There was no way I could have fended off four strong men. No way. It was sheer luck that I had only one and a half blocks to sprint and the right boots to do it in.

Whether for cultural reasons or purely due to the amount of time I spent there, Italy was where I was confronted with the most frequent sexual harassment. Not all of the perpetrators were Italian men, however. The ones who tried to abduct me in their car were American. (They had short, neat haircuts and American accents. They were fit. *Military,* I remember thinking.) Yet it was kind of an unwritten rule in Milan at the time, that women were fair game. If you wanted to pinch or rape a woman who was on her own, you did. It was the price they paid for walking the street by themselves. I remember thinking that if someone saw a woman being raped on the footpath they would probably just walk by.

At the time, the local police cared so little for the safety of women that I developed an ability to move quickly into a blur of physical, sometimes violent retaliation. After I was so close to being abducted – and what? Gang-raped? Murdered? – I set my mind on fighting back. In some cases, it was an instinctive defence mechanism and in other cases it was sheer rage. There was, for instance, the man who followed me beside the tram tracks in the middle of Milan, in broad daylight, openly masturbating and grunting loudly, so that I could hear what he was doing. It was a deliberate act of perverse intimidation and I was so infuriated by it that I turned around and ran at him full tilt with my hands out like claws, screaming like a deranged warrior. He ran off with his tail between his legs – so to speak – and I honestly don't know what I would have done if I'd caught him. I also recall another day in Milan when the taxi I was in stopped at a traffic light and a man jumped in. He leapt on top of me, groping my breasts. When the light changed the taxi driver drove on, as if nothing was happening in the back of his own cab, or as if it was truly unremarkable to have a female passenger assaulted in this way. I kicked and screamed and fought as hard as I could, and because, fortunately, the door hadn't shut properly when the man got in, I managed to push my attacker backwards out of the moving vehicle. The driver seemed unconcerned until I got out and refused to pay my fare.

These experiences were just some among many. A woman being attacked on the street, or even in a taxi, was nobody's business. A woman travelling alone should expect such things. The Italian police officer I spoke to at the time even seemed to believe that to be attacked was essentially a compliment; an attractive, unmarried woman should expect to be pinched, ogled and groped because men couldn't help it. *Bella*, he called me. I learned not to trust any man in a position of authority. When I

was only sixteen the grey-haired head of the Italian model agency I was with asked me to a party, and when I asked who would be at this party he said, 'Just you and me.' The implication was clear: if I spent the night with him, I'd get more work. I declined, but my flatmate from America went. She was fifteen.

Though this was over twenty years ago, I am aware that there are still some concerns about the 'machismo' culture in Italy, with the women's group Arcidonna recently filing a lawsuit against former prime minister Silvio Berlusconi – he of the infamous 'bunga bunga' sex parties – for '25 years of abuse against Italian women'. Catholic priest Piero Corsi used his Christmas message in 2012 to blame the female victims of rape, sexual violence and murder. That year 118 women were killed in Italy in acts of domestic violence. 'How often do we see girls and mature women going around scantily dressed in provocative clothes?' he wrote. 'They provoke the worst instincts, which end in violence or sexual abuse. They should search their consciences and ask: did we bring this on ourselves?'[8]

These attitudes are by no means exclusive to Italy, and my experiences of sexual harassment were by no means limited to that one country (nor were all of my experiences in Italy negative as a teenager). I had many frightening experiences in public places around Europe – hair-pulling, pinching, public masturbation and attempted kidnapping. Once I had to walk out of a professional photo shoot in London when the photographer took his penis out behind the screen of the reflector boards, where no one else could see what he was doing. An elderly man once approached me at a bus stop in Hamburg and, after chatting to me pleasantly in broken English, said he'd like to take my picture. He opened his wallet to show a photograph of a woman's open legs and vagina with his face reflected in the mirror above her, holding the camera.

He was perhaps seventy. In Hamburg my model agency said that a photographer who had seen me at a casting wanted to do some 'test shots'. That meant you didn't get paid, but you got pictures for your portfolio. I arrived at the designated time to find that there were no other models there, and no makeup artist or anyone else. The photographer tried several times to get me to drink shots of vodka, but I was several years underage and refused. Once I had finished my makeup he opened a book of images to show me the kind of pictures he wanted to take. The images were explicit pornography. Naked. Open legs. Fingers inside the vagina. Male penetration. The works. I shook my head and immediately started to gather my makeup and purse, and then he lunged at me. I pulled back and hit him with a right hook to his lower jaw so hard that the somewhat diminutive man fell backwards and hit his head on the concrete studio floor, knocked out. I fled and did not check to see if he was okay. The next day the agency made excuses for his behaviour, implying that I'd exaggerated, or that I could even get in trouble for hitting him. I quit the agency and warned every model I knew about him.

This was all before I was twenty.

Incidents of sexual harassment and assault were such common experiences for me in Europe in the 1990s that I grew almost accustomed to it. I rarely contacted authorities after the first few incidents as they were so clearly uninterested. (I recommend women do, in fact, go to the police every time, if at all possible, but looking back it hardly surprises me that I gave up.) The attacks diminished as I got older, and also, perhaps, as I began to project less vulnerability – a learned survival habit that I would maintain for many years to come. I learned to retaliate at the first hint of threat and that helped to get me out of many situations before they worsened.

Though most random attacks took place in Europe, where I was travelling alone, I was not even safe in my hometown of Victoria. Once, when I was perhaps seventeen, a utilities van pulled up next to me on a main street in broad daylight and a man waved me over, as if to ask directions. When I walked up to the open window on the passenger side I saw that he had his penis in his hand. 'Come on, I know you're curious. I know you want to touch it,' the stranger said. I ran to the nearest open business, a pool hall, and hid inside while the proprietor, whom I'd never before met, guarded the entrance in case the man came after me. A few years later, when I stopped to watch a soccer game at a park, a group of six young Canadian men surrounded me and started making rude gestures, talking about how they'd 'like to rape' me. They were perhaps seventeen years old. I was twenty. One of the young men ran up and grabbed my breast, and when I turned around, infuriated, he ran away, laughing. I gave chase and they all took off, but I caught the one who had groped me, threw him to the ground, straddled his chest and punched him in the face until he cried. He was terrified. To be truthful, I scared myself. And I was crying too. While his friends surrounded us, suddenly aghast and frightened, I made them promise to 'never, ever do that to any human being ever again'. They promised.

I hope those young men kept that promise.

Though I was stalked, pinched, groped, lunged at and chased many times, I tell these stories with some ease because I always got away. In a way, these stories make me sound invincible.

I'm not.

The one time I was raped it was, true to statistics, by someone I knew. He was part of a new circle of friends in Vancouver and when, after an acting class, he offered me a ride

to the friend's house where I was staying, I accepted. Instead he took me to his home, and at first I wasn't sure if it was a problem. I was married (to my first husband) at the time and he knew that. He was tall and not unattractive, and he seemed like a cool guy. He'd had some success as an actor, and this was often referred to by the teacher of the class, and I think that made me imagine that he was someone significant, perhaps even important to know. That he was friendly, inviting me into his apartment for a cup of tea, seemed like a good thing.

It wasn't.

Once I was inside, he didn't take no for an answer. My struggling excited him, as if it was a game he liked, and I remember retreating in my mind, as if it could not really be happening to me, just to my body: there was no way I was being raped.

When it was over, I was lying on his futon on my right side, with my breasts flat against the cold wall. He was six and a half feet tall and he dwarfed me as few men could. His long body was pressing me against the wall, trapping me there.

I didn't speak. I didn't turn. I just stayed awake, eyes shut, pretending to be asleep. Finally, hours later, he moved. I remember how he bent over me, grabbed my face hard by the jaw and said, 'Tell me you love me.' I did. He disappeared into the bathroom and I dressed hurriedly. When I heard the shower come on I ran down the stairs towards the door as fast as I could. He bolted out of the bathroom naked when he heard my footsteps and nearly caught me at the base of the staircase, but when I opened the door I was free. He wouldn't chase me in broad daylight without his clothes on.

A number of women came forward after I went to the police, and he was eventually charged with raping over a dozen women over several years in Canada and the US, but

there were no eye witnesses to corroborate what had happened to me or the others. Eventually he was jailed for the rape of one woman, that case being more provable because he'd boasted to friends about it, and those friends had agreed to testify. He claimed the victims had consented to sex, and his lawyer defended him by claiming that he was a 'seventies kind of guy' in a modern world and didn't know that no meant no. I can tell you, he knew. Years after he was released from jail, an actress he was working with sued TV producers after a violent choking scene at knife point with him left her suffering injuries, including nerve damage, left-facial paralysis and severe neck, back, facial and jaw pain, leaving her unable to work.

When I became a novelist and wrote a long-running series starring Mak Vanderwall, a 'psycho-magnet' who was regularly confronted with violent men, some readers commented that her story was entertaining but, you know, *unrealistic*. No one could be that unlucky. I mean, one woman fending off so many criminals in only five years? There was less exaggeration than most would imagine.

To this day, I retreat to an emotionless, highly alert place of survival when I sense danger. The spectre of sexual and physical violence is always right there, at the edge of my consciousness, and when I feel its presence I focus with a curious hyperawareness on the source of the potential danger, obliterating everything else. I am a good person to have around in emergencies, but having a normal conversation in a public place with someone acting suspiciously nearby? Not a hope.

I remember a moment in 2009 when a journalist interviewed me about my new novel, just months before I was to marry my husband, Berndt Sellheim. She said something

about my charmed life, and then asked – and I'm paraphrasing here – 'Has anything bad *ever* happened to you?'

I was completely taken aback. She seemed to think that everything in my life had been a breeze. I knew I was lucky, but how could anyone think that no horrors had ever visited me? '… I don't walk around with open wounds going "Here, salt me,"' I replied. 'It's not my job to do that, let alone in the public eye.'

But the truth was, I let few people in. It was little wonder I came across as living a charmed life without trouble, pain or heartache. If I ever appeared invincible ('Teflon Tara', one dear friend dubbed me), it was because I was traumatised. I realise that now, as many people who have known me for years comment on how different I seem these days, how much more 'relaxed' I am as a middle-aged woman. The truth is that, decades on, the wounds are healed. I can talk about the bad stuff now. But it is important to remember that there are a lot of people out in the world who are traumatised. There are more of them than we know. They cope in different ways: some with drugs or alcohol, some through acting out, some by retreating literally or metaphorically. You can't know someone's story by looking at them. Everyone has a story and some aren't ready to tell theirs. They need time.

In some ways, the armour I wore to hide my vulnerability helped me a great deal. But so many years on, I am no longer worried about being defined as a 'victim'. I have defined myself beyond that experience. I have become a survivor – one of many survivors of crime. With my scars now faded, I no longer need to protect my wounds as I once did.

Perhaps sharing these stories will help someone else with theirs.

4

THE WRITER

Write what you know.

When, as a twenty-three-year-old working model, I decided to commit to fulfilling my lifelong ambition of writing a novel, I chose to write about a model in the process of getting her PhD, who was stalked and attacked by a serial rapist and murderer of young women. I made her tall, blonde and Canadian. In essence, I did what most first-time novelists do – I wrote about what I knew.

I penned most of that first novel, *Fetish*, in a wooden kitchen chair in the corner of a rented apartment in Bondi Beach and, later, in a bed and breakfast in the Blue Mountains. I had no agent or publisher, and I continued to model to support myself while I was writing. On modelling gigs, when someone asked me what I did on the weekend, I usually said I was writing a novel. Mostly, my answer was met with blank stares.

I rather ambitiously called my main character 'Makedde' because I wanted her to have a new name, and to be a new character, someone who was different to those who came before her. I shortened her name to 'Mak', liking that it took

away some of the gender associations with more common names for girls. By making up a name, I confused a lot of readers, who didn't know how to pronounce it, but I also evidently inspired some readers, who started arriving at book events with daughters of the same name. I met my first real-life Makedde, a three-year-old girl, at a book signing in 2002, three years after *Fetish* was published. I've lost track now of how many novels I have signed for girls named Makedde, the majority of whom are still not old enough to be allowed to read the books they were named for. I gave my character the last name of Vanderwall, taken from Angela Van Der Wall, a friend of mine when I was a kid. It was a classic Dutch name and reminded me of Holland and therefore my mother. Makedde Vanderwall would loom large in my life for at least the next fifteen years as I wrote six novels about her fictional journey, and immersed myself in her dangerous fictional world.

Fetish was a surprise success and when it came time to write my second Mak novel, *Split*, I suffered six agonising months of writer's block. I was feeling the pressure of self-doubt that besets so many writers; it is often called 'second book syndrome'. In my case, it was not helped by the comments of those who so blatantly and publicly wished me to fail.

They're right, I thought in my darker moments. *Maybe I'm not a writer after all and I should stick to modelling.*

I finally decided that if I couldn't write because I was paralysed by fear, the critics would be right about me – I really wouldn't be a writer anymore. I would have lost something that had been essential to me since I was a kid. I struggled through and when *Split* was published in 2002, six months late thanks to that extended bout of writer's block, I was bombarded with rumours that I hadn't written my books

myself, and was dared to take that very public polygraph test in the *Australian*. I like to joke that this polygraph test made me the first scientifically proven author in the world.

I wrote because it was natural to me, and because I had to. It was a compulsion as much as a choice, and I created Mak as a kind of fictional extension of myself – a sister or friend who had experienced more extreme violence than I had, survived it and overcome it. In a series where I would need to research police investigation, private investigation, prison systems, forensic science and criminal psychology, she would be the one character I didn't have to second-guess. She was enough like me, without *being* me. This is an important distinction. In my view it is unwise to write real people into fiction. Identifying a fictional character too strongly with a real person limits that character's possibilities. (I've only done it once, in *Split*, in a cameo appearance of the psychopathy expert Dr Robert Hare, who checked his dialogue before the publication.) Characters can be influenced or inspired by real people, absolutely, but I needed Mak to go through things I would never wish on anyone, and she had to make choices I wouldn't. She could never be me. For the story I wanted to tell, she needed to start out as the smart and capable daughter of a cop, but flawed – a bit naive, even – and she needed to develop, over years of (fictional) experiences, into someone so believably tough and skilled at survival that she would try to take down an empire. She needed to question authority. She needed to be a woman pushed to the absolute limits of emotional endurance, and faced with tough ethical decisions: *How far would you go to protect yourself and others? Would you break the law? Would you kill?*

I described Mak as a 'psycho magnet' – which was, incidentally, the name of my first published short story, which

won the Scarlet Stiletto Young Writers Award in 1998. Being a psycho magnet was a concept that fascinated me, for reasons that shouldn't be too difficult to guess. That quality was a central part of her character, an experience I wanted to describe on the page. I put her through all I'd been through and more, and while she started out as naive as I'd once been, she grew tougher and more capable through the series, until in *Assassin*, the sixth and final book, she was a true force to be reckoned with – a reluctant saviour and criminal with an impressive skillset earned through years of trouble. A woman pushed to her limits. A vigilante. An anti-hero.

In order to make Makedde believable, I needed to live her world as much as I humanly, legally could. Before *Fetish*, I did not know any cops. I had not spoken to a police officer for longer than was required to report the kinds of incidents I outlined in the previous chapter, and that was sometimes a frustrating experience. For my crime series, I needed to get to know investigators and experts. I needed to see their lives from the other side. I needed to understand them. Over the years I spent time in squad cars, in morgues and at crime scenes. I toured the LAPD and passed the Fire Arms Training Simulator at the LA Police Academy. I had the privilege of seeing the FBI Academy in Quantico, Virginia, first hand. Here was a place where the budget constraints that hindered so many good cops seemed not to apply. Instead of a standard Hogan's Alley (a tactical exercise area built a bit like a bricked-up alley where cardboard cut-out crims pop up in empty windows and you shoot at them to practice response time) the FBI Academy has, since 1987, had the town of Hogan, with actors playing citizens and criminals. An entire *town*. When I visited, in the late 1990s, Hogan had an operating deli, a theatre (where they taped and transmitted FBI TV to all of

their headquarters around the country) and the Bank of Hogan – which is, unsurprisingly, the most robbed bank in the world. Every day of the week, the tellers, played by actors, are held up and the FBI agents-in-training need to apprehend the (pretend) bank robbers and save the hostages.

Over the years, my respect for good police officers deepened. They were often badly paid for a job that could carry great risk of injury or even death. Most of the detectives I met had at least one case that haunted them. There was often a picture on the shelf of a murdered child whose killer had not been brought to justice, or a file in their desk on a case that had been long since closed, but not forgotten. One LAPD officer kept a file on a murdered mother of four whose killer was still free. It was no longer his jurisdiction, no longer his business, long since given up on by the department but he couldn't let it go. The responsibility haunted him. For my crime series, I was interested in the limits of police work. What happens to the police officers who know, absolutely, the identity of the killer, but can't do anything about it? What does that do to them psychologically? What happens to someone like Mak, who is raised by a cop to believe that justice is truly unbiased and neutral (or blind, to use the popular symbolism), when she discovers that some people are so powerful they are beyond the reach of the law?

People sometimes mistake my father Bob for the formidable ex-Detective Inspector Les Vanderwall. My father is tall, handsome, has a full head of silver hair and looks like the central casting version of an FBI agent. I don't think he minds this mistake terribly much, as he has taken to wearing the FBI sweatshirt I got for him at Quantico when he goes shopping for groceries. But rather than talk of murder and crime over the dinner table when I was growing up, we were treated to

discussion of fridges, stoves and life as a commission salesman. He sold white goods at the Canadian department store Eaton's for over twenty-five years. Until my mother's death, my childhood was idyllic. I knew nothing of crime and murder, injustice or rape. Our lower-middle-class life was happy, healthy and safe. I was one of the lucky kids.

The first time I saw a dead body was life-changing. It was at a morgue, late at night, with a bunch of male cops who had agreed to help me out with my research for *Fetish*. They pulled out some trays full of old bones found in the woods, all the most innocuous stuff, sure that was all I'd be able to handle. For the scene I had to write, though, I needed more – and then a shout rang out through the morgue: 'We've got a fresh one!' Contractors had arrived with the body of a woman who had been found at home days after passing on. When the contractor saw me, he cringed on realising a civilian had been in earshot.

They opened up the body bag, sprayed her down with tea-tree oil and weighed her while the male police officers around me waited for me to go green and pass out. I felt their eyes on me. I came up as close as I could while respecting that I was a bystander, and gazed at the corpse of that woman. 'That's post-mortem lividity, isn't it? So she was found on her back?' (Post-mortem lividity is the dark pooling of blood that shows under the skin, indicating which parts of the body were lowest at the time of death and soon after, as the blood pooled.) It was my first time in close proximity to a dead body, though it would not be the last. I was fine. I am much more comfortable in morgues than in hospitals, as it turns out. The pain and suffering is over.

If I had showed even the slightest queasiness, it would have confirmed the men's belief that women were unsuited to such

places, especially ones that fit my profile (blonde, former model etc.). Things have changed somewhat since, and there are many more women working in morgues and far more female detectives and senior officers (as of June 2006, 23 per cent of Australian police were women, almost double the percentage in 1996).[1] Women in law enforcement may still be outnumbered by men more than two to one, but a (living) woman in a morgue is no longer such a novelty.

I did just about everything I could to experience what the characters in Mak Vanderwall's world experienced. I earned my private investigator credentials (Certificate III) when Makedde did. I got a motorcycle licence when she did. I visited prisons. I travelled to the places I wrote about, from Darlinghurst and St Kilda to Hong Kong and Barcelona. I witnessed autopsies, engaged in firearms training and sat in on criminal trials. I met and researched with international military personnel, FBI agents, homicide investigators, paramedics, undercover officers, survivors of crime, private investigators and more. Though I am a civilian, I often had access to non-civilian areas and have been made privy to highly sensitive information. It is a personal point of pride that I have, over many years, earned a considerable level of trust with many highly trained professionals I deeply respect, and have been able to share through fiction the difficult stories of survivors and professionals with the tough job of protecting others in an imperfect and sometimes violent world. Such is the level of trust that when violence unfolded at the Australian-run Manus Island immigration detention centre in February 2014, resulting in the murder of an asylum seeker, with scores of others seriously injured, I was contacted by a long-standing crime research contact on the ground. The person needed to

remain anonymous, but wanted the public to know that what had really taken place was not what was, at that time, the official government line. I was one of the first civilians able to report the incident to the public, and I managed to obtain some of the only images from the night. I was contacted privately by ex-military and police who knew what had happened and thanked me for my 'efforts in getting the truth out'. But the public reaction from some was that Tara Moss was a model, so why would a whistleblower contact her? What would some model (forget the fifteen years of crime research) know about murder?[2]

I've been out with SWAT teams, raced cars and done loops over the Sydney Opera House with the RAAF, and in 2008 I took the physical aspect of my research to a new level when I was choked unconscious and set on fire as research for two scenes in *Siren*, the fifth book in the series. (This is not – I repeat, *not* – something I'd try at home.)

For the choke-out, which I would later describe in detail in the novel, I went to an expert – the famous Ultimate Fighter and referee 'Big' John McCarthy, a retired police officer who teaches hand-to-hand combat to officers of the Los Angeles Police Department. Big John is not only an expert but the approximate dimensions of the fictional hit man Luther in my crime series – over six foot four, 270 pounds and heavily muscled. He was perfect. I flew to Los Angeles, met the man himself and we talked over, in detail, what would take place. Wrestlers train hard and they are choked out often in the octagon, but for a mere mortal like myself, there is some additional risk. I am adventurous, though not particularly athletic, and I certainly don't have the strong neck muscles of a wrestler, let alone the muscles of someone like Big John. The plan, then, was to choke me out 'slowly' – more gently, if you

will – so as to lessen the risk of any permanent injury. To demonstrate, one of the best Ultimate Fighters around choked Big John unconscious. She was literally half his size, as strong as a boa constrictor – and with similar moves. Convinced that I should go ahead with it, I got into my gym gear, climbed into the octagon and took my spot on the mat, standing at attention with my knees shoulder-width apart and hands ready, as if that would help.

This 'slow' choke-out business seemed like a good idea at the time, but when Big John got me down on the mat in a flash, locked his ankles around mine from behind, and locked his huge arms around my neck (his biceps were bigger than my head) I felt the panic surge through me. I was basically sitting between his legs, dwarfed by him, when he said in a low voice, right at my ear, 'Okay, you're going to feel yourself start to go …' and began to squeeze my neck in the crook of his gigantic arm.

Just as we'd planned, this wasn't a snap choke like you'd see in the movies, but a rather more gradual affair. Every second without air was agonising. I've often been told that I have a high pain threshold, but this was excruciating. It was like being held under a wave too long, with my entire body screaming out for help. It was not so much the pain in my neck, though that was certainly noticeable, but the pain everywhere else, the adrenalised bodily panic. It did not matter what I thought about, or how I tried to relax, my body told me in no uncertain terms that I was dying. Finally, when I was halfway to unconsciousness, my arms began to act out of some kind of separate intelligence, alternately moving to 'claw out the eyes of my attacker' as I'd learned in self-defence training, or tap out on the mat as wrestlers do when they give in. With what remained of my conscious mind, I struggled with the coursing adrenaline and pain and wrestled with my

will power – *make it stop, just let go, claw out his eyes, just wait, try to relax* … In the end I did not tap out. There was no way I was going to fly all the way to LA just to back out. (And, thankfully, I did not claw out his eyes, which, let's face it, would have been rather rude under the circumstances.)

Eventually, much later than I'd hoped, I blacked out.

When I woke, I learned something important about human experience – my autonomic nervous system had kicked in with what is commonly called a 'fight or flight response', that remarkable surge of adrenaline that your body gifts you with, liberating your metabolic energy so that you can run or retaliate. I felt in that moment that I could do anything. I now understand how things that are physically impossible in normal circumstances may become possible, briefly, by this miracle of nature. It's how a mother lifts a car off her toddler. It's what kept me ahead of the man who chased me in Milan. It's what allows a person to jump further, run faster and hit back harder in those life-or-death moments. It is what the body does when it is *dying*, which my body was, because the oxygen being cut off from my brain was literally killing me as I was choked unconscious. (This is why being choked out is incredibly dangerous, particularly without supervision. Do not try this at home, please. Many people die this way each year, quite accidentally.) My neck was red and tender for a day or so, but I'll never forget that lesson. If I'd written the scene without that experience, I would have got it wrong.

Though being choked out hurt a great deal more than I'd anticipated, my brush with fire was in fact far more dangerous. I went to the stunt company WESTefx in California to be set alight, which first involved signing my life away over several pages of legal paperwork. After donning a cold, soaking-wet fireproof jersey – the kind I wore beneath my racing suit

when I got my Confederation of Australian Motor Sport race-driver licence in 2006 – and having my arms smeared with aloe vera and a fire-retardant gel, my arms were dabbed in a few strategic places with a highly flammable gel in anticipation of lighting. I stood in an open warehouse in LA, with one man looking at a stopwatch and one holding a large blowtorch, and I mentally prepared myself. Just before I was lit, the stunt man with the stopwatch got me to 'tap' his forearm. It rang like metal; it was a titanium plate. The stunt man with the blowtorch had me tap his skull. It too was titanium plated after a stunt that went wrong.

After that cheery attempt at a psych-out, he set me on fire.

One thing about fire stunts I hadn't realised previously is that they are generally shot in under fifteen seconds (unless the stunt actor is wearing a special suit, which can have the drawback of looking obvious on camera). The reason is that after fifteen seconds your skin begins to melt. I learned this interesting bit of trivia courtesy of the men at WESTefx just before being set alight, and I have no doubt they were telling the truth, as until about the eleven-second mark, thanks to the cooling aloe vera and the wet jersey, my arms were walls of flame but I couldn't feel a thing. Above the neck, it was like sitting far too close to an open fire, but my arms? Not even warm. It was somewhat surreal to *see* myself on fire and not *feel* it – until, quite suddenly, I could. The heat came swiftly at around twelve seconds and they hosed me down with a high-pressure extinguisher at thirteen seconds. For days afterwards I looked like I had a bad case of sunburn on my arms, where my skin had been seconds from melting. My head was uncovered throughout, and the stunt men actually suggested that I didn't need to tie my hair back, but I decided to put it in a ponytail anyway. It seemed more sensible. If I hadn't trusted

that instinct I believe I would look somewhat different today. (No more modelling to pay the mortgage, that's for sure.) If there'd been the slightest breeze in that warehouse, the flames would have licked my hair. As it was, they were inches away.

Trusting your instincts can be a very valuable thing indeed.

Perhaps as a result of Mak Vanderwall's experiences in my novels and the way she reacts to her difficult circumstances, or perhaps because of my hands-on research into her dangerous fictional world, I'm often told that I write 'strong female characters'. Sometimes this observation comes with the question 'Why?', as if writing about strong women is a particularly fringe pastime. I have always been complimented by the acknowledgement of the strength of the women in my books, but bemused by the question of exactly *why* I would write women that way. Joss Whedon, director, writer and creator of the television show *Buffy the Vampire Slayer*, has often pondered the curious nature of this question. According to Whedon, it is the one question he is asked in almost every interview: '"So, why do you write these strong female characters?" they ask. "Why is this even a question? Why aren't you asking a hundred other guys why they don't write strong women characters?"'[3] Author Neil Gaiman is similarly baffled. In a recent interview he remarked, 'People say, "Well how do you write such good female characters?" and I go, "Well I write people." Approximately half of the people I know are female and they're cool, and they're interesting, and so, why wouldn't I?'[4]

Like many writers I write what I know. And what I know includes a lot of interesting, strong, flawed and fascinating people, approximately half of whom are female. In my life and research I've come across women of all ages, races and backgrounds who are survivors. I've met them, heard their

stories and been one of them. Speaking to survivors of crime has been incredibly instructive. I don't think anyone would ask a person *why* they write 'strong female characters' once they'd seen and heard what some women and girls have been through, survived and risen above.

Writing about strong women is as natural to me as breathing.

*

In my column of 12 September, about celebrity books and ghostwriting, I mentioned Australian model Tara Moss's new novel, *Fetish*. Tara Moss has since written to me to point out that she is the sole author of *Fetish*. I did not wish to imply that *Fetish* was either ghostwritten or heavily edited, and I am happy to make this clear now.

Jane Sullivan, the *Age*, 14 November 1999

Like any celebrity, Moss is used to rumour-mongering. The eternal speculation about who she is or isn't rooting is bearable. But the suggestion that a model couldn't possibly write her own books has really started to get her goat …

Emma Tom, the *Australian*, 16 March 2002

When I started writing *Fetish*, I had no reason to expect I would be published. I wished for it, of course, as all aspiring writers do, but the idea was little more than an abstract hope. Fifteen years later, my Mak Vanderwall series has been published in eighteen countries and twelve languages, and there is talk of screen adaptations. To say that Mak exceeded my expectations would be putting it mildly. It's also safe to say she exceeded the rather lower expectations of some others.

This became especially obvious in 2004, when after five years and three crime novels I was dubbed 'Australia's No. 1 crime writer' by the publishing audit agency AC Nielsen Bookscan.

A 2004 *Sydney Morning Herald* interview with Daphne Guinness gives a taste:

> Moss has big hair, half-mast jeans, size 10 orange boots and obviously doesn't give a damn how she looks. But the battle to remain No. 1 in her genre against the long-time king of crime writing, Peter Corris, et al, is another matter … 'Fetish is still going up by word of mouth five years on,' she says … 'That's more reward to me than any hype about being the number one crime writer.'
>
> That's fine by Corris. 'It doesn't annoy me,' he says. 'I gather her sales are enormous and if that's the case, well, what the hell, I couldn't care less. I haven't read her books, so good luck to her.'[5]

This supposed battle between old and new blood – or, rather, the writers who hadn't been models and the one who had – never really resolved itself for some, not even after I'd passed a lie-detector test, earned my private investigator credentials, donated chapters to anthologies, won awards, spoken at hundreds of literary festivals and events, professionally reviewed crime novels, book-blogged for the ABC, hosted crime documentaries and interviewed other authors – not to mention writing nine novels.

For example, in a 2013 *Sydney Morning Herald* review of the anthology *If I Tell You … I'll Have To Kill You* – a book in which 'Australia's leading crime writers reveal their secrets' to raise money for the Australian Crime Writers Association, edited by Michael Robotham – critic Jeff Popple wrote of my contribution:

Tara Moss poignantly reveals how she once took a polygraph test to disprove claims that she did not write her novels: 'I now have a 30-page report declaring ... that I am an author.' Proof of authorship, however, is no substitute for quality.

As was pointed out in a very witty, but cruel, observation by renowned crime reviewer Stuart Coupe back in October 2004, when he was reviewing Moss's *Covet*. At the time he noted that he did not know which was more depressing, the fact that the Howard government had been returned for another term or that Tara Moss was Australia's best-selling crime novelist.[6]

It must be said that mentioning someone else's nine-year-old 'very witty, but cruel' review of a novel written ten years prior is an unusual way to approach any author's current work, but in my fifteen years of being published, Popple/Coupe's review (whose is it, exactly?) is neither the most 'witty', 'cruel', or most bizarre. Criticism, praise and bad reviews are all part of the trade, of course, but what is relevant to this book is how I have been defined as a writer, and the curious ways that manifested.

For at least the first decade of my publishing career, a startling number of book reviews from every country I was published in included prominent references to my appearance. Also, along with many of the uncomplimentary references to my writing, the reviewer, journalist or columnist took the time to mention that I was a model or ex-model, and even refer to my hair colour ('blonde') or my cleavage (I have some), while failing to analyse the formal aspects − such as plot, characters or pace − of the novel or novels in question. On many occasions even well-known book reviewers failed to review any actual book.

In reviews where the author did bother to analyse my writing, their analysis often contained references to appearances, like Graeme Blundell's 2006 assertion that my prose 'needs honing, with possibly a shot of editorial Botox to tighten the flabbiness, smooth the stretch marks'.[7] In each of his reviews of my novels, Blundell has made multiple references to my personal appearance, my modelling career and my tendency to end up in the gossip pages.

A review at Interrobang in 2012 of the Spanish translations of my first two books took it a step further, detailing my appearance, my modelling shoots, describing my hair, leg length, height, and something about my 'flesh-coloured g-string' (lost in translation, that bit), all accompanied by unrelated photos found on internet search engines, including one in which I was topless, and claiming: '*Está claro que la belleza, el sex appeal, los contactos, el dinero, el glamour, la han ayudado a encumbrarse rápidamente como escritora sin tener en cuenta que para ello no basta con saber escribir.*'[8] Or: 'Clearly beauty, sex appeal, contacts, money and glamour helped her to soar as a writer without her having to know how to write.' They knew I wrote my own books because I had proved it with the polygraph test, but apparently I used my body, money and contacts to get my work published.

I wonder, in fact, if there could be a career where it is less advantageous to look like a model, as you spend the bulk of your working life in a room by yourself staring at a computer, notepad or typewriter and the end result of your efforts is printed words. Writing a novel may take years and pay notoriously poorly, but hey, *Sex appeal! Glamour! Flesh-coloured g-strings!*

Numerous articles written in the early part of my career also used me as a symbol of the superficiality of a so-called

'new' publishing industry, as if one person who had found some success after a transition from working model to working writer was the sign of a worrying trend. Darren Moyle, for instance, in a witty little 2002 *Sydney Morning Herald* article about the difficulty of getting published, wrote that an aspiring writer should 'try to be an ex-model like new Australian author Tara Moss, author of two inventive suspense novels about, well, models',[9] apparently failing to notice the FBI agents, police officers, private investigators, psychologists, professors, university students and other characters in my crime thrillers. Or the plots. He also hilariously suggested that writers ought to get facelifts or nose jobs if they wanted to appear on the back cover in an author photo.

Although this trend was most popular in the first ten years of my publishing career, the temptation to work in fashion-model clichés continues even today. At the 2013 Sydney Writers' Festival I participated as a panellist in sessions on international crime writing and blogging about social issues, interviewed feminist Dr Anne Summers, AO, about her new book, and grilled former *Vogue* editor Kirstie Clements about eating disorders and body image in the modelling industry as depicted in her recently released memoir. After these four sessions, the only mention that appeared in Australia's mainstream press about my participation in the festival read: 'Model-turned-writer Tara Moss and the historian William Dalrymple crossed paths at the threshold to the Sydney Theatre, Moss on her way in to talk about fashion blogging, Dalrymple on his way to talk about the 1839 British invasion of Afghanistan.'[10]

Note the clever contrast of the authoritative male historian and the fluffy lady model. One can only assume that the journalist neither attended any of my sessions nor read the

program very thoroughly, as there were no talks about fashion blogging.

The idea that models must be dumb and/or vacuous featured prominently in coverage of my writing career. There is no doubt that this stereotype and the reactions to it benefited me with more media coverage, though arguably these kinds of headlines lost me as many potential readers as they gained me:

> Model Author: With her covergirl looks, some observers don't want to believe beautiful Victoria-born supermodel Tara Moss could also be bright enough to write a best-selling novel. (*Times Colonist*, Canada)
> What does a beautiful international model have in common with Australia's No. 1 Selling Crime Writer? (*Gold Coast Magazine*, Australia)
> Bombshell with Brains: Model Turned Author? (*Globe and Mail*, Canada)

Similar headlines are still common in countries where translations of my novels are only just coming out for the first time. Fortunately for me, many of these articles are complimentary, more along the lines of 'It's a Crime She Can't Get Respect' (that was the headline for a 2006 *Maclean's* piece) and generously pointing out that I am not, in fact, an idiot. The articles seem to assume, however, that stereotypes about models being dumb were either an accepted fact of biology or at least something that most of their readership believed to be true. I was often presented as an exception to the rule that women had to be dumb if they were professional models or considered conventionally attractive.

There are several ways in which I did not make things easier for myself. I featured on the covers of some editions of

my novels (some of the UK, Canadian, Australian, Hungarian, Czech and Russian editions, that I am aware of). The publishers wanted it and often foreign publishers did it without even consulting me first, but I didn't see a problem. It wasn't like seeing someone actually involved in the book was deceptive to readers in some way – to the contrary, but seeing an author on a cover is conventional for non-fiction books not fiction.

I was not consulted for the covers of the Russian editions, for instance, one of which looked more like a magazine cover than a crime novel, but honestly, it was a lot better than the first edition printed there, which involved a hat silhouette, through which one could see the Sydney Opera House in full colour, though none of the book took place in or around that iconic building and none of the characters, to my memory, dons a bowler hat in the story. The Italian covers were badly illustrated caricatures of blonde models. Anything would have been better. The worst covers I saw had weird images of unrelated people and situations that seemed chosen rather arbitrarily by a foreign art department, so in the balance of things I was fine with being on my covers when it happened. But the added visibility of being on some of the covers, albeit only a fraction, brought criticism at times and in hindsight there is little doubt it added further focus on the author's appearance.

More damningly, I failed utterly to follow well-meaning advice I was given at the start of my publishing career: that I should dye my hair dark and 'sport glasses and black turtlenecks' to be accepted as an author. As I saw it, that would have been trading one tired cliché (busty blonde model) for another (bespectacled, asexual bookworm). If anything, suggestions that I didn't 'look like' an author (what does a writer look like?) made me more stubborn. I dressed, and

undressed, as I wished. To this day I have 20/20 vision (knock on wood), I enjoy wearing makeup most days and I am not especially interested in covering my clavicle. I don't believe that clothing, hair colour or makeup, or even a tendency to be photographed a lot, has any relationship to a person's other abilities, and I do not choose my friends or my reading material by those parameters. But yeah, I wore dresses and stilettos and leather motorcycling pants and was not generally seen in turtlenecks.

Perhaps most significantly, though, I also contributed to the problem by not actively rejecting this 'Stop the presses! Model can actually write!' narrative. While it is true that authors and public figures have little or no say in what others write about them, I nonetheless could have refused to play along with the 'It's a crime she can't get respect' theme. But I didn't. Unfortunately, headlines like *If Looks Could Kill: Despite her successes as a writer, Tara Moss says people fixate on her looks. (Did we mention she is also a supermodel living in Australia?)* from the *Ottawa Citizen* in 2002 were as ubiquitous as lines about 'Gathering Moss'. I cringe at some of my old quotes and photographs. Many of them, actually. But I'm still not sure how I could have handled it differently, knowing my life at the time. I had no media adviser. I was not rolling in dough. I needed to work for a living and as I'd quit modelling, I needed my books to sell enough copies to enable me to write the next one, just like most writers who aren't born into money. Media interest in my novels was therefore welcome, obviously. I did the best I could and told it like I saw it. Sometimes it came across well and sometimes it really didn't. Downplaying the controversy might have kept it from becoming such a defining part of my career in the early years, though truthfully that would have been hard after the now

infamous polygraph test – and without that test I suspect the rumours that I had not written my novels would almost certainly have continued at least until the advent of social media allowed me to write blogs, tweets and other posts directly, giving people a better idea of who I actually was, unmediated by journalists, gossip columnists and reviewers. In essence, it took the advent of social media for me to be really able to write my own story, and undo some of the 'fictions' about me.

Looking back, I can see that by openly acknowledging this particular problem in my life I made myself likeable to some because I was credited with 'breaking a stereotype' about models (something that was frequently reported), but I also made myself unlikeable to many others. It encouraged a lot of 'she ain't all that' comments about how ugly/fat/skinny/masculine and generally un-pretty I was, and it also raised the possibility that I knew I was 'conventionally attractive'.

This was not a very sympathetic position to speak from, as was pointed out in a column titled 'Carrie On: Pretty is as pretty does, just ask Tara Moss' published in the *Cairns Post* in 2007:

> Tara Moss is many things – a bestselling crime writer (her four books have been published in 13 countries), a documentary host, a goodwill ambassador for the UN, a keen motorcycle rider, a keeper of pythons and a meticulous researcher. She is socially generous, happy to talk with her book fans and autograph hunters, and supremely articulate. But Tara can't get past what her crime fiction fans got past several years ago: the fact that she is also outwardly beautiful.[11]

The writer then suggested I 'get over' myself.

I may well have deserved that.

In my defence, it might be closer to the truth to say that it wasn't my outward appearance I couldn't get over, but the way my outward appearance was affecting my life, in both very good and very bad ways – ways that become clearer each year as I get older and those good and bad impacts fade.

Fade, not disappear, necessarily. In 2014 a reader made me aware of a picture at an Australian newspaper's website. The gallery was called 'Big boobs?' and featured an image of me leaning forward, my cleavage therefore visible. The caption read: 'Tara Moss ... she used to be a model, apparently she writes books now.'[12]

These days I can laugh (mostly I was impressed with how, for journalistic reasons, the writer appeared unable to fully commit to whether or not my boobs are indeed 'big') but for years I got slapped with demeaning comments and questions about my looks and former career as a model so often that, for a long time, I couldn't let it go. I kept taking the bait and, of course, every time I did it was those questions and answers that dominated the reporting. It was not until I hit my thirties that I really learned how to divert the conversation to other things when those same old questions about models, appearances and stereotypes inevitably came up. And, not so coincidentally, such questions diminished substantially after I turned thirty-five, though I still don't wear glasses or turtleneck sweaters. (And if I lean forward, yup, I still have cleavage.)

Much of the time, I was just happy that anyone cared what I was doing. But sometimes things were written about me that hurt like hell. I was determined not to let the hurt show publicly. I think that made me seem invulnerable. I hid my

wounds, as always. Anyone can develop a thick skin. But it's still skin. Things penetrate. I believe there were times when I was undeservingly praised and undeservingly attacked. Much of that comes, I think, from finding some success.

My crime series changed my life, both in the experience of writing and in the experience of being published. All of it has been worth it.

5

GOLD-DIGGERS
AND MEAN GIRLS

... the lust of women leads them into all sins; for the root of all woman's vices is avarice.
Marcus Tullius Cicero[1]

There was a time when women needed to marry men so that they could eat or have a roof over their heads; few women were permitted to own property, handle money or hold paying jobs. Until 1883, when English women married, their legal rights and property devolved to their husbands under law. It is both unsurprising and ironic, then, that legend would apportion avarice, *material greed*, to women, and particularly in marriage.

As a young person, my view of marriage was unmarred by the more unsavoury details of the institution's history. I was, and continue to be, modern in my belief that one marries for love rather than money, title, property, to appease warring clans or to garner a large number of cows or other livestock for one's parents. Marriage is something that no person should

be forced into for any reason but, rather, a publicly declared bond that any two consenting adults, regardless of their sex, sexuality, race or religion, should be able to enter into if they choose. My view of marriage was formed by the example my parents set: my mother and father, Bob Moss and Janni Moss (née t'Hooft), were happily married and practically inseparable for nearly a quarter of a century before my mother passed away. Perhaps because their relationship was such a close and happy one and it ended tragically, in my young eyes their marriage became a kind of mystical ideal; something not only important, but also absolutely essential to a happy life, and therefore something I would seek to find for myself – at times with a level of enthusiasm that can only be described as foolish.

Three short years after my mother's death, I made my first attempt to find what my parents had – and it was a spectacular failure. At thirty-three, my first husband, the charming owner of a gym in my hometown, was fourteen years older than me. He turned out to be a domineering, entrepreneurial womaniser with an impressive ability to lie to people's faces. Among other memorable highlights, he screwed his teenage secretary on our wedding day and sold lifetime memberships to his gym hours before taking off in the middle of the night with the thousands of dollars' worth of gym equipment he'd rented, along with many of my belongings, and selling it all at an auction up island while I was working overseas as a model. I had to go through the humiliating process of facilitating a divorce when my other half could not be served with the papers because he was missing, by then wanted by both the police for theft and fraud, and Revenue Canada for tax evasion. During our short courtship and marriage I'd been incredibly naive and gullible, and I doubted myself as a judge

of character after that. It was over a decade before I would make such a commitment again.

When I was around thirty years old, I fell in love with a sweet Australian man with dimples who drove an old MG with broken seatbelts and lived with his sister and brother in a rented apartment in Melbourne. He was charming and sociable. I moved from Sydney to Melbourne for the relationship and it wasn't long before I walked down the aisle with him. He was nine years older but had never married or settled down. Though he had mostly worked as an actor at that point he was trying to get a career in movie producing off the ground. His mother, a singer and performer who quit her career when she got married, as was traditional in her day, was one of the kindest, most beautiful people I'd ever met. It seemed like it would work. Unfortunately, our relationship quickly unravelled after we moved in together as a married couple – two people clearly wanting different things, two people who had seen in each other a level of compatibility and shared ideals that simply was not there. The failure of our marriage hurt both of us deeply. I had not imagined in my worst nightmares that it could happen twice.

My estranged husband stayed in the townhouse we had bought in Melbourne and I moved back to Sydney to be with my ever-supportive friends and the more familiar environment I had known for years before the relationship. I went to ground for nearly eighteen months, felled by clinical depression brought on by the marriage breakdown, and waited patiently for us to get on with selling the townhouse so I could have my life savings back. It was a truly awful time. Though our property was solely in my name and my entire life savings were invested in it, it soon became clear that the public story had it that our home was and somehow always had been *his* place, and

I'd been enjoying his possessions and generous hospitality. One can only assume this was because he was Melbourne-born and those who knew him either didn't realise, or chose to forget, that he had been renting a flat with two siblings when we met. Perhaps it also helped that he was male, and I was younger.

Unfortunately, the rumours were just getting started. The next big story was that my estranged husband had given me a massive payout when we split. We weren't even divorced yet, but supposedly he'd given me *half a million dollars*. For what, I'm not sure. We had been married for a short time and had no children, and I had a successful career as a novelist by that time. I'd even been the bank guarantor on one of his business dealings. But it must have seemed logical and believable, because I was approached by a journalist who said he was going to run a large piece on the payout with or without my side of the story, and I found myself explaining, as diplomatically as I could, that the story was in every way fabricated and incorrect. The resultant headline was 'Beauty Swears She's No Beast' and the article began with the line: 'Glamour queen Tara Moss has hit out at rumours she stripped her estranged husband of almost everything but the kitchen sink when they separated.'[2]

The rumours proliferated, with gossip columnists speculating about my glamorous life as a newly single woman. According to them I was a rich divorcee hanging out with billionaires decades my senior, swanning around on private yachts, in helicopters and expensive mansions. Their stories could not have been further from the truth. In reality I was broke and depressed, living alone in an airless rental in Surry Hills and some days unable even to get out of bed. Looking back, it is alarming to recognise how isolated and dangerously low I became during those months. I felt frightened, foolish and humiliated.

Speculation about a much older billionaire – pay TV tycoon Steve Cosser, with the two-page headline: 'Life's a Breeze for Tara with Steve in Tow'[3] – stemmed from a few hours spent in his company on a single occasion, with others present. As far as I was concerned, I'd been invited to meet with a TV network rep, his wife and Mr Cosser because I was being sounded out for possible involvement with a TV show, perhaps as a host, as that was the sort of work I had done in the past. The meeting resulted in nothing but a nice meal eaten with a handful of people I didn't know, and a bold headline in the gossip pages a few days later.

Not long after, when I found a boyfriend in a then–little-known comedian named Joel Ozborn, I had to try to negotiate a normal dating life in the face of both a drawn-out divorce and some bizarre media speculation, sometimes taking up a full page in the local newspaper:

> While model author Tara Moss last week told friends she
> was happy with a 'lovely new man', being Joel Ozborn, just
> a week later she was busted looking rather cosy with
> another man, being Balance Water CEO Martin Chalk.
> Moss, who had attended the Movie Extra Filmink Awards at
> the State Theatre earlier in the evening, may have been
> looking to gather a rolling stone when she arrived at the
> event after-party held at Kings Cross hotspot Hugo's ... Moss
> was seen swapping saliva with Chalk by several onlookers.
> 'They were sucking face in the VIP room until the early hours
> of the morning,' one witness yesterday told [the columnist].[4]

The truth is I was at the after party with the aforementioned then-boyfriend, Joel Ozborn, and was never alone with Mr Chalk or anyone else, let alone 'sucking face'. But hey, he was

an older CEO, so he must be loaded and therefore I would of course be all over him. Either him or a pay TV tycoon several decades my senior. The idea that I would date someone roughly my age, who was nice, funny and not remotely rich, was not a scenario worth entertaining. Or, rather, it wasn't an entertaining scenario. And it certainly didn't fit the gold-digger narrative. Avarice was the root of my sins, apparently. My other problem was 'ambition'. A newspaper mention of the breakup of my marriage described us thus: 'She is said to be highly ambitious, [Her ex husband, the aspiring movie producer] is said to be warm and easygoing.'[5] There was also speculation that we'd broken up because I did not want to have children. While the rumours continued to swirl about my giant payout and living the high life with various rich dudes I'd barely met, it ultimately took more time to finalise the divorce than the marriage itself had lasted.

Interestingly, around the same time my little breakup played out in the Australian media as some kind of fictional soap opera with characters I didn't even recognise, the worldwide media were busy inferring that actor Jennifer Aniston's childlessness was a reason for the breakup of her marriage with Brad Pitt, as if by failing to reproduce she had pushed him into the arms of his *Mr and Mrs Smith* co-star, Angelina Jolie. According to the popular press, Aniston was 'ambitious', Jolie was a 'home-wrecker' and Pitt was, well, just good old Brad.

The most logical and common-place explanation – that my ex and I simply weren't compatible – was not interesting, so the banal reality of our false expectations and failed romance had to form a more scandalous yet familiar narrative, one of model gold digger and rich man, two things that were quantifiably untrue to anyone who bothered to investigate, and easily disproved by even the most cursory glance over his

circumstances when we met, our professional CVs, home ownership details or bank statements. But with so many photographs of a grinning, blonde ex-model-type arm in arm with a man who had grey hair … well, the fiction fit too perfectly. He had to be a rich producer and me an ambitious gold digger. *Women and avarice*, after all.

I was an 'ambitious' ex-model, so Australia's richest man simply had to enter the equation at some point. This happened in 2002, a couple of years before the aforementioned failed marriage, when a weekend newspaper reported in their gossip section that at Flemington Racecourse, 'Media mogul James Packer made a brief appearance at the Moët marquee and a beeline for author/society sex symbol Tara Moss. They left together a short time later.' This brief report came with a photograph of me (standing by myself, it should be noted) in my race attire, a slinky black dress and headpiece, with the caption: 'Tara Moss, who caught James Packer's eye.'[6]

Of course, like many people with public careers in the small pond that is Australia, I have had occasion to cross paths with a number of well-known rich and/or famous Australians – James Packer, the Murdochs, actors, TV presenters, athletes and so on. A meeting, or even two, does not a relationship make, however. It doesn't even qualify as a friendship. As far as I can remember, Mr Packer and I never even crossed paths that day at the races and we certainly did not leave 'together'. In fact, I left the races that day with a man I'd just met, whom I would marry less than eighteen months later. But never mind that this 'they left together' story was fabricated – I was forever after described as being 'linked with James Packer, Australia's richest man'. Since that single false report, there have been no less than seventy newspaper mentions in Australia of this apparent romantic liaison.

When noting these kinds of stories, which dot gossip pages in international media on a daily basis, it pays to think of whom these unsubstantiated stories actually serve — not the public, because they are frequently being lied to, as many of us now know. (Buy a novel if you want a fabricated romance or love triangle, I say.) But when the celebrities mentioned are big enough — say, a beautiful supermodel or an actor like Angelina Jolie — it sells a large number of newspapers and magazines, and it certainly gets free press for people who own the venue or run the event where the alleged liaison is said to have taken place. It may also provide valuable free publicity for big-money projects related to the person being gossiped about, not necessarily benefiting the person themselves — who may in fact find their careers and personal lives negatively affected — but rather the far wealthier stakeholders in the projects with which those individuals are associated, such as the movie studio, TV network or record company.

This pattern might be a relatively harmless way of making money and keeping people entertained, if not for the detrimental effect it has on some people's lives and, more centrally for the focus of this book, the moralising judgements about women that are never far from the surface. The way gossip is framed tends to make the man mentioned look eligible, successful and virile because he 'scored' with a celebrity or model, while it inevitably makes the woman involved look like a greedy gold digger, a vacuous party girl, a home-wrecker, desperate or even a whore. That the fictions so frequently take this form is disturbing.

I was reminded of the persistence of this narrative again recently, as a rumour went viral about a supposed romantic relationship between James Packer, now forty-six, and supermodel Miranda Kerr, thirty. The world press and social

media went into absolute overdrive, with journalists even setting up camp in Gunnedah, the small town where Kerr was born, just to ask locals what they thought of the rumoured pairing. According to *Woman's Day*, the weekly magazine that is the source of the story, "'Miranda may come across as an Earth Mother but she loves the high life and James can provide the sort of lifestyle and security very few could give her," a source said.'[7]

Now let's remember for a moment that the woman in question is a working, international multi-millionaire supermodel, who made number two on the Forbes list for top-earning models in 2013, the same year the rumour hit. Miranda Kerr clearly does not need a man to finance her lifestyle, as she is perfectly capable of providing for herself – but that this obvious fact does not rate a mention in the *Woman's Day* story is revealing. Instead of acknowledging the woman's independence and self-made success, she is presented as a shiny trophy to be picked up by the highest bidder. The headline in the *Australian* perhaps put it most succinctly: 'Packer Trades in One Model for Another'.[8]

I have no doubt that there are ruthless and cold-hearted women out there who want nothing more than to strip a man of his cash, seducing him out of his wallet with whispered sweet nothings and criminal flashes of cleavage, and there are probably even ambitious women who trick men into marriage by bearing their children (or, because they are ambitious, choose *not* to have children, *the vixens*). Likewise, I am sure there are shallow men who want trophy wives or girlfriends, and will drop their partners at the drop of a hat as soon as they put on a kilo or develop a wrinkle. In fact, I may have even met a few. But is this really the explanation for so many publicly visible relationships?

A look through mainstream publications and entertainment will tell us that women are often shallow gold diggers with transparent motives, and that they are as interchangeable as a car or a nice watch – at least, the young and very beautiful ones are, and that narrow demographic of female human is pretty much the only woman we choose to 'celebrate'. Likewise, women are not trustworthy like men supposedly are, and when they are ambitious, it's not in that good way that men are ambitious. Female ambition is represented as fundamentally suspect and deceptive, a danger to men.

And, it seems, female ambition is also fundamentally dangerous to women.

'Women are their own worst enemies', or so the old saying goes. This notion is something many instinctively agree with.

From the sports field to the boardroom, male ambition and competitiveness is lauded, yet the term 'ambitious', when it describes a female, is often used with ambivalence. There is a particularly nasty side to female competition and aggression, we are told – envy, avarice, cruelty. The perils of female-on-female cruelty continue to be widely discussed by academics and journalists, and frequently portrayed in popular entertainment, from the breakout 2005 comedy *Mean Girls* to reality shows like *Real Housewives* and the popular remakes of *Snow White*, with that vain, bloodthirsty queen intent on killing the only girl more beautiful than she. In 1916 H.L. Mencken wrote, 'When women kiss it always reminds me of prize fighters shaking hands.'[9] It's still widely suggested that 'all women hate each other'. Of course mean girls do exist in the real world, and the negative social behaviours of women and girls can have terrible consequences, encouraging depression, eating disorders and, in extreme cases, even violence or suicide.

Yet this focus on female evil and cruelty seems curious when you consider that 'mean boys' and cruel men are far more likely to cause physical injury and death. According to the Australian Bureau of Statistics, males are 400 per cent more likely to commit an offence intended to cause injury than are females.

Samantha Brick became a household name in 2012 when she wrote a piece in the UK's *Daily Mail* attacking women for hating her on account of her beauty. 'I know how lucky I am,' she wrote of being good-looking. 'But there are downsides to being pretty – the main one being that other women hate me for no other reason than my lovely looks.'[10] The *Daily Mail* published a plethora of images of her to accompany the article, just begging for a response. They got their wish. The article went viral and thousands of people commented, the vast majority ridiculing Brick. Men's comments were largely along the 'I wouldn't f★★★ you' theme, and she was fodder for (mostly male) comedians for weeks, yet once again, it was the unkind responses of women (whom, after all, she attacked directly in her piece) that remained the main focus of debate. Months later, Brick continued to claim that 'women do not like other women who are more attractive than they are'.

This is a classic generalisation about women. In this common narrative, women exist to be beautiful and to compete for the attention of men, without whom they are lost. Women's looks are their most valuable asset in this quest for a man, an asset they'll do anything to retain ('Who's the fairest of them all ...?'). Women must have a man and they must also bear children, without which they are – again – lost. Women's value is derived through their ability to attract a male partner and form a family unit.

Where do we get this fiction? The consistent representation of women's lives as existing in relation to men, rather than on

their own terms, is a logical result of the fact that our stories, on page and screen, are largely created by men. Since the advent of the novel, the vast majority of storytellers have been men (women struggled to get published until relatively recently; some published under male names – Stella 'Miles' Franklin, the Brontë sisters, George Eliot etc. – and men continue to dominate our storytelling, as the statistics in chapter 7, 'The Archetypal Woman', confirm. It is hardly surprising, then, that our stories are frequently told from a male perspective, with most centring on the lives and achievements of men. What we miss out on in these skewed portrayals are the different types of women that exist – the variety of occupations, achievements, attitudes, personalities, experiences, sizes and shapes real women have.

From 2006 to 2009, for instance, not one female character was depicted in a G-rated family film as a business leader, in law, in politics or in the field of medical science, according to a study by the Geena Davis Institute on Gender in Media. In these films, over 80 per cent of all working characters were male, although in the US, where most of the films were made, women in fact comprise roughly half of the workforce. Female characters on screen speak to one another so rarely that it spawned the Bechdel test, popularised by the graphic novelist Alison Bechdel, which rates a film according to whether two named female characters speak to each other about anything other than a man. (Incredibly, the majority of films fail.)[11] Therefore, naturally, the other thing we miss out on in these stories are normal portrayals of female friendship. Female friendship is an important part of life for most women. Though I have many male friends and my father and husband have both been important figures in my life, the majority of my friends, my mentors and most of my supporters –

personally and professionally – have been women. Yet I'm unlikely to see these kinds of positive female interactions reflected in mainstream entertainment.

According to the study 'Mean Girls?: The Influence of Gender Portrayals in Teen Movies on Emerging Gender-Based Attitudes and Beliefs', published in 2008, female characters portrayed in the top-grossing teen movies were 'significantly more likely to engage in socially aggressive behaviours than males'. (This is certainly a curiosity when one considers the known statistics on aggression and harm.) The study concluded that 'teen films have a tendency to rely on the stereotype of teen girls as "mean girls"', and 'the more emerging adults identified with teen movies and characters and the greater the exposure to teen movies, the more likely they were to report negative perceptions of their friends' friendship behaviours'.[12]

These ideas are not only reinforced in film, however. Any opportunity to report, or imagine, a disagreement between two 'celebrity' women seems irresistible to many press journalists. After a beauty article of mine (on vintage-style red lipsticks, of all things) was published with a photo of me sticking my tongue out,[13] humorous comments came in about comparisons to the singer Miley Cyrus, who appears to favour the tongue-out facial expression. I replied, jokingly, that 'I've been sticking my tongue out since before Miley was in nappies.' This single social media comment led to two entire newspaper articles, claiming rather incredibly: 'Tara Moss has taken a swipe at Miley Cyrus, saying she's brought nothing new to the industry', and including a caption that read: 'Tara Moss is less than impressed with Miley Cyrus.'[14]

Notably, the articles took the opportunity to promote the singer's recent releases and semi-nude magazine spread. The

issue of imaginative journalism aside (one headline used the words 'so old hat' in quotation marks, as if to attribute them to me, rather than to the author of the other article), my joke was not a comment on anyone's career, but on the habits of my own tongue. Another way to interpret it might have been 'Moss shows solidarity with Cyrus, saying tongues are no big deal!' But manufactured girl fights are the narrative of choice. It had to be a 'swipe'. One imagines claws.

We all know that some human beings are not very nice. That is hardly a radical idea. Nor is it specific to gender. Just because two women disagree with each other, are openly arguing or even fighting tooth and nail – or are not, as the case may be – does not mean that 'all women hate each other' or that 'women are their own worst enemies'. There's a word for that sort of notion. It's called *fiction*.

6

THE FEMME FATALE

Women are on the side of iniquity, not of justice, of the
dark rather than the light, of Belial rather than Christ; they
are not temples of the living God, but idols and empty
shrines of the dead.
St Jerome, 393 CE[1]

I have sometimes wondered where we get these ideas of
'Woman' as an untrustworthy and evil creature of iniquity,
moral danger and corruption, whose actions are ambitious by
nature, and whose ambitions are suspect and cruel. Where did
the fiction start? Looking through the lens of history, we can
see this mythology form.

Pandora – the first woman on earth in Greek mythology,
created by a male god (Hephaestus) on the order of a male god
(Zeus), as a wife for a male (Epimetheus) – was perhaps not
the ideal first love. She famously opened that box (in fact a jar)
back in the days of ancient Greece, letting all the evil into the
world.

From her is the race of women and female kind:
of her is the deadly race and tribe of women who
live amongst mortal men to their great trouble,
no helpmates in hateful poverty, but only in wealth.[2]

Eve – the first woman on earth according to the Old Testament, created by a male god from a man's rib as a gift for a male (Adam) – was likewise not without flaws. She sought the Tree of Knowledge and famously bit into that apple in the Garden of Eden, ending Paradise and letting all the evil into the world.

Lilith – the first woman on earth in Jewish folklore, created from the earth with Adam and given to him to be his wife – also had her problems. 'As a way of asserting his authority over Lilith, [Adam] insisted that she lie beneath him during sexual intercourse. Lilith, however, considering herself to be Adam's equal, refused, and after pronouncing the Ineffable Name (i.e. the magic name of God) flew off into the air.'[3] Having left Adam and the Garden of Eden, Lilith went on to a notable career as a winged demon, or 'succubus', who made men have wet dreams, killed infants and caused miscarriages.

Lilith, Eve and Pandora were the first bad girls, and ever since, women have been linked in the popular consciousness with the concept of sin and their sins with sex. (The hapless Adam just couldn't catch a break, could he?) Mae West once quipped that there are 'no good girls gone wrong, only bad girls found out'. And she has a point, if you consider that Pandora's sin was to open a box or jar filled with secret wonders, Lilith's sin was to consider herself Adam's equal, and Eve's sin was to 'eat from the Tree of Knowledge'. The Good Girl standard then, of submission and a lack of curiosity about flora and fauna (including speaking snakes), not to mention no

interest in knowledge, would surely make being 'a good girl' a near impossibility. And not much fun, by the sounds of it.

The Greek philosopher Plato, who helped to lay the foundations of Western philosophy and science, offered in *Timaeus* that women are the reincarnation of men who have lived evil lives and, as such, are morally flawed: 'Of the men who came into the world, those who were cowards or led unrighteous lives may with reason be supposed to have changed into the nature of women in the second generation.' The next step down the ladder of being was 'animal'.[4]

Women lack moral fortitude, we are told. It is simply their nature. No wonder they can't be trusted, and no wonder men should be ashamed of their emotions, as they so often lead them to women and, therefore, to their own demise. Sherlock Holmes – that immensely popular fictional character of great logic and high intelligence – was very clear on the matter of that other gender: 'Women are never to be entirely trusted, not the best of them,' he warned.[5]

Women exist at the peril of men like Holmes. In a perfect world they are best avoided. But as things stand, wise men know that women are a necessary evil, because although a male god reportedly birthed the world, these days it's women who tend to have the monopoly on the birthing of humans. As men lead other men into wars, or murder one another in brawls and drive-by shootings at an alarming rate, I guess we could say that 'men are their own worst enemies' – except that they aren't, of course. Deadly is the *female*, you see. The downfall of man is not men. Man must beware of the ultimate danger: the evil woman. She brought all the evil into the world and she's not finished yet. The femme fatale could be lurking around any corner, usually with killer pins, just waiting to put her hooks in.

Even the most highly trained and experienced military men are not immune. The head of America's CIA, General David Petraeus, was just being 'a man' (in the words of evangelist Pat Robertson)[6] when he had an affair with biographer Paula Broadwell – an affair that ultimately led to his resignation. Though both were married, Broadwell was widely accepted as a predatory femme fatale who 'got her claws into' Petraeus. According to the *Washington Post*, the helpless general, two decades Broadwell's senior, 'let his guard down'.[7]

An alluring woman with 'claws' is, of course, a firmly established trope. Bob Kane, on creating Catwoman, Batman's love interest, said this:

> I felt that women were feline creatures and men were more like dogs. While dogs are faithful and friendly, cats are cool, detached, and unreliable … cats are as hard to understand as women are … You always need to keep women at arm's length. We don't want anyone taking over our souls, and women have a habit of doing that. So there's a love-resentment thing with women. I guess women will feel that I'm being chauvinistic to speak this way.[8]

'Love-resentment' or not, a female character who breaks the rules and refuses to belong to anyone holds a lot of appeal to many men and women. I have a long-standing fascination with the femme fatale, or *fatal woman*, the most popular of evil-woman archetypes – that ruthless temptress and female icon of social and criminal rebellion. I love the bad girls of early detective novels and film noir; I wanted to believe in the existence of a cool blonde with immaculate Veronica Lake waves and un-smudged red lipstick, reclining glamorously with one leg over the arm of her chair, cigarette held elegantly in one hand, the other hand

pointing a Saturday Night Special at her shocked male victim. But what I found in the research I conducted as a crime novelist surprised me – and, to be honest, disappointed me as well. Far from the femme fatales of fiction, most real female outlaws were women who thieved to eat or to feed drug dependencies, or were arrested for bigamy, prostitution, performing illegal abortions or simply for being pregnant and unmarried, like many of the convict women who were shipped to Australia's notorious 'female factories' in the nineteenth century.

Perhaps, if irresistible femme fatales didn't exist, we'd have to invent them. And sometimes we do, in the form of, say, Joanne Lees, the survivor of a horrific ordeal. Lees was travelling through the Australian outback with her boyfriend in 2001 when a stranger, Bradley John Murdoch, shot her boyfriend, threatened Lees with a gun, tied her up and covered her head. She escaped while Murdoch was distracted – apparently moving the body of her boyfriend – and, terrified, hid for five hours in the bush before flagging down a truck driver. She was subsequently wrongly portrayed by many as a cunning and unfeeling femme fatale who had murdered her boyfriend and lied to cover her crime. The case had shades of Lindy Chamberlain, another woman who suffered unspeakable loss in the Australian outback and was also falsely accused of callously killing a loved one, in this case her own baby.

Consider the more recent case of Amanda Knox, also accused of being an unfeeling, bloodthirsty woman, initially convicted of the murder of a flatmate in Italy, and acquitted in 2011 after four years in an Italian jail. Despite what is widely considered to be a profoundly flawed case against her, Knox has been tried again, in her absence, and recently convicted once more. Even while she was acquitted and free, the international media continued to brand the attractive young

woman 'Foxy Knoxy', taking great delight in speculating about her supposedly perverse sexual appetite. A 2011 article in British newspaper the *Guardian* claimed: 'Knox knew, it seemed, no boundaries, leaving a vibrator in a transparent wash bag and enjoying one-night stands.'[9] As if engaging in consensual sex and possessing a vibrator were obvious signs of a lack of morals – could, indeed, be signs of a woman immoral enough to kill, the journalist seemed to imply. Whether or not Knox is guilty, one struggles to imagine how, say, possession of lube or condoms might implicate a man as a wanton murderer.

In each of these cases – Chamberlain, Lees and Knox – the suspect woman was young and attractive. They fit the femme fatale role a little too well, particularly the unmarried Lees and Knox.

Yes, women do kill. Women do commit all kinds of crimes, some of them quite horrific. Evil women do exist – just perhaps not usually quite as we imagine them.

Take Sydney's own larger-than-life underworld criminals sly-grogger Kate Leigh and brothel madam Tilly Devine, prominent figures in the razor wars of the 1920s and '30s. Despite the reality of these women's lives and the plethora of images and documents available, when it came time to portray them on television, these notoriously tough women were depicted as femme fatale-style beauties. Kate Leigh was even introduced to viewers of Channel Nine's *Underbelly: Razor* series nude in the bath, supplying us with a flash of breast as she emerged from her tub. The camera zoomed in on a beautifully pedicured foot and panned up a shapely leg. 'Hang on to your hats,' the voiceover said. 'It's not going to be pretty.'[10]

Oh, but it was.

Had *Razor*'s Queen Kate looked more like the woman herself – heavy-set, with belly and breasts thrust forward

under a pleased grin, seeming to carry her extra weight with pride – that opening sequence in the bath would have been very powerful indeed, though in quite a different way. But the fact is, we prefer to see conventionally beautiful people on the screen, and while male crime bosses can safely be depicted as brutish old men with ravaged faces and pot bellies, we aren't quite ready to see the female version of this. 'The criminal woman is a true monster,' nineteenth-century criminologist Cesare Lombroso wrote, and for many that stereotype still holds.[11] The hard, criminal woman unsettles us. We need to soften her edges.

We soften her physically, giving her eye-pleasing curves and even features. Sometimes we soften her temperament, too, as was evident in the portrayal of *Razor*'s pretty Tilly running off quietly into the backyard to have a cry by herself when she catches husband Jim Devine in bed with one of her young prostitutes, Nellie Cameron. A very human response, yes, but arguably improbable for a woman with such a famously vicious temper that she shot both of her husbands in quarrels.

We like our female criminals to be beautiful and to fit the mould of the femme fatale popularised by the glamorous bad girls of 1920s detective novels, and the American film noir of the 1940s and '50s. Like the sirens of old, they lure men to their deaths. When women are criminals, we want to make them beautiful, seductive, and when a real-life crime unfolds with beautiful women involved, it's awfully tempting to cast them as the femme fatale, even when they are innocent.

In reality, a life of crime and violence isn't pretty for men or for women.

The most terrifying of all killers is the serial killer – that stranger who kills for pleasure, again and again. In popular

culture the female serial killer was perhaps most famously portrayed by Sharon Stone as Catherine Tramell in the 1992 blockbuster film *Basic Instinct*. Tramell was a bisexual beauty who bedded her male victims and then stabbed them to death with an ice pick. In Australia her real-life equivalent would be someone like Katherine Knight, a victim of appalling sexual abuse as a minor who grew into a violent woman and, in 2000, at the age of forty-four, had sex with her partner then stabbed him repeatedly in bed, skinned him, decapitated him, hung his hide on a hook and put slices of his buttocks in a pot in the oven to cook. Katherine was found asleep at the blood-soaked crime scene and never had the opportunity to kill again.

US sex worker Aileen Wuornos, on the other hand, did. She murdered seven men and was put to death by lethal injection, aged forty-six. Like Knight, Wuornos was nothing like Stone's Catherine Tramell; neither woman was rich nor dangerously alluring. Wuornos was raised in an atmosphere of grinding poverty and abuse and ultimately became a 'monster' of Cesare Lombroso's description, as the title of the Oscar-winning 2003 film based on her life, *Monster*, suggests.

As far back as the sixteenth century we find a tale of a female serial killer, Countess Elizabeth Bathory, dubbed 'the Blood Countess', who was charged with torturing and killing hundreds of her servant girls. She was walled into her castle as punishment. Her actual guilt is debated – as royalty she was not allowed to stand trial, but she could nonetheless be convicted without a defence, and her accusers stood to gain her vast wealth and properties of strategic military significance – but that hasn't prevented her from becoming a legendary femme fatale. She is often depicted as a bisexual or

lesbian sexual sadist, bathing in the blood of her virgin servants to maintain her great beauty. We just can't help attributing beauty, vanity and an intriguing sexual appetite to even our most terrifying female killers.

For centuries female criminality was primarily regarded as taking the form of sexual immorality; women who led men astray with their feminine wiles, a danger to the fabric of a good and functioning society. While the evil men in history are generally associated with violent war and tyranny – say, Vlad the Impaler, Adolf Hitler and Pol Pot – evil women, both in real life and particularly as fictional creations, are almost invariably popularly associated with emotion, sexual sin, perversity and, of course, physical vanity. In this way, we take the criminal actions of women and again tie them back to those early suspicions – that women's sexuality and desires are fundamentally dangerous.

Yet for every Tilly Devine, Kate Leigh, Katherine Knight or Aileen Wuornos, we have many more examples of equally vicious deeds committed by male criminals and killers, and worse. Take Ted Bundy, a true homme fatale – a term I've never otherwise heard used, despite how well it fits. Bundy decapitated at least twelve women and confessed to murdering at least thirty. He used his charm, good looks and sex appeal, along with feigning injury, to lure the women he then kidnapped, raped and killed.

But perhaps the idea of a woman committing a crime at all shocks us as much as the crimes themselves. It challenges our perceptions of women as innocent daughters, loving wives and nurturing mothers – the 'fairer' and 'weaker' sex – while simultaneously fitting neatly into those long-standing parables about the temptations of evil women.

Sherlock Holmes would only shrug and say, 'I told you so.'

Any wound rather than a wound of the heart! Any spite rather than the spite of woman! … No wickedness comes anywhere near the wickedness of a woman, may a sinner's lot be hers! … Sin began with a woman, and thanks to her we all must die.

Ecclesiasticus 25:13-24

Perhaps it is inevitable, when our hearts are broken, to talk about love itself as evil, along with those who represent love to us. For most storytellers throughout history, the focus of those particular emotions has been attractive women, because those storytellers were primarily males and primarily heterosexual.

But women now write many of the novels published each year, and after only eighty-two years, a woman even won an Oscar for Best Director – that coveted mark of acceptance in the Hollywood system. Increasingly, women are making headway. More women are becoming accomplished journalists, playwrights, producers and novelists. More and more, women are participating in the storytelling that shapes our perceptions of the world. Perhaps in time, with a different balance of storytellers, we will be less reliant on the old sexual stereotypes born of Eve and Lilith, less prone to exaggerate the wickedness of ordinary women, and less tempted to dress up the truly wicked in the form of the archetypal alluring femme fatale.

7

THE ARCHETYPAL WOMAN

No black woman writer in this culture can write 'too much'.
Indeed, no woman writer can write 'too much' ... No woman
has ever written enough.

bell hooks, *Remembered Rapture: The Writer at Work*[1]

Who are our modern storytellers? Who were the storytellers of the past? How might the storytellers of the past influence the way we regard storytellers, and their tales, today?

A look at most bookshops and bestseller lists will reveal an assortment of offerings written by male and female authors. This has not always been the case, however. Many women writers had to write under male names to get published and even contemporary writers sometimes do this, or simply use initials, like J.K. Rowling, P.D. James, P.M. Newton, K.J. Taylor, to make themselves more gender neutral.[2] Nonetheless, it is here that we see what may at first appear to be a relatively equal or even female-dominated industry. Yet closer

examination reveals some curious issues. VIDA – Women in Literary Arts conducted a thorough analysis of international publications and discovered that male writers were more than 400 per cent more likely to be reviewed in the major international literary publications.[3] Books by men tended to dominate reviews. In Australia, of the authors reviewed in the now-defunct *Australian Literary Review* in 2011, 81 per cent were male. Likewise, the *Australian Financial Review* featured 80 per cent male authors in 2012 and 70 per cent of the authors reviewed in the *Weekend Australian* (Australia's only national newspaper at the time) were male in both 2011 and 2012.[4]

Male writers are also more likely to win literary awards. In Australia this has led to the establishment of the Stella Prize, for which I am an unpaid ambassador. Sophie Cunningham, writer, editor and current chair of the Literature Strategy Group of the Australia Council, told the *Guardian*: 'We would prefer it if this award didn't have to exist – if writing by women was rewarded and valued on its own terms, with equal merit to the way that work written by men is. Women continue to be marginalised in our culture. Their words are deemed less interesting, less knowledgeable, less well formed, less worldly, and less worthy.'[5]

Any marginalisation of women's writing seems surprising when one considers that the publishing industry is largely female-dominated in terms of the number of people employed, and that most readers are women. On closer examination it becomes clear, however, that the majority of book reviewers are men and the senior positions in most publishing houses are held by men.[6]

As Amanda Hess wrote in *Slate*: 'In 2012, 79.8 per cent of the authors of books chosen for review in the *New York Review of Books* – and the critics tapped to review them – were men.

"We certainly hope to publish more women writers," editor Robert Silvers insisted last year. Now, Silvers has made good on his promise: In 2013, the review featured exactly one more woman than it did in 2012, bringing its percentage of male authors and reviewers down to 79.5 per cent.'[7]

Men dominated early publishing, the classic writers taught in schools are disproportionately (sometimes almost exclusively) male, and so it can be argued, rather convincingly, that this dynamic of (white) male writer as authority and thinker, and woman as reader and student, was set long ago. White men, as a demographic, also continue to dominate positions of authority in our broader culture, so their writings continue to carry, for many, a kind of unconscious authority. As Dr Kerryn Goldsworthy, a former editor of the *Australian Book Review* and a former member of the Literature Board of the Australia Council, told me, 'Most of the unconscious bias I have seen in the literary world, and I have seen a great deal, has been to do with the male-centred values of a dominant culture whose values most people wrongly think are universal and gender-neutral.'

Where would we continue to get the impression that the stories of men – male detectives, male soldiers, male doctors, businessmen, male superheroes, boy wizards, male monsters, bears, lions and trains – were simply gender-neutral? Dr David Anderson and Dr Mykol Hamilton gave some clue as to the answer when they examined hundreds of award-winning and top-selling children's books and found that there were nearly twice as many main male characters as female and males appeared in illustrations 53 per cent more often.[8]

Of course there are those who feel that exposure to work by women, or about women and girls, doesn't particularly matter (sometimes this feeling is so strong that they are

compelled to attack those who discuss the relevant research), or that the available statistics could simply reflect that – pick a year – was a bad twelve months for literature written by women. Sadly, the same pattern recurs again and again, with some exceptions. We can always name a great female writer or character, perhaps even a female-dominated shortlist. However, what is important here is not the exception to the rule, but the dominant rule itself – the larger pattern. And a lot of people really don't want to see that pattern at all. Or they think this larger pattern is just fine.

As author David Gilmour, who teaches at the University of Toronto, explained to an interviewer in 2013: 'I'm not interested in teaching books by women … I don't love women writers enough to teach them, if you want women writers go down the hall. What I teach is guys. Serious heterosexual guys.'[9] Note the implication that women or non-heterosexual men are not 'serious' writers.

As a novelist, I naturally tend to notice what is happening in publishing, but it has been evident for some time that film and television have become our most popular forms of mainstream storytelling and entertainment. This is where the most influential fictions are to be found.

As storytelling has traditionally been used to transmit ideas about the world and our place in it, so this powerful media can go some way to shaping an individual's idea of the world and sense of personal identity. This is why I will focus primarily on films and not books in this chapter; movies are still considered by many to be more prestigious or 'important' forms of storytelling than either TV or books (many people, on discovering that a new book of mine has been published, immediately tell me that they 'hope it will become a film', as if only through screen adaptation the book will become real).

Crucially, films also require enormous financial backing to get made (even hundreds of millions of dollars), which tells us what stories are deemed worthy of support for their cultural, artistic and financial value.

So, how do we begin to analyse women's representation in film? We can start by mirroring Dr Anderson and Dr Hamilton's examination of children's books, by looking at the proportional 'space' women and girls occupy in modern cinema. One of the most compelling, albeit imperfect, tools we have to gauge women's involvement in the stories that make it to our big screens is the Bechdel test, referred to in chapter 5, a test originally used in jest by cartoonist Alison Bechdel. As I explained earlier, to pass the Bechdel test, a movie needs to have two named female characters who talk to each other at some point about anything other than a man.

You'd think this would be setting the bar fairly low; however, a remarkable number of films (some I dearly love) fail this test. In fact, at the time of writing, the majority of top-grossing films do not pass. The entire *Stars Wars* series, the *Lord of the Rings* trilogy (including *The Hobbit*) and other classics do not pass. Even the film adaptations of J.K. Rowling's *Harry Potter* series fail in all but one film. It remains true today that a surprisingly large proportion of films are dominated almost entirely by male characters and any named women characters only speak to men or about men. Women, where they are represented, still frequently provide the background for the male protagonist's cinematic journey.

The Bechdel test does not tell the whole story, of course. It measures only one key dynamic and does not indicate whether or not female characters, if they do exist, are well written, truly valuable to the plot or empowered in any way. Neither does the test indicate whether or not a film is any good. Many

of my favourite films fail the test needlessly, however. Is it so hard, during a two-hour film, to have two female characters speak to each other about something other than the male protagonist's progress through the plot, about something other than their desire to be with, or get over, or help redeem a male character? (No wonder we end up with the idea that all women hate each other – they don't even *speak* to each other.)

Once you start applying the Bechdel test to films, it is hard to stop. Take *The Empire Strikes Back*, which came out when I was seven. Though I did not notice it as a kid, looking at the film now it becomes clear that the most unrealistic aspect of the two-hour story is not the monsters, the spaceships, light-speed travel, carbon-freezing or the mystical 'Force', but the fact that there is only one female in the entire known galaxy, including all of the humans, soldiers, bounty hunters, monsters, droids and holograms, across several planets, star fleets and a floating city. Actually, that isn't *quite* true. There are six women – but five of them are extras. (Two of them are walking extras and the other three are answering communications at the Rebel base on Hoth – answering the phones, basically.) This 'only named woman in the galaxy' is the love interest of both male protagonists, Han and Luke, and for all of Princess Leia's strengths and progressive leadership dialogue, she spends a lot of time getting saved or kissed, or asking Han to take his hands off her. And, later, wanting his hands on her. Make of that what you will.

The Bechdel is best used as a tool to broadly analyse popular contemporary storytelling, rather than to critique a single film. It does open one's eyes to the extent of female exclusion in modern mainstream cinema. Out of the top-grossing 100 US films in 2011, women accounted for only one-third of all characters and only 11 per cent of the main

protagonists, according to a study by the San Diego-based Centre for the Study of Women in Television and Film. That's right – in the top 100 US films, 89 per cent of the main protagonists were male.

The irony is that, according to an analysis of 2013's fifty most successful blockbusters, films with a better balance of women made more money overall. The analysis was done using a modified version of the Bechdel as a guide and cited several successful 2013 films that passed the test, including *The Hunger Games: Catching Fire*. While only 36 per cent of the top fifty films passed the test, the 'grand total domestic box office number for the movies that passed is significantly higher than the box office totals for the movies that didn't. We're talking billions.'[10] It would seem that the marginalisation – or flat-out exclusion – of women and their stories on film is a matter of Hollywood habit, rather than shrewd business acumen.

When the Bechdel is reversed, do we see a similar pattern in, say, female-oriented films? Interestingly, no. The majority of female-oriented films still pass the reverse of the Bechdel test across multiple scenes, with male characters effortlessly chatting about things that don't involve women, even if it is about a business deal, a car or their latest golf game. As blogger and website developer Jennifer Kesler points out: 'Imagine how hard it would be to avoid a scene in which two named men chat about something other than women. Why do you suppose that is? Because virtually every movie and TV show contains multiple, developed, relevant male characters who have some part in advancing the story.'[11] It is worth noting here that truly female-oriented mainstream films are comparatively rare and often fit into a 'looking for love' plot formula (often called 'chick flicks') which naturally involves a lot of discussion of men. Perhaps most significantly of all, such

films are generally marketed as only relevant to women in ways that male-dominated films are not. The same argument can be applied to books, which are often labelled officially or unofficially as 'chick lit' if they are written by women, and feature female characters noticing something of their (female) lives, while there is no equivalent term like 'bloke lit'. The main definition of 'chick lit' is of interest here:

chick lit
noun informal derogatory
1. literature that appeals to young women.[12]

Note that this dictionary definition labels 'chick lit' an informal *derogatory* term. The fact that the work appeals mostly to women (and particularly young ones, apparently) means it must be signalled as such, essentially warning potential male readers away from stories about women. In essence, women's lives in both film and literature are regarded as only being of interest to women, while men's lives are represented as everyone's business.

So why is this self-created male-oriented cinematic universe, a fictional world that focuses so consistently on men, so successful at perpetuating itself? One factor is the phenomenon of big-budget remakes of tales that were written more than half a century ago – and sometimes quite a bit more. Take, for example, the 2013 production of *The Lone Ranger*, stemming from a radio play that was first broadcast in 1933, which was in turn inspired by a book from 1915. Even in the 2013 version the female character doesn't get a lot of lines, and spends a fair bit of time being rescued by men, as one would expect considering the formula of the original tale. Likewise, the swashbuckling Zorro was first created in 1919 and remains

a popular figure, with over forty Zorro films produced since 1920, and with two more Hollywood adaptations rumoured to be in the pipeline. Sherlock Holmes, created by Sir Arthur Conan Doyle in 1887, is often cited as the most frequently adapted screen character in movie history. Starting with his first short foray into film in 1900, Holmes has been played by at least seventy actors in well over 200 film adaptations and close to 100 TV appearances. (As you may recall from the chapter 'The Femme Fatale', his view of women was not exactly flattering.) The next most popular screen character is Count Dracula, who originated in the Bram Stoker novel of 1897 and has also featured in more than 200 films, usually involving numerous beautiful female virgin victims who need saving by wise old Van Helsing and his team of men.

The ever-popular James Bond franchise, which from 1962 to 2012 has produced twenty-three official big-budget Bond films (not including *Casino Royale* and *Never Say Never Again*, which were not part of the Eon Productions series), is based on Ian Fleming's novels, the first of which appeared in 1953. It goes without saying that the portrayal of women in these stories has been considered problematic. Then have remakes of Shakespeare's plays from the sixteenth to the early-seventeenth century; the story of the medieval character of Robin Hood and his 'merry men'; remakes of the story of Peter Pan, who first appeared in a 1902 novel; and remakes of classic noir films and westerns, the formulas of which have notoriously retrogressive roles for women – being saved/killed or betraying husbands in all but a few shining examples of brilliantly playing against type.

Other notable popular remakes are those centred on the stories of male comic-book heroes. While Batman, Spiderman and Superman are rebooted multiple times, often only a few

years apart, many fans have expressed interest in getting to see at least *one* Wonder Woman film. One. Again, these stories are generally based on work created half a century ago or more. Of note is the fact that a large number of these stories utilise the saving of a 'damsel in distress' to show the hero's worth. In many cases the entire world, even *the known universe* needs saving and 'one man' can do it (as so many movie trailers point out in less-than-subtle voiceover), but saving what is pure and good is symbolically embodied by the rescue of that single virgin/Princess Leia character, the special lone woman who ultimately cannot fend for herself.

Naturally enough, men remain the central characters in remakes of old stories, and a woman who is anything other than a love interest who needs rescuing (or a sexual conquest, in the case of Bond) is considered progressive in this context. The love interest of Batman, 'feline fatale' Catwoman, who first appeared in 1940, became a feminist icon for this reason, though her character was still presented as secondary to Batman in all popular screen adaptations – except for the failed 2004 film *Catwoman*, starring Halle Berry. (Yes, it took sixty-four years for her to get her own stand-alone movie, the character strayed far from the comic creation, and Batman did not appear in the film at all, evidently unable to play second to her even once. And yes, it was terrible.)

Though we may enjoy these popular tales (I often do), it is not radical to point out that independent or well-rounded women characters feature rarely for the simple reason that the original stories were written in a time when women generally did not work outside the home and had little or no control over their lives – and that reality was considered by most people (though certainly not all), including the vast majority of the writers, to be both acceptable and natural. The

exception, of course, speaks precisely to the time of character creation when both Wonder Woman and Catwoman were introduced. It was the early 1940s, a time when gender roles changed dramatically during the push to enlist women in the war effort. Propaganda encouraged women to enlist and to work outside the home, taking the jobs left vacant by enlisted men who were on the frontline. For many, Katharine Hepburn embodied the newly independent woman during the 1940s, and the Hepburn/Tracy comedy *Adam's Rib* (1949), about married lawyers who end up representing opposite sides of a domestic violence case, showcased the cultural struggle over women's changing role in society. In the comic-book world, Catwoman and Wonder Woman were both created, and caused a stir, though these women were 'neutered', so to speak, once men returned from war and wanted their jobs back, and the domestic homemaker role of women became glorified in the 1950s. In the 1960s Wonder Woman literally gave up her Amazonian super powers to open a mod boutique.

Over the decades, women's roles in film gradually changed, but they were, and still are, outnumbered by male characters and have overall fewer lines and less involvement in the plot. But is that just because there are no great stories about women to be told?

The answer is an unequivocal 'no'.

Though historical context tends to lend status and credibility to stories, when drawing on history for our storytelling, female protagonists are rare even when there are extraordinary tales to be told within a cultural framework cinema-goers already know and love – for example, stories of pharaohs, pirates, sharp-shooters and war heroes. Consider Hatshepsut, the powerful female pharaoh who reigned or co-reigned from 1479 to 1458 BC, leading an expedition into

Punt and creating some of the most memorable building projects of Egyptian times, including her spectacular colonnaded temple at Deir el-Bahri. She has been the subject of TV documentaries but, incredibly, her story has never been told on the big screen. We love a high-seas adventure, yet Anne Bonny and Mary Read, infamous eighteenth-century pirates who feature in the Disneyland ride Pirates of the Caribbean, are yet to have their lives played out on our big screens (with the exception of a 1961 Italian film about Read) – though they do feature as anime characters in the Japanese movie *Detective Conan: Jolly Roger in the Deep Azure*. Annie Oakley, the sharpshooter who came to fame in 1887, is a household name described as the 'first female American superstar', and has been played on stage and in episodes of children's programs, but since the 1950 musical *Annie Get Your Gun*, she has only been on the big screen as a peripheral character to a central male hero (as in 2004's big budget film *Hidalgo*, for instance). The New Zealand-born World War II hero Nancy Wake, the 'White Mouse', killed Nazis with her bare hands, was a leading figure in the French Resistance, was the Gestapo's most wanted person by 1943, and became one of the Allied forces' most decorated servicewomen, but no big-screen movie has been made about her extraordinary life.

While there are important and entertaining stories to be told about historical figures of both genders, stories of notable women are commonly given less financial backing, typically resulting in historical documentaries and made-for-TV movies. A few notable exceptions aside – such as *Norma Rae* in 1979, *Erin Brockovich* in 2000 and 2009's *Amelia*, about Amelia Earhart – the film industry seems reluctant to stray from the 'central male protagonist and secondary female love interest' formula.

Unfortunately, in the frequently remade tales of old where women do actually feature as central characters, the stereotypes tend to remain firmly in place. Take the oft-remade fairy tale *Little Red Riding Hood*, a classic cautionary tale of the girl (damsel in distress) who is saved from a dangerous wolf by the (male) huntsman. Or the ever-popular *Snow White*, made as a silent film in 1916, remade by Disney as *Snow White and the Seven Dwarfs* (1937), and appearing on the big screen twice in 2012, as *Snow White and the Huntsman* and *Mirror Mirror*, both with major casts and budgets. Like the original Grimms' fairy tale of 1812, each of these adaptations pits a vain beautiful older woman against a younger, virginal beauty (her daughter in the original telling and later her stepdaughter). Here, at least, we have a truly female-led cast, yet the best we can do in modern remakes is have the innocent Snow White learn to fight with some mentoring from central male saviours and/or love interests, because presenting her as fully independent and capable would stray too far from the story's familiar past. (She was a babe in the woods, after all.) And, of course, the central theme that women and girls are the sum of their beauty and must compete to be the 'fairest of them all' (Samantha Brick, anyone?) and that ageing women are vain and treacherous (the classic witch/crone archetype) can't possibly be omitted from the retellings. These themes are common to many fairy tales from this period, a time when there was a rather nasty tradition of torturing, burning and drowning women suspected of being witches.

With the virginal maiden so often portrayed as a passive victim in need of saving, one can't help but be grateful for Alice, of Lewis Carroll's 1865 *Alice's Adventures in Wonderland*, with her imagination, spirit of adventure and brave defiance against the regime of the unjust Queen of Hearts – and, in the

2010 Tim Burton retelling, her Joan of Arc armour and Jabberwocky-slaying abilities – even if her story was a classic cautionary tale against the girl's 'curiosity', with madness and chaos represented, as was popular at the time, by the kingdom of an ugly queen (the homicidal Queen of Hearts).

'Tut, tut, child! Everything's got a moral, if only you can find it.'

Lewis Carroll, *Alice's Adventures in Wonderland*

Storytelling often took the form of moral cautionary tales, and female characters essentially had three primary uses in the plot – the innocent virgin maiden, the temptress who manipulates men with her sexuality and leads them to ruin, and the evil knowing witch, embodying the 'unnaturalness' and danger of power in the hands of women. Though many current films do not conform to these representations, and generally independent and art films buck this trend entirely, a surprisingly large number of big-budget Hollywood films still include one of these three primary archetypes for their central female character.

Arguably, what is most important is not that these archetypal women still persist in our storytelling, but rather that they still too often serve a specific *moralising* purpose (whether conscious or otherwise) which is largely absent in the depictions of other characters. In other words, while both the hero/superhero/anti-hero/prince/knight and the virgin may be presented as wrestling with moral dilemmas in these stories, most often it is the hero who drives the storyline while his female opposite or opposites have already been branded as sinner or saint, Madonna or whore – according to her moral sins or virtues. The presence of one or more of these

archetypal women is frequently part of the static moral landscape which the hero must navigate. While the hero in these types of stories is free to be complex and flawed, and may be redeemed in the climax, having escaped the clutches of the temptress or witch, and having successfully won the virgin's affections by saving her life, the women remain in their places, their emancipation (for the virgin) or demise (for the temptress/witch) dependent on his actions.

Typically, when these women's roles are not static, we still see that their choices frequently come with heavy moral judgement, and they often pay the ultimate price: death. Double standards are particularly clear when looking at those characters shown to have a sexual awakening/interest in sex, or an interest in power. In the finale of 2006's superhero film *X-Men: The Last Stand*, for instance, the powerful female mutant Jean Grey, played by Famke Janssen, begs Hugh Jackman's Wolverine to kill her, as she feels she cannot control her incredible powers. (He does.) While interest in sex and power are commonly shown as natural attributes for our male heroes, they are often represented as highly problematic, even downright deadly when the character is female. James Bond, for instance, pays no moral price for his sexual entanglements, though the women he has sex with frequently die in the subsequent scene. The connection is clear.

Old ideas are given weight through regular repetition, until, over time, they come to form popular notions about the essential human struggle. What is deeply familiar after centuries of storytelling comes to be seen as what is 'natural', normal and universal – more of a representation of essential truths than entertaining fiction, unless it is consciously unpacked and inspected for what it is: *fiction*. The answer is not to erase these popular stories from our cultural canon or deny

the fascinating histories of important men, but for producers and investors to more frequently support original work by contemporary writers (at least *living* writers) rather than settling on Zorro film number forty-something or another *Snow White* remake, to look to the wealth of previously unmined historical material when featuring real-life figures, and to consider breaking type when presenting women on screen (or at least pulling back on the moralising double standards of times past). Likewise, casting directors can consider both men and women for many lead parts, including some parts that may have originally been imagined as male characters (like Judi Dench as M in the Bond franchise, or the lead character in the 2010 film *Salt*, a role that was originally going to be played by Tom Cruise but eventually went to Angelina Jolie) as many characters can change gender without influencing any central aspect of the plot, and that simple change may even add a valuable, previously unexplored dynamic. Director Ridley Scott, among others, has provided box-office proof of the success of this approach with his *Alien* series starring Sigourney Weaver, and in his characters played by Noomi Rapace and Charlize Theron in *Prometheus*, not to mention the hugely successful female-led adventure buddy film *Thelma & Louise*, which was attacked at the time as 'toxic feminism'.[13]

For their part, audiences can seek out films beyond those big-budget remakes or near-identical formulaic films that come through town with enormous marketing budgets, while smaller films are commonly overlooked. Essentially, audiences can vote for new kinds of work with their ticket stubs – though they must, of course, be given the opportunity. Parents with daughters frequently complain of the difficulty in finding just a handful of age-appropriate stories driven by lead characters who are girls. With the success of recent female-led

movies like *Brave* (Pixar's first-ever film with a female lead), *Frozen, The Hunger Games*, the comedies *Bridesmaids* and *Pitch Perfect*, perhaps, just perhaps, more studios will take a gamble on female-led stories, giving them better budgets and backing, rather than viewing the box-office success of female-led stories as anomalies.

There is another reason this peculiarly male-oriented cinematic universe is self-perpetuating – the nature of the creators themselves.

According to the New York Film Academy, of the top 250 films of 2012, 91 per cent of directors were men, as well as 85 per cent of writers, 83 per cent of executive producers and 98 per cent of cinematographers.[14] Current research also indicates that there are nearly five men to every woman working behind the scenes in film and television, and female characters are outnumbered by three to one on screen, a ratio that hasn't changed since World War II. Actor Geena Davis, who has campaigned tirelessly for better women's representation on screen, points out that women have only about 28 per cent of the speaking parts in mainstream movies. 'We're teaching kids from the very beginning that women take up less space.'[15]

Not only are the creators of our screen entertainment overwhelmingly male and white, but so are those who choose what films will be rewarded. Over 75 per cent of members of the Academy of Motion Pictures Arts and Sciences, which votes for the Academy Award winners (an Oscar being the single most respected award in film), are male – and 94 per cent of members are white.[16] Representations in popular storytelling may reflect some reality, but that reality relates to the perspective of the storyteller. As my father used to say, 'consider the source'. This is a good lesson. So while I am in

no way suggesting that every man will tell stories only relevant to men or that every woman will tell stories only relevant to women (in fact, I am arguing the *opposite* of that position, as the perspectives and stories of members of both genders need to be broadly heard and recognised), it is demonstrably true that groups that are disproportionately made up of one demographic are far more likely to create and promote stories that disproportionately involve that same demographic.

And that means women, once more, are outnumbered.

What about the art world? Surely women and art are a perfect marriage. Art is largely understood to be about creativity, aesthetics and emotionality, after all (and aren't women supposed to be the 'emotional' ones?), without all that business about, well, business. Artists don't need the backing of institutions like old Hollywood to get their art out in front of audiences, do they?

Yet, as I mentioned in the introduction, out of the 2300 works the National Gallery in London had in its 2010 collection, only ten were by women.[17] This statistic would not be so damning if it weren't for the fact that this male-centrism is reflected again and again across the art world.

The majority of art collectors have traditionally been, you guessed it, wealthy men, so the old establishment issue comes up again, not in the creation of the art but in the recognition of it and selective support for it. And something else comes up in relation to the art world, too. When I was at the Tate Modern in London recently, I picked up a postcard by Guerrilla Girls, a group dedicated to increasing representation of female artists. The card said: 'Less than 5% of the artists in the Modern Art sections are women, but 85% of the nudes are female.'[18]

At first this seems like an incredible statistic, but anyone who has spent time in an art museum will immediately recognise it as true, give or take some percentage points, and any students of art history (or John Berger's excellent 1972 essay and documentary series *Ways of Seeing*) would see how this tradition in oil painting developed in Europe around the fifteenth century and continued as a prominent style until at least the twentieth century, informing our ideas of what art and highbrow culture looks like, and through that, how women fit into the picture, so to speak – not as landowners or political figures but as sensual nude bodies, the artist's muse, or the lover of the wealthy man commissioning the portrait. Interestingly, this is not generally true of art before this period. Ancient Greek art, for example, while it was also largely executed by male artists, nonetheless portrayed and celebrated both the male and female nude form, rather than specifically endowing one gender with sensual attributes. In fact, we are now so accustomed to seeing sensual female nudes painted by male artists that we have become blind to the imbalance, as with so many other issues related to representation. The tradition continues in modern art and photography.

It can be argued that through European classic art and modern advertisements our eyes have been trained to view the female body through the gaze of the male artist or photographer and, likewise, through literature, cinema and television we have been trained, through the perspective of the male director and writer, to value the importance of male stories, experiences and opinions over women's.

If it can be said that art imitates life, one must conclude that, to a large degree, the life art imitates is that which is experienced by and imagined by men.

8

THE INVISIBLE WOMAN

'... how to speak to a man who does not see you?'
Virginia Woolf[1]

In 2012 I came across an interesting chart. Online media-analysis site 4thestate.net had been dissecting US election coverage in national print, TV broadcast and radio outlets, and quantified how often men, women and organisations were quoted in relation to the specific women's issues of contraception, abortion and women's rights during a six-month period (1 November 2011 to 1 May 2012). The chart showed that 81 per cent of statements about abortion were made by men. Some of the remaining 19 per cent of statements were made by organisations, leaving women with just 12 per cent of the public voice on the issue of abortion.[2] And it is women, needless to say, who face the quandary of whether or not they can afford the social, financial, emotional and physical consequences of an unplanned or medically dangerous pregnancy, whether that pregnancy resulted from consensual

sex or from rape. As political satirist Stephen Colbert put it, 'If you want to avoid getting pregnant there is only one sure-fire way. Be a man.'[3]

After seeing that chart, I had to ask myself: *How can women's representation be so poor on issues that specifically relate to women's bodies?* It shone a light on a problem many women of my generation were not entirely aware of before – the truly striking lack of women's voices in public debate. How can one gender so outnumber and dominate the other in public life? How can women and girls, who make up 50.2 per cent of Australia's population, remain a 'niche' or marginalised group?

Today, when we read front-page newspaper headlines, we are still overwhelmingly reading male journalists. Estimates are that 78 per cent of front-page headlines across the nine major newspapers in the UK are written by men and 83 per cent of those quoted are male. Of lead stories, 76 per cent of 'experts' quoted were men and 79 per cent of 'victims' quoted were women.[4] Here in Australia, on average more than twice as many front-page by-lines belong to male journalists, despite an equal number of men and women being employed as journalists.[5]

In 2011, an iconic photograph known as 'The Situation Room' was widely published. You may remember it. The image was captured by White House photographer Pete Souza, and showed US President Barack Obama with his national security team receiving live updates on Operation Neptune Spear, which led to the killing of Osama bin Laden. The photograph shows the faces of thirteen people, eleven men and two women, all intensely focused on the unfolding operation, but when Jewish newspaper *Hamodia* published the image, there were only eleven people. The two women, Secretary of State Hillary Clinton and Audrey Tomason,

Director for Counterterrorism for the National Security Council, had been literally Photoshopped out of history. As a matter of editorial policy, *Hamodia* refuses to publish photographs of women. The reported reason is that the female body is 'immodest'. *Hamodia* has been in circulation since 1910, and has never published a photo of any woman, including former Israeli prime minister Golda Meir.

In 2012 Swedish company Ikea was forced to apologise after the newspaper *Metro* compared the Swedish and Saudi versions of its catalogue and found that they were identical – except that the women had been airbrushed out for Saudi Arabia.

Though these examples are striking, it may be tempting to attribute this 'invisibility' to outdated notions no longer present in our own culture. When we think about media, news and advertising in the mainstream western world, there seems to be no real shortage of women. We see a lot of women, in ads for cars, for insurance, for bras, for shoes. On morning television. On movie posters. But what you discover very quickly is that we have an *advertising-heavy* representation of women – usually women between the ages of seventeen and thirty, who are chosen for their beauty to sell products, including fashions and entertainment. (See chapter 'The Visible Woman'.) It is outside of this very commercial, beauty-based representation where women's visibility plummets.

In July 2013, for instance, I photographed the *Age* newspaper's online front page on two different days and found that in the entirety of the featured headlines, national and world news, federal politics, business, entertainment and video sections, as well as all of the online ads shown on those days, no women were visible.[6] Actually, that is not quite true. I looked *very* closely and among the forty-four people shown on

those two front pages, there was one partially visible woman standing behind our male prime minister (part of the face of Senator Penny Wong shown behind then Prime Minister Kevin Rudd). That was one partially visible woman out of forty-four human beings. Of course I could have checked on a different day and seen, I imagine, more than one woman (I've visited many times since and found both a mix and this all-male pattern, actually), but the fact that it is *possible* to have one gender entirely excluded from seven sections of a mainstream newspaper, and also have women entirely absent in the ads promoted there, was to my mind extraordinary. There is no doubt that it would take an enormous cultural shift to flip that gender balance – and show forty-three women and one man – without everyone deciding that the paper was only for women. Ironically, on the days that I photographed the *Age*, the *Daily Life*, which is also published by Fairfax and is promoted as focusing on women's voices and perspectives (though by no means exclusively), featured many men's images and by-lines.

What about laws? Legislation? The allocation of public funds? Superannuation? What about women's representation in parliament? What about the people who actually make the public policies we are required to live by?

As the government web page Australian Women in Politics points out, 'While New Zealand had granted women the right to vote in 1893, in 1902, Australia granted women the right to vote and also to seek election … The victory was indeed groundbreaking, but the next hurdle proved even more difficult as it took nearly 22 years for a woman to enter federal parliament. Ironically, this "time lag" was the longest of any Western country.'

It's interesting to see the government page on women in parliament use Carol Porter's clever 1997 poster *Don't Get*

Mad, Get Elected. The image plays on two damaging stereotypes about women's rights activists. First, that they are 'mad'. (Their male counterparts are what ... determined? Focused?) The other is the image of the dangerous woman destroying civilisation, in this case Parliament House itself. (An image conjured recently by broadcaster Alan Jones's now infamous 2012 claim that women in positions of power were 'destroying the joint'.)

So, where do we stand now? Not straddling parliament in a two-piece, I feel sure.

In her 2012 *Sydney Morning Herald* piece 'The Truth About Sex and Power in Australia', Katharine Murphy pointed out that 'Women comprise 50.2 per cent of Australia's population but new Parliamentary Library research finds women "comprise less than one-third of all parliamentarians in Australia, and occupy less than one-quarter of all Cabinet positions."' That means that even during the reign of our first female prime minister, men outnumbered women in parliament by a minimum of two to one, and Australia's rank internationally for representation of women in parliament had actually slipped from twenty-first to thirty-eighth within a decade, despite all the fanfare (and concern) about the new place for women in Australian politics.

Now, with the Tony Abbott-led Australian government, women occupy not 'less than one-quarter of Cabinet positions' but a mere *5 per cent.* When I presented these statistics online, they were immediately met with this response: 'Shocking that people KEEP those stats! Reverse sexism is equally bad! SHOULD be about correct person for position, NOT some "Divine" gender balance.'

It must be noted here that there is technically no such thing as 'reverse sexism'. There is only sexism, and sexism is

most centrally an issue of *systemic discrimination* (as are racism, ableism, homophobia, and so on) and not a matter of specific focus on a group or social dynamic by keeping statistics and documenting them. As Eric Stoller, an academic adviser at Oregon State University, succinctly explains: 'women do not have the power to institutionalize their prejudices against men, so there is no such thing as "reverse sexism" ... Likewise with racism or so-called "reverse racism."' Stoller points out that the 'argument against affirmative action is constructed within a context that is void of a historical context and knowledge of the existence of institutionalized racism.'[7] So the acts of noticing sexism or racism, documenting it, and/or taking action to lessen the problem are not forms of sexism or racism, or – as the person responding to my blog post suggests – 'equally as bad' as the institutionalised sexism that, for instance, prevented women from running for office, or prevented them from working once they married.

I need to make myself absolutely clear: I agree with those who insist that gender 'shouldn't matter'. In fact, I *wholeheartedly agree*. That is precisely why such statistics are painstakingly recorded in the first place – because what you don't measure, you can't change. When it comes to representation in parliament, statistics both historically and presently indicate that greater equality in women's political representation equates to better policies for women and children. And that absolutely does matter.

To give an example, Nordic countries – which have excellent maternity policies, to name just one issue – have the highest representation of women in parliament. Arab states have the lowest. These parliamentary statistics also tend to correlate strongly with the annual *Global Gender Gap Report*, released by the World Economic Forum, a rating system

described as 'a framework for capturing the magnitude and scope of gender-based disparities and tracking their progress. The Index benchmarks national gender gaps on economic and political empowerment, access to education, health and survival, and provides country rankings that allow for effective comparisons across regions and income groups, and over time.'[8] As with women's representation in parliament, Nordic countries do best across the board. Iceland ranks the highest, in front of Finland, Norway and Sweden. The Philippines comes in at number five, followed by Ireland. New Zealand makes number seven, but the US and Australia make twenty-three and twenty-four respectively. Yemen comes in last, behind Pakistan and Chad. The wealth of a nation is not the key to the rating, but rather how equitable the distribution of that country's wealth and opportunity is.

Let's consider one of the major measurements for gender equity and one of the most significant factors in women's health, life expectancy and opportunity: pay.

The Federal Workplace Gender Equality Agency recently released a study showing the gender pay gap in Australia is estimated to be on average 17.5 per cent. This means that women working full time are on average paid 82.5 cents for every dollar their male counterparts earn. This discrepancy reportedly adds up to about one million dollars on average over a lifetime. A one-million-dollar gender tax does seem steep, doesn't it? In December 2013, the Australian Bureau of Statistics released a report stating the following:

> Women are earning only 64 per cent of the average male's wage and salary income – Australia wide ... ABS Director, Lisa Conolly, said that 'While average wage and salary income in Australia for 2010–11 was $51,923, males

recorded a higher average of $62,699 compared with $40,312 for females. The report shows that men earn more than women in every state and territory with the gap being particularly large in Western Australia where females earn only 55 per cent of the average male income. These figures have not changed much since 2005–06.[9]

Even more galling, a 2009 study published by the National Centre for Social and Economic Modelling (NATSEM), a research centre within the University of Canberra, found that a twenty-five-year-old woman with a post-graduate degree would over the course of her working life take home less than a man with just a high school credential.[10]

As our superannuation system is based on financial earnings, women also retire with less than half the superannuation of men. In fact, according to the Australian Human Rights Commission website in 2013: 'The average superannuation payout for women is a third of the payout for men – $37,000 compared with $110,000. Many Australian women are living their final years in poverty.'[11]

So why does anatomical sex difference have such an impact in areas unrelated to sex and reproduction? Why are the accomplishments, needs and voices of half the population so invisible, even when it comes to laws pertaining to their own bodies? How could it be that one sex is so overrepresented in positions of power and authority while the other is so consistently underrepresented and unheard?

To find out why this may be, we can look to the history of one primary idea of difference between human beings – gender.

9

THE 'GENDER WARS'

There is no female mind. The brain is not an organ of sex.
Charlotte Perkins Gilman[1]

Women are supposed to be very calm generally: but women
feel just as men feel; they need exercise for their faculties, and
a field for their efforts as much as their brothers do; they suffer
from too rigid a restraint, too absolute a stagnation, precisely
as men would suffer; and it is narrow-minded in their more
privileged fellow-creatures to say that they ought to confine
themselves to making puddings and knitting stockings, to
playing on the piano and embroidering bags.
Charlotte Brontë, *Jane Eyre*

W hat is it about gender that makes it such a significant factor in determining social expectations, social class and status, and economic and political opportunity? What are 'gender wars'?

In order to understand why gender remains so influential, we ought to, at least briefly, touch on what gender is. The word 'gender' derives from 'genus' or 'genre' and refers to

categorisation. Thus, when we speak of 'gender wars' (a terribly misleading and overused term of late), in one real sense we are saying 'category wars'. This would have been seen as a fairly nonsensical statement until at least the mid-1950s when the term gender reportedly first became equated with attributes associated with sex difference, a change often attributed to the work of sexologist Dr John Money. Prior to that period, it was uncommon to use the term gender to describe sex characteristics. Though gender has long been a term used for grammatical categories in language, the term 'gender' has since replaced 'sex' on most health forms and official paperwork as a primary, if not *the* primary, way we literally 'categorise' ourselves and other people. Making life for someone transgender, for instance, especially difficult.

This association between 'gender' and 'category' is a helpful insight, as it touches on the idea of categorising, or defining, people by a particular characteristic, in this case by their sex. A separation of the terms 'sex' and 'gender' is one useful framework to adopt to look at how influential this categorisation of person by sex difference still is, and to see the ways in which this has manifested. Using these definitions, you have a 'sex', usually defined at birth, but you also have a 'gender', defined for you by your social group, starting as early as the hospital, and extending to expectations of appropriate behaviours, occupations and other life choices. This is essentially what Simone de Beauvoir was saying when she famously wrote that: 'One is not born, but becomes a woman.' Your gender (in de Beauvoir's example, 'woman') is not a matter of simple biological destiny, but is strongly socially and culturally influenced. So while sex is assigned by the appearance of the genitals of a newborn at birth – male genitals, female genitals or a combination, intersex – sex in

this context is not quite the same as gender. While sex may be your anatomical type, gender brings with it a cluster of ideas to do with behaviour, social status and expectations that are not natural or unavoidable extensions of those different bodily combinations.

For example, just because a person is born with a penis doesn't mean he will have short hair, strong muscles, be the breadwinner in the family, be less emotionally engaged than others, be less interested in being actively involved in raising his children, or even that he will not have a slender waist or a 'beautiful' face.

To further clarify this point, some ideas about the essential qualities and appropriate place in society for men and women from, say, the days of Ancient Egypt, the Middle Ages, the Victorian era or even twenty years ago are not what they are now, and also vary between different cultures and social groups within the same period – for example, in very conservative circles versus moderate or progressive circles, and in the USA broadly versus in Saudi Arabia broadly. This means that gender is not the same as sex, as the physical anatomy of human beings remains essentially the same, but ideas about their gender category change, sometimes radically.

'Gender', in this context, is the phenomenon of flexible notions about what the two primary categories, masculine and feminine, mean: the sort of 'male = strong, female = nurturing' gender binary that assigns ideas of masculinity and femininity to different behaviours, modes of speech, even colours and decor, sometimes with about as much logic or randomness as we assigned the categories of the feminine and masculine to language. As any student of romance languages will tell you, most of grammatical gender needs to be painstakingly memorised, as it makes little logical sense. For

instance, in French, Italian and Spanish the sun is 'male', and the moon is 'female' (*le soleil* versus *la lune*; *il sole* versus *la luna*; *el sol* versus *la luna*), while in German the moon is male and the sun female (*die sonne* versus *der mond*). Likewise, much of what we identify as associated with a particular gender is a question of a degree of recognisable femininity or masculinity, within the framework of a certain social group at a certain time, though reasons why we recognise some things as feminine and others as masculine are not always clear.

Long hair is feminine/Short hair is masculine. But the hair on the human head grows roughly the same in both sexes, until later in life, when some men lose their hair at a faster rate than some women. In some cultures (and counter-cultures), men traditionally wear their hair long and women wear their hair short.

Pink is feminine. Yet pink was once considered a masculine colour. In Edwardian times it was common to dress young boys in pink and even decorate them with pink ribbons. Some suggest this was because of pink's association with the strong colour red. Young girls were often dressed in blue, perhaps in part because the Virgin Mary was also often shown in blue. It was some time before any kind of general consensus was formed regarding masculine and feminine colours, and to this day matadors, those iconic figures of traditional Spanish bravery and masculinity, wear long pink socks when they perform. (And a very tight traditional costume, bejewelled with rhinestones, beads and shiny sequins, called 'the suit of lights'.)

Physical decoration or embellishment is a 'feminine' pursuit. Indian maharajas wore ornate jewellery with sparkling gems, as have many kings, popes and other powerful men. Traditionally men have worn wigs, lace, stockings, gold jewellery, velvet robes, tribal makeup and perfumed scents, among other supposedly

'feminine' accessories. Decoration of the human body has been practised across cultures for millennia.

Wearing makeup is feminine. But pharaohs wore makeup. And warriors. And kings. And male tribal leaders.

Nurturing is feminine. Many men are fathers and carers and very clearly nurture others, and some women are not nurturing at all.

If you are still unsure, conjure for a moment an image of a person in a skirt and makeup, with a trim waist, high cheekbones and long glossy hair. Am I describing a female fashion model? Or a male Polynesian warrior?

When we speak of 'gender wars' we are in fact speaking of a war of notions – specifically notions about categories of people and things, and the role of those categories. We are not literally saying 'penis versus vagina', or 'person who identifies as a man versus person who identifies as a woman', but *ever-changing and culturally specific* idea versus other *ever-changing and culturally specific* idea. Discussions of gender are not man versus woman, but idea versus idea. And for all the gender difference we imagine, we actually have much more in common than not.

The American Psychological Association has this to say:

> Are boys better at math? Are girls better at language? If fewer women than men work as scientists and engineers, is that aptitude or culture? Psychologists have gathered solid evidence that boys and girls or men and women differ in very few significant ways ... Evidence has piled in for years ...
>
> For example, in 1990, Hyde et al. concluded that there is little support for saying boys are better at math, instead revealing complex patterns in math performance that defy easy generalization. The researchers said that to explain

why fewer women take college-level math courses and work
in math-related occupations, 'We must look to other factors,
such as internalized belief systems about mathematics,
external factors such as sex discrimination in education and
in employment, and the mathematics curriculum at the
precollege level.[2]

It is hard to overemphasise just how radically the American
Psychological Association's statement that 'boys and girls or
men and women differ in very few significant ways' contradicts
the traditional teachings about men and women that
influenced generations of thinkers until only very recently.
For centuries it was taught that women were mentally inferior
to men, and could not engage in critical thinking.
Enlightenment philosopher Jean-Jacques Rousseau, for
instance, believed men and women to be so fundamentally
different that the severe disciplining of girls should begin at
birth, to prevent the chaos their unfettered exposure to the
world would cause: 'Do not permit them an instant of their
lives free from bondage ... always justify the burdens you
impose upon girls but impose them anyway ... They must be
thwarted from an early age ... They must be exercised to
constraint, so that it costs them nothing to stifle all their
fantasies to submit them to the will of others.'[3]

Clearly, having women in any positions of power would
throw the state into chaos and peril. As German philosopher
Georg Wilhelm Friedrich Hegel put it: 'When women hold
the helm of government, the state is at once in jeopardy,
because women regulate their actions not by the demands of
universality, but by arbitrary inclinations and opinions.'[4]

Women were long considered to be so different from men,
by virtue of their sex, that they were thought to have

'wandering wombs'. It was believed that a woman's uterus was erratic and destructive, and could float freely through the body causing a medical condition (actually a number of conditions) called 'hysteria'. In fact, the word hysteria derives from *hystera*, the Greek term for uterus, or womb. Thus the term 'hysterical', which is used to describe irrational, disruptive behaviour and lack of self-control, could be translated roughly as 'acting like someone with a womb' (i.e. acting like a female). This gives some insight into the history of the notion that women are irrational at an essential, biological level, in a way that men, who do not have wombs (but, it should be noted, have penises and plenty of testosterone), are not. This idea of the 'wandering womb' dates back to at least the fifth century BC – with Hippocrates, usually dubbed the 'father of western medicine' (there is apparently no 'mother') – and was taught as a medical fact for generations, right up to the modern era. This is just one example of the ways in which a woman's entire existence was thought to be defined by her sex. In her book, *Delusions of Gender*, academic psychologist and writer Cordelia Fine compellingly outlines centuries of 'neurosexism', prophesising that 'in fifty years' time people will look back on these early-twenty-first-century debates with bewildered amusement and wonder how we ever could have thought that *that* was the closest we could get to equality'.[5]

While it may be easy to scoff at the idea of a 'wandering womb' now, it is prudent to again consider how influence tends to perpetuate influence. Old notions perpetuate themselves from generation to generation while new ideas encounter the most resistance and require greater force and activism to take hold. It is then notable that the same philosophers who laid the early groundwork for our modern thinking – men like Hippocrates, Plato, Rousseau and Hegel,

whose names are as familiar to us as our own, and who are still taught to each new generation in our schools – are the same men who taught that women were inferior and incapable of rational thought, ever at the mercy of their sex. (In *Timaeus*, Plato likened the womb to a wild, independent animal that moved through the female body, 'blocking passages, obstructing breathing, and causing disease' at will.)

The traditional 'cure' for hysteria was heterosexual sex. It was through heterosexual sex that the wandering womb would be put in its 'proper place'. By a penis. In Greek mythology, when Argo's virgins refused to honour the phallus and fled to the mountains, they were thought to be mad. The Argonaut Melampus, a physician, urged them to have sex with virile men. Upon doing this they were reportedly healed and recovered their wits. In Victorian times hysteria was often dubbed the 'widow's disease', because without sex the 'female semen', stored in the (presumably wandering) womb, was thought to turn venomous.[6] Without a husband and his penis, women were in peril.

In the Victorian era some doctors reported that at least a quarter of women suffered from hysteria. Though some of those patients suffered from disorders we now identify in both men and women as schizophrenia, anxiety attacks, depression and so on, many of the women diagnosed and treated for hysteria were not sick, but were simply displaying a normal emotional response, including frustration with a situation we now acknowledge as oppressive. Their resistance to servility and restrictive (male) authority branded them difficult or 'uncontrollable'. It was common at this time to warn women that they would be at risk of this terrible disease if they engaged in 'unfeminine' pursuits and did not recognise their proper place in society as wives, mothers and homemakers.

Keeping in mind this long-standing notion of the woman's body falling into disease without the penis, popular Freudian ideas about 'penis-envy' seemed like a logical next step.[7]

> The old prejudices – women are animals, less than human, unable to think like men, born merely to breed and serve men – were not so easily dispelled by the crusading feminists, by science and education, and by the democratic spirit after all. They merely reappeared in the forties, in Freudian disguise.
>
> Betty Friedan, *The Feminine Mystique*, 1963

It is noteworthy that many of the influential philosophers of the past taught that women had, and should have, secondary status to men. Michèle Le Doeuff, in *The Philosophical Imaginary*, writes of significant 'philosophical anti-feminism' and states that it 'would be all too easy to compile a large book based on the horrors voiced by philosophers, notably from the eighteenth century onwards, on the subject of women'.[8] With some restraint, she quotes only three examples in her chapter 'Long Hair, Short Ideas', including Rousseau, who stated in *Émile* that 'the search for abstract and speculative truths, for principles and axioms in the sciences, for all that tends to wide generalization, is beyond the grasp of women ...' Again, exaggerating difference (in essence *stereotyping*) protects the logic of inequality and in many cases, including this one, reinforces the privileged position of the author.

'Natural order' and the threat posed to society by women's changing roles has been argued since long before women's suffrage, and continues today in different guises. Take, for example, a segment televised on America's Fox News on 29 May 2013 discussing the results of a study showing that 40 per

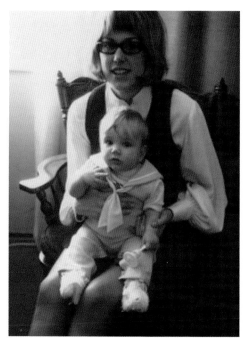

My late mother, Janni Moss, holding my older sister Jacquelyn, circa 1970; Jacquelyn taking me for a ride in our hometown of Victoria, BC Canada, in the winter of 1974.

Out on Halloween night with my sister Jacquelyn collecting money door to door for UNICEF in1977, thirty years before I became a UNICEF ambassador.

A safe and idyllic childhood in BC with my mother Janni, father Bob and sister Jacquelyn. Here we are at our townhouse on Vancouver Island, wearing matching Mickey Mouse T-shirts in the summer of 1978, not long after a road trip to Disneyland, California. I am on the left, with my mother holding my hand.

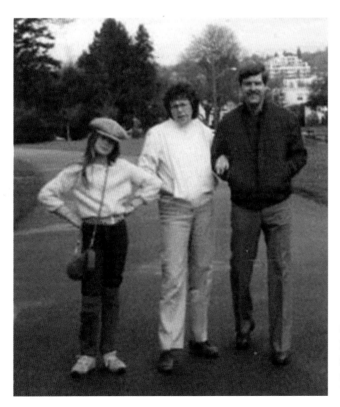

Clearly I was a fashionable kid, as evidenced by my turquoise leg warmers and matching handbag, circa 1983.

Autumn 1988: My first ever modelling job at age fourteen was at the local mall. I was told to keep my mouth closed – to hide my braces. A fashionable hood helped cover my mullet. Robert Moss

Looking slightly dangerous: Casting agents saw this shot and asked me to come to Europe in a year's time – when I would be fifteen and my braces would be off. When I arrived they found, with dismay, that I was no longer quite so skinny.

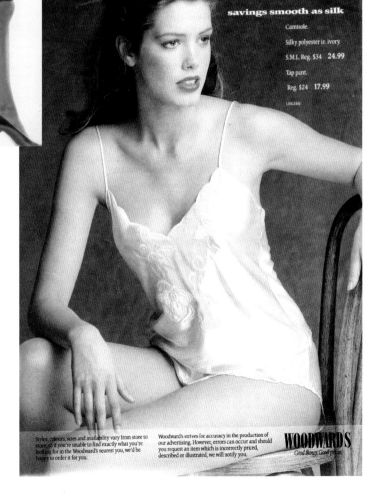

savings smooth as silk

Camisole.
Silky polyester in ivory.
S.M.L. Reg. $34 24.99

Tap pant.
Reg. $24 17.99

LINGERIE

Styles, colours, sizes and availability vary from store to store, so if you're unable to find exactly what you're looking for in the Woodward's nearest you, we'd be happy to order it for you.

Woodward's strives for accuracy in the production of our advertising. However, errors can occur and should you request an item which is incorrectly priced, described or illustrated, we will notify you.

WOODWARDS
Good things. Good prices.

This lingerie advertisement for a local department store was made when I was fifteen. It was taped to the wall in my late mother's hospital room, along with family photos and cards, when she was undergoing her bone marrow transplant.

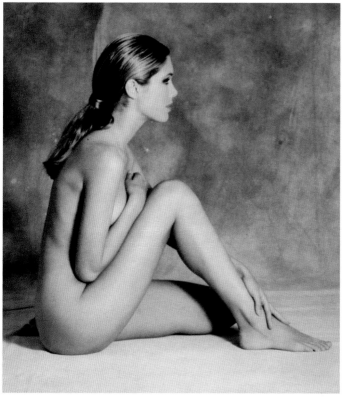

After this photo was taken in Europe, the agency asked me to lose weight – there was pressure on all models to maintain a certain weight. I went on a diet of around 500 calories a day – my lunch was one rice cracker and an apple.

(left) Paris thin: Working for the big designers of Europe in 1990 at age seventeen I weighed about 15–20kgs less than I do now. I sent this photo home to my dad and he became extremely concerned. I was starving. Thankfully I soon gave up on skinny and had a successful modelling career at a healthy weight. (right) Healthier and happier days: Modelling for Australian brand Jacqui E, twenty-three years later, at age forty. Courtesy of Jacqui E, photographer Simon Upton

A new career: At twenty-five I quit modelling to concentrate on writing. My first novel, *Fetish*, was launched at the Justice and Police Museum, Sydney in 1999.

At work in 2013 in my vintage Viscount caravan – my preferred way of travelling.

Do not try this at home: Research for my novel *Siren* involved being choked unconscious by Ultimate Fighter 'Big' John McCarthy and being set on fire by stunt company West FX – I very nearly lost all my hair.

The 'model-turned-author' tag hung heavily over my early career and provided both wanted and unwanted attention. I appeared on some of the book covers in the eighteen countries I was published in – publishers requested this and I didn't see it as a problem, although it did ultimately put more of a focus on my appearance. The Russian cover of *Hit* (ХИТ), which I didn't see beforehand, looks more like a magazine cover than a crime novel, but considering the previous edition, featuring the Opera House inside a silhouette of a man in a hat – a figure who does not appear in the book – using the author's face seemed like an improvement.

With Egyptian-American journalist and activist Mona Eltahawy. What an inspiring woman – and brave. In Tahrir Square she was physically and sexually assaulted, her arms and wrists broken, but they could not silence her.

Chatting with bestselling author Lynda La Plante for my TV series *Tara in Conversation*. Her crime research is incredible.

Interviewing cartoonist and author Alison Bechdel, who popularised the 'Bechdel Test' for film. To pass, two female characters need to have a conversation about anything other than a man. Suprisingly, not many films pass.

Culturally uncommon: 'Woman Regarding Man', Calvin Klein, American *Vogue*, Saint Tropez, 1975 © The Helmut Newton Estate

The cultural norm: the male appreciating the female. The woman in the centre of this famous Ruth Orkin image explains, 'It's *not* a symbol of harassment. It's a symbol of a woman having an absolutely wonderful time!' Ruth Orkin, *American Girl In Italy*, 1951

IF YOU WANT TO EVEN THE SCORE, FIRST EVEN THE NUMBERS

DON'T GET MAD

GET ELECTED!

Carol Porter's clever poster highlights the lack of female representation in parliament. Currently less than one third of Australian parliamentarians and just five per cent of cabinet are women. In 1997, when this poster was made, there were roughly the same number of female parliamentarians, and twice the number of women in cabinet. Carol Porter, courtesy of State Library of Victoria.

Representations of older women, when they do exist, are still dominated by the damaging archetypes of the witch and the crone. In the Middle Ages the witch was shown clothed or partially clothed with sagging breasts to signal lack of fertility, as shown in Albrecht Durer's engraving, *Witch Riding Backwards on Goat*, which illustrates the unnaturalness of power in the hands of a female.

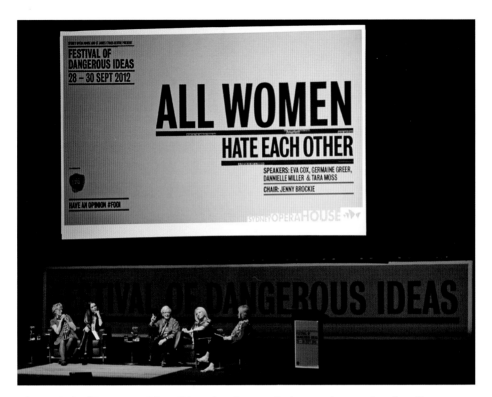

The Festival of Dangerous Ideas: Discussing the popular but spurious notion that all women hate each other, with Germaine Greer, Eva Cox, Danielle Miller and moderator Jenny Brockie at the Sydney Opera House in 2012 Prudence Upton; (below) Panel on sexual ethics with Dan Savage, Emily Maguire and Christos Tsiolkas in 2013. I was unable to explain to my fellow panellists what I was suffering through that day. Prudence Upton

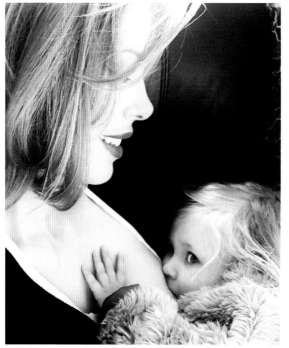

The Mother: (above) with newborn Sapphira and my husband Berndt in the birth suite in 2011; (left) Breastfeeding Sapphira, aged two. The World Health Organization recommends breastfeeding to two years and beyond, however many mothers are labelled as strange or selfish for breastfeeding after even a year.
Berndt Sellheim

Addressing the crowd at Sydney Town Hall on International Women's Day 2013, before leading the annual march. Victoria Brookman

At Parliament House in my role as UNICEF Australia National Ambassador for Child Survival in 2013, with Senator and UNICEF Parliamentary Chair Simon Birmingham, UNICEF Australia Chief Executive Dr Norman Gillespie, UNICEF Emergency Chief Luciano Calestini, and UNICEF Parliamentary Deputy Chair, MP Melissa Parke. Photo courtesy of UNICEF

Celebrating my 40th birthday with my beautiful father, Bob, in Hawaii in late 2013. It was a memorable and emotional trip.

Introducing Sapphira to my home town of Victoria, and her grandmother Janni Moss's final resting place, in 2012. Berndt Sellheim

cent of households in America now have a female breadwinner. In the segment, host Lou Dobbs spoke of 'troubling and concerning statistics', and society being 'torn'.[9] In no uncertain terms, he indicated that women breadwinners were a clear sign of the dissolution of American society. Fox contributors including Doug Schoen, Juan Williams and Erick Erickson (all working men) expressed dismay over working women, and in particular working mothers, and the damage feminists had done to the institution of marriage and to the welfare of children and the family unit. Schoen claimed that women who earn more than men 'could undermine our social order'. (Oops, my bad.) Williams declared that women breadwinners were an indication of 'something going terribly wrong, and it's hurting our children', and Erickson asserted that, 'When you look at biology, look at the natural world, the roles of a male and female in society, and the other animals, the male typically is the dominant role. The female, it's not antithesis, or it's not competing, it's a complementary role.' Closer to home, Prime Minister Tony Abbott has previously claimed that it would be 'folly to expect that women will ever dominate, or even approach equal representation in a large number of areas. Simply because their aptitudes, abilities and interests are different for physiological reasons.'[10] These seemingly deeply held essentialist positions on gender remain surprisingly common, despite research showing that 'one's sex has little or no bearing on personality, cognition and leadership'.[11]

Male ideas about the 'mysterious' female reproductive system have long provided fantastical excuses for restricting women's rights. In 1873 Harvard president Edward Clarke famously argued against women's education, claiming that the blood demanded by the brain would prevent the female reproductive system from developing properly.[12] The German

philosopher Friedrich Nietzsche claimed in 1888 that, 'When a woman becomes a scholar there is usually something wrong with her sexual organs.'[13] Neurologist Charles L. Dana wrote in 1915 that women's upper spinal cords were smaller, thereby affecting their abilities in 'political initiative or judicial authority in a community's organization' and thus compromised women's ability to vote. Revealingly, he also wrote that the push for women's rights was 'selfish', 'an echo of the childish demand: I want my doughnut and I want it now!'[14]

More recently, US politician Todd Akin bestowed extraordinary powers of selective sperm extermination on women's sex organs when he explained in 2012 that no woman should have legal access to abortion even in the case of rape because, 'If it's a legitimate rape, the female body has ways to try to shut that whole thing down,'[15] and Sheikh Saleh bin Saad al-Lohaidan, an adviser to a group of Gulf psychologists, claimed in 2013 that women should not be allowed to drive, on account of their ovaries, because 'functional and physiological medical studies show that it automatically affects the ovaries and pushes the pelvis upwards ... That is why we find those who regularly drive have children with clinical problems of varying degrees.'[16]

We now have a body of scientific knowledge to inform us that men and women have much more in common than not, much more than previously believed – both sexes having similar cognitive skills, verbal skills, intelligence, non-floating reproductive organs and so on – yet despite all of this available knowledge, notions of gender have not entirely caught up. It is popular to suggest that men and women are not simply two sexes of the same species, but from Mars and Venus – different planets. Sex difference is still used as a primary way to categorise people even where reproduction and the

arrangement of the genitals has no bearing, and when we analyse statistics in just about any area of life, we see how our gender category correlates strongly with pay and opportunity.

Gender mattered when people were not allowed to vote, stand for office, own their own property or earn their own money simply because they were born female, and although those battles have been won by the feminists of the past who cared enough to fight for equal rights, sadly gender still matters. It is only when we consider these various imbalances in representation, pay and financial security for one half of our population that we begin to see the true status of that half. And seeing that true status at all may not be easy for some. According to research from the Annenberg School at University of Southern California, when men make up 83 per cent of a group, the men in that group think it's fifty-fifty men and women, and if just 33 per cent of the people in the room are women, the men perceive that there are more women in the room than men. In other words, having women as only a fraction of participants seems to read incorrectly as gender equal participation – or even female 'domination'.

So while it is common to imagine that the struggle for equal recognition and participation for women was over when women's rights activists won the right to vote or access birth control, many people today forget that life outside the home was not an option for most members of society who were female – just because they were female and not male – until only relatively recently. Many forget that their own mothers were not allowed to open bank accounts without permission from a male family member, and most were not encouraged to imagine that they could have fulfilling careers, let alone run a company – or an entire country. In the United States, until the passage of Title VII of the Civil Rights Act of 1964,

women could legally be passed over for promotions in the workplace, and it was not until 1972 that married women who were teachers in South Australia won the right to keep working, for example. That is barely forty years ago. Married women needed the consent of their husbands to obtain a loan as recently as the 1980s, and marital rape was not widely recognised as a criminal act until the past thirty years (and in some countries a man can still legally rape his wife even if they are estranged).

Is it realistic to imagine we would have no cultural hangover from such recent legal practices? Yet the gender inequities we see are so often described as 'natural', 'biological'. Inequity based on gender is not inevitable or 'natural' any more than keeping women from voting because they had wandering wombs, or smaller spinal cords, was natural. It would be quite remarkable if the influence of centuries of teachings about women's inferiority didn't have an effect that took multiple generations to resolve. When we see how far we've come towards greater gender equity (and it really is extraordinary) we are seeing the work of feminists, some of whom were beaten or jailed for their troubles. The women's rights movement is one of the most successful civil rights movements in history and when we see statistics like those in the previous chapter, we see why it is still very much needed today.

This doesn't mean it is the only type of activism needed, or even that the need for activism will always be evident on a personal level to individual women, however. Many women and girls will find that the category 'female' defines them more than any other primary category, but others find their primary category as, for example, non-white, lesbian, a person with disability, a person of a minority culture or faith, or a person of low socioeconomic means may instead take

prominence (generally *in addition* to the category of gender). They are made aware, often from a young age, that perceptions of them largely stem from that characteristic.

A primary category can be thought of as a response to the question: What characteristics make me most 'other' from the dominant group in my culture? When several of these primary categories intersect, the experience of being 'other' than the dominant group is increasingly problematic, as various forms of discrimination intersect (as has been pointed out by feminists like Kimberlé Crenshaw, who coined the term 'intersectionality' to study this effect).

For this reason, and because the experience of gender roles changes through different stages of life and in different social groups and environments, gender is situational. For some girls, particularly in an institutional setting with an equal or dominant representation of women – for example, a girls' school with a lot of female teachers – it may be hard to relate to the idea of gender-based inequity at all. *But what about *name one great female character in film*? We had a female prime minister, right? My teachers are all women. I see women in leadership roles all the time. So what's everyone still banging on about?* It may only be on graduation, when those same young women find themselves with generally lower salaries and therefore less financial security than their male friends and colleagues (with one major factor being that traditionally female-dominated occupations pay less than work in traditionally male-dominated occupations, and males tend to hold the higher-paid leadership roles in both) that any inequities become clear. As of 2013, for instance, the health care and social assistance sector had the highest gender pay gap (32.3%), followed by the financial and insurances services sector (31.4%) and the professional, scientific and technical services sector (30.1%).[17]

For others, it isn't until maternity issues arise that any inequities become clear. In job interviews there may be questions about 'settling down' (a roundabout way of asking: Will you get pregnant and stop working?) asked of women of child-creating age and not men of child-creating age.

These things can seem like isolated incidents at first – in any individual case you could say the woman was less ambitious, chose a less well-paying position, wasn't suitably qualified for promotion – until the larger pattern, or the statistics I've mentioned, becomes clear. If women do have a family, there is likely to be a moment when they discover that what they *thought* the domestic agreement was is not the reality at all. A full-time working woman may find that her partner and family members do not think the father in the relationship should be equally sharing childcare or housework after all, and that she is expected to quit paid work, or accept only part-time paid work, or work full time *outside* the home while also doing the majority of the housework and childcare *inside* the home, paying for any additional childcare out of her salary rather than a shared account, and driving the kids to and from childcare or school. In fact, even today, 'among couple families whose youngest child is under 5 years, mothers do the lion's share of child care and home-making, even if working full-time.'[18]

A report in 2013 by the Australian Institute of Family Studies found that mothers working full time with a youngest child under five were spending on average an additional 3.6 hours on childcare and 2.4 hours on housework a day.[19] That is *per day*. Imagine the toll that takes on a person's energy levels or ability to succeed outside the home. In *Delusions of Gender* academic psychologist Cordelia Fine describes a fascinating phenomenon: When both parents work full time in a household 'women do about twice as much childcare and

housework as men', but when a woman starts to earn *more* than her male partner, the gap may actually widen, rather than diminish, with some studies showing that the more a woman earns over and above her male partner's salary, the more housework *she* does.[20]

One posited explanation for this otherwise seemingly illogical phenomenon is that the division of housework and the effort put into the performance of the traditional good wife role is a conscious or unconscious strategy by one or both spouses to avoid criticism for the woman's choice to have a high-powered career, and the fact that the man's choice, or circumstance, means he does not occupy that expected breadwinner role. This effect appears to be most salient in a cultural or social context where the traditionally masculine role of breadwinning and income-earning is particularly highly valued.[21] Basically, she has to be seen as not neglecting her wifely duties (*See, I'm still a good wife! I'm still a good mother!*) and he doesn't want to risk further deviating from gender expectations by taking on 'feminine' duties, hence sociologists have dubbed this phenomenon 'gender deviance neutralisation'.

And after all this paid and unpaid work, when it comes time to retire, women are penalised for their lower salaries and the unpaid work they have done throughout their lives with substantially less superannuation. (Just like any other unpaid carer, the vast majority whom just happen to be women.)

These issues are all common experiences for women in contemporary Australia, and elsewhere.

In some periods of a person's life, the experience of gender may be entirely positive, particularly when gender-based expectations and opportunities appear to fit the desires of the person in question at that life stage. Indeed, it's rather helpful not to be drafted to the front in a war you don't want to fight,

because you are a woman, but not so helpful to be excluded utterly from the corridors of power where decisions about war and the future of your community or nation are made. Likewise, it is not so helpful to be excluded from major decisions about your own family for the same reason. Though women have traditionally been associated with 'running the household' and all that entails, including providing meals, teaching children, and so on, there was little doubt to whom people referred when they mentioned the 'head of the household'. There are benefits to belonging to a gender that is considered weaker, but relatively few, because the area you are permitted to occupy is so much more narrow. (There are also real drawbacks for men to traditional or mainstream ideas of masculinity, and though this book focuses on women and girls, I do discuss some of this briefly in chapter 12, 'The Beautiful Man' and chapter 15, 'Playing Mothers and Fathers'.)

Gender inequity may or may not have much effect on an *individual* woman at any given time, particularly one of less common circumstances – say a woman born into wealth, or a woman who broke through a particular barrier into a position of power, or who found great financial success in a traditionally female-dominated domain that didn't offer much resistance (fashion, beauty, interior design, cooking, baking, caring roles, etc). Some of these women will quite vocally insist that no woman experiences disadvantage because of gender because *she* didn't, cheerfully ignoring all statistics to the contrary, and often such women will be rewarded for taking that position because it protects the status quo and she doesn't risk being thought of as a troublemaker, complaining about the boys, and being 'shrill' or 'tedious' by pointing out the broader issue of inequality. But as women have traditionally been afforded only a very narrow role in public life as carers (the more

poorly paid positions in childcare, nursing and midwifery, for example), we see that the majority of occupations unrelated to those traditional caring roles have been resistant to change, and over decades of activism and social change some professions have been more receptive to including women than others. Therefore the negative aspects of gender become particularly salient when stepping outside of those female-dominated settings.

How to counter this? Should we reconsider the value we place on different types of work and insist on better pay for traditionally female-dominated work? It seems sensible, considering that involves, among other things, the early teaching of our children, the citizens of the future. Or do we push to get more women involved in powerful, male-dominated professions? In parliament? In decision-making roles? Does that mean cultural change and, if so, just how long will that take? Does that mean quotas? Or do we focus away from the paid workplace and begin to view unpaid caring work as the vital thing for our communities that it clearly is? All of the above, perhaps – hence there are so many levels of ongoing activism.

And then for many women, added to these issues is the spectre of physical and sexual violence and domestic abuse, something one in three women,[22] including myself, have experienced in their lifetime, with domestic abuse being the number one cause of homelessness for women.[23] In Australia, on average, each week one woman is killed by a partner or former partner.[24] Three-quarters of the women killed in NSW in the twelve months before September 2012 were killed by someone with whom they were in a domestic relationship.[25] Sexual assault happens to males and females, across all age groups, but is significantly higher for females aged ten to twenty-four.[26]

For a lot of women and girls, that reality follows them, influencing even the most basic choices in an otherwise free society – Can I walk home alone? Should I take a taxi alone at night? How do I respond to my male boss's sexual advances? Will I lose my job if I say no, or lodge a complaint? Will my ex show up angry? Am I safe?

There can be a moment of realisation, perhaps even a 'welcome shock of recognition that other women had experienced the same things', as Elspeth Probyn describes it in her book *Sexing the Self*.[27] In my case, it was both deeply gratifying and infuriating to discover I was not alone – that so many other women had experienced sexual assault and abuse and, like me, suffered in silence. Recognising the larger picture helped me to realise that gender still matters, still lays out a certain path for us (one we can resist, albeit not without effort), and still presents particular gendered experiences – and that realisation helped me to break my silence.

The fact that women were once barred from owning property, or voting, or working once married *because of* their gender is one reason why it is helpful to separate the ideas of sex and gender, recognising sex as anatomy (including different genitals, hormones, reproductive functions and so on) and gender as a cluster of historically specific and changing social ideas about the masculine and the feminine, with many of those ideas differing from person to person and social group to social group, and with many of those ideas existing without good reason (like the now debunked 'wandering womb' theory).

I prefer this way of thinking, this separation of gender and sex, because it can act as a bridge. It is the recognition that there is less difference between us than we thought. Because I have a vagina and you have a penis just means we have a

different sex. Because so much of what we think we know about those two categories, male and female, is informed by flexible and culturally specific notions, we can change our notions about each other. We can bridge the gap between the sexes to create more liberated and well-rounded lives for women and men. We can see that women are also breadwinners and scientists and drive cars, and that men are also emotionally engaged, capable parents and carers. We can enjoy both hot rods and an attractive piece of clothing, or enjoy music, science, maths, painting or hands-on parenting, while being of either sex. We have aspects of what we think of as masculine and feminine traits in each of us.

While recognising that there are differences caused by a combination of biology and cultural influences that inform our experience of the world and our own bodies, we can nonetheless also see that *we have far more in common than not.* Our sex need not primarily define who we are, what we are capable of, or what we can be expected to enjoy or engage in. In other words, the boy with the Barbie doll does not have a problem with identity. He simply has a Barbie doll. The full-time working mother and full-time stay-at-home father have not given up something essential to their identities by taking on those roles: they have negotiated their lives as it works for them. Likewise, a stay-at-home mum is not anti-feminist any more than a stay-at-home dad is. Other characteristics, such as individual ability, personal relationships, personal choice, past experience and education, are far more important than that box you tick defining yourself as M or F.

10

THE 'REAL'
WOMAN

The Campaign for Real Beauty launched in September 2004
with a much talked-about ad campaign featuring real women
whose appearances are outside the stereotypical norms of
beauty. The ads asked viewers to judge the women's looks
(oversized or outstanding? and wrinkled or wonderful?), and
invited them to cast their votes.

The Dove Campaign for Real Beauty[1]

This year I was twice sent tweets from high-profile blogs
containing a 'challenge' to post a make-up free
photograph of my face – both in the space of under a month.
'No makeup, no filter. Go!' the latest one read. '*#bodypositive,
#challenge.*' The *Go!* seeming to suggest that I was to comply
immediately.

A few minutes of searching online and I could see that this
particular campaign was promoted as being about self-esteem
and positive body image, but I had to wonder, what does my
face (without makeup) have to do with 'body positive'? Whose

body exactly? A few minutes more, and I could see that the campaign was being sponsored by a women's gym, and a lot of great women had answered the 'challenge', many women I respect, all looking wholesome with their clean-scrubbed features and beaming smiles. Tweets like these had been directed to a number of high-profile TV presenters, actresses and fashion models in recent months. That was why it was a challenge, I guess, because these women normally wear some makeup when they work or are photographed for mainstream publications. The campaign had already received a lot of coverage, and I noted that some famous men had even jumped on board, photographing themselves 'No makeup! #*challenge!*' – though of course their 'selfies' looked intentionally goofy. This contrasted with the women's images, which are almost uniformly soft and pretty, with serene smiles and bright eyes, projecting an unquestionably 'wholesome' idea of womanhood.

'You look so much prettier without makeup!' one commenter wrote beneath a photograph of an Australian supermodel. 'You are so brave! You look beautiful!' wrote another.

The campaign extended to a segment on a morning TV show, with the executive producer explaining, 'One of the most common questions I get asked is "What do the girls look like without makeup?" So I thought, why not do a reveal, live on air.'[2] The presenters then went on air without makeup so everyone could look at them.

I confess, I hear alarm bells when words like 'brave' and 'challenge' are bandied about with invitations to look at women's faces and bodies – the truth about their appearances finally 'revealed', and exposed for our judgement. It brings to mind Dove's highly successful 'Real Beauty' campaign, which explicitly invited viewers to look at women photographed without clothing or makeup and judge their looks.

I don't know if it makes me a bad feminist or out of touch, but this feels a bit like a beauty pageant, only with different parameters. The voyeurism is there, as is the judgement based on appearance. Only this time there are no clothing designs to be displayed, no millinery, no art or craft (except perhaps the skill of the photographer), no tools of adornment or external self-expression at the disposal of the participants. While beauty pageants are judged by a panel of supposed 'experts' with contestants aiming to win material prizes, these campaigns invite us all to be the judges, and in the case of Dove's campaign, register our public votes in judgement of women's bodies and faces on a website that sells us soap and beauty cream.

I am forty years old and for a few decades I have noticed that there is a lot of interest in the bodies and faces of women – a lot of questions about what women in the public eye are wearing, how much they weigh, whether they go to the gym, what exercise they do, what their beauty routine is, which products they recommend, what they look like without cosmetic products, what they look like with different cosmetic products, what they look like with a makeover (or in the morning, or in their underwear in middle age), what their natural hair colour is, whether or not they've had plastic surgery, what they look like in swimwear after having a baby, and whether they have stretch marks, cellulite, blemishes. The list goes on. Over the past twenty years I could not have missed the fact that questions of this kind take up an increasing, not decreasing, amount of media space. Some of that space, of course, is normal and good. Some of it worries me.

There is often something present in the discussions of women's appearance that extends well beyond a natural human interest in people's lives, or in different aesthetics and how to achieve them. Frequently, there is a fixation on women's

appearance or aesthetic choices at the *expense* of their other qualities, a tendency to judge the entire woman by what can be seen at a glance. Many interviews about successful women feature drawn-out descriptions of their faces, bodies, clothing and shoes, even when those women's achievements or occupations bear little or no connection to their outward appearances; for example, this exchange between Hillary Clinton and an interviewer:

> Moderator: Which designers do you prefer?
> Secretary Hillary Clinton: What, designers of clothes?
> Moderator: Yes.
> Secretary Clinton: Would you ever ask a man that question?
> (Laughter.) (Applause.)
> Moderator: Probably not. Probably not.[3]

Whether flattering or unflattering in tone, such a focus can be distracting if it is not related to the woman's career (if she is, say, a fashion model or designer) or, some academics argue, even detrimental. In the case of politicians, some argue that a focus on appearance, particularly for women, can lower perceptions of authority, a kind of career death by way of flattery (or by way of appearance-based insults, again distracting from the content of the message). Other professionals, like TV presenters, often find themselves ruthlessly criticised for their hairstyles and outfits (too sexy, too dowdy etc.), and for every wrinkle ('She's over the hill!'). As *Today* show host Lisa Wilkinson wrote in 2013: '... when you're a woman doing breakfast TV, you quickly learn the sad truth, that what you wear can sometimes generate a bigger reaction than any political interview you ever do ...'[4]

While television is notoriously ageist for all sexes, it is a widely accepted fact that women journalists are criticised for

the appearance of age far more often, and decades earlier, than their male counterparts. Former BBC presenter Michael Cole recently commented on complaints by female TV journalists that they didn't have the career longevity of their male colleagues, saying, 'What do these women expect? It matters how you look on television … Gargoyles are for cathedrals.'[5] US radio host Rush Limbaugh said of Hillary Clinton's prospects as a future US president: 'So the question is this: Will this country want to actually watch a woman get older before their eyes on a daily basis?'[6]

Bizarrely, wrinkles are commented on as a point of national interest. Even a *lack* of wrinkle. Australian Sky News presenter Jacinta Tynan received hate mail from viewers for supposedly getting a breast enhancement and Botox when she became pregnant and presented on air with a noticeably fuller face and bust, which gradually went away after she had her child. American actor Ashley Judd was widely attacked for her 'puffy face' and accused of 'having work done'; such was the media frenzy that she wrote a piece in the *Daily Beast* to explain herself: 'When I am sick for more than a month and on medication (multiple rounds of steroids), the accusation is that because my face looks puffy, I have "clearly had work done," with otherwise credible reporters with great bravo "identifying" precisely the procedures I allegedly have had done.' Judd also documented media reports accusing her of being a 'pig' or 'cow' when she gains weight, and suggesting she 'better watch out' because her husband will leave her due to her weight. 'Did you catch how this one engenders competition and fear between women? How it also suggests that my husband values me based only on my physical appearance?' she wrote.[7]

The most common accusations are made as personal attacks, not simply against perceived flaws in the woman's

outer appearance, but on her moral character and judgement. ('What was she *thinking?*') These attacks are often framed as an unmasking of the woman's public 'deception' as a form of civic duty, a kind of win for 'real women'. The tone is often self-righteous. Articles and TV segments that are ostensibly centred on 'truth-telling' about famous women's appearances ('Caught out! Her plastic surgery secrets!') are frequently peppered with vicious critiques of the woman's face and body, often with body parts circled and examined like so many cuts of meat. These segments or magazine features may cite 'experts' who are plastic surgeons by trade, and who garner financially valuable publicity for their expensive services by listing what (alleged) procedures the beautiful, famous person supposedly has had done to look the way they do – or what they *should* have done to gain a better beauty rating. Often these discussions involve openly moralising about the woman's faults.

Though there may be some measurable benefit to campaigns that broaden the images of women seen in certain circles, to counter a narrow 'beauty standard' (I support this idea), and though the organisers of visual campaigns that aim to celebrate 'real women' or encourage women to reveal themselves through image are well-intentioned (or, at worst, simply driven by good old-fashioned capitalism – we all have to make a buck, after all), I see some disturbing similarities between the kinds of appraisals of women's appearance that we commonly view as misogynistic, and appraisals that present themselves as 'pro-woman'.

'I feel duped, frankly. I have spent all this money trying to look like a supermodel, and even supermodels are not like supermodels ...' Liz Jones wrote in the *Daily Mail*, before going on to dissect candid paparazzi images of forty-year-old model Kate Moss in a bikini enjoying a beach vacation,

unaware of the camera lens tracking her. Next to the series of images, under bold category headlines – including but not limited to: *Furrowed Forehead*, *Dried-Out Décolletage*, *Belly Bloat*, *Tacky Trinkets and Tattoos*, *Low-Slung Breasts* and *Blobby Bottom* – Jones's in-depth appraisal of the woman's body parts included: 'Kate has an over-baked, bottom-of-the-cake-tin-parchment décolletage'; 'Champagne gives you this tummy'; 'Any woman over 25 who wears string friendship bracelets needs to grow up'; 'She has saddle-bags'; and '[She has] a ghost of a caesarean scar, and her shape isn't helped by her awful posture'. This was all published with the author's stated claim that 'to realise what Kate is like in the flesh (and there is a surprising amount of it) will encourage the wobbly women of Britain to shrug off their sarongs and reveal their own imperfect bodies on the beach'.[8] In other words, this was a win for women.

Rather than criticising market forces, we attack the woman. Rather than questioning the systems that require some women either to try to stop the age clock or find themselves out of work, women themselves are attacked for any sign of apparent surgery, enhancement or supposedly deceptive covering of physical 'flaws'. Rather than unmasking or tearing down the underlying cause, the individual woman becomes the easy target. We are invited to gaze on the female face and body and judge not just what we can see on the surface, but what kind of person she is: Does she lack self-control? Is she unfeminine? Has she let herself go? Is she vain? Is she dishonest? Has she 'duped' us?

Increasingly, a popular question to ask is: Is she 'real'?

By definition, 'real' is 'proper', 'actually existing' and 'not imitation or artificial', so the use of 'real' to describe particular women in contrast to others (as is popular in relation to the

curvy women versus skinny women dynamic, or women without makeup versus women with makeup) implies that one is more proper than the other, or that the kind of artifice created by grooming (lipstick, hair dye, and so on) contains some moral hazard. (Notably, just as the term 'real' often seeks to define what women should be or how they should represent themselves, the term has long been deployed in the judgement of men and boys as part of a policing of a sometimes toxic masculine culture: 'real men don't cry'; 'be a real man'.)

Grooming and adornment have been human traditions for millennia. Long before the conventions of western twenty-first-century presentation, ancient Egyptian and Chinese men and women wore makeup to indicate social class, and traditional Celtic, Polynesian, Aboriginal, African, and North American first nations peoples (including male warriors) wore makeup, body paint and elaborate adornments. Alexander the Great wore makeup, as did Tutankhamun and his contemporaries. Showing oneself to others 'ungroomed' has been considered a quite intimate act, or even voyeuristic, until very recently – with the notable exceptions of the naturist or 'nudist' movements, and the hippy counter-culture movement in the 1960s, during which growing facial and body hair and wearing bright, non-traditional clothes and fresh flowers went hand in hand with a total rejection of capitalism (and most certainly did not involve taking photographs of oneself to help market women's gyms or soaps).

Not so long ago, a woman 'letting her hair down' was a sign that she was in private or in trusted company, usually after wearing her hair up outside the home. Figuratively, the term means 'to tell [someone] everything; to tell one's innermost feelings and secrets'. For centuries, proper attire for

men involved a variation on suits, shirts, ties, tights, breeches or trousers and hats or powdered wigs, and being seen without a good shave was a sign of poverty or illness. The efforts made for photographs in the past reflected the idea that one needed to present oneself in a 'proper' way, and this is clear in historical images. Families would put on their best clothes, take time to style their hair, shave their faces (men) and rouge their cheeks and pin back their hair (women), among other rituals. Being ungroomed was the domain of very young children or the very poor, who could do nothing about it. (Indeed, just try to imagine someone of low socioeconomic circumstances photographing themselves without makeup to improve their self-esteem or the self-esteem of others.)

Frontline soldiers in World War II, facing the terrors of war, carefully shaved their faces and groomed their hair. Photographs even show soldiers shaving in trenches with small hand mirrors. When financial struggles and rations during the Second World War limited access to grooming products, clothing and stockings (not to mention food), women used leftover beetroot to rouge their cheeks and gravy to paint 'seams' on the backs of their legs. Frugal beauty tips – like bicarbonate soda for face powder, beer for hair-setting lotion and beetroot for blush and lip stain – are still taught at a grassroots level across generations, and in classes like the ones put on by Australia's amusingly named The Lindy Charm School for Girls, which aims to 'empower girls of all ages to enhance their own, natural outer and inner beauty through the best of vintage styling ...' Thrifty women with a desire for a more individual style that bucks modern fashion trends are shown how to recycle and mend vintage clothes as their 'foremothers' did, how to achieve hairstyles without electricity or hair spray, and how to achieve glamour at 'any age or size',

generally with a good dose of fun. The expressed purpose of such classes is 'looking after oneself and one's self-esteem'.

During World War II women were urged to wear lipstick to 'improve morale' and this was deemed so important that the War Production Board kept cosmetics off the list of restricted wartime industries. The idea that going *without* makeup will improve the morale of others is a very new, distinctly middle-class concept, although the notion of women's appearance having the power to corrupt or damage the mental health of others is not. The belief that the makeup and clothing worn by women is capable of causing a deterioration in the mental health (in this case, 'body image') of others and that the sight of the (immodest/voluptuous/sexy/skinny) female body is dangerous has precedent in interpretations of religious texts from the Middle East, Asia and Europe, including those of Christians, Catholics, the Amish, Mennonites, Muslims and Buddhists. For example:

> Timothy 2:9: In like manner also, that women adorn themselves in modest apparel, with shamefacedness and sobriety; not with braided hair, or gold, or pearls, or costly array.

> Quran 24:30: Tell the believing men to lower their gaze and be modest. That is purer for them. Lo! Allah is Aware of what they do. And tell the believing women to lower their gaze and be modest, and to display of their adornment only that which is apparent, and to draw their veils over their chests, and not to reveal their adornment.

While many indigenous cultures did not view the exposed male or female body, or adornment of the body, as any moral

threat, and freely exposed all of the body except for the penis, wearing only body paint as a cover, conservatives have long taught that exposure of the female body could cause serious harm and that female adornment is destructive, and have used selective interpretations of religious texts to back up their claims. In 1613 the English author Barnabe Rich warned against provocatively dressed women and women who painted their 'shameless faces', writing that their appearance offended God and provoked terrible destruction: 'Now besides this garishness in apparel what are these paintings of shameless faces ... these impudent gestures without modesty ... this excess that is now used in apparel doth certainly bring three things with it. The first, offence to God, the second, It giveth hope to the vicious, and thirdly, It bringeth destruction to the husbande.'[9]

The idea that going without makeup and adornment is not just a personal choice or the natural result of having other things to do, but is a significant factor in society's collective mental health (ie: in this case the 'body image' of that person and significantly, of *other* women and girls) is not a new notion. But while concepts like 'makeup free' or 'body positive' are promoted as progressive or even important for feminism, I have yet to see anyone consciously make the connection between the damaging notion that the sight of a voluptuous woman can cause sin and collective moral or spiritual danger (a rather medieval idea), and this 'new' belief that the sight of a skinny woman or a woman wearing makeup can cause serious health problems in others (such as eating disorders, low self-esteem etc.).

Being new does not necessarily make an idea wrong, however. The world does change. To examine the underlying

logic of some of these campaigns, let's consider an article on a pro-makeup-free website that (quite nobly) raises money for an organisation helping young women with body-image-related disorders. The piece is titled 'a man's view', and the author writes: 'Believe it or not, ladies, you are beautiful without your half-inch plaster mask caked over what you've so disgustingly been taught are "imperfections". If that's too much truth to take on at once, then consider this: Do you really want to be imprisoned by the pressures of excessive makeup for the rest of your life?'

The writer catalogues the disgustingness of makeup ('Let's get one thing straight: I hate makeup'), the hardships involved in kissing women ('I'm sick of kissing people through layers of powdered goo'), and goes on to imply that he dumped a woman because of her use of makeup. 'I dated a lawyer, very briefly. She was gorgeous.' But she wouldn't take off her makeup for him. 'This standoff became the reason we ended the relationship. I simply wanted to see and appreciate her for everything she was!'

And therein lies the problem with his argument. If this 'gorgeous' lawyer refusing to change her grooming routine (i.e. her outer appearance) for him was something he could not accept, then he did not, in fact, appreciate everything she was. On the contrary. Of note is the patronising tone – the 'believe it or not' and 'If that is too much truth to take at once' truth-telling, and the inference that adult women, even lawyers, have personal preferences because of what they have been 'taught' and 'imprisoned' by, while presumably this man has formed personal preferences about women's appearances through a higher form of free thinking.

This condescending approach, which assumes greater knowledge and denies adult women their agency, is all too

common in discussions of body image. For every woman and girl sharing her personal struggle with heartbreaking honesty, there are many more people openly moralising about young girls and their inability to think for themselves, or even to know how to eat. It is now all but impossible, for instance, to look at old Hollywood photographs or mid-century pin-ups without coming across a comment similar to this one: 'Take note, women. This is how men like their women to look. Not twigs with their ribcage protruding from beneath your skin. TAKE NOTE, AND EAT.'

Yes, take note ladies.

Significantly, that was a 'top' comment (most liked) beneath illustrations by the noted Peruvian pin-up artist Alberto Vargas. That's right, *illustrations*. Of *pin-ups*. So men like 'their women' to look like Vargas illustrations. Well, that's news.

That these sorts of comments can so easily pass as pro-woman or even feminist in today's public discourse tells us something about how far we have moved from the central philosophies of the women's movement, which holds women's bodily autonomy as a primary principal. Since when did pin-ups go from being a risqué pleasure – literally a fantasy – to something to body-shame women about while simultaneously being self-righteous? Where did we get the idea that body-shaming was helpful? Instructive? Even somehow 'feminist'? Think of the now omnipresent assertion: 'REAL women have curves!' Or worse: 'Bones are for the dog. Meat is for the man. Real men like curves'; and 'You wouldn't order a steak if it was nothing but bone, so why would you want a woman that way?' These kinds of slogans on T-shirts, posters and social-media posts are often bandied about as pro-woman. They are not.

As a rule, if a slogan compares women to pieces of dead meat, it is not pro-woman. And if a slogan explains that 'real'

people have one body type (curved) and not another (slim or straight), then they are not pro-woman, but pro-one-kind-of-body-type and anti the rest. This is distinctly different from statements like 'embrace your curves', or 'love your body', which express a philosophy of accepting what you have, rather than saying that either a) curves are the only natural or 'proper' shape for women, and b) you are not 'real', feminine or desirable if you don't have curves. Accepting what you have is not the same as disapproving of or even crusading against what others have.

We must be mindful, when promoting what we think of as a healthier image, not to demonise those who do not fit that image. And it is prudent, as a consumer of these images and campaigns, to think about what makes these discussions so prominent.

Makeup-free campaigns often go hand in hand with anti-Photoshop campaigns. I have seen quite a few unaltered modern images; many of us have (though not normally in the pages of commercial fashion magazines). Those that are in mainstream fashion or women's magazines get a lot of publicity, are often sponsored and are usually promoted as being part of a body-image campaign about improving women's confidence and body image (and by association women's mental health). Frequently, the models are naked or wearing underwear. I note this not because I am a puritan or against nudity – far from it – however, it is significant that putting naked women on magazine covers is often regarded as 'degrading to women' by the very same people who regard a naked woman presented as part of a body-image campaign as actually helpful to women in some significant way. This is curiously contradictory, but is a clear win for marketing. Sometimes, as in the case of former Miss Australia Jennifer

Hawkins or other models, the woman photographed for men's magazines is also used in women's body-image campaigns and the images differ little, except perhaps for the presence of coloured lipstick or a stiletto heel. She is obviously gorgeous, hence the reason she has a job as a model in the first place. The word 'brave' comes up often, as do comments like: 'She still looks perfect! She doesn't need Photoshop/makeup.'

That is just great for self-esteem, I imagine, but *whose* self-esteem is the question.

I enjoy a variety of images, from the beautiful to the confronting, and the 'natural' to the artificial, the artistic or fantastical, revealing or conservative, and the truth is I am not a cynic when it comes to what I'll call 'fashion reform', either, particularly after years in the industry. Fashion designers and women's fashion magazines really would do better with a greater range of models, images, body shapes and ages. But there is an inherent problem: using images to make the claim that you are freeing women from the prison of image is a tricky thing to pull off. This is particularly clear when the project is subjected to, or defined by, the laws of the advertising world. Advertising money is what runs mainstream women's magazines and, now, most mainstream websites and blogs, and it is in this commercial context where the underlying logic of many pro-woman image-based campaigns falls down the most:

The ads asked viewers to judge the women's looks (oversized or outstanding? and wrinkled or wonderful?), and invited them to cast their votes.

One of the most common questions I get asked is: 'What do the girls look like without makeup?' So I thought, why not do a reveal, live on air.

A piece written by Clementine Ford for *Daily Life* echoes some of my concerns about how such campaigns often devolve into a particularly voyeuristic form of beauty pageant: 'What benefit can it possibly serve for women's self-esteem to replace one beauty standard for another even less achievable one?'[10]

In other words, the politics of beauty hasn't changed one bit, just the chosen aesthetic. This is an obvious problem when models and female celebrities known for their beauty are targeted with such public 'challenges'. If anything, a picture of a model without makeup is likely to result in the desire to look more like them. 'That skin! That healthy, youthful glow!' And what if they *don't* look good? Well, they will possibly find themselves out of work. Likewise, many TV presenters or women of authority require a polished public appearance for their work; to appear otherwise would be seen as 'off brand'. This is not necessarily true of most men (hence the goofy 'makeup free!' shots, offered without the need for a public challenge). Neither is it true of the few high-profile women who successfully make their careers and pay cheques organising sponsored campaigns like the ones I mention here, to promote their products or blogs. For them, it is precisely 'on brand'.

Challenging conventionally beautiful women to show how they look without the aid of makeup? As a picture, lovely, but as a bid for improving other people's self-esteem, I am not convinced.

And then there is the fallout. If we present women as 'brave' when they go makeup-free, what are we to think of women in makeup? Or the same women – like the television presenters I mentioned earlier – when they return to makeup? Have they lost their bravery? Are they letting women down? 'Duping' everyone? As women age and wear more makeup (as

some do to cover changing skin tone, for example), are we to think increasingly less of them? Are they betraying us? Being inauthentic?

> As far as cosmetics are used for adornment in a conscious and creative way, they are not emblems of inauthenticity; it is when they are presented as the real thing, covering unsightly blemishes, disguising a repulsive thing so that it is acceptable to the world that their function is deeply suspect. The women who dare not go out without their false eyelashes are in serious psychic trouble.
>
> Germaine Greer, *The Female Eunuch*[11]

Women who truly feel that their faces must be disguised because they are repulsive are indeed in 'psychic trouble', as Germaine Greer wrote in *The Female Eunuch* in 1970. Surely the solution to such a problem is not to judge women for the appearance of their makeup, but to stop judging women by their appearance. Colour on a woman's lips is no more an emblem of dishonesty than the shining gel in a man's hair or the frame on a picture. It is adornment, and human beings have been practising it for millennia. It was, in fact, only very recently (the prudish Victorian days) that men of all classes were encouraged to adopt the most drab attire possible, the plain suit, having for centuries added colour or texture to their bodies through paint or bright, attractive feathers, tights, buckles, shiny buttons and the like. The British dandies (Lord Byron, Oscar Wilde and their ilk) of the eighteenth and nineteenth centuries were quite something to look upon. That women are encouraged to adorn themselves for their own pleasure and the pleasure and acceptance of others while men are now actively discouraged from such demonstrations –

instead finding themselves sentenced to careful regular shaving of their faces, trimming and grooming of their hair and the wearing of nearly identical business suits, and for other occasions almost identical tuxedos or jeans-and-shirt combinations – says more about the stifling of human expression than it does about a more honest appearance.

Has Australia's governor-general Quentin Bryce been showing a lack of confidence and/or care about women's issues by wearing makeup in public all these years? Or former Australian of the Year Ita Buttrose? Has she been letting us all down during her long career by not posting photographs of her face without makeup? Perhaps we should invite politician Malcolm Turnbull to express his inner confidence with a photograph showing five o'clock shadow and unkempt hair. And comedian Eddie Izzard should dump his signature nail polish and lip gloss. Amanda Palmer should get rid of those dishonest eyebrows. Okay, David Beckham: show us a selfie of your love handles. Men's self-esteem is at stake! Ready, set … GO!

While feminists were once scolded for not grooming ('Underarm hair!' 'No makeup!'), they are now scolded for grooming. Scratch that. They are now scolded for *both*.

To be clear, there is no vow of grooming/makeup/pretty dress-chastity required in order to identify as a feminist. Nor is there a 'girl power' lipstick that needs to be purchased. The aim of the normalisation of bodies, with their ribcages and fat rolls and mastectomy scars, grey hair, vulvas and penises, smoothness and wrinkles, frailness and strength, can make for compelling and even useful or instructive art and imagery. The world would be far poorer without such images. But the moralising that comes with so many commercial body-image and makeup-free campaigns, whether intended by the

organisers or not, works directly against the aims of normalisation and inclusion.

Historically, the use of makeup has been tied to many social movements and subcultures of rebellion. Take the short hair and red lips of the Weimar era in early-twentieth-century Germany, for example, or the bright makeup and outlandish clothes of the Zazou subculture of Paris during the German occupation in World War II, when the Nazis were propagating a wholesome 'natural' look. (Christian Dior described how the Zazous '... floated through Paris like revolutionary banners'.) Similarly, punk, goth, rock-and-roll, rockabilly, the disco era, cross-dressers and 'high femme', among others, all use makeup to subvert cultural norms. (Think of David Bowie's Ziggy Stardust years, for instance.) This contrasts starkly with conservative groups which have tended to embrace a code of minimal or no makeup, with the focus being on how women ought to present themselves for the greater social good, with a woman's body, face, hairstyle and dress apparently holding the power to corrupt the pure and cause sin. Though some of our mothers may have said that it is good 'to take pride in one's appearance' as a way of encouraging us to look after ourselves, 'pride' in the context of religion is one of the seven deadly sins.

Undeniably, we already have countless reasons to criticise a woman's appearance (a man's too, but less frequently, most would agree). Must we really coax women into showing themselves in ways they wouldn't normally, as a way to acceptance? Because it isn't a 'challenge' otherwise, is it? The word would not otherwise apply. Plenty of modern women go makeup-free all the time. It's the women who normally wear makeup whom we want to see without makeup. It's a form of voyeurism. It becomes makeup-free as virtue versus made-up

'perfection' as virtue; naturalness as virtue versus digitally or surgically enhanced as virtue. Is the better woman the one who 'looks after herself' and 'takes pride in her appearance'? Or is the better woman the one who shows herself to be 'modest' and uninterested in artifice? Is vanity evil now? Is this the Middle Ages?

As usual, when it comes to the way women appear there is no real winning, but plenty of voyeurism, judgement and division. Thin woman versus fat woman. Woman who wears makeup versus woman who doesn't wear makeup. There is no 'right' way to look, even if you could magically achieve any size, shape or appearance you wanted, because every aspect of appearance is something open to criticism, defining not just a woman's surface, but her apparent honesty or moral status. This is the problem with the popular misuse of the term 'real' – real curves, real women, real bodies etc. Real for one person is not real for another. Just because your real involves physical curves (mine does) or an aversion to makeup (mine doesn't), that does not make you more or less actual or proper.

So whether or not you join a visual art project or, on the other hand, a visual commercial campaign to help normalise some aspect of natural, unadorned and unaltered human appearance, I hope we can all agree that a woman's 'realness' is not found in the measurements of her body or the transparency of her skin. You can't tell by looking at someone whether they are dishonest (or lazy, sinful or virtuous).

And all of us are 'real'.

11

THE BEAUTIFUL AND THE DAMNED

You painted a naked woman because you enjoyed looking at her, you put a mirror in her hand and you called the painting Vanity, thus morally condemning the woman whose nakedness you had depicted for your own pleasure.

John Berger, *Ways of Seeing*[1]

In early 2013, I spoke at an author lunch for my eighth novel, *Assassin*, the final volume in the crime series that launched my writing career. Afterwards, during the signing, a woman approached me with a story to share. As I sat behind the signing table, pen poised over her copy of my book, she explained that in 2000 she and her partner saw me walk through Sydney airport and she said, 'Oh, she must be a model.' According to the recollection she felt compelled to share with me, I then proceeded to sit down nearby and read a book as I waited for my plane, while they joked that I was 'probably reading the book upside down … because I mean, obviously, right? You're too beautiful.' The woman went on

to say: 'When I heard you talk today about what you went through when you were first published … I just needed to let you know that I was one of those people.' She smiled cheerfully, her confession made.

This story is by no means unique. A review of one of my other novels, published recently, summed it up well: 'My expectations were low for this one,' the reviewer wrote. 'I am ashamed to say, I think I was a little biased towards the author, but Tara Moss dispels the myth that models are air-headed clothes horses.' This was a professionally penned review of my work, coming after thirteen years of being a novelist. In other words, had I not gradually over the period of more than a decade built up the possibility of this reviewer reading my work, she would have almost certainly continued to believe that I was an 'air head', end of story.

I have heard variations on this theme nearly every week of my writing career, from men and women of all ages. It's not exactly a terrible burden to bear, ranked against other obstacles or even other damaging stereotypes, but it does trouble me for a few reasons. Naturally, there is the fact that I've only heard all this over the years *because* I am a published author; it is safe to say that if my only public career had been that of fashion model, I would not have heard these stories – certainly not as 'confessions'. As I grow older this reaction is no longer the problem it once was, but what troubles me is the certain knowledge that mine is not an isolated experience.

There are a lot of people who walk through life being pointed at, and sniggered at, and underestimated for no logical or meaningful reason whatsoever, thanks to a variety of unpleasant stereotypes to do with physical appearance, size, disability, race, the status implied by their clothes, and so on. Some people will find out that others perceive them that way.

Some won't. Some will have the chance to address the prejudices against them, as I have over the years in great abundance, thanks to my writing and the opportunities afforded by countless interviews, blogging and social media, and that infamous polygraph test. But most people, I'd venture, will not have that opportunity.

Now I have certainly never uttered the adage 'Don't judge a book by its cover' while referring to anything other than literal book covers, and I doubt I have ever said, 'Don't judge me by my appearance'; nonetheless, these sentiments do explain a theme that arose regularly throughout at least half of my lived years so far, from my teens to the age of thirty-five – not so coincidentally, the age window during which models and actresses generally get the most work, and the age range of most of the 'visible' or celebrated women in our culture. As the theme does come up in this book, it is important to clarify my own position here: 'Don't judge me *by* my appearance' is quite a different statement from 'Don't judge my appearance'.

While judging someone's non-visual attributes by their appearance is at best misleading and at worst outright harmful, if I were to claim that I wanted to rail against all visual things being judged in any form, that claim would not only be naive but also out of keeping with the fact that I enjoy aesthetic things as much as, or perhaps even more than, the 'average' person (whoever that is). It's no secret that I actively enjoy adornment and visual expression.

Everyone with functioning eyes uses their vision, and some of the things they see strike them as interesting or vibrant or otherwise aesthetically pleasing, and some do not. Aesthetic visual judgements are often intuitive and always subjective, but are nonetheless present, consciously or not, in the lives of those who have sight. The fact that aesthetic

judgements have become extreme and harmful in certain circles, with body policing, bullying, body dysmorphia, eating disorders and so on, does not mean that the ultimate goal can or should be the denial of the sense of sight, or a selective sense of sight when it comes to anything attached to the human condition or human form (wherein it is acceptable to notice and appreciate artwork but not a garment or hairstyle or physique). So yes, by all means, judge appearance. Judge art and design and the cut of coat and cuff. Glance at a face and decide whether you find that face attractive or not, all the while knowing that it is a person's face, not a person's character, that you are looking at. Judge *appearance on appearance* – just don't judge intellectual capacity, personality, politics, personal interests or sexual habits by the way someone happens to appear to your eyes.

Our eyes are wonderfully useful. They help us to navigate and better understand the world. But, make no mistake, our eyes also deceive us. Or perhaps, more accurately, our *interpretation* of what we see deceives us. Many people mistake balanced features for balanced personalities, yet a handsome young man named Ted Bundy was one of the most notoriously vicious serial killers. Some of the stockiest people are the fittest (shot put, anyone?), as are some of the slimmest (marathon runners). Both Stephen Hawking (physically disabled) and Sharon Stone (able-bodied and 'conventionally beautiful') have Mensa IQs. Rock stars and those who dress like them are usually thought of as rebellious and anti-establishment, yet rock stars also become politicians (Peter Garrett) and are knighted by monarchs for their charitable work (Bob Geldof). The stereotype of a black man as an anti-establishment figure still persists, yet Barack Obama is the current US president.

You cannot accurately assess a person's character by noting whether or not they are fit, fat, frail, thin, old, young, able-bodied, disabled, black, white, Asian, tattooed, male or female. It is irrational to judge the character of a person by the appearance of the body they inhabit, and it is precisely this tendency to judge a person's interior by their exterior, often at first sight, which has led to fatal errors of judgement, and unnecessary divisions between individuals and entire social groups. The divisions caused by physical differences help excuse atrocities like rape, murder, genocide and slavery. The history books are filled with stories of entire peoples who looked different and were deemed to be subhuman as a result.

> That's what he [Martin Luther King Jr] was saying, the civil rights movement … judge me for my character, not how black my skin is, not how yellow my skin is, how short I am, how tall or fat or thin [but] by my character.
>
> Pam Grier

Skin colour is not character. Clothing is not consent. Feminism is not a lipstick or a body shape. You cannot reliably determine someone's past, present or future, their sins or their virtues, from their appearance. Despite this, visible differences are given too much weight, and this diminishes us. In public discourse we police appearances at least as much, or perhaps more, than we police actual crime. We unnecessarily ostracise people who don't look 'right' (i.e. like *us*) and this tendency encourages bad decision-making and, importantly, encourages biases ranging from the minor to the very serious. Effeminate men are beaten. Women with short hair are harrassed, abused. The colour of a person's skin still brings judgement.

This problem of disproportionate judgement on appearance has a particularly significant effect on women and girls.

In late 2013, the University of Messina published the results of a study in which 1100 fake résumés were sent out to 1500 advertised job openings. The résumés were identical except for the pictures of the 'applicants' and the names and genders used. A hundred university students had graded the applicant photos (which were reportedly downloaded from the internet and then Photoshopped so that the original people would not be recognisable) as either 'attractive' or 'unattractive'. The study found that attractiveness played a large role in whether the applicant would make it to the next stage of the application process. This was true for all of the (fake) applicants but particularly true for applications using women's photos and names. 'Attractive' female applicants were called back 54 per cent of the time. 'Unattractive' female applicants were called back only 7 per cent of the time. This compares with 'unattractive' male applicants, who still got a call-back rate of 26 per cent – a rate nearly four times higher.[2] Though the study was not designed to determine whether the more attractive applicant was ultimately more likely to *get* the job, the study did show that job opportunities for most people, but particularly women, were profoundly affected by perceptions of appearance.

And the downside of the very same perceived attractiveness that may increase your job chances?

As Naomi Wolf writes in *The Beauty Myth*:

> Beauty provokes harassment, the law says, but it looks
> through men's eyes when deciding what provokes it. A
> woman employer may find a well-cut European herringbone
> twill, wantonly draped over a tautly muscled flank, madly

provocative, especially since it suggests male power and status, which our culture eroticizes. But the law is unlikely to see good Savile Row tailoring her way if she tells its possessor he must service her sexually or lose his job.[3]

The notion that a woman not only *has* a physical appearance, but *is* the sum of her physical appearance as seen through the eyes of a spectator, a watchful judge who can tell every important thing about her and her life by a glance at her physical form, is a fiction that many women encounter on a regular basis, and it has its roots firmly in the past, when women were (literally) the property of men, and were chosen primarily for their beauty and fertility, so they might provide healthy male heirs. Today many men and women, but particularly women, have come to believe that if they could only *look* right, they would finally *be* right in the eyes of that ever-watchful spectator. They would finally gain acceptance, happiness, success and love. This belief, which is unconscious in many of us, has been manipulated for commercial interests. This is why it is no longer enough to decorate our body and hair: we must also change that decoration regularly, in step with the trends of 'fashion', as promoted by various designers and businesses.

In the common fiction directed at women, there is an idea that beauty and clothes maketh the woman. The (ever-changing) beauty standard is the mark by which many women are measured in both their personal and professional lives. This goal has launched a thousand beauty products and fashion lines, as the (always temporary) achievement of that beauty creates repeat consumers.

Contrary to popular sales pitches, there is no truly 'correct' way for a woman to look. For women, any appearance or

mode of dress has consequences. While a business suit, which confers economic status, can get an adult male through all professional interactions and many social ones, an adult female will find herself pigeonholed by the same uniform. If it is not the right suit, worn in a pleasing way, she will not get that job interview call-back. In the boardroom her dress must be serious, but not too severe. In the evening she must change her shoes and jewellery at the very least, though an entirely different outfit is advised. Wearing a business suit on a date is thought to send all the wrong signals ('But you want him to see you as sexy, don't you?'), but the wrong length of skirt or depth of neckline could be 'asking for' harassment or rape. Such is the quagmire of dress code for women that there are many tutorials to be found on appropriate wardrobe choices to achieve the desired social acceptance, determined by age, weather, season, the hour of the day and the setting. These are found even in contemporary magazines. And for all the money and time put in to running this particular race, as presided over by a changing beauty standard, there is no winning post, only the certainty that you will one day be put out to pasture.

Now any discussion about beauty is somewhat fraught, but here is the reason why, in my view, the way we treat conventionally attractive women matters (hear me out):

- In developed countries we have never been more exposed to advertising, entertainment and popular media than we are now.
- Women in advertisements are almost exclusively conventionally beautiful.
- Film and television shows cast a disproportionate number of beautiful actors, particularly when the role is that of a

female character. The most famous and celebrated women in entertainment are, with some rare exceptions, conventionally beautiful. Generally they are also portrayed as sexually attractive, and their roles thin out once they no longer fit the youth/beauty/sex symbol ideal. (This is true of many male actors also, though the standards are not as narrow and the presentation is rarely as sexual).

• Women's visibility plummets outside of advertising and entertainment.

• The perception of beauty is a key aspect of many women's experiences in life in mainstream western culture, in how they are perceived or valued by others, and in many cases how they perceive themselves. This could be said to be emphasised through popular entertainment and advertising, as stated above, in that it almost exclusively presents beautiful women, and makes women who are not young or conventionally attractive symbolically invisible.

So here's the rub: if, as I've outlined above, a large proportion of women are encouraged to strive to be 'beautiful' in a way that is sexually appealing to men, and are judged on, and judge themselves on, how well they conform to those conventional ideas of beauty, *and* at the same time those who are conventionally beautiful – the women who are by far the most prominent examples of what a 'woman' is expected to be – experience culturally endorsed assumptions that they are stupid, slutty or deserving of hate and mistrust, this allows us, as a culture, to hate, ridicule and dismiss nearly every woman we see in mainstream culture. That is, in my view, a problem.

This paradox at the very heart of our mainstream popular culture does the status of women no favours. Attractive young girls are encouraged to be models and actresses, who are

frequently portrayed as the 'ideal woman'. Everyone wants to look at them, or so we are told, and, it seems, we will also want to hate them or dismiss them for precisely the same reasons. Of course, those who don't fit conventional ideas of beauty may be labelled stupid or slutty as well. No woman in the public eye can guarantee she comes away without labels regarding her physical appearance. Think of 'Here comes the weather girl' being hissed by the opposition at Senator Kate Ellis in parliament. Think of author Bret Easton Ellis's response to Kathryn Bigelow winning an Academy Award for Best Director in 2009 (for *The Hurt Locker*): 'Kathryn Bigelow would be considered a mildly interesting filmmaker if she was a man, but since she's a very hot woman she's really overrated.'[4] Think of the assumptions of stupidity and vacuousness, accusations of whorish gold-digging, the ease with which we dismiss women when they have bodies we like to look at and, significantly, bodies that arouse our sexual interest.

The dynamic is something like this: Without sexual currency, women are thought to have nothing. With sexual currency, women are treated as objects, something which is acceptable because 'they asked for it'.

Notably, there is no true male equivalent to this paradox. While an attractive man – George Clooney, for example – may be the envy of men and the 'sex symbol' of choice for many heterosexual women and homosexual men, he is not a 'sex object', as he is not reduced to or by his appearance, which is rarely presented in an openly erotic context, as this would put off male audiences. A handsome and talented man like Clooney is not hated or dismissed for his beauty in the same way his female co-stars frequently are. Take Oscar-winner Nicole Kidman, for example. Or Charlize Theron. Like Clooney, they were elevated in their profession thanks to a

combination of physical beauty and acting talent, yet these women nonetheless must balance the tightrope between exploiting their physical gifts so as to stay relevant, while not letting the same physical gifts obscure their talent. Both actresses, for instance, needed to mask their beauty to win an Academy Award (Charlize Theron with significant weight gain and unflattering makeup for *Monster*, and Nicole Kidman with a prosthetic nose for *The Hours*). Because actresses are still disproportionately hired for their sexual currency, as objects of desire, as they age they will be excluded from many roles for no longer being 'bankable' enough. If they attempt to avoid this career death with cosmetic surgery, they will be judged vain and, in some cases, if the result of the surgery is considered unsightly, unemployable. For many of these women, to 'grow old gracefully', as the saying goes, is simply to disappear from view without a fight. Those women who manage to pull off the incredible feat of remaining sexually attractive to a broad audience while not appearing to have succumbed to surgery (Helen Mirren, Susan Sarandon) are praised most of all, though their work opportunities are still scant compared to their younger, more conventionally alluring counterparts.

In an advertising-soaked culture, those who do the work of product promotion have reached new levels of celebrity. But for all of the elevation of models (and the actresses and reality stars who have now taken over the professional model's job as the 'face' of products) to superstar status, even the status of 'role models' by some, we simultaneously admire and resent their presence in our lives. Every advertisement is a display intended to show us what we don't yet have but could, if only we tried hard enough, were clever enough, and spent enough money. We resent the influence of all that superficiality and

product promotion, and we resent the envy we are encouraged to feel, yet our resentment is directed almost exclusively on the subject pictured in the advertisement – the one who is, in the vast majority of cases, the least involved in the creation of what we are seeing, is the least invested, and actually has the least to gain. The model in most advertisements is literally taking the role of a living 'mannequin'. Before I began modelling I assumed that models were on the top rung. I soon learned that they were on the bottom. Expendable and interchangeable, the model often has little or no say in how she is presented.

Though we may admire their beauty, may be aroused by their bodies or compelled to purchase products in light of their pleasing aesthetic, we resent the models used to sell to us. Why else would the *Sydney Morning Herald* write in 2012 that 'Tara Moss has overcome her "model" tag by more than proving herself as a successful author'.[5] A 'model tag' must be 'overcome', it seems, like syphilis or a criminal record. But if becoming a model is something one must overcome, why do we have top-rating reality TV shows about becoming one of these tainted creatures? It's a curious paradox.

Why is it commonplace to pretend we want to kill a woman for her appearance, as when I took to the Town Hall stage for a panel at the Sydney Writers' Festival in 2012, and author Kathy Lette gestured to me and joked 'sisterhood is powerful but she has to die.' (There were huge laughs. To be clear, she is a wit and I like Lette a great deal, but having a packed town hall laughing about your necessary murder moments after being introduced onstage is, well … uncomfortable.) It is okay to pretend this, because ultimately, on some cultural level, we have come to expect that: a) women are natural competitors because they evidently can't exist without male attention and their primary value is aesthetic, so

a woman will naturally wish another woman death if she is younger or thought to be prettier (take the film *Malèna*, starring Monica Bellucci, in which the town's women physically attack Bellucci's character for her beauty); and b) ultimately, again on some cultural level, it is what 'she deserves'. These links are reinforced with regularity, and not normally with the irony and levity of Lette.

The trope of alluring dead (female, *always female*) beauties persists in storytelling, perhaps most obviously in the action, horror and crime genres (genres I enjoy and have produced in my fiction). To return momentarily to film, consider for a moment film noir classics past and present (in which the supposed 'femme fatale' doesn't literally prove fatal to anyone and is herself knifed, shot or strangled), Hammer horror films (in which beautiful women are impaled with vampire stakes in their lovely cleavage), and the popular James Bond franchise (in which Bond girls make rather a habit of being killed off in fetching ways: naked in bed, or covered in gold paint or oil, or ...) Yet this trope also crops up with stunning regularity in even the work of the most modern and experimental directors. Take Quentin Tarantino's reimagining of World War II, *Inglourious Basterds*, in which the male heroes who have killed numerous Nazis are allowed to live by the Nazi colonel Hans Landa, while Bridget, the beautiful German film actress, 'got what she deserved' – being strangled by him, while wearing a stunning sequinned dress displaying her décolletage. And despite her wonderfully well-rounded, and non-stereotypical role, even our magnificent heroine Shosanna, one of my favourite-ever women on film, has to die in her most beautiful dress at the end, therefore making certain that all of the named female characters are both beautiful and dead. Likewise, in Jim Jarmusch's *The Limits of Control* – a film that subverts noir racial

stereotypes and narrative form – the only two central female characters are, despite the experimental nature of the film, straight out of the playbook. Both are beautiful, both are victims, and the one who appears the most often is – as her name 'Nude' suggests – naked throughout and asking for sex with the male protagonist, before ending up dead and unclothed in his bed. (Her opening line is: 'Do you like my ass?')

Of course we recognise the familiar texture of this storytelling, and the directors play on it to great effect. It's entertaining, after all, and ultimately we are left taking this link for granted – the glamorous and sexually attractive woman must die. If they are beautiful but virginal/wholesome, they may be granted life, upon being saved by the hero, but the *sexy* ladies? Spoiler alert: like Elizabeth Taylor's gorgeous bed-hopping character in the 1960 film *Butterfield 8*, for which she won her first Academy Award, we know these women will die tragically in the end. The moral lesson is clear.

What is most notable about this trope is not so much these particular storytelling moments (I enjoy all of the films mentioned above, even the ridiculous Hammer films. Call me a B-film diehard), or even how often this trope plays out (though it is frequently annoying), but that *there is no equal opposite trope*, wherein we know that a seductive man, whom the protagonist(s) are attracted to, must die by the end, preferably nude or in revealing and sensual attire. There is no film graveyard of dead gigolos or Lotharios, dead male strippers or glamorous dead boyfriends. There just isn't.

The fact that this phenomenon co-exists with a dominant commercial entertainment/storytelling/marketing industry wherein women commonly must exploit or be exploited for their sexual currency in order to be successful or relevant seems, at best, problematic.

*

A woman must continually watch herself. She is almost
continually accompanied by her own image of herself ...

John Berger, *Ways of Seeing*

Women cannot possibly miss the implication that they themselves *have an image*, the characteristics of which may have a real-world impact on their lives, but we love to hate and ridicule women who seem even fleetingly aware of this — particularly if they take control of their image.

In 2012 the Duchess of Cambridge, Kate Middleton, was photographed topless, on private property, with a long-range lens used by a photographer who was approximately one kilometre away. When the royals successfully sued the magazine that published the photos, the publication was fined a measly $2600, a mere pittance compared to the profit made with their front-cover exposé and the five pages of topless photos inside. (A Danish magazine published twenty-six pages of the shots. *Twenty-six pages!*). Yet it was the duchess's apparent wrongdoing that was roundly condemned by many media outlets and pundits. The *Sydney Morning Herald* ran an article with the headline: 'Topless Choice a Bit of a Booboo', and Donald Trump commented on Twitter that: 'Kate Middleton is great — but she shouldn't be sunbathing in the nude — only herself to blame.' She only had herself to blame for her exploitation, you see? Her choice was a 'booboo'. Being on private property, far from the reach of human eyes, did not enter into it. If she could be photographed with the technology of a long lens from a kilometre away, that was her fault. She should know that her body belonged to the world — all of it, all the time.

Harry Potter star Emma Watson found out on her eighteenth birthday that even wearing a simple skirt was a liability: 'It was pretty tough turning 18. I realised that overnight I'd become fair game … The sickest part was when one photographer lay down on the floor to get a shot up my skirt. The night it was legal for them to do it, they did it. I woke up the next day and felt completely violated by it all.'[6] Presumably she only had herself to blame for wearing a skirt, so let's not talk about that. Let's not think about the disturbing sense of public ownership shown over women's bodies and instead talk about the images young women *choose* to show of themselves. You know, *selfies*. Let's talk about that.

These self-photographed images, existing as they do in an image-saturated culture, reflect some real aspect of people's experiences. They are neither inherently empowering nor inherently disempowering. How can we pretend that beautiful young women in advertisements are just good old capitalism, that the publication of revealing paparazzi shots should be blamed on their beautiful, unsuspecting subjects, but selfies are morally dangerous because they sometimes reveal that young women (shock, horror) may try to look pretty or even hope to appear attractive? *They are so self-absorbed! Narcissistic!* So, we talk about what a big problem it is that *women are taking photographs of themselves*, without a middle man, and choosing to present those photographs publicly, *for their own purposes*, rather than the fact that images of women are used to sell everything from beer to automobiles to magazines.

The fact remains that the majority of the women we see on billboards, on TV, in film, in magazines and advertisements are both conventionally beautiful and sexually attractive, that is precisely the *reason* they have been selected, and because of that very same fact they fit a stereotype that provides a

culturally acceptable excuse for the rest of us to demean their intellectual capacity, dismiss their achievements, underestimate them, ridicule their vanity, dehumanise them as 'gold diggers', 'slags', 'hot morons', 'skinny bitches' or 'vacuous starlets', invade their privacy and blithely announce that they must obviously die. If we can judge a woman more harshly for the invasive images taken of her body without her consent than we do the people responsible for that invasion of her privacy, what does that say about the role of women and their bodies in our culture?

If the majority of the women we see in public life can be safely regarded according to this standard, it goes a long way to excusing that treatment for every woman.

And in my view that really is a problem.

12

THE BEAUTIFUL MAN

There are some who think the expression 'male beauty' is oxymoronic, even perverse. Students of English as a foreign language are taught that it is incorrect in English to use the world 'beautiful' for a male.

Germaine Greer, *The Beautiful Boy*[1]

In 2013, while on tour in Spain for my novel *Te Encontrare*, my Spanish literary agent and her partner took me to see flamenco in a small tavern in Madrid called Cafetín La Quimera.

Having never seen authentic flamenco, I expected a woman in a polka-dot dress dancing around the stage in that famously strong and emotional Spanish style. Instead, I saw a beautiful man. He was perhaps thirty, fresh-faced and handsome, unmistakably masculine and virile. He wore a male corset and a small but flamboyant turquoise polka-dot scarf tied around his neck. His black ensemble – pants, shirt, corset and bolero – enhanced and showcased his masculine

physique as he ran his hands over the tight black fabric that encased his trim torso, expressing a kind of bursting emotionality, strength, vulnerability and sensuality. He wept at one point in the performance, as did the female dancer in her performance later in the show.

In Spanish, *flama* means 'fire' or 'flame', and *enco* or *endo* means 'quality of', or 'pertaining to' – thus describing the incendiary quality of this dance. Despite the focus in contemporary postcards and tourist advertising on the female flamenco dancer in her long ruffled dress, in authentic flamenco, the men are at least half the show. They are not the backdrop to the female beauty: they are themselves figures of beauty. They are passionate and emotional, just as the women are, and they are unmistakably alluring. Their traditional costumes are designed to be looked at, the male body to be admired and desired. The corset sits hard against the body to emphasise the male musculature, the pants exaggerating the buttocks. While the female dancer traditionally has layers of ruffles to move with her, the male shows every muscle in his performance. Both male and female flamenco dancers show an extraordinary fierceness and strength, and not once does the viewer sense that the woman, specifically, is a passive or decorative object, succumbing to a dominant man. Man and woman are presented as forces of nature, clashing, moving together and showing their pain, anguish, lust and determination.

I have always found that the appearance of men dressed extremely casually, in the comfort of jeans and gym gear, walking alongside women teetering in high heels and tight dresses, gives me a discomfited sense of imbalance – a feeling, rightly or wrongly, of one trying much harder to please than the other. When I observed this 'beautiful man' – not only on the flamenco stage, but also with the famous matadors, that

other idealised symbol of Spanish masculinity, the men who are dressed in the tight, revealing, sequined and ornate costume known as the 'suit of lights' – the effect was interesting. It seemed as if the male and female form were more equally imbued with sensuality. On the footpaths both men and women appeared to dress to please themselves and the world around them. When I wore high heels one morning to a book interview, several locals commented, including my taxi driver, who politely asked whether I was on my way to a wedding. It was considered strange to wear 'uncomfortable' shoes except on special occasions or after dark, perhaps mostly because the Spanish commonly walk everywhere. The assertiveness of Spanish women, the more 'balanced' aesthetic of Spanish dress, and the visible public representations of both the male and female bodies as sensual, reduced the uncomfortable feeling I often get that 'prettiness', all that physical aesthetic effort, is considered the rent that women must pay for being women. This isn't to say that gender relations in Spain are superior or without problems, or for that matter that I don't enjoy dressing up (I clearly do), but there was something there, something I couldn't quite put my finger on …

Then I noticed it, quite suddenly: the profound *absence* of the sensual, idealised 'male beauty' in the Anglo-Saxon culture so dominant in Australia.

This recognition of absence brought to mind a comment by controversial feminist academic Hugo Schwyzer: 'Reminded again this morning that so many men can't admit – and sometimes can't even name – that they want to be beautiful too.'[2]

Why has our culture, specifically, rejected or forgotten 'male beauty'? Why are men and boys commonly humiliated and ridiculed for grooming or dressing in a way that aims to

be aesthetically beautiful, or aims to attract a partner, when this is a common part of living in other cultures, and what we are taught to expect of every single woman and girl? Why is the business suit, with all its lack of individuality, the extreme coverage from neck to cuff, and quality of an occupational uniform (i.e. businessman, capitalist, proprietor) regarded as the highest form of male style and presentation?

As I have already outlined some of the issues relating to women and 'image', it would be remiss to omit a mention of this curious absence pertaining to mainstream masculine image. This is not merely a matter of the superficial, in my view. These questions go to the heart of some of the key differences in the representations of men and women in our popular culture – an issue of both gendered objectification and a difference that reflects an ongoing taboo regarding male emotion and vulnerability, and masculine representations of 'wanting to be desired' by others. There is a conspicuous lack of mainstream images of men photographed looking *'available'* to heterosexual women (or homosexual men for that matter) – something which contrasts sharply with the strong presence of images of women looking sexually or romantically 'available' to others, i.e. to heterosexual men.

To examine our popular culture's ideals, let's consider for a moment the key ways in which famous men are portrayed differently from famous women. What do you think of when you think about a man in a suit or tuxedo? What do you most associate with that image? Financial success? Authority? Perhaps a groom? And what do you most associate with a woman in lingerie? Sensuality? Eroticism? Sexual availability? Isn't it interesting that when you peruse the pages of *Vogue* or *Vanity Fair* or *Esquire*, or any number of high-end popular magazines, you see representations of famous, desirable women

in sensual lingerie and figure-hugging dresses, and famous, desirable men in suits and tuxedos? While the sensual female body is shown, the male sensual body is usually covered. His attractiveness is not embodied, but buried in his possessions.

Likewise, even when the clothing or possessions are not so obviously coded in this way, the expressions and body language are. The man is adjusting his collar, checking his watch, gripping the steering wheel of a car, engaged in an action or on the verge of acting.[3] The woman is reclining, luxuriating, waiting.

When this trend is reversed, the results are often striking. A woman in action, looking like she has somewhere else to be, may automatically be considered a leader, perhaps even 'masculine'. The half-clothed man stretched back on a lounge or desk with his body exposed may be considered outright confronting to some. Outside its usual context of action – preparing for a fight or sport, to show domination or brute strength – the exposed male body, appearing more vulnerable, even available, takes on an otherwise ignored sensual aspect.

In Helmut Newton's iconic black-and-white image of 1975, dubbed 'Woman Regarding Man' (see picture section), there is a clear subversion of the traditional roles of man as observer and woman as passive object of desire. The female model in Newton's image is femininely dressed and conventionally beautiful, and the man is not shown in an overtly sexualised way. She is sitting, he is standing. Yet the simple fact that the woman is taking up space in her posture, at ease in the environment of the image, her body language open as she gazes at the man's form, gives us a clear sense of her power, even a sense of *masculinity*, inasmuch as we do not associate this ease of body language and this gazing at the bodies of men as a feminine behaviour.

In the far more common, mainstream representation, one gender (category) of person, the male, has a body that is neutral or asexual (apart from the primary sex organ, the penis), while the other, the female, has a body that is sexual, from the ankles (in Victorian days) all the way to the area of the upper chest, where a curve of fatty tissue associated with the female breast has the ability to cause controversy even today. The male body is somehow regarded as all but aesthetically unremarkable while the female body is 'beautiful', or 'immodest', or 'obscene'. From ankle to chest and everything in between (and also the hair and face, in some cultures) the female body is the object of sexual desire, while the male is the supposed source of sexual desire. He feels desire and it goes to 'Woman', not simply as an individual female human partner, but as an idea of sex and desire: as an object. It is culturally accepted that a woman, simply by existing in the open, may cause great excitement with her presence. She may invoke public displays of appreciation for her appearance that we do not ever expect a man to invoke, no matter his appearance or dress (see picture section, *American Girl in Italy*):

> That was something my mom would always point out to my brother and me – that our culture does often portray women especially – it happens to both women and men but women especially – like objects … I do call myself a feminist. It is worth paying attention to the roles that are sort of dictated to us and realise that we don't have to fit into those roles …
> Actor, screenwriter and director Joseph Gordon-Levitt[4]

This dynamic is very rarely reversed; we see the body through ideas of male sexual desire and female physical beauty, and very rarely through the perspective of female sexual desire and

male physical beauty. When we do, the results invariably shock some.

Australian women's magazine *Cleo* reintroduced its male centrefold recently, to some debate. The magazine's tradition of publishing a male centrefold was started by editor Ita Buttrose in 1972 and was ended by editor Lisa Wilkinson in 1985. (Of the famous *Cleo* nude centrefold of actor Jack Thompson, Wilkinson cheekily recalled that his 'hand wasn't quite large enough to do the job required and it was only discovered after the mag went on sale'.) The chosen images for this modern return of the male centrefold were of Jordan Stenmark, a twenty-one-year-old Calvin Klein model. He was photographed looking wholesome and shirtless, his modesty preserved by a crisp white bedsheet. Outgoing *Cleo* editor Sharri Markson said, 'I think girls want to see gorgeous men every month instead of just once a year.'[5] When I presented this information online, readers questioned the 'sexualisation' of men, and some even accused me of being hypocritical – as someone who identifies as a feminist – for linking to the pictures.

Now I confess, I enjoy aesthetics and photography, including but not limited to nude photography, and I have quite happily been photographed topless in my younger years, as many female and male models routinely have. So while the issue of the commodification of bodies for commercial purposes is a worthwhile discussion, I am one among many who are *not at all* shocked by images of topless women and men, to put it mildly. The irony in this specific discussion of the 'male centrefold' and its appropriateness, of course, is that images of women in the same issue of the same magazine, and many similar magazines, are pin-ups in all but name and centrefolds in all but staple placement. A woman in swimwear

or 'tastefully' topless or nude is frequently presented as a figure of beauty and allure — so much so that many traditional crests and symbols have been built on the female nude or semi-nude form. These kinds of images of women are utterly commonplace and do not generally warrant comment unless that image is considered overtly degrading — as with, say, a woman in a g-string on her hands and knees, in a dog collar or similar, being dominated by a group of men. Every month body creams and perfumes are sold to adult women using images of other women, showing more of their bodies than this 'male centrefold' reveals. Some are even in the same poses, with the same style of white bedsheet or towel, or nothing at all. But to frame an image of a man as 'beautiful', as a 'centrefold' for heterosexual female enjoyment, is still apparently controversial on some level, as we seemingly prefer to deny not only that the masculine form is also beautiful, but also that women have desires of their own and eyes to see.

Bear in mind, these centrefold images were not exactly out there — Jordan is hardly on his hands and knees, and his facial expressions are fairly neutral and pleasant. Nor is he heavily airbrushed. He looks healthy, human, masculine and conventionally beautiful. Sitting in bed. Stepping out of a shower (cropped for modesty). Basically, he looks like your normal (if unusually beautiful) boyfriend. While it's true that men appear topless in advertisements from time to time, or on screen, deliberately presenting an image of a man, with the stated aim of providing enjoyment for women, had the power to confront.

If readers feel sexualising male images is uncomfortable, what does it say about the acceptance of female ones?

Eva Cox

Because the attractiveness or 'eligibility' of a male, in our culture, is so tied to issues of ownership and class, we do not see nudity or revealing of the body as a primary aspect of the idealised male image in the way that the body is emphasised in representations of the female. Instead, we see the suit come up again and again. Even in male strip shows that are intended to arouse the female viewer, the most frequent costume is that of the shirtless man in a bow tie. The idealised man is strongly linked to occupation and economics. Of course there are female versions of this – the nurse, the teacher etc. – but this does not so completely fill the spectrum of what is presented as the idealised, desirable woman in the same way that the idealised man is almost entirely linked with capital.

Now that roughly half of the workforce is female, it seems especially peculiar that these clichés remain so strong. Why do we retain this idea that successful men must be owners (of property, of cars, of that suit and all that it implies) and successful women must be primarily sexually desirable and available to those men? Even (dare I say it?) available as a type of *property* for men to own ('Packer Trades in One Model For Another'), harking right back to when women had the legal status of 'property' owned by their fathers and, later, their husbands. Because women have historically *been* a type of property, and men property owners, it seems even more extraordinary that this representation, this gendered split, has not been more enthusiastically and consciously discarded. We can see that the dynamic for women in this is poorer than it is for men, but the truth is, both genders miss out, as the man is yoked with the responsibility to earn his validity in the world only through his capital, and the woman only through her (fleeting) sexual desirability to men. It is widely known that some male TV executives only hire female newsreaders they

view as 'bonkable', for example. Journalist and newsreader Tracey Spicer recalls:

> When I started working in television nearly thirty years ago, there was a 'fuckability' factor which was taken into account when hiring female presenters. Then, once they 'lost their looks', or had children, they were no longer considered to be sexy enough to appear on camera … There are still some [TV exec] dinosaurs who are lumbering around, carelessly ruining women's careers. But, on the whole, the situation has improved …

Notably, both of these extreme but commonly represented values have negative impacts for the average man and woman, while only one small group, who happen to be those with the most power, actively benefit from the stereotype – because a man with a lot of money (the dominant power in our culture) is being valued the most highly in this equation. A very beautiful woman is privileged over other women, but she is still not respected for her asset. She didn't 'earn it', after all. She is seen by some as a kind of prostitute.

But we do see unclothed men, do we not? Yet it is worth noting how many images of partially clothed men show the man appearing angry or ready to fight, playing sport or performing a task – anything but passively 'available' to the viewer. Brows are furrowed. The gaze looks off to the horizon or down the lens with aggression. Exposure of the male body is frequently framed in the context of action or aggression (or both) whereas exposure of the female body is frequently framed in the context of passivity or sexual availability (to heterosexual men). In fact, even a cursory perusal of mainstream publications shows that the more famous men

become, the *less* likely they are to be photographed in a sexually available way.

This is inversely true for famous women, who, as their star rises, are if anything *increasingly* required to be pictured in passive, partially clothed poses with a look of sensuality and availability, as such 'glamorous' images are considered an unremarkable publicity requirement of the industry – Emma Watson bejewelled and nude in a bathtub or lounging languidly in a couture gown, in a man's lap in *Italian Vogue*; Nicole Kidman sexed up and topless (and rather bottomless, also) on the cover of *V*; a nude Keira Knightley and equally unclothed Scarlett Johansson photographed with Tom Ford, fully dressed in a suit, on the cover of *Vanity Fair*, a shoot that actress Rachel McAdams reportedly walked out of, refusing to participate. The examples are too numerous to mention. (Of course Adam Driver was also photographed semi-nude in *Vogue* – topless – but then he was carrying a goat.) These images are beautiful, but anything that could be considered an equal opposite – say two men pictured naked with a fully suited woman – is extremely rare.

One can interpret this pattern thus: mainstream images of famous women must appeal to men. Mainstream images of famous men must also appeal to heterosexual men. There are exceptions, of course, particularly in niche modelling, alternative media or in careers that thrive on playing against type, but as a strong and persistent trend, famous men in the mainstream must appear powerful and ready for action so that they appeal to other heterosexual men. Above all, they *must not* appear to invite the viewer to see them sexually because this would be considered homoerotic and therefore off-putting to other men. An image of a man looking into the camera with sexual desire or a look of sexual availability is therefore most

often interpreted as a *homoerotic* image, not simply erotic. Hence the sexually 'available' man is rarely seen, though the sexually available woman is the absolute standard. A woman's sexually available body is erotic and a man's sexually available body is homoerotic. This tells us what the dominant gender and sexual orientation is in our culture, if we were not already convinced.

This is further confirmed by the popular term 'metrosexual' – an amalgam of metropolitan and heterosexual – to describe a man with sophisticated (some claim 'feminine') grooming habits. When a man puts effort into personal grooming, it is implied that his identity as a heterosexual male is called into question. Though the history books are filled with images of well-dressed men, dandies and ornately dressed priests and warriors, these days ornamentation and noticeable grooming on a man implies a loss of masculinity.

Young heterosexual women, as they begin to discover sex, will find their own reflection thrown back at them. Their form is thought to embody the sexual in a way the male form does not, and problematically so, as their clothing and bodies are judged harshly on the scale of the 'provocative', according to 'appropriateness' and 'indecent exposure', with even public breastfeeding causing controversy because of the association of their breasts (and not men's breasts) with sex. In fact, women themselves are often thought to be the object of desire in others, but not to have any true desire of their own. Naomi Wolf touches on this in *The Beauty Myth*:

> The alien beauty of the bodies of men, though girls stumble upon it in a Phaedrus or a Dorian Gray, is nowhere to be found in a culture meant for them; the glamour and allure of men's bodies is not described for them in a woman's voice ...[6]

And so we see the beautiful, naked torso of a famous actor, but only as he is preparing for sport, or engaged in work, or in the act of dressing in his suit before leaving for the office. Or we see the reclining male subject, relaxed and somewhat more available, but fully clothed, with at most a button or two of his shirt undone. He is arranged in a nonchalant pose, just there, hanging out gorgeously but somewhat asexually. He may be beautiful but he could not be accused of trying to attract us. Much more unusual is the partially unclothed male body, displayed, waiting passively for his desired one to notice and desire him, in the way we often see attractive women posed. When we do see such images of famous men they strike us as profoundly different due to their rarity. There is a quality of vulnerability one immediately recognises as conspicuously absent from most other images.

How curious that we have defined various essential human characteristics, needs, emotions and actions as masculine and feminine, including sexual desire. As we associate emotion, caring and sensuality with the feminine, and we penalise men for identifying with these traits, we have in essence excised male vulnerability, caring, emotion and the 'desire to be desired' from mainstream representations of the 'ideal male', and therefore from the popular idea of the sexual exchange – and with that, we have excised the recognition of both male humanity and complexity, and female sexual desire itself, turning what should be a mutual sexual exchange into one of desire versus his desired, of ravisher versus ravished one. As author Emily Maguire writes:

> The adversarial model of heterosexual interaction rests on the assumption that women do not enjoy sex and therefore, without payment, coercion, grand promises or vats of vodka, they would never do it ...[7]

Arguably the perpetuation of this imbalance – the idealised man as active participant versus the idealised woman as passive – sets a dangerous precedent for what is acceptable, expected and rewarded in the culture of masculinity and the culture of femininity.

Perhaps it's time for the 'beautiful man' to be permitted by the producers of our mainstream visual culture to show himself – to loosen his tie, look us seductively in the eye, and admit that he is human and he wants to be wanted, too, and for more than his brute strength or his bank book. I, for one, would welcome the sight.

13

THE VISIBLE WOMAN

When I was young, I did actually model and was much photographed by famous photographers. But I was always a bookworm. One of the achievements of our generation of feminists was to emancipate women from the division between being interested in clothes and appearance, and being serious and ambitious.

Marina Warner[1]

Somehow, in the popular public discussion of the lives of women and girls, the topic of glossy magazines and the images within them has become more of a focus than perhaps any other aspect of women's lives: 'Do models oppress girls?' 'Can you be a feminist and wear lipstick/heels/dresses?' 'Is Photoshop oppressing women?' That these questions of surface have gained such prominence bears some examination.

A concern is often voiced that women and girls define themselves by images in women's magazines — that they mould themselves, starve themselves and hurt themselves to

conform to the images of the bodies within those pages. Yet we rarely define boys and men by the content of the magazines marketed to their demographic. There is no consistent concern voiced about the beefed-up blokes on men's fitness magazine covers, whose bodies could be seen by impressionable young men as an advertisement for steroid abuse, nor the men seen cupping a glass of whisky, pressuring men into thinking they have to drink to be a 'real man'. We aren't so worried about impressionable young men and boys, it seems (despite the serious social problems associated with their demographic, including significantly higher rates of suicide and violence), and we infrequently associate men, as an entire sex, with the advertising aimed at them, in part because we see men in so many different contexts, doing so many varied things in their public lives, that their presence in public life is not so easily reduced to a one-dimensional glossy photograph. The public representation of 'Woman', however, remains closely tied to image and advertising, and despite the fact that men hold most of the wealth in the world, there is a tradition that associates men with wealth creation and women with its consumption. (Perhaps you've seen that annoying sign that sits in so many shop windows? *Your husband called. He says to buy anything you want.*)

One reaction to this cliché about women is to rebel against any show of interest in surface or consumption. This is a sound position but not a necessary one.

Can a feminist like looking at pretty things? Can she wear makeup? Enjoy well-made garments? Well, yes, she can. Can she peruse magazines or look at ads? Yes. No break of the essential contract there. These are not central issues. While there are issues of diversity to be addressed (the 'symbolic annihilation' of women who are not white, thin, able-bodied

and young in advertisements and elsewhere), and also pressing issues of consumerism and ethical production, these are large, complex issues about prejudice, institutional power imbalances, the economy and public policy, and not about a bunch of women looking at pictures of other women in fancy clothes.

Wars are not waged in the name of underwear, and although it is generally true that women in developed countries spend more on grooming and clothing than men do (which can go some way towards affecting their financial status), it does not follow that this is a significant problem for most of those women, let alone *the* significant issue for women in general. As long as we continue to live in a democratic country fuelled by capitalism, and it remains illegal to walk around naked, we can expect to see ads about clothing and we can expect people to look at those advertisements and, if they have enough money or interest, buy what is on offer.

So how did the matter of magazines and makeup become hot-button issues for women, and not for men? Why is so much time spent debating this topic? Women's identities have long been entangled with appearance, but is there more going on?

One thing to keep in mind in these discussions is that although all publications need to be economically viable to remain in print (likewise all productions, to a large degree), glossy magazines are designed as a medium for the promotion of goods and services – cosmetics, upcoming film releases, fashion lines, new cars or gadgets – and this advertising-heavy composition is generally one of the defining features of their format. So what we are talking about when we talk about magazines is largely or entirely a discussion of *advertising* and not specifically storytelling. This is not to say that the content within magazines lacks quality or art (Annie Leibovitz's

photography for *Vanity Fair* or Irving Penn's for *Vogue,* for example, or some of the wonderful journalism found between the ads) but, rather, the forces at work in the production and distribution of the content in magazines is strongly, and in some instances entirely, driven by economic factors. This is true for all markets, though it's particularly true of the magazines that are most often the focus in this debate about women and image: women's glossy magazines. (It is also true of popular men's magazines such as *GQ, Esquire* and the like.)

The issue of how women are visually represented is a legitimate one, and something I take interest in, but primarily in so much as women are represented far too narrowly. It's not so much what's found within the pages of glossy women's or men's magazines, but that women are too infrequently celebrated outside of that highly visual, advertising-driven domain. The problem, as I see it, isn't that this or that model or singer is pouting in her underpants on the cover of *GQ* or *Vogue,* but that her image will commonly fit a dominant pattern of representation which positions her as the target of both disproportionate praise (goddess) and vitriol (whore), and significantly, that *we aren't hearing enough about someone else.* And this brings me back to my earlier point about magazines being driven by advertising: I suspect this is precisely *why* we hear so much debate about advertisements, airbrushing, makeup and magazine models – because beautiful and highly successful women exist within those pages, and there are clear income streams to be made in those associations. Models, actors and entertainers are celebrated, watched and criticised down to the last microscopic detail, page after page of speculation, praise and denigration, while professional women in other fields go largely unnoticed. We don't hear from them or about them because the promotion

of their work does not so easily coincide with the promotion of something that is for sale.

The visibility of women in the public domain is dominated by those who are included (i.e. 'celebrated') primarily to sell products, either directly or indirectly – and sometimes even involuntarily, as candid images of famous women are now used to promote publications, weight-loss products, diets, creams and so on. This is one reason why advertising has become so entangled with women's identities, and now feminism.

Women who work in advertising and commercial publications have powerful public voices due to the nature of their occupations and the mainstream reach of those publications. This is to be expected. I can like some of the magazines and the people in them, and agree with their arguments and intentions, but it doesn't change the simple fact that a large amount of the debate surrounding women's rights has been channelled towards the comparatively superficial, image-based issues that relate directly to the magazine industry, and are specific to soft targets – individual ads, bodies and images – rather than the larger system. Hence a call for a blanket banning of all Photoshop in magazines is elevated to a central issue of women's equality. The right to 'feel beautiful' at any size or age becomes as prominent an idea (and then, naturally, as seemingly important) as the right to bodily autonomy and reproductive rights, and that feeling of beauty is seen as achievable only if it is reflected in an ad. The concept of feminism becomes tied up in the promotion of a soap because the ad uses a naked, makeup-free, middle-aged woman. This progress within the limited confines of the commercial world is seen as a mark of all progress.

If we take a step back – and I believe we must – we see that debates about models come with pretty pictures that are

nice to look at. Inevitably, it all looks fantastic in newspapers, magazines and on TV: all visual mediums that lend themselves well to marketing soaps, vitamins, gyms, diets, health products, you name it. Some campaigns even come resplendent with supermodels liberated of every stitch of clothing, showing how they look without Photoshop – the answer being, of course, splendid. A lot of the complaints that would normally come with printing photographs of naked women are absent when the images are presented as being a win for women's body image. Domestic violence, equal pay, reproductive choice, inequity in superannuation, the promotion of women in the sciences and women's representation in political decision-making, for instance, rarely come with sexy pictures or a seamless product endorsement in the sidebar.

Unfortunately, the general tendency for women's voices to be heard primarily in relation to causes defined as 'women's issues' in the domain of women's-only publications, rather than issues for society as a whole has the result of very effectively segregating thinkers and writers who are female from the public more broadly. This means the space allotted to women journalists is often the same advertising-soaked space, the very same magazines we debate about. Essentially, *Talk amongst yourselves, ladies.* And so we do.

Cover girls without collarbones. Models without pores. Hips as narrow as thighs and waists sliced down to the slenderness of a neck. These fantasy advertising images, as revolting as they sometimes look, are more talked about in our current culture than images documenting real-life atrocities.

I understand why there is public debate over the excessive use of Photoshop. I've seen the silly ads, and I imagine that if you also live in the developed world, unless you have been living under a rock, you have too. Some of it is offensive, even

insulting. When a product blatantly misrepresents itself, there is an issue of ethics that needs our attention – for instance, digitally extending eyelashes and claiming this is the work of the product. (A number of cosmetic companies were recently caught out using false eyelashes to sell 'lengthening' mascaras, while implying in their advertisements that the look could be achieved with their mascara alone. No Photoshop needed there, just old-fashioned glue.) It is important to regulate false claims on packaging and advertisements, particularly related to drugs, health products and cosmetics. But is the invention of Photoshop really responsible for the mass oppression of women and girls?

Often the discussion of Photoshop is a rather exclusive one, and implies that without digital retouching, an image would be natural and therefore real. I don't believe this is the case.

First, we must consider the source of the images we are discussing – almost always advertising images and editorials in glossy magazines. Then there is the somewhat more complex nature of photographing a person to advertise a product. In my decades of professional modelling I could not miss the fact that it was largely the professional makeup and hair styling, the age of the models and the elaborate lighting that once provided the flawless and rather 'unreal' look we associate with advertising. Light boxes, reflector boards and flashbulbs were all used, so that as a fifteen-year-old model I was surrounded with banks of light, my young skin turned flawless, shadowless and ultra-bright. (Often, you can see the large, square glowing light box reflected in the model's pupils, and if you look at her pose, you will see that her arms are leaning on the white surface – a reflector board.) Though digital manipulation is used on many ads now, it is the manipulation of light, particularly in skincare ads, that is still

most responsible for this effect. The white studio with its rows of bright lights, and the reflector boards, cannot be replicated in real life, of course. (Unless, perhaps, you live in a glowing space station.)

To be a model on a studio shoot was to be completely surrounded by white foam boards and soaked in hot lights. If on location outside, you were flanked by reflectors, held by photo assistants whose explicit job it was to aim them right at your face. The dreaded silver ones, which I came to object to (not that my protests made a scrap of difference), had a surface like tin foil. It felt like being an ant under a magnifying glass. My eyes have never fully recovered from the years of blinding reflector boards used on bright, sunny days. Many models abuse whitening eye drops for this reason, using them several times a day, against recommendations, to cover persistently bloodshot eyes. When every other human being was either in the shade or wearing sunglasses, or both, we had to look down the lens and appear relaxed, berated for any involuntary squinting. To say the set ups were unnatural would be putting it mildly. The photographer, assistant, makeup artist, hair stylist and client would all stand outside this circle of light, usually around the camera lens, talking about you in the third person, as if you could not hear, or you literally were a mannequin. This experience is different to the sometimes clumsy slicing of body parts with the digital wand, reducing a model's size, but the truth is that even before the means existed to do that digitally, advertisers already used a vast arsenal of tools to achieve 'unreal' images.

I recall standing in front of a couple of thousand high school students at Sydney's Town Hall about ten years ago and explaining what went into the creation of images, and how some were altered. In the years that have followed, many

people have focused on the alteration of images, making the process of advertising more transparent in some ways – but not others. While we are discussing the digital manipulation of images, we also need to be honest about the other aspects of manipulation: the choice of model, lighting and product placement. I must stress that these are not *moral* choices (with rare exception, anyway). However, if you are a person who peruses ad images, and many of us are, it can be helpful to know what you are looking at. It is also good – vital, actually – to keep in mind the purpose of advertising: to sell. Nothing an ad presents to us will have been designed with simple reality or truth-telling in mind.

What is seen in an individual image may not have as profound an effect on our collective consciousness as what is consistently omitted (i.e. that issue of symbolic annihilation). This is where campaigns against excessive Photoshopping come into their own, exposing Photoshop not as a tool that makes otherwise realistic images unrealistic, but rather as a tool of visual censorship.

As there is already an excess of homogeny in commercial images, the use of digital manipulation, when used to 'smooth out' or 'even up' features, erases any natural differences in the already narrow selection of models chosen. Aspects of physical diversity are symbolically made invisible within the confines of that commercial space. This has long been a problem within commercial spaces, where lack of ethnic diversity has been and still is a significant omission, and where conventionally attractive faces (whatever that is deemed to be in any particular era or cycle of fashion) are presented within a limited ideal. Photoshop can further limit that narrow field of visibility.

Though it is true that Photoshop has the reassuring ability to remove temporary flaws – like bloodshot eyes (a frequent

problem for me when on writing deadlines), or a spot of acne, the removal of which I'll happily accept – the lovely imperfections of human beings are also smoothed out of far too many images. Yet one need only look at old photographs to see that images always have had the ability to distort reality. Even unaltered happy snaps are extremely variable and the outcomes selective. Picking the pretty, kooky or unflattering picture is a matter of aesthetic not ethical choice. The idea that the 'camera does not lie' is a fallacy. Photographs are not strictly a mechanical record. They are manipulated by framing, by angle, by intention, by accidents of flare and light. They are representations from a single perspective, manifested as a one-dimensional image. There are levels of manipulation and artifice before and after that click of the shutter, but photographs are not, and never have been, the *real*.

Even campaigns that aim to lessen the use of Photoshop, which is a broad industry issue, can often devolve into – you guessed it – tirades against individual women and girls. The comments beneath Ashley Judd's piece in the *Daily Beast* on the lunacy of criticising women for the minute details of their appearance (see chapter 10) involved plenty of moralising about how she was 'complicit' in women's low self-esteem because she had 'willingly posed for images that were Photoshopped'. I have been attacked for supposedly refusing to show people what I look like without makeup. This is usually framed as proof that I am not a feminist, by people who are not themselves feminists, and who openly state that they disagree with feminism and its aims. A man recently used the fact that I wouldn't post a makeup-free photograph of myself on cue, at his command, to try to show that I am to blame for women's self-esteem problems. In truth, because I

have been a public figure and a model there are literally thousands of photos of me online, with makeup, without makeup, with clothes and without clothes, caught mid-speech, smiling, pouting, walking, with stitches on my cheek, with lipstick on my teeth, with puffy eyes, weight gain or loss, in images both flattering and unflattering – but the demand was that I reveal my naked face *now, for him,* how *he* wants it, because it was my duty as a woman to prove myself to him. Likewise I was recently criticised on social media for posting a blurry iPhone photo someone had taken of me and another author at a book signing. 'It's a shame you won't post a clear, honest photo of yourself,' the woman wrote.

Honest?

How is a blurry or unclear photograph dishonest? Practically every photo taken before 1930 would then be dishonest.

This person was implying: *I'm better than you because my photo is 'honest'.* (With 'makeup-free' campaigns there is a similar moral claim: *My face is 'honest'.*) The idea of honesty is central to most ideas of morality. To claim that someone is not honest is a moral judgement, an accusation of moral inferiority. To apply this not to actions and statements, but to perceptions of the images captured through the distorting lens of the camera is problematic at best (even before pointing out that the specific photograph this person was responding to was taken by someone other than its apparently 'dishonest' subjects).

Arguments about the evils of otherwise legal images (she's not doing anything illegal, but she is 'skinny', for example) frequently centre on a convenient scapegoat. These scapegoats are often the models themselves, and almost always young women. Think of the demonisation of supermodel Kate Moss,

mentioned earlier, a model who was blamed for making people anorexic, smokers and, later, drug addicts, as if the complex causes of serious conditions like eating disorders and substance addiction was really just about impressionable young girls wanting to look like a model. These types of arguments trivialise serious medical conditions, bring media attention to products worn by the scapegoat in question – say, Calvin Klein underwear, to continue with the Kate Moss example – and once again distract from other issues. The voices of those who sensibly point out that the actual company is responsible for the image – the CEOs, the shareholders, the larger industry – rather than the individual woman, are usually drowned out of the debate.

To continue with my example, we can examine one early Calvin Klein advertisement in which Kate Moss was pictured in black and white, sitting in a pair of jeans (the product). She was wearing no other clothing and was not engaged in any activity apart from the aforementioned sitting, which is really more of a non-activity. Her body is turned away from the camera slightly, so her breasts are not fully visible, and she is looking into the camera with a neutral expression. Is there any circumstance in which a slim young man simply sitting in a pair of jeans would be thought of as morally dangerous or capable of causing serious medical conditions? The controversy surrounding this image had the effect of increasing sales and there can be no doubt that the image was intended to create controversy precisely for that purpose. What does it say about our culture that a young woman sitting in jeans, not breaking any laws or engaged in any discernible activity, can cause such a (predictable) reaction of concern for young women and their morals? Why would the sight of the partially-clothed female body be regarded as having the potential to corrupt and cause

physical or moral danger? And, crucially, why has advertising been given the status of moral guide – as if we believe that the 'right' image could keep us from harm? Is the acceptance of this level of influence not a significant conflict of public interest, regardless of the product or how the brand chooses to advertise it? Why has the increasing corporatisation of public life gone all but unquestioned while we continue to moralise about the exposure to and appearance, shape and size of the (almost exclusively female) human body?

Personally, I am more offended by the ongoing policing of, and demonisation of, the female body than I am by pictures of bodies that are not like my own. I am more alarmed by the idea that young women cannot think for themselves and need moral guidance and policing that young men do not require than I am by the sight of a young person sitting in a pair of jeans, whatever their sex or size (Though of course the choices made so often fit the larger pattern – white young female). We have no such moral panic about the boys and men who are exposed to images of other men, whether they be fully clothed or naked (though there are many specific types of images of men we omit from popular culture, like those I referred to in the chapter 'The Beautiful Man').

When not singling out a particular scapegoat or source of corruption – Twiggy, Kate Moss, Paris Hilton, Kim Kardashian, Miley Cyrus, Beyoncé and so on; take your pick – the popular discussion of mainstream entertainment and advertising images tends to lean the way of either a) mass censorship of certain images and bodies, presumably with the aim that only acceptable bodies are shown (though one wonders who gets to decide that), or b) active participation in marketing a 'different look' for the purpose of selling products to a demographic who prefer their ads to look a different way.

In current discourse, the term 'real' is frequently employed in these campaigns. There is merit in encouraging a broader range of models and types of images (I encourage this), though pretending that 'unreality' in clothing advertisements is a key ethical problem strikes me as terribly misguided, when unreality is the essence of the consumer exchange. Notably, the kinds of ads we are talking about are the ones selling things we don't need. The ones that sell us things we do need – like washing detergent or vegetables – are rarely, if ever, targeted for being damaging.

When we speak of how unrealistic advertising images are – and magazine covers and editorials are first and foremost advertising, hence the list of products and prices listed in association with each image – we tend to assume that advertising images are less realistic now than they were previously, and that images are or at least *ought to be* realistic. This argument does not account for the fact that advertising was, until well into the fifties, traditionally made up of illustrations, and content was previously less – not more – regulated than it is now. It is only very recently that the idea that advertising images told the literal truth became popular. Like many people, I find the odd crooked tooth or freckle charming in older advertisements, and I wish for the return of those human qualities, not to mention some wrinkles, more size diversity, racial diversity and so on, but by the standard of 'real' used in many Photoshop debates today, literally all advertisements of the past were less, not more real than they are now, because they were drawn by commercial illustrators.

While we can reasonably believe that (distorted and in many cases problematic) depictions of real life can be found in storytelling – fables, fairy tales, documentaries, books, film and

television – and the role of cultural or moral teacher has long been tied to such mediums, advertising's role is quite specific. Perhaps changes in the aesthetic content of advertising images are not as significant as our changed relationship to those images. Culturally, we have allowed business and advertising to take centre stage, and those images have been created with increasing precision thanks to the wealth of knowledge about consumer habits and advertising effectiveness now at the disposal of big corporations. In many countries, more people now gather in shopping malls than parks, town squares or churches combined. It was the same for me. Growing up in Canada, we met at the local mall or at the convenience store after school. For many, the corporate has become the cultural and that part of our culture has indeed become powerful.

The very fact that we now accept the idea that it is normal to look to advertising to be culturally informed, to 'find' ourselves and help form our identity, and that advertising is an *unavoidable* part of our daily lives, a near-seamless wallpaper surrounding our experiences, is a relatively new development and is of great significance. And this creates a real, unresolvable conflict of interest.

Advertising images will only present an aesthetic someone finds more 'real' if they think that will do a better job of making us buy something. (The Dove 'Real Beauty' campaign, discussed earlier, is an example of this.) If you want to present the argument that we should be advertised to *differently*, I am all for it. Variety and diversity is lacking in the mainstream advertising world. Companies aim to give us what we collectively desire, and on that score it's worth noting that in European ads we tend to see more character, more wrinkles, irregular teeth and pale, natural skin. They use retouching sparingly for a different aesthetic (one I happen to prefer).

In advertising and the modelling of clothes in publications and on runways, it seems logical that adults model for adults and children model for children. I support the initiative in the fashion industry to stop using underage models or models known to be suffering from eating disorders, primarily because this is a clear issue of occupational health and safety. ('Known to be suffering from eating disorders', of course, is no guarantee at all, as these disorders are not always detectable and many people are just naturally thin.) As a consumer I'd also like to see more range of size, shape, cultural background and age reflected across media forms because it makes sense and, frankly, having all models look the same is boring and it doesn't make me want to buy things. So when MAC runs that ad with fifty-seven-year-old Jerry Hall looking drop-dead gorgeous in a Halston gown, I stop and notice, and I like it. I enjoy the image, but I know all the while that it's not, in the literal sense, real life I'm looking at. It's a product promotion. I'd rather see Jerry Hall with brightened eyes than not see anyone over twenty-five at all. I'm being sold to, sometimes rather well.

An advertisement would not be effective if it didn't make us feel we were missing out on something – the specific something it is selling. The Latin *ad vertere* translates roughly as 'to turn towards'. Advertisements exist solely to turn someone towards something, so that person acts in a prescribed way: buying a product or service, or, in political advertising, casting a vote for a particular party. As John Berger writes in *Ways of Seeing* (he describes all ads as 'publicity'):

> For publicity the present is by definition insufficient ... The publicity image which is ephemeral uses only the future tense. With this you will become desirable. In these surroundings all your relationships will become happy and radiant.[2]

This is the contradiction in so much advertising – it intentionally creates a lack, a sense of not being whole without the product.

Make no mistake. Advertisements do not represent *you* or any other real-life person. Ads represent products and the interests of the businesses who bought that media space. Will the product *actually* enhance our lives in the way the advertisement implies? Perhaps. But we must remain clear-eyed about the intention of the images while we enjoy these beautiful, glossy, ephemeral bits of product promotion.

The primary issue that has arisen stems from our *changed relationship* to advertising rather than any significant change in the content of that advertising. Although popular culture has for some time been tied up with things that could be purchased – a painting, a book, a movie ticket – only relatively recently has the advertising itself come to be seen as art, as a central part of our culture, as an influential educator and guide to life, part of our personal identities.

There is a clear and important need for reform within areas of advertising to increase business ethics and transparency, but I cannot bring myself to accept advertising as a moral influence or cultural teacher in the way fables, film, literature and other forms of storytelling have traditionally been. Advertising's avowed purpose must remain forefront in our minds when we encounter it. Enjoy it or despise it, but do not forget what it is, because if art and storytelling were once primarily used for guidance, even moral teaching, as a way of understanding the world and our place in it, how can we now hope to interpret the lessons in advertising? There can only ever truly be one message: *Buy.*

We need to ask ourselves: How did the advertising of products become so entangled with mainstream culture, our

ways of seeing and socialising, relating to our bodies and private lives? How did it become so entangled with female identity in particular? How did advertising cease to be a thing that existed to try to turn us towards something, but actually became as real to us as the thing itself?

As many of us move increasingly towards a lifestyle where we meet in shopping malls instead of public parks, where we discuss the content of commercial magazines – even commercials themselves – more than books; where our movie theatres offer us advertisements before our films instead of news reels or cartoons, and the actors in those films sell us skin creams and colognes; where we socialise online in the space between advertisements; where we are required to walk through banks of product displays to catch a plane and pass hundreds of advertising billboards on the way to work; and where athletic activity is contained between commercials (as with hugely popular televised sport) and adorned with banners and logos, we must stop to question this new, central role of advertisements. Does it suit us and what we want from our lives? Are these promotions still a convenience? If so, for whom? Is this a moderate exposure to commercial pressures? Is it the right balance? Do we want to be sold to, and if so, how often? How much do we want to buy? Where is the tipping point when it ceases to make us happy to buy, gaze at what can be bought, and buy again – or wish we could, if only we had the money?

Over forty years ago Germaine Greer wrote that 'Women must also reject their role as principal consumers in a capitalist state ... I am considering ways to short-circuit the function of women as chief fall-guys for advertising',[3] and all these decades later, with the measurable rise in the polarisation of wealth – a polarisation that serves most consistently to impoverish

women, children and the elderly, with the richest 10 per cent of people in the world owning 86 per cent of the world's wealth[4] – this consideration seems more urgent, not less. There is a place for advertising and consumption, for products, shopping and debt, but just how big a space in our lives should it inhabit? If people are truly being damaged by advertisements, perhaps one solution is to make it at least *possible* to avoid them.

So while we continue to debate, seemingly endlessly, the content of advertising and the ethical concerns raised by individual images and bodies, let's also have a broader debate. Let's ask ourselves: How much of our world and the living things in that world should be commodified? How much of our bodies, our lives and our public spaces ought to be decorated by and influenced by advertisements? Is our consumer-driven lifestyle, this constant looking to advertisements, really working for us, or are we working for it?

14

THE MOTHER

[E]ffectively telling women what is and isn't good for them, cuts to the heart of women's collective dignity and autonomy. While women were once routinely patronised in this way, the contemporary assumption is that those bad old days are behind us. Sadly, this does not appear to be the case when it comes to birthing.

Monica Dux, *The Age*[1]

'I died, but it was fine,' a woman at a barbecue told me when I was nine months pregnant.

She was a stranger, her story unsolicited. As I nodded and nervously sipped a glass of water, she explained that she'd suffered from pre-eclampsia, died on the obstetrician's table and been brought back to life. Not long before, at the Under the Blue Moon festival in Newtown, a mother of two had looked at my belly and declared, 'Well, you won't be writing books anymore,' as if having a child would stop me from being able even to put pen to paper, and, well, I guess it had only ever been a frivolous hobby all those years, after all. I explained that I wasn't planning on quitting work and she told me I would

soon learn that I was wrong. She even took to her blog to explain that my career was over but I 'didn't know it yet, the poor thing'. The 'you won't be writing' remark and the woman's death story were only two among numerous unsolicited comments that might have been enough to act as excellent birth control, had that ship not already sailed, at the ripe old age of thirty-six – already comparatively late in the piece, particularly for a woman who'd always planned to have kids. One family member, on hearing of my pregnancy, congratulated me and then immediately launched into a story in which a woman had her 'pelvis sawn in half' to accommodate the larger head of her baby. The alleged incident had taken place more than half a century before. 'I had two C-sections; I still can't sit up,' a waitress announced on seeing my burgeoning belly in my third trimester. 'You'll never be able to have decent sex again,' lamented one mother. 'Just say yes to the epidural,' warned another. A few days before the birth, as my husband and I were buying baby supplies, the woman behind the counter told me, 'The next time I see you you'll have matted hair and you'll hate the world.'

Wonderful.

As my first birth neared, the extreme birth stories increased, many of them told third and fourth hand by strangers, like a gruesome game of telephone.

There is a dominant idea in the western world that, for women, having a child ushers in an utterly new personal identity, bearing no relationship to whom she was before. The person with a career no longer feels ambition, if she is female. Likewise, the writer who is a mother no longer writes, or writes only about motherhood. And, perhaps most relevant to those final weeks before birth, there is also a dominant philosophy that birth itself is something women *survive*, not something they

actively participate in or, heaven forbid, actually enjoy. The Monty Python film *The Meaning of Life* captured this particular version of birth culture to much hilarity – not to mention disturbing accuracy – over thirty years ago, with comedians Graham Chapman and John Cleese dressed as doctors in scrubs, surrounded by expensive hospital equipment (including the machine that goes 'ping'). 'Don't you worry, we'll soon have you cured,' Chapman tells the panting woman enthusiastically, as she is in labour. When she asks, 'What do I do?', Cleese replies: 'Nothing, dear. You're not qualified.'

As fewer women experience vaginal birth, with caesarean births having more than doubled in the past fifteen years (now 32.3 per cent on average, more than 40 per cent in private hospitals),[2] fewer mothers will have a different story to tell.

Author Andie Fox recalls:

> I was sitting at the management end of the table, surrounded quite naturally by men, and we were talking vaguely about my pending birth. I told them how amused my partner and I were by our hospital's policy of prohibiting men from being naked during their partner's labour. Amused because a birthing suite was the last place my partner felt like getting his kit off, and amused because enough men had got naked during births to warrant a formal policy …
>
> The men at the table were surprised. All but one of them has children, and all but one of those fathers has children born in the last couple of years, however they all thought fathers routinely wore surgical gowns during labour as a precaution for mothers and babies. Why? Because all of their babies had been born via caesarean. It dawned on me then … among this group, vaginal birth itself was radical. You have to be very careful defining what is radical

and what is mainstream when it comes to legislation, especially when legislation is going to limit choices.[3]

Women who choose natural births (wherein medical interventions are minimised or avoided where possible, particularly elective surgical interventions such as episiotomies, forceps and caesarean sections, and the use of spinal and epidural anaesthetics that numb feeling – often all feeling from the waist down – during labour and birth) are commonly dismissed as hippies, insane or worse, so it can be easy to forget that the 'survive it; don't expect to enjoy it' mentality is not shared by everyone who has given birth, let alone women in countries where natural birth is more popular. In Nordic countries the caesarean rate is less than half ours, at 14 per cent, and in the Netherlands approximately 25 per cent of mothers experience planned home births in the presence of midwives, under a system that supports the practice.[4]

This willingness to accommodate alternatives to hospital care contrasts sharply with the reactions to Australian women who want to try water births or natural pain relief or who mention that they didn't need intervention or anaesthesia for their particular birth – basically, anything other than putting themselves in doctors' hands with no plan of their own. They are commonly told they are 'boasting', a 'zealot', or something called a 'Birthzilla'. Even having a birth plan can trigger this reaction:

'My personal view of birth plans is that they're most useful when you set them on fire and use them to toast marshmallows. But there are some women who live for them: I call them Birthzillas because just like a Bridezilla focusses on the wedding not the marriage, The Birthzilla appears more interested in having a birth experience than a baby,' Mia

Freedman wrote in the *Sunday Telegraph* in a piece on the decidedly ugly game of 'My Birth Was Better Than Yours'.[5]

Birthzillas, Bridezillas and perhaps all 'Zillas' are bad news. It's amusing stuff, but the thing is, birth plans are helpful for many parents, and an increasing number of obstetricians and midwives request them. There are a number of reasons for this.

The vast majority of Australian women choose to birth in hospital and not all hospitals have the same protocols. It is easy to imagine they would, but they don't, not from state to state and not even from hospital to hospital in the same city. Even individual health practitioners in the same facility sometimes do not follow the same protocols. For instance, unless specifically requested, many hospitals do not automatically offer valuable skin-to-skin time, where baby is simply placed on mother's chest straight after birth for about an hour, despite research showing substantial health benefits including increased success with breastfeeding and mother–baby bonding.[6] (I recommend this very beautiful experience and thankfully most hospitals will offer it on request, including in circumstances where mum has given birth by caesarean.)

You can put things like skin-to-skin in your birth plan, along with other important requests, including who you would like present during birth: 'I'd like my husband to be there to support me', 'Under no circumstances should my in-laws be allowed into the birthing suite' etc. If you want those things but don't express them, you may find bub whisked away for weighing and washing before you get the opportunity for skin-to-skin or your first breastfeed, and you might find your well-meaning mum-in-law wandering in when you aren't ready for company.

Do you want pain medication offered, or would you rather ask for it yourself? Do you want to avoid certain optional

medical procedures, like an episiotomy? Do you want cord blood saved for cord banking? The list goes on.

Women have the right to control what is done to their bodies, always, including during the intense process of birth when the body is arguably most out of our individual control. Informed consent is important in birth, as it is in our sexual experiences, in breastfeeding, and in the sadder times when illness and death take over. During all of these times it pays to be particularly clear about our wishes and requests, to ourselves, but most importantly to those who will be present for the experience – our carers, our partners, our midwives, our doctors, our families, our friends.

Clearly communicated requests about what we would or would not like to have done to our bodies is important, which is why birth plans are recommended by many obstetricians and midwives. These plans are not set in stone, of course, but it pays to write our requests down and talk them through with our chosen health practitioner beforehand because: a) we then don't have to worry about what unknown things will be done to us in various circumstances, as the different scenarios will have been discussed beforehand, b) our carers will know what our wishes are and can communicate them to all of the staff who will be involved in our care, and c) we are actively involved in the decisions made about our bodies and the bodies of our newborn children.

There is a lot of talk about birth in Australia, in the newspapers, on blogs and at medical conferences (some of which I have attended in my role as UNICEF's national ambassador for Child Survival and patron for the Baby Friendly Health Initiative), not just because birth is a major event, and that ideas about birth differ, but because, among other issues, birth is changing, with caesarean rates and other interventions on the

rise. Many of the procedures are requested by women who, thankfully, have the option in our medical system to make those requests (though again, it is not uncommon for a mother's wishes about what is done to her own body to be derided with degrading terms like 'too posh to push'). But many of the procedures are not requested by women, happening instead in the moment, and this is where it gets interesting: a report on the results of twenty-two international studies, published in a recent edition of the *Australian Health Review*, revealed something curious. It found that low-risk pregnant women being cared for by midwives were more likely to have a 'normal birth' than equally low-risk women being cared for by a doctor.[7] (I should note here that the common medical term 'normal birth' refers to a birth with little intervention, though I feel this terminology may be unhelpful, as it seems to imply that other types of birth are 'abnormal' or wrong. They are not.) According to Dr Meredith McIntyre of Monash University, this phenomenon, and 'the need to curtail the financial extravagance that comes from treating most women as if they need specialist medical care to give birth safely when many do not',[8] has prompted the federal government to announce major reforms of maternity care.

Cost-cutting is no reason to rob women of birth choices and there is no doubt that interventions save the lives of mothers and babies every day. In Africa, for instance, where the caesarean rate is only about 9 per cent, greater intervention would prevent a significant number of deaths. But the World Health Organization, which estimates the 'ideal' rate of caesarean births to be about 15 per cent, says there are concerns that go beyond the financial. WHO has found that women who undergo caesareans that are not medically necessary are more likely to die or to be admitted into intensive care units, require blood transfusions or encounter complications that lead to

hysterectomies. In China, nearly half of women give birth by caesarean, a rate WHO blames in part on the higher fees paid for the procedure. WHO findings in developed countries suggest 'the importance of a previously under-recognized model for determinants of caesarean section, one related neither to supply or to demand factors but rather to the health system itself.'[9]

While headlines in Australia brand any woman who gives birth outside of hospital as an extremist – rarely specifying the difference between, say, a planned and medically supervised homebirth and 'free birth' (the practice of birthing without a medical attendant), with claims like: 'But homebirthers are zealots, carried away with a quasi-religious fervour, and unhinged when it comes to unleashing vitriol on anyone who dares to criticise their selfish choice'[10] – a look at recent studies and international practices shows the issue to be more complex. In Canada, a study that examined 2889 home births attended by registered midwives in British Columbia and 4752 planned hospital births attended by the same group of midwives, compared with 5331 births in hospitals attended by doctors, concluded that 'women planning birth at home experienced reduced risk for all obstetric interventions measured and similar or reduced risk for adverse maternal outcomes'.[11] In 2009 the largest study conducted into home births – examining 529,688 births and published in *BJOG: An International Journal of Obstetrics and Gynaecology* – concluded that home births for 'low risk' or normal pregnancies (single births, not breech etc.) were just as safe as hospital births.[12]

The more you look into the subject, the more you realise how much women's choices over their bodies have become deeply politicised, with various medical systems making certain birth choices illegal and not others. For instance, a woman can fail to make it to hospital in time, and birth at home or on the

side of the road without any assistance whatsoever, and that is just fine, legally speaking (though it is obviously a potentially nightmarish unplanned scenario for the woman and baby), but if a woman actively chooses to birth outside a hospital with a midwife, something that has been done for centuries, in a number of countries that midwife can be jailed for participating. For instance, in one famous international case, Dr Ágnes Geréb – a Hungarian gynaecologist, midwife and psychologist who founded the Napvilág birthing centre, is the pioneer of fathers' participation in births at both hospital and home in Hungary, and has helped deliver 3500 babies at home – was held in maximum security in a Budapest prison, and at the time of writing is under house arrest.[13] Combine this policing of women's birth choices with the fact that elective caesareans are painted by some as 'lazy' and 'selfish' in the mainstream narrative, planned homebirths are painted as (again) 'selfish' and 'irrational', and even having a birth plan can see you branded a 'Birthzilla', and it's clear that the issue of women's bodily autonomy, particularly as it relates to reproduction, is far from settled. This is, let's face it, a rather familiar topic for women's rights.

The experiences of women in birth vary enormously, and the perspectives of maternity caregivers also vary. One mother I interviewed said of her birth: 'I chose an elective [caesarean] because as a doctor I did gynaecology terms and then I did a postgrad diploma in obstetrics: I saw all the worst cases that women have to go through.'

Dr Hannah Dahlen, professor of midwifery at the University of Western Sydney, has a different outlook.

The amazing thing for me is [that] after twenty-four years of working mainly in hospitals and seeing so much fear, I now

hardly ever see it when women birth at home ... Women
get to climb their own Everest in birth and we rip them off so
often by not putting into place systems of care and birth
environments that will enable them to get there.[14]

Whether or not a woman wants to 'climb her own Everest' (or
whatever analogy you wish to use) is up to *her*. Some women
want to birth at home and many do not. And some women
would rather skip the process of birth altogether if they could,
while others cling to a kind of 'just survive the experience'
mentality – just get it over with, and come out alive. Given that
women still die in childbirth around the world – albeit mostly in
developing countries – this fear, though it may be extreme for
some, is not entirely irrational. I was one of the 'just survive it'
mentality, which may be unsurprising after so many dramatic
stories reinforced my every fear before and during my pregnancy.
Then I attended a course called Calm Birth (I paid the standard
fee like everyone else who takes the course and no, I am not
being paid to spruik it). Calm Birth was recommended by my
obstetrician, who had found that it regularly helped reduce birth
trauma and medical intervention in her patients, ultimately
leading to better health outcomes. In the end I was able not only
to survive the birth of my daughter but enjoy it, and in my case,
none of the extreme horrors I'd been led to expect came to pass.
All that fear-mongering – the talk of death, sawn-open pelvises
and the claim that I'd never have decent sex again, or write
another book – had been entirely misleading and unhelpful.

I later realised that apart from that birth class and the
gentle reassurances of my obstetrician, I had not heard one
single positive birthing story. Not one.

On one level, the 'just survive it' mentality and rising fear
of childbirth is paradoxical, as perinatal morbidity and

mortality for mum and baby have become very rare, particularly in countries like Australia, where birth outcomes are considered to be excellent, with about seven women per 100,000 dying due to pregnancy, birth or postnatal issues.[15] We have a perinatal mortality rate of less than 1 per cent across all births, with most of these deaths attributed to prematurity or congenital malformations.[16] Low-risk women have only about a one in 1000 chance of losing their baby in labour. Yet I was far from alone in my fears. According to some experts, tocophobia, or fear of childbirth, is on the rise. A reported 80 per cent of women express common childbirth anxieties and up to 10 per cent of women report 'pathological levels of fear'.[17]

In today's confessional culture, extreme stories are always retold with greater frequency than those that are more common and positive. The 'I died, but it was fine' mum had been telling her story to unsuspecting pregnant women for two decades. But perhaps the oft-repeated war stories about birth aren't as harmless as some believe. In otherwise healthy and normal births, fear can lead to low levels of oxytocin, a hormone involved in lovemaking, breastfeeding and in the normal stages of labour. Fear is also known to lead to lower levels of pain-relieving endorphins and higher levels of adrenaline, which can lead to panic, increased pain, lengthening labour and foetal distress.

Obstetric physiotherapist JuJu Sundin says, 'The fear each woman has as she enters childbirth will have a direct relationship to the progress of labour.'[18] Further confirming something many midwives and doctors already know, a study published in 2012, looking at 2206 women with intended vaginal births, concluded that 'Duration of labour was longer in women with fear of childbirth than in women without fear of childbirth.'[19]

A study published in 2013 titled, *Why Are Young Canadians Afraid of Birth?* connected attitudes towards birth to 'the larger socio-cultural context into which young adults are socialised. We hypothesised that young women and men, who have been socialised into a birth culture characterised by medical management and over-use of obstetric technology would express loss of trust in normal physiologic birth and exhibit fear of birth.'[20] They pointed to unrealistic media portrayals of birth among other issues.

I recall one of my closest friends telling me years ago that if men had to give birth, caesareans would be mandatory. I had believed I would want to have a caesarean, until my own experience changed my mind, not because childbirth was necessarily my own Everest, but because it was an extraordinary moment in my life, something I will never forget and will always be part of me, and something I may only ever experience once. I am glad I had the chance to know childbirth in that primal, embodied way.

Birth is different for everyone. My experience does not define your experience and vice versa. There is no right or wrong way to approach birth – whether that means a planned caesarean or a medically supervised home birth – as long as we make informed choices. More than ever, women need to consider what is right for them and their babies, and what is right for their own bodies. As women we should share, communicate, be heard, be realistic about the broad range of experiences that birth can involve and support one another, but we must drop the social convention of unloading the most extreme birth war stories we know – some of which took place under vastly different circumstances, and have only been heard fourth- or fifth-hand – to every pregnant woman we meet. And we should not stand idly by while women's birth

choices, choices over their own bodies, are dismissed as unimportant or made legally untenable.

When I talk with a pregnant woman I often say, 'I hope you have a beautiful birth and a healthy baby.' And I do. Maybe it will be a beautiful birth for her, maybe it won't, but in any event, it will be her own.

Sometimes there is a pregnancy, but no birth.

I am ashamed to admit that I wavered on whether or not to write about this subject.

When I started writing this book I had thought about writing something of my miscarriage in 2009. Later, I changed my mind. It was too dark and unwelcome a memory, and now I had a little girl, had started my own family, and I was not keen to revisit that experience.

And then it happened again.

For only two sweet days my family and I had been delighted by the news of a positive pregnancy test. I'd felt the changes in my body one night and I knew. I could feel in my body that something was different, just as I had with both of my previous pregnancies. And then there it was in the morning, that crucial second line on the store-bought pregnancy test. We were in Hawaii, with family gathered from three continents to holiday together and celebrate my fortieth birthday, and there was no way we could have hidden our joy. We celebrated over dinner with a round of cocktails (mine virgin) and I thought about what would need to happen in my life to accommodate this very welcome news. I'd have to sell my apartment as soon as possible, as our family income would be reduced by somewhat more than half. I'd have to push back the publication of this book, as it would come out when I was due to give birth. We wanted a second child. It was really happening. We were excited.

Had I waited another two days to take a pregnancy test I might never have known with absolute certainty that I was pregnant. I may have strongly suspected it (I know my body well enough not to miss the signs) but I would not have known for sure. But at the airport, having said goodbye to my sister, my father and stepmum, my body told me that things were not right. I was bleeding and there was no escape. We were already in the gate lounge, among the rows of identical chairs, illuminated with artificial lights that reminded me, too much, of a hospital waiting room. There was no space. No place to cry. We had to catch a plane in an hour. It was time to go home, with one fewer than I'd thought we were becoming. All I could do was buy sanitary napkins and try to come to terms with what was happening inside my body.

I reminded myself of the good things in my life, counting them in my head one by one, like the knotted threads on a lifeline. Throughout this I had the significant comfort of my two-and-a-half-year-old daughter running back and forth in front of me, giggling and shouting, undeterred by our early wake-up that morning. I thought of all the women who, like myself, had always wanted to have children, yet did not have the comfort of their own healthy child when they miscarried. I knew this from conversations with friends, but most of all I knew because the last time it happened to me, I did not have that comfort either.

I had miscarried four years earlier, shortly before I got married. I was living with my husband-to-be, Berndt, in my flat in Sydney when two pink lines explained my slightly swollen belly and my late period. I'd taken tests in the previous weeks and they'd come up negative. But something seemed to be up and so there it was.

Two pink lines.

I had never seen those lines before and let me tell you, if you are a woman who hopes to one day have a family, the first time you see them it is thrilling and frightening and wonderful. My fiancé and I were intoxicated with joy at the news. Yes, it was before we'd planned to become pregnant and our wedding was only a couple of months away, but we were damned excited. I'd wear a muu-muu for a wedding dress if I had to. I didn't care. The experience of being pregnant for the first time was remarkable, truly. We told our families, though swore them to secrecy. We were too thrilled to hold it in.

Hello, you
Almost a person
Swell of my belly
My genderless, nameless hope

Faced with that first, exhilarating news of pregnancy, I managed to forget that I'd only just recovered from a urinary tract infection (a common risk with pregnancy, I later discovered) and that before I'd known I was pregnant, while the tests still came up negative, I had taken medication for a fever. Aspirin. A lot of it. As I now know, it may be safe to take some paracetamol during pregnancy, but not aspirin.

When the pregnancy test came up positive a week and a half later, all that was forgotten. I was too overjoyed to think about what I'd just been through. All I knew was that this was my first pregnancy and I was going to be a mother. But my doctor was uncertain. Thinking back, I remember the look in her eye, her quiet caution. She set up an ultrasound for the following week and when the day came, the day when we would see our pregnancy on the monitor, we walked to the clinic from my city apartment, marvelling at the little swell in my belly, holding hands, giddy.

What we found in my womb, instead of a growing child, was a sac without a heartbeat.

I saw it on the monitor for only a moment, before they removed the ultrasound wand and told us they were sorry. Berndt had been holding my hand, and I just remember saying, 'That's terrible news,' and falling silent. There was something inside me that had never become someone. Something foreign, and yet inside me. It was horrible and I had not seen it coming at all. Pregnancy was supposed to be a joy. The ultrasound clinic gave me time to cry it out, and then the doctor booked me in to a hospital to have it removed, only a few days later. I wept when they put me under for the dilation and curettage, after several blood tests – performed at my insistence – showed the diagnosis to be absolutely true. The hCG hormones were falling. The pregnancy had not developed. There was no blood flow.

A sac with no one in it.

For some reason, the worst part about the experience, the thing that sticks in my head, was that although everyone was very professional, before they put me under a young nurse asked me a list of questions. One of the questions she asked was, 'Are you pregnant?'

There could hardly have been a crueller question.

'*Am I? Pregnant?*' I repeated incredulously, unable to find any other words.

I guess they always ask this before giving a patient a general anaesthetic, but I was blindsided. I didn't know what to say. Yes and no was the answer. If I took a pregnancy test that day it might come up positive, as some of the hCG hormones were still present. But the hormones were falling, because the pregnancy had failed to develop. That was precisely the thing, wasn't it? Why else would a woman be booked in for a D&C

other than to clean out her uterus so she wouldn't get an infection or suffer a long and drawn-out bloody miscarriage?

They say when you first miscarry you lose your innocence about pregnancy. It was that way for me. The roses and balloons and pink and blue Hallmark cards don't really cover it. It's also tears and blood and uncertainty. The cycles of reproduction are grand and yet common, extraordinary, heartbreaking and life-affirming. Pregnancy is life or death, and sometimes both. The brutality and beauty of the way we all come into the world – every last human being – is something truly fragile and beautiful. And mysterious. For all the science we throw at it, with all the control we like to believe we have over our lives, this is the one thing that can't quite be nailed down. It's a roll of the dice, every time, even for the healthiest and luckiest of us.

You never were, except to me.

Four years later, at the small Hawaiian airport, waiting for a flight after a long and much-needed family holiday, I was faced with what appeared to be my second miscarriage. Not an invisible one like the first time, where naively I had not even imagined it would happen to me and it took an ultrasound monitor to make it clear, but something I could feel. Something I could see. I'd only just said goodbye to my father, who was about to fly back to Canada. I had not seen him in over a year, and it would be a year before I saw him again. He'd been so happy when I told him I was pregnant that the tears were visible in his eyes. After such a joyous family holiday, and the wonderful news that a baby was coming, I was in the airport miscarrying as I waited for the plane. I could feel it drain out of me and the brutality cut me to the core.

Some life-changing things, because of their innate darkness and intimacy, and also because they are exclusive to the female

experience, are rarely talked about publicly. Until relatively recently, it was taboo to show off a pregnant stomach or even to discuss the details of pregnancy and childbirth. My father had been banished to the waiting room for my sister's birth, though only a few years later, they allowed him to attend mine. Even to this day, reproduction is misunderstood by many, reproductive rights remain a hot topic, and even sex education and contraception remain highly controversial in many places. Miscarriages are not discussed in public with any ease, or at all. Like so many of the experiences related to sex and reproduction, this common experience remains all but invisible.

While on holiday in Hawaii, newly pregnant, I spotted a woman with a beautiful pregnant belly, wearing a bikini, and my stepmother explained that she'd worn a popular pleated style of dress in the early seventies that hid her stomach so well that even close family friends did not know she was pregnant until she was in the hospital after the birth. Pregnancy was simply not discussed and a swollen belly was something to be hidden. Often, pregnant women avoided being seen in public at all. Things had changed a lot, she told me, and in many ways they have.

In other ways, though, things haven't changed nearly enough.

Interestingly, it took becoming a parent myself, and becoming a writer on issues of maternity, breastfeeding and child survival for UNICEF, before most of my friends' experiences with miscarriage became known to me. One friend confided in me that she'd fallen pregnant to her boyfriend and miscarried on the way to my wedding – just a couple of months after I'd had that first miscarriage. Another friend had a surprise pregnancy with her boyfriend and gave birth to a healthy baby girl, but

when she tried again, experienced six miscarriages in just one year. She kept a little rock on her mantelpiece to represent each one, needing some tangible way to acknowledge them. Another close friend became pregnant with a third child and when the doctor explained that the foetus was not healthy and would not survive in the womb, she 'flipped out completely', as she put it. She told me she'd never seen herself like that. Yet another friend was in her eighth month of pregnancy and laboured through a stillbirth. Of those friends, few of them had told anyone except their doctor and their partner at the time. For most of them, it took many months, even years, to be able to talk about it. Had they been in a car accident or fallen and broken so much as a thumb, they would have felt free to discuss what had happened as soon as it had occurred and would have been receiving commiserations as they healed. But many women tell no one at all about their pregnancy until they show in the second trimester, and may not even tell their husband or partner when they miscarry.

One friend expressed her disgust with the common saying 'she lost the baby', as if somehow the woman had misplaced her foetus in a moment of profound forgetfulness. Another explained how barbaric and impersonal the medical terms for miscarriage were. There is something called a 'blighted ovum', when the fertilised egg implants in the uterus but doesn't develop. 'Blighted', of course, is also a term meaning spoiled or diseased, and is used to describe the condition of a rundown urban area. Blight is a plant disease. Then there is the spontaneous miscarriage, like I had in the airport, which doctors refer to as a 'spontaneous abortion', despite the association with medical terminations that are carried out for unwanted or unsafe pregnancies. There is also the kind of miscarriage, like my first one, called a 'missed abortion', when

the pregnancy has naturally terminated before the twentieth week but the body has not expelled it. 'Silent miscarriage' is the preferred term, but many doctors still use the term 'missed abortion', and I saw it on my medical paperwork.

I remember how incensed I was by the testimony of US Republican politician Terry England, when he voted in favour of the so-called 'fetal pain' bill, House Bill 954, that would ban all abortions after twenty weeks, robbing women of reproductive choice even in cases where the baby was not expected to live, effectively forcing women to carry stillborn foetuses. In his testimony, he said, 'I've had the experience of delivering calves, dead and alive – delivering pigs, dead and alive … It breaks our hearts to see those animals not make it.'[21] I recall the doctor who performed the D&C to remove my first miscarriage, and how she gently explained the importance of making sure the body was not carrying dead tissue, because it could cause infection. And then there was this politician, comparing women to cows and pigs, and expressing his sympathies with farm animals as he tried to restrict, by law, with penalty of imprisonment, the possibility of doctors removing the dead foetuses from women's bodies. Psychologically, not to mention medically, it was a barbaric sentence to try to place on any fellow human being.

In 2009, when I'd called my family in Canada to tell them the sad news that I had miscarried, I remember my father telling me that no one in our family had miscarried before. He seemed really to believe this was true, as if he would somehow know the history of all of the pregnancies and miscarriages in his family tree. He genuinely wondered why it had happened to his daughter when we didn't have a family history of miscarriage. I knew that he was thousands of miles away, across a crackling phone line, trying to deal with news that

made him both sad and puzzled, but it stung. This is the deception that comes from the taboo around miscarriage, the deception that allows us to think that miscarriages only happen to *other* people. Because we do not talk about it, particularly with men, most people do not know how common it is. March of Dimes – a non-profit organisation concerned with the health of mothers and babies – estimates that half of pregnancies end in miscarriage, often before women even know they have missed their period. Once that first trimester is over, the risk drops significantly. (The majority of medical sources estimate that less than 5 per cent of pregnancies end in miscarriage after that first crucial trimester.) According to most estimates, about one in four or one in five known pregnancies end in miscarriage. The real numbers are hard to calculate, of course, because many people don't know they are pregnant before a miscarriage shows as a late, heavy period. And because, well, we don't often talk about it.

One reason we don't talk about it is that miscarriage is personal and often intensely difficult news for someone who hopes to have a child. The other reason, I believe, is internalised shame. As with most subjects on which we remain silent, the silence connects with a feeling of inadequacy and personal grief. Many women experience a concern that others will see them as a failure or 'damaged' in some way if they reveal they have experienced a miscarriage. Then there are inevitable questions of 'What happened?' (or *What did you do wrong?*) when there are often no answers, or the internalised question of 'What's *wrong* with me?', one that can come up so often in life but is especially brutal in matters of reproduction, as if unless we are able to reproduce, we don't quite fully exist ourselves.

Sometimes there is a reason for the miscarriage that can be identified – a health condition or, in the case of my miscarriage

in 2009, an infection and medication that interrupted the fragile early stages of development. But often there is no clear reason at all, and the body has simply decided it is not the right one, or the right time. The vast majority (an estimated two-thirds) of early miscarriages occur because of chromosomal problems in early development. With pregnancy tests now being widely available and increasingly accurate, women can know they are pregnant long before they would have in the past. Increasingly, this knowledge will come very early. Some chemist packs, like the one I used, claim to be accurate six days before your missed period, little more than a week after conception. Because the confirmation comes so early, perhaps as much as half of the time it will end something like it did in that airport for me – with a woman knowing without a trace of doubt that she was pregnant and now she is miscarrying.

> Decades ago now, I had an abortion. I wasn't happy
> about it. I felt it was deeply unfair … we had been using
> contraception but, as it occasionally does, it failed …
> For the few weeks that the pregnancy lasted I always felt
> it had happened to my body and not to me.
>
> Jane Caro[22]

People often ask how many children a woman has, but rarely if ever do they ask how many pregnancies she has had. The number of pregnancies is likely to be different – either because of wanted pregnancies that did not progress, or unwanted pregnancies that ended in abortion or adoption (where the woman is not encouraged to think of the child as her own). Though the experiences of miscarriage and abortion differ significantly in some ways, and at the time of writing I have experienced one twice and the other not at all, both situations

are emotionally loaded and life-changing, and both are the result of something happening to a woman's body against her will. At least half of my close friends have told me their experience of one or the other, or both, but only after some prompting.

The difference between having a child or not is one of the most significant variables in any person's life, and as the pregnancy happens within the woman's body and no one else's, and as child-rearing responsibilities are still disproportionately allotted to the mother (unreasonably, I believe; men and women can both be excellent parents and carers), the effect on a woman's life can be dramatic. For some, it can mean profound social marginalisation and being ostracised by family members who disapprove, and for many women, particularly those who are younger, it can mean a lack of access to education and work opportunities, resulting in financial insecurity for life. For others it can mean health complications, even death.

The pregnant woman trying for a family has her fate changed dramatically by the miscarriage or stillbirth that determines that she will not, in fact, be having a child. (*This time*. The majority of women who experience an unsuccessful pregnancy will be able to have a healthy pregnancy and child.) The woman who finds a pregnancy progressing in her body, whether it was planned or whether it is a surprise, likewise finds her fate changed, and is faced with reimagining both her short-term and long-term future in a way that the father of that potential human being will not. This is true of even the most stable and equal partnership. For the few days before my second miscarriage I ran through various issues and consequences: the time I would have to take off work in the near future; pushing back publication dates; how we would pay the mortgage given the decline in my paid work; the

possibility of selling property to cover the costs of supporting my family; the anticipation of morning sickness; the recognition that I would not be able to, or would not feel well enough to, travel or work for a period of a couple of months or much longer, depending on the pregnancy; the knowledge of the blood tests to come (I'd felt like a pin cushion during much of my first successful pregnancy, particularly as I was thirty-six years old and regular tests are considered the standard of care); the emotionally charged ultrasounds (Will the baby be okay? Does she have all of her vitals?); the impending roller-coaster of hope and worry. In my case this was all tiny compared to the prospect of the child that my husband and I had hoped for and could afford to care for, but all of these issues and more needed to be considered and adjustments made.

And all of them evaporated when I miscarried.

Such are the misunderstandings about women's reproductive cycles, the lack of knowledge about pregnancies, how often they occur, how they develop and how frequently the body ends them, that politicians (i.e. those who actually create the laws that apply to everyone) have been known to voice their opinion that a foetus is 'a person' at 'zero weeks of pregnancy', even though zero weeks represents the first day of the woman's last period, and ovulation and fertilisation occur roughly two weeks later. (Being six weeks pregnant indicates that a pregnancy has been progressing for four weeks, not six).[23] In other words, the woman has not even had the sex that will make her pregnant yet. Bills like US House Bill 212, known as the Sanctity of Human Life Act, which seek to define a fertilised (or cloned) egg as a person from the moment the sperm enters the ovum, rather than when the foetus is considered medically viable, insist that a fertilised egg that has

not even yet attached to the lining of the mother's womb has more legal rights than the woman herself. Bills like this can not only make reproductive choice illegal, but also criminalise many forms of birth control, as well as miscarriages and stillbirths. When laws, and the personal beliefs of politicians or doctors, elevate the wellbeing of the foetus over the wellbeing of the woman, women inevitably suffer.

> [I]t was a shock turning up on the day to discover another pro-life protest: placards, loud hailers, and mounted police. As a woman alone, I felt threatened, frightened, and vulnerable. But nowhere near as vulnerable as the women who risked their lives in back yards with coat hangers or knitting needles … No one 'wants' to have an abortion.
>
> Tracey Spicer, The Hoopla[24]

The blanket ban on abortion in El Salvador, for instance, has the result of turning women who miscarry into murder suspects: 'According to data from the Citizens' Group for the Decriminalization of Abortion, more than 200 women in El Salvador were reported to the police for miscarriages between 2000 and 2011. Of these women, 129 were prosecuted and 49 were convicted, some receiving sentences of up to 50 years.'[25]

There is a similar outcry in America, where thirty-eight of the fifty states have introduced foetal homicide laws ostensibly intended to protect pregnant women and their unborn children from violent attacks by third parties (generally cited as violent domestic partners), but that are being used by prosecutors against the women themselves. The group National Advocates for Pregnant Women estimates there have been up to 300 women arrested for their actions during pregnancy, but has found only one case of a South Carolina man who assaulted a

pregnant woman having been charged under the law – and his conviction was overturned.[26] At the time of writing, thirty-four-year-old Bei Bei Shuai has spent months in a prison cell charged with murdering her baby after she tried to end her life while pregnant, by taking rat poison when her boyfriend left her.[27] Strict abortion bans lead to preventable deaths of women, either by forcing them into the hands of unqualified 'back room' abortionists, or by preventing appropriate treatment in hospital, as in the case of thirty-one-year-old dentist Savita Halappanavar, who died of sepsis in 2012 in an Irish hospital after being denied an emergency abortion after presenting with a miscarriage at seventeen weeks of pregnancy. She was in hospital under medical supervision for a full week before she died.[28] The official report showed that doctors had been worried that they could fall foul of criminal law if they saved the mother by aborting the miscarrying foetus. Unfortunately, it would be incorrect to assume that something like this could not happen in Australia. As Dr Leslie Cannold writes:

> In Australia a pregnant woman scheduled to give birth at a Melbourne public hospital run by Catholic Health Australia was devastated when her membranes ruptured too early, dooming the pregnancy and her non-viable foetus. Denied both standard care options of medication to speed delivery or surgery to end the pregnancy – and unable to transfer to another hospital – she was forced to wait nearly a week until sepsis was diagnosed [before] the foetus was removed.[29]

You don't want to believe it is possible, but this is happening now. The existence of cases like these, and the legislation that supports it, require a belief that the situation could never happen to us, or to anyone we love. That belief is only possible

if we think such situations are extraordinarily rare. That belief is only possible if we believe the *fictions* about pregnancy.

Perhaps the most profound similarity between the experiences of unwanted pregnancy and unwanted miscarriage is that both are common experiences for women who share their sex lives with men. Both experiences carry emotional weight and, for many, a sense of grief and shame. And both are kept secret.

This is why I needed to write about my miscarriages. If we don't talk about this experience more freely, we won't talk about how to support women when this happens. The taboo around miscarriage is also responsible for the taboo around early pregnancy that leads many women to try to hide symptoms like swelling bodies and morning sickness in the first trimester because they don't want to announce their pregnancy in case it leads to miscarriage. It is a common convention to announce a pregnancy only after the first trimester, though we don't often mention *why* that is. We don't talk about it. One friend of mine passed out at a lectern in front of a crowd of people early in her first pregnancy. Though some of the women in the audience might have guessed the reason, she felt she could not simply come out and explain why she had passed out.

As a result of this taboo, these ongoing fictions about pregnancy, women around the world suffer dizziness, nausea, and even fainting spells in silence. Enough.

Back at home after the Hawaiian trip I could finally do the crying I couldn't do in the airport.

After a week or so of feeling unusual fatigue and a touch of nausea (both common signs of pregnancy), my hormones were slowly levelling out, hour by hour. I had miscarried a very early pregnancy. With the news confirmed by my doctor, I

was able to grieve and start to come to terms with it. And this time, because of my previous experience and what I'd learned from it, and because of the discussions I'd had with my father, and what he'd learned, I had a completely different experience when I told my family the news. This time we had the tools to understand what had happened and were able to deal with it and support one another, and it brought us together. I felt far better for talking it out with my loved ones, and I feel far better for writing about the experience here (as for many writers, the page has been a solace throughout my life).

A few days later, I was scheduled to appear at the Sydney Opera House to speak on a panel as part of the Festival of Dangerous Ideas. I had been looking forward to participating – particularly as I admired my co-panellists, Emily Maguire, Dan Savage and Christos Tsiolkas – though I'd had no idea I would be going through something like this. My family were a great support, and though I wasn't quite through the physical experience of the miscarriage yet – I was still slightly nauseous and suffering from light cramps – I felt I could cope. As it happened, just before we went on stage one of my fellow panellists, Seattle sex columnist Dan Savage, explained to us that he had been up all night vomiting due to food poisoning. He hadn't slept and warned us that he might need to leave part-way through the session to be ill. We all expressed our sympathy and understanding.

It occurred to me that if we had a different relationship to the realities of miscarriage, it would be possible for me to explain that I was unwell because I had been miscarrying, and might need to excuse myself if overcome by nausea, dizziness or severe cramping. But of course I said nothing. It felt surreal to step onto the stage, but the session went off without a hitch, and both Dan and I made it through, the audience none the wiser.

Slowly, I was getting to the other side.

And so was my husband, Berndt:

> As an event, it's important. There's so much hope when you
> first find out about the pregnancy, and then so much sorrow
> with a miscarriage. But it's given the status of a non-event:
> you don't tell anyone your partner is pregnant, just in case it
> doesn't work out, and then when this fear is realised, and
> you're gutted by it, you can't say anything. But talking it
> through with friends helped to make it real: something that
> happened, something sad, which I could then get past.

By keeping these discussions taboo, we rob people of the basic
support and understanding necessary to deal with their loss.
By keeping these discussions taboo, we force women and
families to suffer in silence.

<div align="center">*</div>

> In modern consumer society, the attack on mother–child
> eroticism took its total form; breastfeeding was proscribed
> and the breasts reserved for the husband's fetishistic
> delectation. At the same time, babies were segregated, put
> into cold beds alone and not picked up if they cried.
>
> <div align="right">Germaine Greer, Sex and Destiny[30]</div>

I never thought I'd say it, but these days I love mornings.

As the sun comes up, my daughter crawls into bed, cuddles
me and breastfeeds. Sometimes we play or doze off more than
feed, while other times she seems earnestly in need of the
sustenance and comfort my breast milk brings her. Occasionally,
we skip a morning, even a weekend, but for two years now,

nearly every morning (and many afternoons and evenings, too) we hold each other this way.

We very nearly missed out on this experience. When I was a new mum having trouble breastfeeding, I could not have imagined how relaxing and easy breastfeeding would one day be. Now I often wonder what we'd do without it – like when we travel on planes or to unfamiliar places and she needs settling and the reassurance of that connection, or on those days when she seems to take particular comfort in me, and me in her. (It works both ways for us, the comfort of breastfeeding.) The World Health Organization recommends exclusive breastfeeding for the first six months of a baby's life, followed by the introduction of solids along with continued breastfeeding 'to two years of age and beyond'. They cite numerous health benefits, but honestly, if breastfeeding my toddler no longer had a single measurable health benefit, I'd still do it. For us, it's been a lifesaver.

I'm lucky that I had the right support to ride through the difficulties and doubts in the early weeks. Many women do not. About two days after giving birth I was asked in hospital to start expressing milk, but I was not very successful at it. My daughter was also prescribed formula 'top ups' in the hospital by a paediatrician. I now realise that this was before my milk even 'came in'. (In fact, milk is already there before you give birth, even if you don't plan to breastfeed. But a marked increase in volume usually arrives three to five days after the birth, which many refer to as your 'milk coming in'.) Days later, when we took our daughter home, we were still breastfeeding and formula-feeding her as the doctor recommended, but she was not putting on weight, had grown sickly and was covered in a rash. The doctor, via a visiting nurse, ordered us to give our newborn girl more formula, so

we did. But we felt something wasn't right. Weeks passed with our daughter crying all the time, vomiting, and barely sleeping. We were all sleep-deprived and stressed out after what had thankfully been a good, healthy birth. She'd been an average weight and now she was unwell. What was making her sick?

As we looked for answers, a visiting family member told me there was something 'wrong' with my milk. She suggested I quit breastfeeding and related how she'd formula-fed her boys in the 1970s and it was the 'best thing for them', and had also recommended her children avoid breastfeeding and give formula to their children. Apparently a doctor had told her, forty years before, that her milk was 'bad', and all these years later she still believed it and believed it of other women's milk, too. She repeated this story to me each day, urging me in less-than-subtle terms to do what was 'best'. I tried to ignore her advice, because after reading government health websites I'd learned that in the 1970s that kind of misinformation was common in hospitals in North America, the UK and in many other countries (recorded breastfeeding rates were at their lowest in that period, before WHO codes changed the practice of giving formula to healthy babies in hospital, leading to higher breastfeeding rates since) and such myths about 'bad milk' had now been debunked. Still, I knew that in some cases women couldn't breastfeed. I heard the stories all the time in the media. Was this the case for me? Was I not providing enough milk? I was a new mother and still trying to learn to breastfeed, but I felt certain that I at least *had* milk. I could feel it in my breasts, even if expressing in the hospital had only provided small amounts. I didn't know what to do so I followed the doctor's advice and hoped that things would resolve themselves, one way or another.

By now our daughter was being weighed twice a week, as she still wasn't gaining sufficient weight. 'Failing to thrive' was

the term used. This had gone on for weeks despite the increasing amounts of formula top-ups, and my best efforts to breastfeed. Again, the doctor told the community nurse to get us to formula-feed more, and she let us know this during one of her twice-weekly visits. Finally, we indicated to her that we were not happy with the doctor's advice, as our daughter was not doing well. So the nurse decided to try a little experiment. She weighed our baby girl, who was crying and tiny. Having been born a healthy weight, she looked so vulnerable in that weigh scale, wrinkled and skinny. I'll always remember how dry her flaking skin looked, and how frail and upset she was. Then I held her and breastfed her on just one side while the nurse observed the 'latch on'. She weighed her again. Our daughter put on a significant, measurable amount of weight. I had milk, lots of it, and it was getting to our daughter normally. The nurse had actually managed to weigh it. Our girl could breastfeed after all, and I had milk to give her – it was just that, in hospital, having only just given birth, breast-pumping into a plastic bottle was not something I'd been good at. (Apparently this is common. Some women are better able to express milk than others, particularly in the early days. It is, after all, an unnatural process to attach a plastic cup to your nipple and try to get milk out with a loud pump.)

We told the nurse that we were going to try to exclusively breastfeed our child as all the medical associations and the World Health Organization recommended. We dropped the formula top-ups that had started when she was barely forty-eight hours old and her condition changed almost overnight. The rash and flaky skin disappeared. She had often vomited after the formula and now she wasn't vomiting at all. She slept. She cried much less. We all did. Now that she could sleep and keep the milk down she put on weight. For us, the turnaround

in her health was nothing short of miraculous. She'd reacted badly to the formula top-ups, as some kids do, and the doctor hadn't even taken that into account. He'd just ordered us to give her more.

According to UNICEF, exclusively breastfed children have 15 per cent fewer GP consultations in the first six months.[31] We were in and out of stressful and difficult health appointments for the first six weeks of our daughter's life, and I have no doubt that would have continued for much longer if a local nurse hadn't found a way to help us, and hadn't put us in touch with a lactation consultant who, with just a few bits of valuable advice, helped me to learn how to breastfeed my child more easily. (It's a natural process, but also learned. Both baby and mother need to learn sometimes, and that is perfectly normal.) Though I'd had some great advice from midwives in hospital, some of it was inconsistent, and it was also inconsistent with the doctor's advice and advice from family members. Everyone told me something different. It didn't help that I had never seen anyone breastfeed a baby – not once in my life – before it was my turn to try it.

According to experts, inconsistency of information and care is a common story in Australia and abroad, yet it's hard to miss the constant framing of women's experiences of motherhood as *mother versus mother*, not situation versus situation, or health system versus health system. As with birth, the judgements are never far away. The mother who bottle-feeds is 'lazy' or 'selfish', while a mother who breastfeeds her child after six months (one person even told me this about women who breastfeed at three months) are 'only doing it for themselves'. Women who breastfeed toddlers are often told they are selfish, perverse, *sick* – despite the World Health Organization recommendations and multiple studies showing the benefits.

Let's be careful not to perpetuate the so-called 'mummy wars'. Let's take aim not at other women, but at the systems that let women down with inadequate medical, social, cultural, financial and workplace support. According to the Australian Institute of Health and Welfare, over 90 per cent of mothers in Australia will breastfeed, but the majority will quit before they choose to, largely due to external pressures and lack of support. Let's not create false divides between mothers who breastfeed and mothers who don't, or parents who work and parents who don't.

Unfortunately, despite the health push to breastfeed, many Australian mums remain nervous about breastfeeding in public, especially in the early weeks when routines are not well established. Sadly, mums are still frequently told to cover up or 'be discreet'. One breastfeeding mother I know uses only bottles of her expressed milk in public, to avoid embarrassment. While, personally, I support anything that helps mums cope with the challenges of parenthood, it is perhaps a sad sign of the times that doing what is natural (and free) is a challenge for so many, and confronting for so many others. Even I was worried about breastfeeding in public early on, and I considered all kinds of ways to avoid it. In fact, I clearly recall my first outing to a cafe with my daughter. She became restless and needed feeding, so out came the blanket. I couldn't see what she was doing, and our mother–baby attachment skills were not well honed, to say the least. I kept adjusting her. She began to sweat beneath the blanket. The wind kept flipping it off. In the end I had to ask myself why I was covering my baby's head. Her needs were more important than the risk of flashing a nipple.

As if the topic were not sensitive enough, the very sight of breastfeeding remains inexplicably controversial. Take a recent cover of *Time* magazine as an example. The now infamous

cover featured a mum feeding her three-year-old. The image was hotly debated for a variety of reasons. (The intentionally divisive headline *Are You Mum Enough?* didn't help, and implied that the majority of women were not in fact 'mum enough' for not being able to breastfeed for as long. Nonsense.) Most of the controversy centred once again on public breastfeeding and the idea of feeding past age one, despite the World Health Organization recommending all mothers breastfeed to two years and beyond.

But you don't need to be feeding a three-year-old to cause offence. US actor Angelina Jolie's appearance on the cover of *W* magazine in 2008, breastfeeding one of her twins in a modest black-and-white photograph taken by her partner, Brad Pitt, caused a furore. Her baby was a newborn, the image showed no cleavage and no, her child was not standing on a chair, as on the cover of *Time*. Similarly, a natural-looking photograph of supermodel Miranda Kerr breastfeeding son Flynn met with mixed reactions, both praise and disapproval, while provocative photographs of her in lingerie and swimwear don't cause so much as a whiff of controversy.

> The taboo on the display of nipples reveals what, for patriarchy is the worst scandal of all: the relationship of sexuality and motherhood. Indeed, much of patriarchal culture is founded on the separation of motherhood and sexuality – e.g., the double standard, the focus on female purity, the sanctity of motherhood, the division of women into madonnas and whores.
>
> Iris Marion Young[32]

Images of breastfeeding are still routinely flagged as offensive on Facebook and banned, accompanied by this message: 'Shares

that contain nudity, pornography, or sexual content are not permitted on Facebook ... refrain from posting abusive material in the future.' Facebook updated its policy in direct response to the breastfeeding issue: 'Yes. We agree that breastfeeding is natural and beautiful, and we're very glad to know that it is important for mothers to share their experiences with others on Facebook. The vast majority of these photos are compliant with our policies, and we will not take action on them.' Yet regular reports of banned breastfeeding photos continue.

The supposed controversy has even hit comic books. The well-regarded illustrator Dave Dorman wrote a post on his popular blog recently, venting his disgust at a cover for the *Saga* series featuring breastfeeding, although no suckling, nipple or even cleavage can be seen. In fact, the majority of breastfeeding images deemed 'offensive' in these various examples show comparable skin to an uncontroversial low-cut top and less flesh than even a standard bikini.

By definition, the nipple is covered by the mouth of a child during breastfeeding. Every magazine stand in the western world and rafts of advertising images feature a sea of exposed female upper body flesh. See that *Vogue* cover with the plunging gown? Is it offensive? Now imagine that a baby's head is covering the nipple, instead of designer silk. Now is the image offensive? Why? It's not the skin we have a problem with, but the act of breastfeeding itself. And that response has been taught to us.

It wasn't always this way. The popular American children's program *Sesame Street* once routinely showed breastfeeding, but since the 1990s it has reportedly shown only babies being fed by bottle. In one older episode, for example, Sonia Manzano, the actor who plays Maria, breastfed her own child, and a child actor asked her if that was 'the only way to feed

her?' Maria responded: 'Sometimes I feed her with a bottle. But you know? I like this way best. It's natural, it's good for her and I get a chance to hug her some more.'

Surely this balanced approach is something we should see more often. Here you have a recognition of the naturalness and importance of breastfeeding, that breasts are in fact designed primarily for this purpose rather than for display, while acknowledging that breastfeeding isn't the same for everyone, or isn't possible in every case.

Children do not find breasts offensive or sexual until we teach them to, and the complaints of people like Dorman, or those who report breastfeeding images on Facebook, reveal a learned bias that may ultimately be damaging. What is the signal being transmitted here about breastfeeding? Since when did the natural way of feeding your child come to be seen as offensive or controversial?

Our rates of exclusive breastfeeding in Australia are a low 15 per cent at the medically recommended six-month mark – about half the world average. Most women know about the benefits for mums and babies, including lowered cancer rates, fewer infections, lower risk of SIDS. The latest statistics, for example, show that an estimated 53 per cent of diarrhoea hospitalisations could be prevented each month by exclusive breastfeeding.[33] Despite this knowledge, and despite the fact that about 90 per cent of Australian women are breastfeeding when they leave hospital, they are quitting early. They need to know that breastfeeding is normal and acceptable once life inevitably involves feeding a child outside closed doors – at the supermarket, the park, or the office. We have to see it. Babies feed every few hours, and it is not reasonable, healthy or legal to demand that mothers hide away every time they need to give their children sustenance.

Our choices are influenced by what we see and what society portrays as normal or aspirational. In a very real way, visibility is acceptance. Unfortunately, while we have become accustomed to seeing the fertile female body used to sell us all kinds of products, we are no longer accustomed to seeing it perform this most natural task. But though anti-discrimination laws protect a woman's right to breastfeed in all public places, without normalising the sight of breastfeeding in our society we have little hope of making more mothers comfortable enough to engage in the practice of publicly feeding their children naturally.

When mothers make informed choices, let's respect those choices, regardless of whether that means breastfeeding or bottle-feeding, or styles of parenting we don't agree with. And for the majority of Australian women who do choose to breastfeed, let's give them our unreserved support in the healthcare system and at work, but also in the community and in public spaces, so they can more easily develop healthy, long-lasting breastfeeding relationships with their children, without the kinds of problems I faced, and so many other families experience in a multitude of different ways.

15

PLAYING MOTHERS AND FATHERS

Every time we liberate a woman, we liberate a man.
Margaret Mead[1]

There is an old riddle I remember from high school. It involves a terrible car accident in which a father is killed and his son injured and taken to hospital. When the boy is brought into emergency for surgery, the doctor looks at him and says, 'I can't operate on this patient. This is my son.' The riddle then asks: 'How is that possible?'

I've since heard multiple variations on this riddle, and people still get tripped up by it. 'I was so cross with myself,' one friend told me. 'I couldn't figure out how the boy could be the doctor's son, when the father had died in the accident. And I was a med student at the time!' she said.

The doctor, of course, is the boy's mother.

It is so obvious, yet many people routinely fail to see the answer. Despite increasing numbers of female doctors, the stereotype of doctors as male remains, as does that of the woman as a full-time parent with no job outside the home, and man as full-time breadwinner and anything but a 'hands-on' parent. This idea, though many of us now consciously reject it, is nonetheless still consistently, if unconsciously, present in our lives.

As we saw in chapter 7, an analysis of G-rated films conducted by the Geena Davis Institute for Gender in Media found that between 2006 and 2009 not one female character was depicted as working in the field of medical science, as a business leader, in law, or politics. In these films, slightly more than 80 per cent of all working characters were male and slightly less than 20 per cent were female, despite the fact that in reality women are around 50 per cent of the workforce.[2]

But, of course, not all working women are equal. Sociologists often refer to something known as 'the motherhood penalty'.

> … women with children are hired 79 per cent less often than those without kids, according to a Cornell University study from 2007. Once they find employment, moms are offered starting salaries that are $11,000 less than men's.[3]

Many women find themselves faced with questions by potential employers about marital status, family status and future family plans. Kiki Peppard, who is seeking intervention from the newly formed White House Council on Women and Girls, points out: 'Employers are using [parental status] information to eliminate qualified female candidates from positions just because they either are a mother or have the potential to become a mother.'[4]

The assumption that when a child is born the man's career will be unaffected but the woman will quit working outside the home has form in legislation. Prior to 1966, women in the public service in Australia *had to* quit work when they got married, and it wasn't until 1972 that female teachers in all Australian states won the right to keep working once married.[5] The idea was that children needed their mothers at home – rather than needing a *parent* (male or female) – and the law took away any choice the family might have in the matter of how they best saw fit to manage their family life and childcare. This underestimated the abilities of fathers and denied many men the opportunity to be hands-on parents, while women were forced (rather than given a choice) to assume a traditional gender-based role as stay-at-home mothers. The law also presumed that all married women would reproduce. The law has since changed, but in many ways cultural attitudes have not. Unfortunately this is abundantly clear to working women who become pregnant, and to families who do not fit the mould of mother as stay-at-home carer and father as breadwinner.

> All of the lip service to motherhood still floats in the air, as insubstantial as clouds of angel dust. On the ground, where mothers live, the lack of respect and tangible recognition is still part of every mother's experience. Most people, like infants in a crib, take female caregiving utterly for granted.
> Ann Crittenden, *The Price of Motherhood*[6]

There is, at the time of writing, not a single mother in Australia's federal Cabinet. This is not a reflection on the abilities of those who are in Cabinet, but it does speak to a larger issue of work culture that sees mothers as less capable of devoting themselves

to work outside the home, while a man's parenthood status remains irrelevant to perceptions of his ability.

In September 2013, after Labor lost the federal election and Kevin Rudd stepped down, there was much speculation about who would take over the leadership of the ALP. Former prime minister Bob Hawke spoke of the contenders, flagging Bill Shorten as his strong favourite (he later became the new leader) in an interview with Sky News Australia's political editor David Speers. Hawke said of another popular candidate, minister Tanya Plibersek (while gently shaking his head), 'I don't think she's a candidate for leadership, she has a three-year-old child.' He went on to say that Plibersek was 'a very, very impressive representative … she's proved herself a capable minister …', however, 'I think the most that Tanya would be interested in would be … deputy.' Interestingly Shorten, whom Hawke considered the best candidate for the job, had a child of exactly the same age. Speers did not press Hawke on why a woman with a three-year-old would not be interested in leadership while a man with a three-year-old would be a perfect choice. Both men seemed to find the assumption unremarkable.[7]

As it happens, while there are no mothers in Cabinet, the majority of Cabinet members are fathers. The only woman in Cabinet, Foreign Minister Julie Bishop, suggests that this is just the way it is: '… women can't have it all. They can have plenty of choices, but at the end of the day, they choose something which means they can't have something else.'[8]

Leaving aside the seemingly obvious fact that no one can technically 'have it all', in the real sense, why is it that, even now, the most powerful people in our country believe that work/life balance and the important role of parenting is simply 'women's business' rather than the business of both parents?

*

When I researched where to give birth to my first child, I looked for a place that would welcome my baby's father and accommodate him. Parenting was a priority for both of us, and with each of our careers being where they were at – including the fact that I would be hosting a crime documentary series only months after the birth, and we knew I would be the primary financial contributor in the near future – Berndt's role as a hands-on father was an important consideration. He took time off from teaching at university to welcome our child and to be there throughout her first year of life, and he came with me every day on set so she could be near and I could breastfeed. We did it together and that was our plan. It was a plan that started with the birthing classes we attended together to prepare for what was to come, and included him being in hospital when I gave birth, and while I was recovering.

When I was pregnant we found a suitable private hospital nearby and did a tour in my second trimester, as parents-to-be were encouraged to do. The hospital's brochure promised private rooms, in-room beds for partners and an excellent level of care. We were lucky enough to meet the manager, something organised by our obstetrician. She welcomed our insistence on my husband being there in the room. Everything was set – as much as it could be, considering the variables of birth – and when I went into labour months later, right on schedule, we were calm. The birth went well, and was a truly beautiful experience. My husband was right there with me. When we arrived in our room with our tiny newborn, however, and asked about bringing in a bed for my husband, we were told that it was 'not possible'.

We were stunned. Of course my main focus was the incredible creature in my arms, the fact that she was healthy and the fact that my body and hers were both in one piece. But the hospital we'd specifically chosen for this reason couldn't accommodate my baby's father? In 2011? This was, after all, when his presence was most needed – to bond with his newborn child, to hold her in his arms while I slept off the rigours of labour and birth, to talk, to share, learn and support each other, to advocate for my needs and for hers. We were a team. I needed and wanted him there, and it meant a great deal to him to be there every moment during that important time. Then he was told, within earshot of me, that the reason the hospital no longer accommodated fathers was that 'men are hopeless'.

I was livid.

I am a writer and, as of three years ago (at the time of writing), a parent. Though my career requires some travel, usually I work from home. My husband is also a writer and a parent, and also usually works from home. We are, apart from my ability to breastfeed and, previously, my ability to carry our child to term in my womb, about equal in our various parenting abilities. (Actually, he is much better at all things relating to food, but that is another story.) Yet we are not perceived as such.

My very capable husband is often wrongly assumed to be either bad at parenting (i.e. 'hopeless') or to have no interest in it. When we are out he is often asked what he has been up to – a pretty normal question. But when he replies that he is busy writing a novel and being a full-time father the response is, 'Yes, but what do you *do*?' For a man, parenting isn't perceived as a job. Meanwhile the same people will ask me, 'How are you *coping* with being a working mother?' as if I must feel terribly guilty being able to provide for my family, the word 'coping' so loaded that I can just picture 'Working Mother'

having 'Nervous Breakdown'. (That and 'Poor Neglected Lonely Child'.)

Out on his own, running errands or seeing friends, my husband would be asked, 'How is the baby?' When out alone, even just getting groceries or picking up the mail minutes from the house, I would be asked, '*Where* is the baby?' The question was, at times, quite aggressive. When she was very young, the obvious answer was that she was at home with her father, or vice versa, one benefit of being two working stay-at-home parents. But we soon learned that while a father leaving the house without his child is just a man, a woman leaving the house without her child is seen by many as a neglectful parent. To counter this, when I was asked in a particularly pointed way where my child was, I took to responding, 'Oops! I left her in the car park at the casino *again*. My bad.' After some nervous laughter, they left me alone.

We also discovered that when fathers are hands-on child carers – even seen to be changing a single nappy – it's still common to hear terms like 'Mr Mum' bandied about, or for him to be called a 'wife'. As with women in leadership roles being referred to as 'men', fathers involved in caring for their children are often referred to as not quite being men at all – they become mothers, female. During the book tours for the novels I have published since my daughter's birth, I have been asked many times about how I 'juggle' parenting with being a writer. Berndt, who has also published a novel since our daughter's birth, has yet to be asked such a question.

We are hardly alone in this experience. A number of fathers I know are told it is 'so sweet that you are babysitting' when they spend time with their own children in a public park. One father retorted, with considerable frustration, 'It's not babysitting to look after your own child!'

Until we can get to the point where men and women can complete the same parenting tasks and the reactions are the same, we will have problems. If you want to create a statue for me for taking care of my daughters, create one for the moms who are doing the same damn thing every day for their kids without receiving a 'Thank you' or an 'Ooooh' or 'Ahhhh.' These behaviors should be expected of moms and dads. No exceptions.

Doyin Richards, The Good Men Project[9]

'It does often feel like the bar is very low for many dads and it's difficult to break out of this mould that's been formed for them,' Murray Galbraith told the *Sydney Morning Herald* in 2013. 'Much of the parenting advice is heavily geared towards women.' (His response was to launch a group called Pretty Rad for a Dad, with the first project being a documentary on the subject.)[10] I was asked many times in my daughter's first year if I'd 'joined a mother's group', while my husband was never asked about, or invited to participate in, a 'father's group'. The term 'parenting group' was never used. The implication was clear: 'Women look after children. Men don't belong here.'

Dr Anne Summers recalls her time in the Office of the Status of Women in the 1980s, and one small but important victory for parental equality:

As a result of OSW intervention, the place where parents could go to change their baby's nappies was removed from the women's toilets. This meant fathers travelling with young children could use them and, to underscore this, we ensured they were called Parents' Change Rooms rather than the proposed Mothers' Change Rooms. Sure, it was a small thing, but ... a necessary facility for parents was established

which, at the time, challenged the assumption that only
mothers cared for small children.[11]

According to the Australian Bureau of Statistics, as of 2003
there were 'over 5.5 million families in Australia and 87% of
the population lived in a family household'.[12] The vast majority
of men will become fathers. Statistics from the Australian
government's Workplace and Gender Equality Agency put the
number at just under 80 per cent. In their recent survey of
2887 workers, the agency saw what they describe as 'strong
evidence for the gendered nature of flexibility requests', with
fewer men requesting, or successfully accessing, workplace
flexibility. In particular, fathers working in male-dominated
fields were less likely to request time off after the birth of their
child, or to request more flexible hours, and they were also
less likely to get the requested flexibility if they asked for it. It
seems that in many circles, asking for time off to be a dad is
not considered professionally (or socially) acceptable. The
report stressed that: 'Flexibility provides the opportunity for
men to be more engaged in both caregiving and parenting. A
significant number of men are seeking to be active fathers.'[13]

In a 2011/2012 study, Converge International and the
Boston College Center for Work & Family surveyed 784
Australian fathers and 963 American fathers. They found that:
'Australian fathers … showed a very large gap between their
desired and current state: 65% said that both parents should
provide equal amounts of care while only 34% said that this is
actually the case …'[14]

Individual choices are vital, but so too is a work culture
that allows for choice, as well as an attitude among health
providers, in hospitals, in the general community and in
extended families, that men and women have equal status as

parents. If caring is seen as exclusively 'feminine' and fathers are not considered capable of caring for their children, that 'very large gap between their desired and current state' is unlikely to close. When families make decisions that are best for them, those decisions should be respected (two working parents, a stay-at-home mum or a stay-at-home dad, etc).

The subject of work/life balance is often raised in public forums, however the issue is almost invariably framed as a problem faced by mothers exclusively, and not an issue for fathers or the community in general. *Can women have it all?* the headlines commonly ask, clearly inferring that attempting to both care for and financially provide for one's family is asking for 'it all' – even *too* much, as if the average family even had the choice to have one parent stay at home if they wished. Clearly work/life balance is something every person must negotiate in order to live a full life. Men can't have it all either (though if we were to imagine what that 'having it all' would be, it would surely imply something more grand than simply the ability to care for and provide for their own kids, wouldn't it?). That men would also naturally need to, or desire to, live a well-rounded life somehow doesn't enter into the discussion.

As with so many issues relating to gender roles and pressures, legislation and policy are important, but even when laws technically allow for flexibility of individual choice, culture needs to catch up. Social pressures remain. The New Dad report of 2012 found that roughly 90 per cent of fathers expressed that they 'would like to be remembered for the quality of care rather than size of the pay packet'.[15] How curious, then, that men are less likely to be granted work flexibility in order to be active fathers, and images of the 'ideal man' in our culture still so consistently revolve around physical strength and material wealth (the sporting hero, the business

suit, the car, the expensive watch), while mainstream male characters in entertainment still so consistently focus on the qualities of brute strength, aggression and stoic lack of emotion.

In a small win for work/life flexibility in Germany, the second most powerful person in German politics, Vice-Chancellor Sigmar Gabriel, told the tabloid *Bild* in 2014 that he would be taking time off on Wednesday afternoons to be a dad. 'My wife has a job, and on Wednesdays it's my turn to pick up our daughter from nursery. And I'm looking forward to it.' He explained that politicians needed to take time off to be parents, 'otherwise we don't know what normal life is like'.[16]

One can only hope that, in time, the issue of work/life balance will be acknowledged as a struggle that we all share to varying degrees.

*

Strongly gender-typed toys might encourage attributes that aren't ones you actually want to foster. For girls, this would include a focus on attractiveness and appearance, perhaps leading to a message that this is the most important thing – to look pretty. For boys, the emphasis on violence and aggression (weapons, fighting, and aggression) might be less than desirable in the long run.

Professor Judith Elaine Blakemore[17]

Researchers invariably agree that the toys our children use during their early playtime and explorations of the world are vital to their development. While, with a bit of imagination, many household objects can be used as toys (mixing spoons for magic wands, cardboard boxes for cabins, tea towels for hero capes, etc), it is a modern convention to buy ready-made

toys for children, and there are many on offer. As of 2010, the children's toy industry was estimated to be worth over US$83 billion annually.[18]

As most parents have no doubt noticed, many commercially available toys are aimed specifically at boys *or* girls in design and packaging, using themes and colours considered specific to one gender and picturing children of that gender playing with the toys in the marketing material. And this is where it gets fascinating – a large number of toys aimed at girls have *fewer functions and less power.*

For instance, a grey electronic toy was recently advertised as a 'Boy's Laptop' with fifty functions while the 'Girl's Laptop' in the same advertisement was bright pink and had twenty-five functions. The price was similar for both, despite the fact that the 'Girl's Laptop' had only half the functions.[19] A 2009 Toys "R" Us catalogue featured both telescopes and microscopes for kids. Cool, right? Except in both cases, the versions made for 'girls' (i.e. the ones which were bright pink) were the less powerful toys – 600x magnification on the pink one versus 900x for the regular version, and just 90x magnification for the pink version versus 250x or 525x respectively for the other toys.[20]

Numerous sociologists and commentators have noted how rarely toys marketed at girls have building components, a focus on maths, or even primary colours in their design rather than pink or pastel colours, and the number of toys 'for girls' aimed at enhancing physical 'beauty' – a 'mermaid vanity', a 'fashion wardrobe' etc. – while there are no similar toys aimed at boys. Toys aimed specifically at girls also tend to encourage caring (cuddly animal toys, babies, prams, kitchenware, tea sets), while boys' toys rarely have a focus on looking after others.

The obvious problem with dividing up toys by gender is that such divisions commonly make certain kinds of early

development exclusive to one gender. When toys marketed to boys promote maths, science, building, problem-solving and being physically active, while many toys marketed to girls promote social skills, caring and decoration, both genders miss out on the early learning skills encouraged by the toys of their opposite gender, and also come to learn that playing or exploring the world in some ways is okay for either girls or for boys, but not both.

The lessons for boys about their supposed 'unsuitability' for caring starts early. Where the girl is encouraged at every turn to care for stuffed animal and toy babies in prams, the boy does not get to play with dolls. The 'dolls' he has are action figures. These toys are created for action, and most importantly for physical violence, not for caring. They come with swords, guns, spaceships and tanks, not blankets and prams. While Barbie may at first spring to mind when we speak of dolls, it is important to remember that the most common dolls have traditionally been those of babies and small children, made for the purposes of imaginative play and dress-up, but most centrally for the development of the instinct to look after others. Like the ever-popular toy kitchen or tea set, dolls of this kind are marketed exclusively to girls, as if to indicate that boys will not naturally be inclined to – nor will find themselves needing to – care for others, not even their own families one day. Or, as implied by the lack of kitchen sets aimed at boys, they won't even need to learn to feed themselves. By discouraging the natural human instinct to care and show emotion in boys from a young age – just as we discourage leadership, building, sport, scientific pursuits and adventurousness in many girls – we cut off the development of fundamentally important human qualities.

The sensitive boy is not 'girly', he is a sensitive boy. The adventurous girl is not a 'tomboy', she is an adventurous girl.

When I was a Girl

When I was a girl they called me tomboy
because I didn't like princesses
I didn't like Barbie dolls
I didn't like skirts

When I was a girl I wanted to be Han Solo
Spiderman not Mary Jane. Superman not Lois Lane.

When I was a girl I wanted Lego.

Books.
Not Barbie.
Hot wheels.
Not hot rollers.

It seemed only fair that I should carry the whip and the blaster.

When I was a girl they called me a tomboy
but now I have a woman's eyes
and I see a child who just wanted life
to be adventure instead of waiting
and skirts were no good for going places fast.

Jumping
fences
Climbing
trees

The most important princess in the galaxy was in chains
on Tatooine, at the fringes of the Northern Dune Sea

at the feet of Jabba the hut.
Barbie wasn't chained up
but all the same she didn't DO anything
She had shoes but no map. A hairbrush but no tools.

So when I won her in a kids' running race I cried. But my
mum helped me dye the blonde hair black, cut the head off
and resew it, and stitch her cheek to make her a raven-
haired monster. *FrankenVampirella*.

She had adventures. She was strong.

Still, Mary Jane was busy getting saved
Wonder Woman had dropped the Wonder
and was going by 'Diana'
having given up her superpowers to open a boutique.

(True story.)

Little wonder I settled on Han.
Spiderman.
Superman.
'Tomboy'.

And now I am a mother

I want my girl to aspire to freedom. To adventure.
I want her to live
Fully

without being called *boy*.

16

THE CRONE

Ageing is not lost youth but a new stage of opportunity and strength.

Betty Friedan, *The Feminine Mystique*

I recently parted my hair on a different side and discovered shining strands of silver, magically new and shimmering from root to end. There were clusters of them secreted beneath my thick dark-blonde locks, and I felt awed and excited to uncover them – perhaps even bizarrely excited. I began parting my hair to one side to show off my earned silver, hoping one day I would have a streak to rival that of the wonderful Susan Sontag or Anne Bancroft's Mrs Robinson. Why, I wondered, did it thrill me so much to be turning grey? It happens to everyone eventually, if they live long enough. Why did it fill me with happiness to see this obvious physical demonstration that I was morphing into an older woman? The conclusion was clear: it's because I am so damn ready for it.

Much of my teens were spent running. I'd enjoyed an idyllic childhood on Vancouver Island. My parents were in love, and they loved my sister and me. We played games in the

snow and sunshine. Life was simple. And then my mother died when she was only forty-three and the whole world shifted, became dark and uncertain. After a few months of paralysis I threw myself at the world, aged sixteen, with a kind of blind enthusiasm and desperation. Life was short. I needed to make something of myself immediately, to show that I was fine, just fine, and I could look after myself. I was stridently independent as a young fashion model, a career I'd been told for years (mostly by strangers) that I should pursue. I worked my guts out and retreated to my room alone each night to read, earnest and introverted.

My twenties were confused, if a bit less Kamikaze. I modelled in different cities every few months. I drifted from one bad romantic relationship to another, acutely aware that I wanted to put down roots, but seemingly unable to emotionally and geographically. I made poor choices, and some good ones too. Finally taking a chance on myself was the best decision I made, and I made it when I enrolled in a writing course to pursue the career I'd wanted since I was a kid. By twenty-three I knew I wanted to be a published writer and everyone else's opinions be damned. It didn't matter what people thought I should be anymore. I'd given modelling my best shot and the life wasn't for me. Henceforth, I would dedicate myself to the page.

My thirties started badly, with an unpleasant divorce and a stretch of terrifying self-examination. I took eighteen months off writing novels. I just couldn't find words. But at the end of that very bad stretch, I'd made it. I'd stopped running. I'd peeled off all the layers and taken a good, hard look at what was left. After nearly two decades without my mum I could finally just *be*. I dived back into life a stronger person. I suppose I could have reached that stage earlier, without all the loss and

trauma, but frankly I doubt it. Every experience adds another piece to the puzzle. I wouldn't give a single piece back.

Now forty, I am at my best age yet. My life and career are challenging and fulfilling. I'm going to university at last. After nine novels I'm writing this, my first non-fiction book. I am the mother of a mischievous, giggling girl, the wife of a man I love and admire, and a woman with opportunities and experiences I am deeply grateful for. I welcome the coming years.

And I truly believe my best age is yet to come.

This isn't just a trite bit of self-encouragement either. If I am lucky and live to the current life expectancy of eighty-four, I have more than half of my life still ahead. Sometimes, however, it can be easy for all of us, particularly women, to forget that our life expectancy is over eighty and not, say, forty. There is a reason for this.

In Australia, as in many other countries, we too rarely see representations of women over forty, let alone as octogenarians. Aged people are shuffled off into retirement villages and homes. Our mainstream culture has little interest in their stories or images, perhaps as they inconveniently remind us of our own mortality. Poor urban planning and high real-estate prices push seniors out, while a lack of rural planning puts seniors in the tenuous position of being too far from essential services. The main alternative is the senior-oriented suburb or the nursing home. So the generations lose touch. They are segregated.

How far we've strayed from the idea of community, or the city lifestyle that sees a ninety-year-old wander out for her daily cafe au lait, rouge and pearls on – a common sight in places like Paris – as children and parents, or couples arm in arm, stroll past. And so one by one we see seniors off, and we

see most women in the public eye vanish after forty, literally at middle not even late age.

According to Martha Lauzen, the executive director of the Center for the Study of Women in Television and Film at San Diego State University, in the US women under thirty make up 39 per cent of the total female population but comprise 71 per cent of the women on TV. And of course women on TV are still outnumbered by men, so they have a smaller slice of the pie to begin with. 'When any group is not featured in the media, they have to wonder, "Well, what part do I play in this culture?"' she says.

If older women experience a kind of symbolic annihilation, how are they symbolically represented in those instances when they are visible? What are the common *fictions* – the archetypal representations – of older women?

Historically, older men were seen as powerful kings, wizards or venerable wise men, and today it's still older men who tend to hold the reins of power as presidents, prime ministers, senior officials, magnates, media moguls and other people of authority. Men in these areas remain indisputably powerful, relevant and visible. They are kings of a more modern variety, you could say. By contrast to that of older men, the popular historical view of older women – with the notable exception of, say, the current Queen of England, or other royalty – is not particularly positive.

In the discussion of film tropes I mentioned the archetype of witch/crone. This representation, which was very popular in the medieval period in Europe, remains incredibly influential today. Remember, the Middle Ages was a time of plagues and famine (which were attributed to acts of God), peasant revolts, and concern about church authority and the role of women. During this period the underlying suspicions

about the moral inferiority and danger of women, and their feminine power, came to a head in the belief that older women were especially suspect members of society, thought to possess potentially deadly knowledge, and could not be as easily controlled as young women who did not yet have knowledge and experience. Unmarried or widowed women, female healers and midwives were all targeted as dangerous to society (giving some troubling historical context to the controversies around midwifery today, you could even argue). Feminine power, which was an affront to God, was literally thought to cause terrible calamities.

It is little surprise then that the art and literature of this period – and as influential works beget later influential works, also the periods that followed – warns against the moral failings of women. Older women might, like older men, have accumulated some power, and power in the hands of women was not acceptable.

In medieval and renaissance representations, the older woman as 'crone' was frequently represented naked with sagging breasts to indicate infertility, and a sinister, bitter expression on her face as she held a sign with the word 'Invidia' (envy) while staring at younger, more nubile women. (Again, woman is supposedly most valuable for her fertility.) The crone was also commonly shown clothed or partially clothed, again with sagging breasts, but with a snake or series of snakes instead of a human tongue. In *Invidia*, the allegorical painting by Giotto di Bondone, 1305–06, her own snake tongue is shown to bite the woman between her eyes.

The other popular representation of older women from this period was that of the witch – an idea that remains familiar today. This notion of perverse and malevolent magical female power is perhaps expressed most artistically in the

popular art of the Middle Ages, wherein witches were shown in the form of old naked women, again with sagging breasts and wild, unrestrained hair (perhaps because married women commonly braided their hair), arguably the most famous of which is the German artist Albrecht Durer's engraving, usually titled *Witch Riding Backwards on Goat*.

The woman in Durer's work is pictured as naked, with an almost masculine muscularity, her breasts sagging and her unrestrained grey hair flying back wildly. She holds a broom at her groin (the broom along with the boiling pot/cauldron being symbols of a woman's 'proper role' as housekeeper/cook, with the broom subverted into an obviously phallic object to indicate unnatural power in her hands) and riding a goat backwards while cherubic infants or angels toil on the ground beneath her. The goat appears to be moving in one direction while she is moving the other way. The world is chaos; the laws of physics have been subverted by the older woman's wicked powers.

The cannibalistic witch in *Hansel and Gretel*, the vain, homicidal queen in *Snow White* (a combined envious crone and cannibal witch archetype, as she asks the huntsman to bring her the beautiful girl's heart, lung or liver), the evil enchantress in *Rapunzel* and the wicked old fairy in *Sleeping Beauty* who places the girl under a curse are all represented as older females possessing great power and diabolical cruelty in the classic medieval mould. In these old European fairy tales – which were already well known before they were collected and published by the Brothers Grimm in the early 1800s – the goodness of male power in the form of the noble king, prince, woodsman or hunter contrasts with malevolent female evil, and ultimately vanquishes it.

Again, there were many stories of older kings, some good and noble, some greedy or mad, but the issue of stereotyping

arises in the fact that older women were not socially permitted to be powerful or influential in the way older men were, and older women were therefore largely irrelevant to storytellers because men led the plot. A virgin/princess was worth saving, of course, but an older woman? If an older woman was to influence the plot rather than sit mutely in the background of a fairy tale or adventure, she had to be evil – an abomination. This skewed fiction of older women as either irrelevant or evil, invisible, mad or bad, remains influential today. (Think Cruella de Vil, Cinderella's wicked stepmother, the Wicked Witch of the West, Maleficent, the homicidal Queen of Hearts, etc.)

There has been a lot of talk about how things are improving for women in Hollywood – better roles, longer careers. This may be true to some degree but, personally, I am not convinced.

At the 2013 Academy Awards four actors received Oscars for their performances: Daniel Day-Lewis for best actor (age fifty-five), Jennifer Lawrence for best actress (age twenty-two), Anne Hathaway for best supporting actress (thirty) and Christoph Waltz for best supporting actor (fifty-six). All of them are accomplished performers and were wonderful in their roles. However, the traditional snapshot of the four winners together holding their trophies was a touch unsettling. When added up, the ages of the two actresses combined (fifty-two) was still years less than the actual age of either of the male winners.[1] This snapshot of four actors at the top of their game would be insignificant, if it did not reflect the bigger picture in the entertainment industry and representations of life we commonly absorb as consumers, and also in our communities, where aged people are routinely dismissed, and many women over a 'certain age' (on average much younger

than men) will find they are considered at best redundant. We see women disappear at a significantly younger age.

To further demonstrate how this fiction about older women being irrelevant (or stereotypically evil) plays out, great film roles for women over fifty are still so rare that at the time of writing, only seven women (compared with nineteen men) have won an Oscar for Best Actress when over the age of fifty, in the eighty-six-year history of the Academy Awards.[2] The wonderful Katharine Hepburn is the exception to the Hollywood age rule, having won four Best Actress Oscars in her career, none of which she attended the awards to accept, and three of which she won when she was over fifty.

Stories about women, particularly older women, their lives and adventures, their fears and triumphs, are rarely celebrated.

Though not all films have so skewed a romantic pairing as the 1999 film *Entrapment* starring sixty-eight-year-old Sean Connery and twenty-nine-year-old Catherine Zeta Jones, it takes only a glance at the latest blockbusters to see the same dynamic play out again and again: mainstream films are largely directed by men, are male-dominated and feature central male characters with younger female love interests. This is common today, and was also common in old Hollywood. The wonderful Humphrey Bogart, born in 1899, for instance, found his most famous on-screen (and off-screen) pairing in Lauren Bacall, born in 1924 – an age gap of a quarter of a century. At the time of their first screen appearance together in the classic *To Have and Have Not*, she was nineteen to his forty-four. Similarly, Audrey Hepburn and Fred Astaire starred in *Funny Face* with a thirty-year age gap, Hepburn in her twenties and Astaire nearly sixty. Astaire also starred with Leslie Caron, thirty-five years his junior, in

Daddy Long Legs in 1955. It's a pattern the Hollywood establishment still loves.

In 2006 the US film industry bible *Vanity Fair* featured a cover with the ever-handsome George Clooney coupled with Australian supermodel Gemma Ward, photographed by Norman Jean Roy. At the time, Clooney was forty-five and Ward was eighteen. The opener for the story (by Rich Cohen) described the subject as 'Hollywood's silver-haired statesman, making movies and speaking out for a basic American decency …' How would the opening have read had a forty-five-year-old actress been posed with a teenage male beauty, I wonder? Whatever the angle, the story would probably not have centred on 'American decency', I'm guessing.

Though most often the age difference is undeclared and unrelated to the plot, actors in mainstream films are commonly more than a decade older than the actresses whom they star alongside. As a general rule, the bigger a film's budget, the more likely it is to follow this pattern, as 'bankable' male blockbuster movie stars get older and their (ever-changing, one might even say interchangeable) co-stars remain the same young age.

One example is Hollywood A-lister Tom Cruise, who starred with French beauty Emmanuelle Beart, thirty-three, in the 1996 blockbuster *Mission Impossible*. As the series continued the actor aged but his co-stars did not. Next up was Thandie Newton, twenty-seven, in *Mission Impossible II,* then Michelle Monaghan, thirty, in *Mission Impossible III* in 2006. In 2012's *Jack Reacher* there were seventeen years between Cruise, by then fifty, and his co-star Rosamund Pike – Pike being the age that his co-star Beart had been in 1996. The pattern holds across the industry. In 2013 the *New York Magazine*'s entertainment and culture publication *Vulture*

compared the ages of ten A-list male stars and their female co-stars in consecutive films.[3] The charts were fairly startling and were published under the self-explanatory headline: 'Leading Men Age but Their Co-Stars Don't.' As a pattern across male A-listers' careers, co-stars were younger from the beginning and then stayed young.

Despite the numerous examples of on-screen pairings in big-budget mainstream films where the man is more than two decades older than his female co-star, films where the woman is older than the man by more than just five years remain as rare as same-sex pairings and are often treated with a significant level of sexual taboo. This isn't to say that such roles don't exist. The 1971 film *Harold and Maude* featured a relationship between a young man and a much older woman, as did 1967's *The Graduate* and 2008's *The Reader*, though in all of these films (unlike those mentioned above, where the man is older) the presentation of the age gap was a central plot point – the equivalent of, say, the controversial *Lolita* or *Last Tango In Paris*. As far as I am aware, there are no mainstream films where a generational age gap between a younger man and older woman is treated as unremarkable. (Same age or similar age pairings do happen on screen from time to time, of course. Consider, say, the 2004 Oliver Stone film *Alexander*, starring Colin Farrell, then twenty-eight, and Angelina Jolie, twenty-nine. Then again, *she played his mother.*)

I'm not saying these are not great films (some really are) or indeed that I'm not a fan of some of the actors who appear in them. Neither am I claiming that each individual film should have been cast differently. Just as using slim, white, able-bodied young models in ads is not a problem in any individual case, it is the omission of others as a larger pattern where problems arise. Thus, seeing an age gap between a younger woman and

an older man in a film is not in itself a problem; rather, it is the lack of variety that bears mentioning, and the consistent exclusion of certain types of people and relationships.

This pattern of pairing women with older men or having women play a part much older than their real age is, in my experience, common to modelling as well. When paired with a male model, I was always significantly (ten–plus years) younger. Once I hit my twenties (I quit at twenty-five, so we're talking about my early twenties), I started getting offered jobs where I would be posed as a wife alongside a male model 'husband' in his forties or as a mother alongside children I would have had to give birth to at the age of twelve. Perhaps this was peculiar to my experience and I looked older than I was, but I don't think so. I believe we read women as 'older' because of constant reinforcement. I am not immune, either. When my husband is described as a 'young man' the term seems to fit, though I would baulk at being called a 'young woman', despite the fact that we are only three months apart in age.

Just how much life imitates art – or, for that matter, mass media, with women frequently vanishing from the screen by the age of forty – is a subject of heated debate. One thing is certain, though: a gendered and ageist pattern is still prominent in our popular culture, privileging the fertile woman over the infertile, and the wise man over the wise woman, influencing the representation – or more to the point, the *under-representation* – of our older female population.

I don't expect every woman to do the same or even feel the same, for all the reasons listed above and more, but I have always been partial to simple truth-telling when it comes to the question of my age. This practice is not recommended by some of the most successful older women I know, but I am not

discouraged. In part this is because it seems logical to me that if women deny that they are ageing, then women over a certain age are, in some ways, participating in their own 'symbolic annihilation'. The only way to remove the taboo of age is to own our ageing, and also to recognise that a chronological age is not in itself a determination of health, sexual libido, intelligence, vitality or ability, let alone *relevance*. If we stop and think about it, most of us can name a person over fifty who has the vitality of a teenager – and, conversely, a teenager with the smarts (if not life experience) of someone decades their senior. Age does not define us as much as we are often led to believe, particularly now that health care in countries like ours has improved significantly for all but the most destitute among us (significantly, our Indigenous population has a lower life expectancy – 69.1 for men and 73.7 for women[4]). The only certain thing is that we all age and, if we are lucky, we grow old.

As a woman of forty, I can't yet comment on the experience of old age, but I do know many older women and men who have taught me how important the lives and contributions of my seniors are. That they are too often swept to the fringe bothers me a great deal; there is a wealth of knowledge being discarded, and often real lives, too. It's madness and it's cruel.

I volunteered for years in a seniors' home on Vancouver Island when I was a teenager. I went once or twice a week (when I was in town) for a chat with a senior who did not get many, or any, visitors. I was paired with Edna, a tall woman in her nineties who needed a special wheelchair after an accident involving some stairs. Because of the nature of her injury, her long legs had to remain straight, so her wheelchair was quite unwieldy. As a tall girl myself, I was a perfect fit for her physical needs. We spent many hours talking and I learned a

great deal from Edna about her fascinating life as one of the first pioneering women in Canada. It was a valuable experience for me, and one I will never forget.

In an unquestionably ageist culture, reading women as 'older' and reading older people as irrelevant can have detrimental real-life consequences, as the perspectives, achievements, needs and struggles of women in middle and later age go largely ignored. For instance, we do not often hear that women in Australia retire with far less superannuation than men and many women live out their golden years in poverty.[5] We don't think about it, even though we will become the aged population one day. If older women were a more powerful group, this problem would surely have been made a true priority already.

With all this in mind, it is not surprising that so many women feel that their lives must essentially be complete by age thirty-five or forty. Symbolically, it *looks* like that is the end. The end not just of our 'fertile' years, but also the supposed completion of every achievement of significance a woman should expect to aim for, even though statistically they are not even halfway to their life expectancy. This is a fiction we must discard.

So today, as I part my hair to one side to show off my silver, I contemplate the possibilities offered by the years to come. And I remember the words of Betty Friedan: 'Ageing is not lost youth but a new stage of opportunity and strength.'

I do not miss my youth. I would not return to it if I could. I look forward, instead, to new stages of opportunity and strength.

THE FEMINIST

I myself have never been able to find out precisely what
feminism is: I only know that people call me a feminist
whenever I express sentiments that differentiate me from a
doormat or prostitute.
Rebecca West, *You Rebecca*[1]

Not long after writing a blog post in 2011 about some
international statistics showing the under-representation
of women authors in book reviews, I found myself being
interviewed at the ABC about my own newly released novel.
The interviewer had read the post and seen the controversy it
caused (one male arts critic rather infamously accused me of
'privileged whining' for publishing the stats) and to my
surprise, for the first time in my life, I found myself being
directly asked on camera if I was a feminist.

'Yes, I am a feminist. I believe in equality,' I responded, or
something to that effect (notice how I felt I needed to explain
what feminism was), but I'm ashamed to admit that in that
moment, in the glare of the TV lights, I did feel a ripple of
actual fear. Part of me was afraid of the vitriol I would be

subjected to for publicly identifying with the very movement that had given me the right to vote, the right to own property, the right to work and earn my own pay.

How can that be?

While I happily call myself a feminist, I recognise that there are a number of people who still recoil at the word, including a generation of young women who happen to agree heartily with feminist principles – their right to vote, to bodily autonomy, to work, and to demand equal pay and own property, all things fought for by the feminist movement. It often goes something like this: 'I believe in equality, obviously, but I'm *not a feminist.*' Agreeing with the principle of social and economic equality – the foundations of feminism – does not necessarily mean you will identify with the movement called feminism, or at least with some of the 'feminisms' you've heard about. And, naturally, not everyone relates to, or cares about, the concerns of the women's movement, just as the civil rights movement, or movement for marriage equality, or equal rights for gay, lesbian, bisexual and transgender citizens are not necessarily on everyone's radar. There are many kinds of inequalities in the world, but without lived experience it can be hard to understand the issues and some people frankly don't care. That reality has never seemed particularly remarkable to me.

What is remarkable, however, is the level of vitriol aimed at those who push for equal rights, or even bring up gender-related issues.

US media mogul and TV evangelist Pat Robertson believes: 'The feminist agenda is not about equal rights for women. It is about a socialist, anti-family political movement that encourages women to leave their husbands, kill their children, practice witchcraft, destroy capitalism and become lesbians.'[2]

You read that right: witchcraft and the destruction of capitalism is what I keep busy with.

In 2012, conservative journalist Piers Akerman referred to the women's movement as 'radical', and there is a lot of talk about the evils of the so-called 'feminist agenda'. (Read: 'equality agenda'.) On 8 November 2012, after Barack Obama's re-election, Steve Kates, who teaches economics at RMIT in Melbourne, wrote in conservative academic journal *Quadrant*: 'The confluence of the mendicants, the envious, the abortion lobby, what I will call the cohort of damaged women, and the social sciences know-nothings has proven a formidable combination.' He went on to say, under the heading of 'Damaged Women', that women were 'living in a world of paranoia' when concerned that their reproductive rights might be restricted, and their 'anger is beyond all understanding'. In the same piece he laments the sexual revolution and 'the feminism of the 1960s which unmoored women from their traditional roles'.[3]

Opponents of feminism frequently claim that feminists don't know what they are after. They do. Feminists want gender equity or fairness. They want equal opportunity, equal rights, equality for women. (Equality = same value or status. They want to be equal to, not the same as, men.) This is no mystery. And there is no disputing that self-determination has not traditionally been afforded to women, and they have had to campaign, fight, face beatings and endure imprisonment in order to achieve the basic rights they now have.

Self-determination is as important to me as a woman as it is as an Aboriginal person. Through structural forms of oppression over time we have been continuously denied

the right to define ourselves and set the course of our own
lives, and that's why it's important to fight on both fronts.

Celeste Liddle

While some women's rights advocates may disagree on which
approach is needed to best achieve greater gender equity, there
is no disputing that this is what they 'want'. Of course, those
who fight for, say, democracy, disagree at times on just how it
should be achieved or what the 'ideal' democracy should look
like. And in some rather bloody ways, too. Disagreements
occur with all groups and thinkers, but logically occur with
more frequency in progressive movements than conservative
ones due to the simple fact that conservative principles
frequently involve apprehension about change and innovation,
an instinct to keep things the same, 'protect' what is or was, or
to go back to some previous, better time (even if that era is
viewed through rose-coloured glasses), while progressive
principles involve changing things with the aim of social
reform, moving towards something that is 'better' than what
has come before (again, even if that 'better' time is viewed
through rose-coloured glasses).

There is also disagreement about what it means to be a
feminist, as well there ought to be. There is no single
figurehead for the women's movement and no single
prescription for what *your* feminism should be, so long as it fits
broadly into this set of principles:

feminism
(noun)
the advocacy of women's rights on the grounds of political,
social, and economic equality to men.[4]

You must believe women are of equal value to men and deserving of the same rights over their bodies and their lives. If you are willing to advocate for this belief, whether at the dinner table or in a women's march, then you are – to my way of thinking – a feminist.

In Caitlin Moran's 2011 book *How to Be a Woman*, she articulates her (oft-quoted) method for finding out if you are a feminist:

Put your hand in your pants
A) Do you have a vagina? And
B) Do you want to be in charge of it?
If you said 'yes' to both, then congratulations! You're a feminist.

Moran urges readers to 'reclaim' feminism. I agree this would be a very good thing. My definition does not necessarily involve having a vagina, but logically, historically, and of course humorously, Moran's simple definition works because one of the primary goals of the women's movement, along with involvement in decision-making in society, has been achieving bodily autonomy for women and girls. Basically, feminism has had to wrest the control of women's vaginas (i.e. women's bodies and reproductive abilities) away from the state, the church, male family members and husbands, and give it back to the individual to whom the body belongs. This is an ongoing battle in many places of the world where, for instance, women cannot obtain safe and legal abortions even when the pregnancy threatens their lives, and wives can legally be raped by their husbands, even when the couple is separated, to give but two examples. As I previously mentioned, this marital rape immunity was even written into Australian law until the 1980s.

The battle for women's rights over their own bodies has a

long and well-documented history, as women and their bodies literally belonged to others (fathers, husbands) under law until only recently, and women's bodily autonomy was considered limited or 'conditional'. Marriage was originally a contract of ownership between a groom and the patriarch of a household, hence the 'handing over' of a bride from father to groom during the traditional ceremony. This cultural belief was also spelled out clearly in the Bible:

> To the woman he said, 'I will make your pains in
> childbearing very severe;
> with painful labor you will give birth to children.
> Your desire will be for your husband,
> and he will rule over you.
>
> Genesis 3:16
> (New International Version)

And:

> You shall not covet your neighbor's house. You shall not
> covet your neighbor's wife, or his male or female servant, his
> ox or donkey, or anything that belongs to your neighbor.
>
> Exodus 20:17
> (New International Version)

The *Jewish Encyclopedia* (1906) provides further commentary on the subject 'Husband and Wife'. It says, in part:

> As a punishment for her initiative in the first sin, the wife is to
> be subjected to her husband, and he is to rule over her
> (Gen. iii. 16). The husband is her owner ('ba'al'); and she is
> regarded as his possession (comp. Ex. xx. 17).[5]

When man and wife 'became one' through marriage, the woman, now 'wife', was absorbed into the man in the eyes of the law. She had no separate identity. This is why the wife traditionally took the man's name (after previously having her father's) and why, in the most traditional correspondence of wedding invitations and cards, the couple will often be addressed as Mr and Mrs John Citizen, and not Mr and Mrs Citizen, or Mr John and Mrs Jane Citizen. The wife is Mrs John Citizen. She loses even her first name.

The notion of *woman as property/man as property owner* has a long association in law, culture, religious teachings and tradition, all of which has required vigorous and at times dangerous activism to overturn, just as it was in other circumstances where humans were property – for example, in the reprehensible tradition and history of slavery. Interestingly, where both men and women were owned by a 'master', women still appear to have been worse off in many cases, as some laws stated a manservant could go free after seven years, but not a woman, as per Exodus: 'If a man sells his daughter as a servant, she is not to go free as menservants do.' Women and girls were also often made to submit to the sexual demands of a master, were taken as concubines or owned as part of a group of female sex slaves and were frequently forced to bear their master's children. This was a common trauma borne by African-American slave women in the US.

> [P]atterns of oppression and privilege are rooted in systems that we all participate in and make happen. Those patterns are built into paths of least resistance that we feel drawn to follow every day, regardless of whether we think about where they lead or the consequences they produce.
>
> Allan G. Johnson[6]

We know that the systems in place today, in our dominant culture, were for the most part created by one demographic – educated white men of European descent. I am not taking anything away from their various accomplishments by simply stating that fact. That the systems of government, law and commerce which exist today were largely created by this one demographic, and that this same demographic continues to hold power within these systems is not shocking, but a logical extension of what Allan G. Johnson refers to as 'the paths of least resistance'. Wealth, influence and opportunity have largely been passed down from generation to generation – not just in a financial sense, but also in terms of access to the best education, most influential people and most promising opportunities. Breaking in from the outside is harder than simply following your 'birth right' or 'destiny'. This is a pattern we have all observed and for the most part accepted: some are born into privilege. That the systems we exist within today were created by men means that women have had to work against considerable obstacles and resistance to be included at all. It has required activism.

Feminist activism seeks to achieve political, economic or social equality for women, agitating against this established history of oppression, but though most people would happily claim that 'men and women are of equal value', calling yourself a feminist is still considered a tricky matter.

In a 2003 interview, journalist and radio broadcaster Derryn Hinch said the following with regards to whether or not he was a feminist:

> I try to be. I've always said I'm as much of a … of a feminist as I could be. No man can be an absolute feminist. First of all, we don't have a clue about the pains of childbirth and

never will – that's number one. You can't be an absolute
feminist but you try to be as much as you can. I grew up …
In my twenties, I was interviewing people like Betty Friedan
and Gloria Steinem, so that gave me a pretty good
grounding. No, you can't be a total feminist, but you try.[7]

While I can see where Hinch is going with his assertion that
he can't fully understand the female condition without being
female (which is absolutely true), the pain of childbirth does
not make someone a better or more complete feminist. Yes,
childbirth gives you some first-hand experience of what is one
of the major life-changing experiences in many women's lives,
but many prominent feminists have never given birth. No, it's
not giving birth that makes you a feminist.

So can men be feminists or not? Can they be not 'total
feminists', but half-feminists?

Academic Brian Klocke writes, 'If feminism is to attain its
goal of liberating women, men must be a part of the
struggle …' but goes on to say: 'To be a feminist one must be a
member of the targeted group (i.e. a woman) not only as a
matter of classification but as having one's directly-lived
experience inform one's theory and praxis.'[8]

Feminism is an ideology. It seems logical to me that one
does not have to be born with a particular gender, or to identify
as a particular gender, to believe in a set of ideals – that those
without the Y chromosome are equal to those with the Y
chromosome, and deserve to be treated as equals, given equal
opportunities, rights over their own bodies and so on. The belief
in women's rights and equality, and advocacy of those principals
is what makes you a feminist, not your chromosomes. You don't
need to be a woman to believe in feminism any more than you
need to be same-sex attracted to believe in marriage equality.

Of course, you can be absolutely all for feminism without personally identifying as a feminist. Emer O'Toole, an assistant professor at Concordia University (who does identify as a feminist), suggests a helpful distinction. For those who believe in equality but aren't interested in or comfortable with advocating women's interests (because they are male, for example) or, say, are focused on gender issues, but primarily in so much as gender affects men, she proposes the term 'pro-feminist: that is, someone who supports the goals and objectives of the movement for equal women's rights, but who is actively working on male issues'.[9]

Using the definitions I've outlined, I know many feminists, and pro-feminists, most of whom are women, but many of whom are men. When I asked a range of people – journalists, academics and writers – whether men could be feminists, there were some excellent responses. Here is a small sample:

> Feminism is a belief, it is not restricted to women because it is a belief about women … You can't be feminist if you're not a feminist, that is all … we need more awesome feminists, and I don't care which gender they are.
>
> Ella James, broadcaster, journalist and performer

> Of course. And I find it quite difficult to be close with men who aren't.
>
> Emily Maguire, author

> Yes! I think?
>
> Ben Pobjie, writer and comedian

Feminism must always be led by women, just as the fight for racial equality must be led by those who are most affected by systemic racism. Men can and should be advocates (advocacy in

general being very in line with feminism), but not the *deciders* of what women should or should not do or what should be done within the women's movement. In this way, having our male Prime Minister (Tony Abbott) as the Minister for Women is inappropriate, in my view, just as it has been inappropriate to have a non-indigenous Minister for Indigenous Affairs. In a male-dominated culture men often speak for women and women therefore struggle to set their own agendas, or get the same respect for their ideas that their male colleagues receive, even when those ideas are identical, as writer and filmmaker Ruby Hamad suggests:

> It just so happens we live in a world where male (specifically, white male) privilege is firmly entrenched. This means feminists who discuss violence against women, both inside and outside the home, are readily dismissed as man-haters and accused of 'playing the gender card'. And that when men grace us with very similar, even identical, opinions, they are hailed as reasoned, objective truth.[10]

It's vital that women are able to participate fully in our democracy, and we need to recognise them when they do.

I see myself as a 'practising feminist', and being a feminist does indeed take practice. The goal is clear but the path is not always clear and the micro-choices one must make each day on how to handle the reality of being a feminist in a non-feminist world are not always clear. Feminists are trying to change the dynamics that adversely affect their gender, while being affected by those very same things. I am not immune to the issues described in this book. I am not perfect.

There are circumstances in which women are going to feel betrayed – they expected something different from another

woman/feminist: better choices, more synergy in thinking and agreement on approach – but the fact remains that women exist in a world that is not primarily feminist and that reality brushes up against us in a multitude of ways. Demanding a kind of 'feminist perfection' would result only in inaction. No person is *only* a feminist: they are also employees, business partners, parents, spouses, friends, human beings – in my case also a professional writer, a mother, a model, a human rights advocate, a journalist among other things, and all of these responsibilities and commitments brush up against one another, often with harmony, because that is what I aim for, but occasionally with a loud bang. Sometimes I do something, find myself uncomfortable and think, 'I'm not doing that again.' The tenets of feminism inform everything I do (that is, I never forget my views on gender equity), just as all of my personal beliefs inform everything I do, but I cannot always embody all of these roles in my life perfectly to the satisfaction of others.

I often hear the argument that 'Woman X can't comment on Sexist Exhibit A' because she is complicit in some way, by allowing the existence of some other type of sexism. For example, 'How can that newsreader criticise Exhibit A when she took a job at a network that shows Sexist Exhibit B at seven o'clock on weeknights?' or 'She works with Sexist Man X so how can she denigrate Sexist Man Y?'

Few people, if any, can pass these tests of absolutes – including those making the accusations, ironically enough. I certainly can't pass. What happens, when set to these impossible standards, is that nearly every woman's comments are rendered invalid when she talks about sexism or discrimination; her insights and experiences are dismissed, generally without actually acknowledging the points made, and once again the conversation is derailed.

Personally, I'd like to see women forgiven more often in these situations, and the actual offenders forgiven less. After all, isn't it these (alleged) abusers and social/cultural/industry patterns we have a problem with, and not those who have to deal with them?

What about feminists who agree with all but the word itself? To me, the important thing isn't the word, but the philosophy and action – the advocacy. The actor Susan Sarandon, for example, is in every way a feminist in my eyes, but does not identify as a 'feminist'. Because I identify as a feminist I'd like her to as well, but I am not going to get caught up in the word. According to an interview in the *Guardian*, she prefers the term 'humanist', saying 'it is less alienating to people who think of feminism as a load of strident bitches and because you want everyone to have equal pay, equal rights, education, and health care.'[11] Madonna is also among those who prefer the term 'humanist'.

Words are not as important as actions – but there is just one problem. Humanism and feminism may well be compatible, but the two terms are not interchangeable and there are some key reasons why: Humanism is a well-established discipline and belief system of its own, which traditionally dealt specifically with human values and human agency outside of the idea of God or faith, and was not focused on gender-based inequities. On examination, although saying 'I'm a humanist' sounds like a comfortable and perhaps less alienating way of saying that you think all humans are equal, it soon becomes clear that it is problematic to closely associate humanism with feminism or gender equality because it is a movement that was founded by (and still happens to be dominated heavily by) white males, with its origins in thinkers such as Epicurus, Spinoza, Thomas Jefferson, Freud, Marx,

Nietzsche and Darwin. As with other philosophical and academic movements women were actually excluded from the early humanist movement and later, when they participated (as many great women do now), they were often overlooked.

In a speech by Florien Wineriter published in *Utah Humanist*, a chapter of the American Humanist Association, he acknowledges that 'They were all males but there have been many females who have been great teachers and supporters of Humanism … women have been strong, important leaders of the Humanist Philosophy, often overlooked.'

Though as an idea, humanist thinking was 'initiated by secular men of letters' during the Renaissance period, the Yale Humanist Community, in outlining humanist history, writes that, 'The first explicit Humanist document was the 1933 Humanist Manifesto'. This outlines fifteen points, with lots of mention of 'man' as a concept but does not once use the word woman, or women, nor does it mention the women's movement or struggle, or the importance of gender equality or the need for an end to discrimination based on sex. Out of the humanists who signed the manifesto, all thirty-four were men.

Humanism has needed feminism to overcome its bias against women – the same bias that has been widespread across our culture, and has been particularly pronounced in academia, philosophy and other institutions. Women had great difficulty being recognised by the movement until the 1970s, the height of 'second wave' feminism. It isn't until the second Humanist Manifesto of 1973 (which does explicitly mention elimination of discrimination based on sex, race, etc. among many other points) that any women are included as signatories. (Even then, out of the 114 primary signatories, only 11 were women.)[12] The two terms and the two movements (as *complimentary* as they may be in some ways) are simply not interchangeable.

Despite this, humanism is still offered as a preferred term to feminism, and recently the writer/director Joss Whedon suggested something like 'genderist'. While I understand some of the points made by people who dislike the term feminist, both of these descriptions (humanist, genderist) leave out one important part of feminism – the 'fem' part, the recognition that we are tackling something that affects women and girls.

Actions are more important than words, but we still need language to describe actions. With that in mind, there are three reasons why I like and use the words 'feminist' and 'feminism' and have no trouble at all in identifying with them:

- The standard dictionary definition of 'feminism', i.e. 'the advocacy of women's rights on the grounds of political, social, and economic equality to men', describes precisely my position.
- By the standard definition most people ought to believe in the tenets of feminism, being what they are.
- The word 'feminist' not only describes a person who believes in basic equality for human beings, but also mentions *advocacy*. It implies that the feminist realises equality along gender lines has not been achieved, because practically every statistic we have on the matter of social, political and economic differences between the genders shows us that this is the case. Hence the need for advocacy/activism.

This last point is significant. When people take issue with my use of the term feminist and respond along the lines of, 'If you really claim that you believe in equality, doesn't that mean you are a humanist, not a feminist?', they so often follow up with an argument about how equality has basically been achieved

along gender lines and I ought to talk about something else. To which I might respond, 'And I do, actually, talk about many things. But right now I'm talking about how this issue affects women and girls.'

While labels are not always helpful, it is notable that the opposition to the word 'feminism' commonly stems from concerns about how feminists are perceived by others. Some say it is the 'ism' in feminism that people don't like, but I think it is the 'fem' – the reference to a female focus – that people react most negatively to. We may do well to remember that the term 'suffragette' was first introduced as a term of derision, not empowerment, to describe women fighting for the right to vote in the nineteenth and twentieth centuries.[13] It was later embraced and reclaimed by women in the suffragette movement itself. 'Women's Libber' was later used as an insult to describe women wishing to have rights at work and reproductive choice, as part of the Women's Liberation movement of the 1960s and 70s. There has never been a 'safe' term for feminist activism. That in itself tells us something.

It is unlikely there will ever be an uncontroversial word to describe the acknowledgement of issues that specifically affect women and girls, and the fact that being born a girl (still) sets out different opportunities and social expectations, and not all it sets out is fair and good for women and girls, as the statistics in the previous chapters demonstrate. As Ambassador for Women and Girls Natasha Stott Despoja notes, 'Women get cold feet describing their views as "feminist". Perhaps it's because the prejudice they face is insidious … Inequality is the dirty word, not feminism.'[14] Thankfully the term feminist is being embraced by some, and used as a term of empowerment, but still the resistance remains.

As Anne Summers pointed out in *Damned Whores and God's Police* in 1975:

> Feminism has always been sneered at as Messianic man-hating. The most common charge against suffragists was that they were soured spinsters. The *Bulletin* labelled them 'disappointed childless creatures who have missed their natural vocation' … The critics have consistently avoided recognising the distinction between a hatred for a male-dominated system which denies women recognition as complete human beings, and hatred directed against the male sex per se.[15]

Perhaps one day, when gender equity is truly achieved and women and men have equal status and value in our society, the word 'feminist' will become as much a thing of the past as the word 'suffragette'. We'll see feminists on stamps and in photographs, and we'll salute their bravery and success in being part of the revolution that brought equality to half of the world's population. Sadly, we are still a long way from that day. Until then, I will continue to engage in feminism, along with the other forms of activism on issues I am passionate about.

I will be a human, woman, mother, wife, daughter, sister, writer, speaker, human rights advocate and *feminist*.

18

THE NEXT CHAPTER

When women and men understand that working to
eradicate patriarchal domination is a struggle rooted in the
longing to make a world where everyone can live fully and
freely, then we know our work to be a gesture of love. Let us
draw upon that love to heighten our awareness, deepen our
compassion, intensify our courage, and strengthen our
commitment.

bell hooks, *Talking Back*[1]

If men and women, girls and boys, are to avoid having their
lives overly determined by gender fictions, the story needs
changing, as does the balance of storytellers.

We need girls and women to share 'half the sandbox', as
Geena Davis puts it. We need to 'heighten our awareness,
deepen our compassion', as bell hooks explains, and see that as
much as we'd like gender, race, class and sexuality not to
matter, they still do. To change the story, we must look
beyond the fairy tales and storytellers of the past towards a

future that is more balanced and inclusive, more representative of the diverse world in which we live.

Call me an optimist, but I believe we can, in fact, change the dominant narrative one story at a time. We have no more need for the limited fictional archetypes of the Virgin, Temptress and Witch. A woman can be someone else now, a thousand diverse someone elses, as strong, complex and multi-dimensional as her male colleagues, no more or less in need of saving, no more or less human, no more or less flawed.

We must resist when statistics, research, lived experiences and vividly demonstrated examples are swept aside with the most inane and cosy logic – 'Yeah, but everything is equal and just fine, and that thing you mentioned? The low pay? My wife makes more than me. And politics? It's not about gender, it's about the best person for the job. It's about merit.' – happily overlooking the fact that a startling percentage of the time, year after year, the 'best person' just happens to be from the same demographic – the one that has been dominant for centuries.

> The idea that only white straight men from one socio-economic background have the skills and capabilities for leadership is simply wrong.
> Nareen Young, CEO, Diversity Council Australia[2]

It would be easy to blame the aggressive denial of inequality on the very same sexism it allows, to assume that the motivation for excusing racism is racism, and the motivation for excusing sexism is sexism. This may be a significant part of the underlying cause of much of the pushback, but there is another important factor that bears mentioning. I've saved it for this last chapter, not as an afterthought, but as an important

parting one: Accepting that the world is not entirely fair is hard to do. It is not comfortable. It is anything but cosy.

I believe this is one reason why discussions of any of the realities of various inequalities in the world are met so frequently with discomfort and, ultimately, the desire to dismiss, to derail, to turn away.

In order for a segregated class system, feudal system or caste system to exist, the masses have to believe that their position in the world is logical and fair, or at the very least enough of the masses have to accept their circumstances as part of the 'natural' order. It was taught that those who were born into power and wealth had a divine right to their positions. It was their birth right. The privileged needed the myth to feel superior and deserving of their position and the poor had to be made to believe the myth so they would not rebel against it (which nonetheless did happen from time to time; the illusion was not always infallible). The lie of divine, God-given superiority is much harder to pass off now. Few in our culture would believe any royal family was literally chosen by an omnipotent god on high. Today, the more common myth is one of a flawless meritocracy – that merit and hard work win every time and there is no cultural bias or inequality in our society.

A central part of the notion of freedom in the context of what we regard as the 'free world' is that anyone can do or achieve anything, and that all achievement is deserved, based on 'merit'. (It follows that any hardships experienced are also deserved.) This may be the ideal, but it is not the reality. I am not suggesting that people who go to work and earn their salary have not done so fairly, but rather that the system, as much as it may be argued to be the best system, is nonetheless flawed. Any look through the history books can show us a list of reasons

why the imperfections in the system so frequently take the same forms. On a structural and foundational level, some are more privileged than others. I am privileged as a white person, as middle class, as able-bodied. To acknowledge that some people are born 'more equal than others' (to reference George Orwell's *Animal Farm*) is simply jarring. To question the idea of a perfectly functioning meritocracy is deeply uncomfortable for me, because I am doing okay now. I can pay my mortgage and provide for my family, while others cannot. By recognising that I am lucky in a certain way that others are not, I am recognising that I owe some of what I have to the goodwill and sacrifices of others, and giving back some of that 'luck' or opportunity or material wealth is in my social contract. It requires questioning one's own privilege. This means that any discussion of inequality automatically aggravates.

When it comes to the tragedies of others, we have to believe they could never happen to us, that somehow the victims deserved their lot. As for the inequalities still manifest in social, economic and political differences between the genders, hanging on to the idea that 'women are their own worst enemies' feels better, because it implies that the relative lack of female participation and privilege is deserved – a natural state, even.

There is also, I believe, a very human tendency to regard any consistent pattern as evidence of a 'natural state' of some kind. 'It's always been this way' is a reason given not to question the way it is, overlooking the fact that the way it is may only have been in effect for as long as we have been alive – or not even that long. The idea that women were mentally inferior was based on skewed ideas of the 'biological', put forward by a few privileged men whose ideas became regarded as a 'natural' way of thinking. Social privilege was considered 'natural'. White people decided

that white people were a superior race, conveniently enough, and that it was quite okay to kidnap people from other lands or cultures and force them to work. Slavery was considered 'natural'. So now, when someone says that black people are just naturally lazy, or women are not naturally ambitious, it reveals a lazy logic which seeks to persuade us that the marginalisation of women and people of colour is natural.

It's all fine. The way it should be and all. *Forget history.*

And so now, in contemporary times, we examine the numbers of women in parliament, in positions of power and influence, in well-paid versus poorly paid jobs, in positions of authority, winning critical acclaim, prestigious awards or other public recognition for their work, and it is all too easy to regard the imbalances those numbers illustrate as a mere reflection of what is natural. It is easier to fall back on the idea that what exists is what is natural, rather than consider a far more troubling possibility: that we do not, in fact, live in a flawless meritocracy.

This is why we need to question, listen, consider, care and act.

None of us can single-handedly make the world fair and balanced, but that should not dissuade us from actions, both large and small. We can be sensitive to bias, and work to lessen it. We can practice inclusion. We can actively seek out facts to challenge our assumptions and the assumptions of others. We can pull back from the smaller outrages, the individual bodies and images and statements, to connect the dots and see the bigger pictures. We can stop viewing activism, and feminism, as radical.

A small group of thoughtful people could change the world.
Indeed, it's the only thing that ever has.

Margaret Mead[3]

Acting with new knowledge, we change the world, one decision, one action or word at a time, because for all the formidable influence that money and privilege creates – and that is significant – there is still the matter of *people*. There are those who see a problem and will not give up until they have found a solution. There are those who fight for others. Throughout history we have those incredible stories and the possibilities still remain. This is to our great advantage in the 'free world'. We live in a democracy and we should work to make it still more democratic, more representative, and less biased and prejudiced.

If history has taught us anything it is that we all have more in common than we think. The divide can be crossed. And conquered. After all, most people want the same things – safety, acceptance, love, good health, people to share our lives with. Progressives and conservatives, atheists and people of religion all want the world to be a better place. We only disagree on how to achieve it. Understanding that our essential differences are not so great is the way to bridge that divide. It allows us to see and to hear others. It allows us to be heard. So be part of the conversation. We need you.

Accept that equality is not yet here, not across gender lines, race or class, and it is not 'privileged whining' to point that out. Just because a certain reality exists does not mean it must remain a reality. History shows us that. So if you care about making the world a more equitable place for everyone, keep caring and do not give up.

You can effect change, even if that means finding one person in your life and helping them. Even one. It can be a small, simple gesture, or something more life-changing – like journalist Emma Tom (now academic Dr Emma Jane, who not so coincidentally has won the Women's Electoral Lobby

Edna Ryan Humour Award for 'using wit to promote women's interests') when she gave me the opportunity to take a polygraph test to poke fun at the rumours about me, and show just how ridiculous they were. By giving me the opportunity and presenting me with that challenge, Emma changed the narrative of my career, and exposed one significant public fiction about me.

Now I have laid my own truths bare in *The Fictional Woman*, because today I can afford to tell my story, emotionally, but also financially, without worrying about where my next meal will come from, as I once did. I don't need to be 'Teflon Tara' anymore, as my friend put it. I am no longer a *fictional woman*.

The next chapter is yours.

Endnotes

Introduction

1 Cathy Alexander, 'Govt ministry announced: men the 95% in Abbott cabinet', Crikey, 29 March 2014

2 Chrys Stevenson, 'The Blokeyness Index: blokes win the gender war in Australia's 4th Estate, The King's Tribune, 6 December 2012

3 4th Estate, 'Silenced: Gender Gap in the 2012 Election Coverage – Female Voices in Media Infographic' – www.4thestate.net/female-voices-in-media-infographic/

4 Germaine Greer, 'Why the world doesn't need an Annie Warhol or a Francine Bacon', *The Guardian* – Art and Design, 18 January 2010

5 Nicholas Zurko, 'Gender Inequality in Film', Infographic, New York Film Academy, 25 November 2013

6 Workplace Gender Equality Agency, 'Gender pay gap statistics', Australian Government, August 2013

Chapter 1: The Model

1 David Hutchings, 'That's All a Pose: 15-Year-Old Model Monika Schnarre's a Kid at Heart', People Magazine, USA, 30 June 1986

Chapter 2: The Body

1 Kirstie Clements, *The Vogue Factor*, Victory Books, 2013 p. 69

2 ibid.

Chapter 3: The Survivor

1 Attwood, Margaret (1982), 'Writing the Male Character' in *Second Words: Selected Critical Prose,* House of Anansi Press, Toronto, Canada, p. 413

2 Australian Institute of Criminology, Sexual Violence in Australia, 2001
3 Ken Lay on Family Violence – www.vicpolicenews.com.au/blogs/93-oursay/1302-ccp-ken-lay-on-familyviolence.html#.UiSHu8h62nw.twitter
4 Clementine Ford, 'Can we please stop the victim blaming?', Daily Life, 26 September 2012
5 Greg McArthur, 'Women walk the talk after officer's offending 'slut' remarks', The Globe and Mail, Toronto, 4 April 2011
6 Mala Htun and S. Laurel Weldon, 'The Civic Origins of Progressive Policy Change: Combating Violence against Women in Global Perspective, 1975–2005', The American Political Science Review, Vol. 106, No. 3, August 2012, pp. 548-569
7 ibid.
8 Barbie Nadeau, 'Italian Women: We are Treated Like Prosciutto', Newsweek, 17 April 2011; 'Women bring violence on themselves – priest', Herald Sun (via AAP source), 28 December 2012

Chapter 4: The Writer
1 Judy Putt in Rachelle Irving, 'Career trajectories of women in policing Australia', Australian Institute of Criminology, Australian Government
2 taramoss.com/manus-island-insiders-report
3 Joss Whedon's acceptance speech for Equality Now award – www.huffingtonpost.com/2013/10/28/joss-whedon-equality-now-acceptance-speech_n_4169800.html
4 Doug Barry, 'Neil Gaiman Explains How the Term 'Strong Women' Begets Lazy Writing', Jezebel, 29 December
5 Daphne Guinness, 'Death Sentences', Sydney Morning Herald, 9 October 2004
6 Jeff Popple, 'A life of crime can pay', Sydney Morning Herald – Entertainment, 14 August 2013
7 Graeme Blundell, Review of Hit by Tara Moss, The Weekend Australian 22–23 October 2006
8 Alex Ravelo, 'Fetish, Split, Tara Moss', Interrobang, 26 September 2012
9 Darren Moyle, 'First, write great Australian novel; second, get a nose job', Sydney Morning Herald, 27 November 2002

10 Lissa Christopher, 'Lovers of writing pack venues as the words rain down', *Sydney Morning Herald* – Entertainment, 24 May 2013

11 'Carrie On: Pretty is as pretty does', *Cairns Post*, 4 August 2007

12 Appeared on News Limited websites nationally but this was taken down after reader complaints

Chapter 5: Gold–diggers and Mean Girls

1 Attributed to Marcus Tullius Cicero in Tice, Paul and Montague Summers (translators) (2000 [1928]), *The Malleus Maleficarum: the notorious handbook once used to condemn and punish 'witches' by Heinrich Kramer and James Sprenger*, p. 43, Book Tree, US.)

2 Craig Binnie, 'Beauty swears she's no beast', *Herald Sun*, 6 June 2007

3 *Sunday Telegraph*, Ros Reines, Dec 10, 2006

4 *Daily Telegraph*, Sydney Confidential/'Moss's Lips are Sealed on Kiss', 11 May 2007

5 Sydney Confidential, 'Model-turned-author Tara Moss engaged again', *The Daily Telegraph* – Entertainment, 25 February 2009

6 Holly Byrnes, 'Chic overcomes shake despite security fears', *Sun Herald*, 3 November 2002

7 'James Packer and Miranda Kerr in secret relationship just months after splitting from respective partners' news.com.au, Celebrity Life, 2 December 2013

8 Darren Davidson, 'Packer trades in one model for another', *The Australian*, 2 December 2013

9 H L Mencken, *A Little Book in C Major,* John Lane Company, New York, 1916, p. 59

10 Samantha Brick, 'There are downsides to looking this pretty': Why women hate me for being beautiful ', *Daily Mail*, 3 April 2012

11 Of the origins of the Bechdel test, Bechdel writes: 'I am pretty certain that my friend Liz Wallace, from whom I stole the idea in 1985, stole it herself from Virginia Woolf, who wrote about it in 1926.' dykestowatchoutfor.com, 8 November 2013

12 Elizabeth Behm-Morawitz and Dana E Mastro, "Mean Girls? The Influence of Gender Portrayed in Teen Movies on Emerging Adults Gender Based Attitudes and Beliefs, ' *J & MC Quarterly*, Vol. 85 No. 1, 2008, pp. 131-146

13 Tara Moss, 'Tara Moss's Red Lips Roadtest', The Hoopla, 5 February 2014

14 Chloe-Lee Longhetti, 'Aussie model and author Tara Moss says she's been 'sticking my tongue out since before Miley was in nappies'', Sydney Confidential, *The Daily Telegraph*, 6 February 2014

Chapter 6: The Femme Fatale
Parts of this chapter were originally published in the opinion piece 'Beauty Obscures the Beast', *Sydney Morning Herald*, 24 September 2011, and featured in the speech 'Deadlier than the Male', given at the Wheeler Centre in Melbourne, May 30 2013

1 St Jerome, *Against Jovinianus (Book One)*, New Advent, [393 CE] – www.newadvent.org/fathers/30091.htm

2 Hesiod, *Theogony*, Perseus Digital Library, Tufts University, Lines 590–4, 8th–7th century BC

3 Christopher L.C.E. Witcombe, *Eve and the Identity of Women*, Chapter 7, 'Eve & Lilith', Art History Resources: – http://witcombe.sbc.edu/eve-women/7evelilith.html

4 Plato, *Timaeus,* circa 360 BC, Benjamin Jowett (translator) 1891 (3rd edition), p. 58. Classics MIT

5 Arthur Conan Doyle, *The Sign of Four,* Chapter 9: A Break in the Chain, About.Com Classic Literature, 1890

6 'Pat Robertson Excuses Petraeus: "He's a Man"', The Young Turks, Youtube, 13 November 2012

7 Robin Morgan, 'Behind the Headlines – Sharing the Spotlight with David Petraeus', Women's Media Centre, 17 November 2012

8 Bob Kane and Tom Andrae (1989), *Batman and Me*, Eclipse Books, Forestville, CA, USA, pp 107–108

9 Tobias Jones, 'Death in Perugia: The Definitive Account of the Meredith Kercher Case by John Follain – review', *The Guardian*, 27 October 2011

10 *Underbelly:Razor*, series 4, Nine Network, 2011. Voiceover from television promo; Colin Vickery, 'Review: *Underbelly: Razor* a cut above the rest', *Herald Sun* – Entertainment, 22 August 2011

11 Cesare Lombroso and Guglielmo Ferrero, *Criminal Woman, the Prostitute, and the Normal Woman,* Introduction by Nicole Hahn Rafter and Mary Gibson, Duke University Press, 2004, p. 8

Chapter 7: The Archetypal Woman

1 Bell Hooks, *Remembered Rapture: The Writer at Work*, 1999, Henry Holt and Company, New York, p. 30

2 Some women still publish under male pseudonyms in order to appeal to more readers. See: Stephanie Cohen, 'Why Women Writers Still Take Men's Names', *Wall Street Journal*, 6 December 2012. These methods have been employed for as long as writers have. But by insisting on gender-neutral names to help sales, are publishers (or in some cases, writers) inadvertently also reinforcing the idea that the only books worth reading are books by men?

3 VIDA Women in Literary Arts, 'The 2011 Count', 27 February 2012 – www.vidaweb.org/the-2011-count/

4 www.booksellerandpublisher.com.au/DetailPage.aspx?type=item&id=23091. Examination of the database of industry publication Books and Publishing suggests about equal numbers of men and women are published in Australia. This statistic is also quoted by The Stella Prize on their webpage in Stats! And more stats! Sept 9, 2011, http://thestellaprize.com.au/2011/09/stats-and-more-stats/

5 Alison Flood, 'Australian 'Orange prize' to promote women writers' status', *The Guardian* – Books, 4 May 2011

6 "68 per cent of men who work in the industry earn more than $100,000 as opposed to 32 per cent of the women, according to The Bloom Report in 2007. The Stella Prize, 'Stats! And more stats!", 9 September 2011

7 Amanda Hess, 'Which Is the Manliest Literary Magazine of Them All?', *Slate*, 24 February 2014

8 Mykol C Hamilton, David Anderson, Michelle Broaddus and Kate Young, 'Gender Stereotyping and Under-representation of Female Characters in 200 Popular Children's Picture Books: A Twenty-first Century Update', Sex Roles 2006, No 55, pp. 757-765, published online by Springer Science + Business Media, Inc. 6 December 2006

9 Emily M Keeler, 'David Gilmour on Building Strong Stomachs', Hazlitt, Random House of Canada, 26 September 2013

10 Versha Sharma and Hanna Sender, 'Hollywood Movies With Strong Female Roles Make More Money', Vocativ, 2 January 2014

11 Jennifer Kesler, 'The Bechdel test: it's not about passing', the Hathor Legacy, 28 December 2010

12 Oxford Dictionaries – www.oxforddictionaries.com

13 The scriptwriter Callie Khouri and her film were attacked at the time, labelled 'toxic feminism'. She was asked by interviewer, Jodie Burke: '... others have labelled you a toxic feminist. What do you have to say in response to that?' Khouri replied: 'Kiss my ass. Kiss my ass. I was raised in this society. Let them get their deal worked out about the way women are treated in films before they start hassling me about the way men are treated. There's a whole genre of films known as 'exploitation' based on the degradation of women and a whole bunch of redneck critics extolling its virtues, and until there's a subgenre of women doing the same thing to men in numbers too numerous to count, as is the case with exploitation film, then just shut the fuck up.' She goes on to say: 'They only criticize me because I'm a woman, the same way they only criticize Spike Lee and other filmmakers because they're black. Only women and minorities are under this directive to present responsible role models in non-threatening, non-violent movies. All other white guys can do whatever they want. It's just ridiculous.' Callie Khouri, *Thelma and Louise and Something to Talk About (Screenplays),* 'Introduction: An Interview with Callie Khouri', Jodie Burke, Grove Press, NYC, USA, 1996, pp. xv–xvi

14 Nicholas Zurko, 'Gender Inequality in Film', Infographic, New York Film Academy, 25 November 2013

15 Frank Bruni, 'Waiting for Wonder Woman', *New York Times – Sunday Review,* 21 December 2013

16 *Los Angeles Times* reporters looked at 5100 Oscar voters – more than 89 per cent of all active voting members; Doug Smith (data analysis), Robert Burns and Khang Nguyen (graphic), Anthony Pesce (programming), 'Graphic: And the academy members are ...' *Los Angeles Times,* 19 February 2012

17 www.theguardian.com/artanddesign/2010/jan/17/germaine-greer-elles-pompidou

18 Shown here: www.guerrillagirls.com/posters/getnaked.shtml

Chapter 8: The Invisible Woman
1 Virginia Woolf, *Orlando: A Biography,* Bollinger: Urban Romantics, London, UK, 2012 [1928], Chapter 1, p. 13
2 4thEstate, 'Silenced: Gender Gap in the 2012 Election Coverage', Female Voices in Media Infographic

3 Stephen Colbert, *The Colbert Report*, Comedy Central, 12 March 2012
4 http://womeninjournalism.co.uk/wp-content/uploads/2012/10/
 Seen_but_not_heard.pdf
5 Chrys Stevenson, 'The Blokeyness Index: blokes win the gender war
 in Australia's 4th Estate, The King's Tribune, 6 December 2012
6 Tara Moss, 'The Age of Invisibility?', TaraMoss.com, 25 July 2013
7 Eric Stoller, 'Affirmative Action', Eric Stoller's blog, 4 March 2006
8 World Economic Forum, *Insight Report: The Global Gender Gap
 Report 2013*
9 Australian Bureau of Statistics, '5673.0.55.003 – Wage and Salary
 Earner Statistics for Small Areas, Time Series, 2005-06 to 2010-11',
 Media Release, 20 December 2013
10 Rebecca Cassells, Riyana Miranti, Binod Nepal and Robert Tanton,
 AMP.NATSEM Income and Wealth Report Issue 22 'She Works
 Hard for the Money', National Centre for Social and Economic
 Modelling (NATSEM), University of Canberra, April 2009
11 Australian Human Rights Commission, 'The gender gap in
 retirement savings' – www.humanrights.gov.au/publications/gender-
 gap-retirement-savings

Chapter 9: The Gender Wars

1 Charlotte Perkins Gilman, *Women and Economics*, Cosimo Classics,
 Cosimo Inc, New York, 2007 [1898], p. 74
2 American Psychological Association, 'Think Again: Men and
 Women Share Cognitive Skills', 18 January 2006
3 Rousseau, Jean-Jacques in *Émile*, quoted in Carol Blum, 'Rousseau
 and Feminist Revision', Eighteenth-Century Life, Vol. 34, No. 3,
 Fall 2010, p. 51
4 Hegel, GWF (trans. T.M. Knox), *The Philosophy of Right*, Oxford:
 Clarendon Press, 1957 [1820], pp. 263–64
5 Cordelia Fine, *Delusions of Gender: The Real Science Behind Sex
 Differences*, 'Introduction', Icon Books, New York,
6 Mary Roach, *Bonk: The curious coupling of science and sex*. New York:
 W.W. Norton & Co., 2009, p. 214
7 There has been heated academic debate about interpretations of
 Freud's work, with Juliet Mitchell, among others, arguing that his
 analysis reflected the patriarchal culture of his day – penis envy
 presented not so much as a lack in women, but as a logical envy of

male privilege. See *Psychoanalysis and Feminism: Freud, Reich, Laing, and Women*, Juliet Mitchell, Pantheon Press, 1974

8 Michèle Le Dœuff, *The Philosophical Imaginary* (trans. Colin Gordon), Continuum Books, 2002, p.108

9 Emily Arrowood, 'Fox Figures: Rise in female breadwinners is a sign of society's downfall', Media Matters for America, 29 May 2013

10 Joe Kelly, 'Tony Abbott in 'dark ages' on women: Jenny Macklin', *Australian,* 16 March, 2010

11 American Psychological Association, 'Men and Women: No big difference'

12 Laura Briggs, 'The Race of Hysteria: "Overcivilization" and the "Savage" Woman in Late Nineteenth-Century, Obstetrics and Gynecology, American Quarterly, Vol 52

13 Nietzsche, Friedrich, *Beyond Good and Evil*, Translated by Helen Zimmern, Chapter IV. Apophthegms and Interludes,Verse 144, Project Gutenberg E-book, 7 December 2009 [1886]

14 Chas. (Charles) L. Dana, 'Suffrage a cult of self and sex; The average zealot has the mental age of eleven and through a cranny sees the dazzling illusion of a New Heaven, *The New York Times*, New York, 27 June 1915, p. 14

15 Aaron Blake, 'Todd Akin, GOP Senate Candidate: 'Legitimate rape' rarely causes pregnancy', *Washington Post*, 19 August 2012

16 Olivia B. Waxman, 'Saudi Cleric Says Driving Hurts Women's Ovaries', *Time*, 30 September 2013

17 Workplace Gender Equality Agency, 'Gender pay gap statistics', Australian Government, August 2013

18 Ruth Weston, Lixia Qu and Jennifer Baxter, 'Australian families with children and adolescents', Australian Family Trends No. 5, 2013

19 Australian Institute of Family Studies, 'Families working together: getting the balance right', Dr Jennifer Baxter, Australian Family Trends No. 2, May 2013

20 Cordelia Fine, *Delusions of Gender: The Real Science Behind Sex Differences*, 'Introduction', Icon Books, New York, 2010, page 82. See for example Bittman, M, p. England, L. Sayer (2003), 'When does gender trump money? Bargaining and time in household work', Faculty of Arts papers, University of Wollongong Research; Brines, Julie (1994), 'Economic Dependency, Gender, and the Division of

Labor at Home', American Journal of Sociology, Vol. 100, No. 3,
November, pp. 652-688, The University of Chicago Press

21 Sarah Thébaud (Cornell University), Masculinity, Bargaining, and
Breadwinning: Understanding Men's Housework in the Cultural
Context of Paid Work, Gender and Society, Vol 24, No 3, June 2010

22 Janet Phillips and Malcolm Park, 'Measuring domestic violence and
sexual assault against women', E-brief, Parliamentary Library,
Parliament of Australia, 6 December 2004, updated 12 December 2006

23 Homelessness Australia, 'Homelessness and Women', 2011-2012

24 Ken Lay, 'Men have to stand up and change their thinking', *Herald
Sun*, 17 October 2013

25 NSW Department of Family and Community Services (2013),
'Women NSW 2013', Report, Section 1:3 Domestic Violence
Homicide

26 Georgina Fuller, 'Australian crime: Facts & figures, Australian
Institute of Criminology', Australian Government, 2011

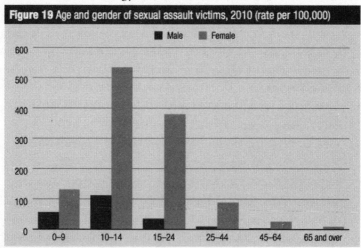

Figure 19 Age and gender of sexual assault victims, 2010 (rate per 100,000)

27 Elspeth Probyn, *Sexing the Self: Gendered Positions in Cultural Studies*,
Routledge, London and New York, 1993, p. 32

Chapter 10: The 'Real' Woman

1 Dove, 'The Dove Campaign for Real Beauty' – www.dove.us/social-
mission/campaign-for-real-beauty.aspx

2 Mamamia Team, 'Sunrise girls go make-up free in an Aussie TV
first', Mamamia, 15 August 2013

3 Dan Amira, 'Hillary Clinton Is Asked What Designers She Wears Moments After Making Point About Sexism', *New York Magazine*, 3 December 2010

4 Lisa Wilkinson, 'When it comes to sexism, media must heal themselves', *The Age* – Comment, 26 October 2013

5 Amy Oliver, 'It does matter how women look on TV': Former BBC correspondent Michael Cole says ageing female broadcasters should stop complaining about sexism', *Daily Mail*, 4 April 2012

6 'Does Our Looks-Obsessed Culture Want to Stare at an Aging Woman?', Transcript, *Rush Limbaugh Show*, 17 December 2007

7 Ashley Judd, 'Ashley Judd Slaps Media in the Face for Speculation Over Her 'Puffy' Appearance', *The Daily Beast*, 9 April 2012

8 Liz Jones, 'Portrait of a slightly saggy supermodel: Liz Jones deconstructs a Kate Moss snap that's worth 1,000 airbrushed adverts', *Daily Mail*, 13 August 2013

9 Barnabe Rich, The Excellency of Good Women. The honour and estimation that belongeth unto them. The infallible markes whereby to know them, London, 1613, p. 16

10 Clementine Ford, 'Why do we bother with make-up free campaigns?', Daily Life, 25 August 2013

11 Germaine Greer, *The Female Eunuch*, p. 325

Chapter 11: The Beautiful and the Damned

1 John Berger, *Ways of Seeing*, Penguin, UK, 25 September 2008

2 Giovanni Busetta, Fabio Fiorillo and Emanuela Visalli (University of Messina), 'Searching for a job is a beauty contest', Munich Personal RePEc Archive (MPRA), Paper No, 49392, 30 August 2013

3 Naomi Wolf, *The Beauty Myth*: How Images of Beauty Are Used Against Women, Vintage, London, 1991, p. 45

4 Ben Child, 'Bret Easton Ellis: Kathryn Bigelow is 'overrated' because she's a 'hot woman', The Guardian, UK, 7 December 2012

5 Christine Sams, 'Eight days: Your Sunday-to-Sunday planner, written by Christine Sams', *Sydney Morning Herald* – Entertainment, 16 September 2012

6 Wendy Boswell, 'Emma Watson talks about "pervy paparazzi"', Crushable, 5 February 2009

Chapter 12: The Beautiful Man

1 Germaine Greer, *The Beautiful Boy*,(Hardcover), Rizzoli, New York, 2003, p. 7
2 Hugo Schwyzer (@hugoschwyzer), Twitter status, 9.12am, 28 June 2013
3 See examples of this at: www.pinterest.com/taramossauthor/the-beautiful-man-part-2-the-suits
4 'Gordon-Levitt on Being a Feminist on Ellen', YouTube video, 1:43 and 3:02, 9 January 2014
5 AAP, 'Cleo brings back the centrefold', *The West Australian*, 15 November 2013
6 Naomi Wolf, *The Beauty Myth*, Vintage, London, 1991 [1990], p. 45
7 Emily Maguire, 'It Takes Two' *Sydney Morning Herald,* 20 November 2010

Chapter 13: The Visible Woman

1 Marina Warner, 'What I see in the mirror: Marina Warner, *The Guardian* UK – Fashion
2 John Berger, *Ways of Seeing*, Penguin, UK, 25 September 2008, p. 144
3 Germaine Greer, *The Female Eunuch* (Paperback), MacGibbon & Kee, 1970, p. 278
4 Richard Kersley & Michael O'Sullivan, 'Global Wealth Reaches New All-Time High', Credit Suisse

Chapter 14: The Mother

Parts of this chapter were first published in Essential Baby, 'In defence of birth plans', Essential Baby, 17 June 2012 .and in the *Sydney Morning Herald*, 'Birth is no time for war stories', 23 June 2012
1 Monica Dux, 'It's a woman's right to choose how she births', *The Age* – Federal Politics, 16 June 2009
2 Tara Moss,'Birth is no time for war stories', *Sydney Morning Herald*, 23 June 2012
3 Andie Fox (writing as 'blue milk'), 'Because reproductive rights include birth rights', Blue Milk blog, 17 July 2009
4 Tara Moss,'Birth is no time for war stories', *Sydney Morning Herald*, 23 June 2012

5 Mia Freedman, 'My view of birth plans is they're most useful when you set them on fire and use them to toast marshmallows', The Sunday Telegraph, 17 June 2012

6 'Early skin-to-skin contact for mothers and their healthy newborn infants', Who Reproductive Library

7 Tara Moss,'Birth is no time for war stories', *Sydney Morning Herald*, 23 June 2012

8 Meredith J. McIntyre (School of Nursing and Midwifery, Monash University), 'Safety of non-medically led primary maternity care models: a critical review of the international literature', Australian Health Review, No, 36, Vol. 2, pp. 140-147, 25 May 2012
See also Australian Healthcare and Hospitals Association (AHHA), 'Midwives as safe as doctors – new study', AHHA media release

9 Jeremy A. Lauer, Ana p. Bertrán, Mario Merialdi and Daniel Wojdyla, 'World Health Report (2010): Background Paper, 29', World Health Organization, 2010

10 Miranda Devine, 'Price of belief may be a baby's life' *Daily Telegraph*, 22 October 2011

11 Patricia A. Janssen, PhD, Lee Saxell, MA, Lesley A. Page, PhD, Michael C. Klein, MD, Robert M. Liston, MD, Shoo K. Lee, MBBS PhD, 'Outcomes of planned home birth with registered midwife versus planned hospital birth with midwife or physician', CMAJ (Canadian Medical Association Journal), Vol. 181, No. 6-7, 31 August 2009

12 A de Jonge, B Y van der Goes, A C Ravelli, M P Amelink-Verburg, B W Mol, J G Nijhuis, J Bennebroek Gravenhorst and S E Buitendijk, 'Perinatal mortality and morbidity in a nationwide cohort of 529,688 low-risk planned home and hospital births', *BJOG* (British Journal of Gynaecology), Vol. 116, No. 9, pp. 1177-84, August 2009

13 Amelia Hill, 'Hungary: Midwife Agnes Gereb taken to court for championing home births', *The Guardian* UK, 23 October 2010

14 Tara Moss,'Birth is no time for war stories', *Sydney Morning Herald*, 23 June 2012

15 Maternal mortality ratio (modeled estimate, per 100,000 live births), World Bank, (1990–2010)

16 Australian Bureau of Statistics

17 T Saisto and E. Halmesmäki, 'Fear of childbirth: a neglected dilemma' Acta Obstetricia et Gynecologica Scandinavica, Vol. 82, No. 3, pp. 201-8, March 2003

18 Tara Moss,'Birth is no time for war stories', *Sydney Morning Herald*, 23 June 2012

19 S S Adams, M Erberhard-Gran and A Eskild, 'Fear of childbirth and duration of labour: a study of 2206 women with Intended vaginal delivery', *BJOG* (British Journal of Gynaecology), Vol. 119, No. 10, pp. 1238-46, September 2012

20 K Stoll, W Hall, P Janssen and E Carty, 'Why are young Canadians afraid of birth? A survey study of childbirth fear and birth preferences among Canadian University students', Midwifery, Vol. 30, No 2, pp. 220-6, February 2014

21 'Rep. Terry England compares women to cows, pigs and chickens', Vimeo video, posted by Bryan Long, 2012

22 Jane Caro, 'The truth is abortions are normal', Women's Agenda, 14 November 2013

23 www.essentialbaby.com.au/pregnancy/due-date-calculator

24 Tracey Spicer, 'No-one 'Wants' To Have An Abortion', The Hoopla, 13 November 2013

25 Katie McDonough, 'Women in El Salvador are being sent to prison for miscarrying', Salon, 19 October 2013

26 www.advocatesforpregnantwomen.org/

27 Ed Pilkington, 'Outcry in America as pregnant women who lose babies face murder charges', *The Guardian* UK, 25 June 2011

28 Henry McDonald, 'Savita Halappanavar died due to medical misadventure, inquest finds', *The Guardian* UK, 20 April 2013

29 Dr Leslie Cannold, 'The questionable ethics of unregulated conscientious refusal', abc.net.au, 25 March 2011

30 Germaine Greer, *Sex and Destiny: The Politics of Human Fertility*, Harper Colophon Books, 1984, p. 248

31 www.unicef.org.au/Media/Media-Releases/July-2013-(1)/ UNICEF-applauds-Australian-first-in-child-and-fami.aspx

32 Ferguson, Ann and Mechtild Nagel (eds) (2009), *Dancing with Iris: The Philosophy of Iris Marion Young*, Oxford University Press, Inc., New York, p. 44

33 Tara Moss, 'Geeks, not all breast exposure is naughty', Essential Baby, 9 February 2012

Chapter 15: Playing Mothers and Fathers

1 Margaret Mead, quoted in International Federation of Women Lawyers, 'La Abogada', Vol. 3, 1967, p. 5

2 In the USA women comprise roughly 50% of the workforce. In Australia women comprise 45.7% of all employees. (Workplace Gender Equality Agency (2013), 'Gender workplace statistics at a glance', WGEA website

3 Shelley J Correll, Stephen Benard and In Paik, 'Getting a Job: Is There a Motherhood Penalty?', *American Journal of Sociology*, Vol. 112, No. 5, March 2007, pp. 1297-1339

4 Steve Twedt, 'Women end up on the spot when employers ask about plans for motherhood', *Pittsburgh Post-Gazette*, 15 May 2009

5 State Library of South Australia, 'Some significant dates in the history of women in South Australia', Government of South Australia

6 Ann Crittenden, *The Price of Motherhood: Why the most important job in the world is still the least valued*, Metropolitan Books, February 2001

7 Sky News Australia, 'Bob Hawke Interview – 06/09' – www.youtube.com/watch?v=0t7OxT5gKUs

8 Jordan Baker, 'Julie Bishop says women can't have it all', *The Sunday Telegraph*, 10 February 2013

9 Doyin Richards, 'I Have a Dream: That People Will View a Picture Like This and Not Think It's a Big Deal', The Good Men Project, 6 January 2014

10 Jill Stark, 'Dads army hopes to galvanise fathers with documentary', *The Sydney Morning Herald* – Life & Style, 24 November 2013

11 Anne Summers, *The Misogyny Factor*, NewSouth Publishing, UNSW Press, NSW, 2013, p. 41

12 Australian Bureau of Statistics, '4102.0 – Australian Social Trends, 2006: Fathers' Work and Family Balance', 20 July 2006'

13 Workplace Gender Equality Agency with Dr Graeme Russell, 'Engaging men in flexible working arrangements', Perspective Paper, Australian Government, 2013

14 Converge International and Boston College Center for Work & Family, 'The New Dad: A Study of Fathers from Australia: Executive Summary', 2012

15 Dr Lindsay McMillan (Converge International), 'Are men given enough time to be great fathers?: Best Father's Day present?

Flexibility', *The Sydney Morning Herald* – Federal Politics, 2 September 2012

16 Oltermann, Philip, 'German vice-chancellor takes time off to be a dad', *The Guardian* UK, 6 January 2014

17 www.naeyc.org/content/what-research-says-gender-typed-toys

18 NPD Group – 'The European Toy Market in 2011: Specially prepared for ICTI', May 2012

19 Gwen Sharp, PhD, 'Girls vs. Boys "Laptops": Guess Which Does More?', The Society Pages – Sociological Images, 28 November 2012

20 Lisa Wade, PhD, 'Girls Need Less Power?', The Society Pages – Sociological Images, 29 December 2009

Chapter 16: The Crone

1 It should be noted that 2014 was unusually balanced and diverse in Academy terms, as Cate Blanchett and Matthew McConaughey won the top gongs in 2014 and they are the same age (44 at the time of the awards), however best supporting actress winner, Lupita Nyong'o (31), was the approximate age of the previous best supporting actress Anne Hathaway (30) and more than a decade younger than the best supporting actor winner, Jared Leto (42)

2 http://en.wikipedia.org/wiki/List_of_Best_Actress_winners_by_age; http://en.wikipedia.org/wiki/List_of_Best_Actor_winners_by_age

3 Kyle Buchanan, 'Leading Men Age, But Their Love Interests Don't', *Vulture*, 19 April 2013

4 www.aihw.gov.au/deaths/life-expectancy

5 Australian Human Rights Commission, 'The gender gap in retirement savings, 2012

Chapter 17: The Feminist

1 Rebecca West, 'Mr Chesterton in Hysterics: A Study in Prejudice', *Clarion*, 14 November 1913, p. 5, reproduced at Marxists Internet Archive

2 'Robertson Letter Attacks Feminists', *New York Times* (archive), 26 August 1992

3 *Quadrant*, 8 November 2012

4 www.oxforddictionaries.com/definition/american_english/feminism?q=feminism

5 JewishEncylopedia.com (the unedited full-text of the 1906 *Jewish Encyclopedia*), 'Husband and Wife – Legal Relations'

6 Allan G. Johnson, Privilege, *Power and Difference*, McGraw-Hill, 2001, p. 90

7 *Enough Rope* with Andrew Denton, 'Derryn Hinch', Transcript, ABC-TV, 7 July 2003

8 Brian Klocke. 'Roles of Men with Feminism and Feminist Theory', National Organization for Men Against Sexism (NOMAS). 8 July 2013

9 Emer O'Toole, 'Men – if you're not a feminist, it's fine, just move on', *The Guardian* UK, 10 January

10 Ruby Hamad, 'In the shadow of men', The Drum, ABC News, 14 January 2014

11 Elizabeth Day (interviewer), 'Susan Sarandon: 'Feminism is a bit of an old-fashioned word'',*The Observer*, 30 June 2013

12 Paul Kurtz and Edwin H Wilson, 'Humanist Manifesto II' American Humanist Association,

13 The term 'sufragette' is attributed by some to journalist Charles E. Hands from an article in the *London Daily Mail*

14 *Harpers Bazaar,* April 2014

15 Anne Summers, *Damned Whores and God's Police*, Penguin Books, Melbourne, 1994, p. 398

18: The Next Chapter

1 bell hooks, *Talking Back: Thinking Feminist, Thinking Black*, South End Press, Boston, 1989, p. 27

2 Jenny Macklin, Paula Matthewson, Karen Pickering, Nareen Young and Jane Caro, 'The panel: why is there only one woman in Tony Abbott's cabinet?' *The Guardian*, 16 September

3 Attributed to Margaret Mead in: Frank G. Sommers and Tana Dineen, Curing Nuclear Madness, Methuen, London, 1984, p.158

Reading List

John Berger, *Ways of Seeing*, Penguin, 1972

Nerida Campbell, *Femme Fatale: The Female Criminal,* Historic Houses
 Trust of NSW, 2009

Eva Cox, *Leading Women*, Random House Australia, 1996

Simone de Beauvoir, *The Second Sex,* H M Parshley (Translator), Vintage,
 1989 [1949]

Susan Faludi, *Backlash: The Undeclared War Against American Women,*
 Random House, 2010 [1991]

Michel Foucault, *The History of Sexuality, Vol. 1: An Introduction,* Robert
 Hurley (translator), Vintage, 1990 [1976]

Michel Foucault, *The History of Sexuality, Vol. 2: The Use of Pleasure,*
 Robert Hurley (Translator), Vintage, 1990 [1985]

Michel Foucault, *The History of Sexuality, Vol. 3: The Care of the Self,*
 Robert Hurley (Translator), Vintage, 1988 [1984]

Betty Friedan, *The Feminine Mystique,* Norton, 1963

Germaine Greer, *The Female Eunuch*, MacGibbon & Kee, 1970

Maxine Hong Kingston, *The Woman Warrior: Memoirs of a Girlhood Among
 Ghosts,* Vintage Books, 1975

bell hooks, *Feminism is For Everybody: Passionate Politics,* South End Press,
 2000

Michèle Le Dœuff, *The Philosophical Imaginary,* Colin Gordon (Translator),
 Stanford University Press, 1990

Caitlin Moran, *How To Be A Woman*, Random House, 2011

Meaghan Morris, *The Pirate's Fiancée: Feminism, Reading, Postmodernism,*
 Verso, 1988

Avital Norman Nathman (Editor), *The Good Mother Myth: Redefining Motherhood to Fit Reality*, Seal Press, 2013

Elspeth Probyn, *Sexing The Self: Gendered Positions in Cultural Studies*, Routledge, 1993

Anne Summers, *Damned Whores and God's Police: the colonization of women in Australia*, Penguin Books, 2003 [1975]

Marina Warner, *Monuments & Maidens: The Allegory of the Female Form*, Weidenfeld and Nicolson, 1985

Naomi Wolf, *The Beauty Myth: How Images of Beauty Are Used Against Women*, Vintage, 1991

Virginia Woolf, *A Room of One's Own*, Martino Fine Books, 2012 [1929]

Acknowledgements

I am deeply grateful for the generosity and guidance of Professor Meaghan Morris and Professor Elspeth Probyn, my patient and inspiring doctoral supervisors at the University of Sydney's Gender and Cultural Studies department. I am also grateful to Hannah Dahlen, Professor of Midwifery in the School of Nursing and Midwifery at UWS, for her expertise and advocacy in the area of midwifery and maternal and neonatal health, and for making herself available for my many questions over recent years, particularly through my UNICEF work as National Ambassador for Child Survival, and Patron for Breastfeeding and the Baby Friendly Health Initiative. Thanks also to Dr Ruth Barcan, Emily Maguire, Eva Cox, Andrea Fox, Alex Heatwole, Alifa Bandali, Sophie Johnson, Emilie Jervis, Grace Sharkey and Karen Pickering for their support and many discussions over coffee, wine, emails and textbooks, and to Chrys Stevenson for the late night – and often complicated – fact checks. I would be remiss not to mention the influence of Professor Patricia Simons' brilliant 'The Crone, the Witch, and the Library in Renaissance Italy,' paper for *Undoing the Ancients* at the University of Sydney, which inspired key aspects of 'The Crone' chapter, and Nerida

Campbell's exhibition, Femme Fatale: The Female Criminal, that I launched at the Justice and Police museum in 2009, for inspiring the writings that became the basis for 'The Femme Fatale' chapter. Thanks also to the influential writings of Cordelia Fine, John Berger, Naomi Wolf, Simone de Beauvoir, Germaine Greer, bell hooks, Alison Bechdel, and the women I have quoted in this book, including Anne Summers, Clementine Ford, Celeste Liddle, Kerryn Goldsworthy, Natasha Stott Despoja, Dr Leslie Cannold, Sophie Cunningham, Tracey Spicer, Ruby Hamad, Nareen Young, Monica Dux and Jane Caro for their work, and for opening up this conversation. Last, but certainly not least, thank you to my friend Dr Emma Jane for the polygraph test that helped change the narrative in my own life.

In truth this is a book I have had locked within for decades. I have many people to acknowledge for their role in helping me bring *The Fictional Woman* to the page.

*

I'd like to sincerely thank everyone at HarperCollins, and particularly Anna Valdinger and Shona Martyn, for supporting my decision to write this, my first non-fiction book, and for their unwavering support of me as an author since *Fetish* in 1999. (And for running with my idea for the cover of this book, including all of my word choices – and managing to pull it off without any digital alteration.) Also thanks to Ali Lavau for her deft carving, Katherine Hassett for putting up with my thousands of emails, and Kelly Fagan for letting me drag her around the country.

Thank you to my agent Selwa Anthony for her ongoing and vital support and friendship. You and Brian are family.

To my extraordinary friends Linda (Thank you for looking into details at Lambrick Secondary) Ali (Gothmother), Helen, Liz, Tracey and Charlie, Mindi, Mat and Irene, Grainne and Zok, Dana and Robert, Juno and Bob, Ted and Helene, Pene and Karim, Natasha and Ian, Lisa and Julian, Nige and Brig, Jack and Venetia, Adam and Susie, Charlotte, Jenny, Lewis and Dan, Di, Dom, Sarah, Josh, Jacinta, Emma, Alicia and Carlos, Anne and Chip, Kate and Pete, Marianne, Martin, Charlie, Julia, Desi and Amelia, Marieke and Michaela, Linda, Eva, Lizzy, Lauren and Josh, Kathy, Amanda, Brenda, Susan and Sham, and all of my other dear friends.

Most of all, I need to thank my family for their love and acceptance, and their support of this book, especially my father Bob, for whom some of these recollections would have been very difficult indeed, and my sister Jacquelyn, for whom the same emotional memories of mum's death still linger, as they do for me. Thank you both for trawling through old family photos and diaries to help me with dates and details for the memoir sections of this book. Mum, we never forget you. Thanks also to my late Oma and Opa and late Grandpa and Grandma Moss. Lots of love to Annelies (Auntie Annie!), Dorothy and Nik, and Maureen, and of course my beautiful husband Berndt, with whom I shared many of these stories before anyone else, and who patiently listened to hours of my thoughts on these issues. (Oh, and for those excellent, life-sustaining coffees.)

This book is dedicated to my daughter Sapphira and the girls who are the women of the future. May they find adventure, challenge, support, opportunity and a safer, more equitable world.

Be kind to each other.